D1346563

# DRAWING
## A COMPLETE COURSE

# DRAWING
## A COMPLETE COURSE

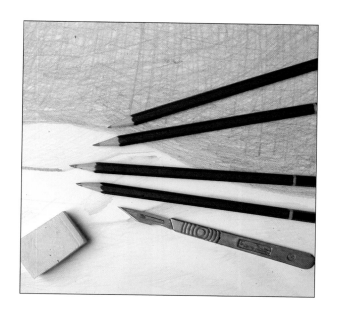

JENNY RODWELL

WITH CONTRIBUTIONS FROM JACK BUCHAN, JONATHAN BAKER
AND GERALDINE CHRISTY

Bounty
Books

First published in Great Britain in 2002 by
Hamlyn, a division of Octopus Publishing Group Ltd

This edition published 2004 by Bounty Books,
a division of Octopus Publishing Group Ltd,
2–4 Heron Quays, London E14 4JP

Text and Photography Copyright © 2002 Jenny Rodwell,
except:
Text and Photography Copyright © 2002 Octopus Publishing
Group Ltd: pp. 12, 13, 16–21, 26–31, 56–75, 94–99, 100–105,
128–131, 138–203, 224–235, 252–257, 270–275
Photography Copyright © James Martin at Rachel
Collingwood Management: p. 70

ISBN 0 7537 0941 4

A CIP catalogue record for this book is available form the
British Library

The material in this volume is taken from the following titles
in the Hamlyn Step by Step Art School Series: *Drawing, Still
Life, Landscapes, Pastels, Portraits.*

Printed and bound in China

CREDITS
The artwork, demonstrations and step by step projects were
done by Roy Ellsworth and Ian Sidaway

*Photography*
35mm photography: Ian Howes
Studio photography: John Melville and Mac Campeanu
Additional photography: John Freeman, Paul Forrester and
Chas Wilder
Other photographs: Paul Barnett, Architectual Association, p. 188

*This edition:*
Executive Editor **Anna Southgate**
Editor **Charlotte Wilson**
Design Manager **Tokiko Morishima**
Production Controller **Ian Paton**
Typesetting **Dorchester Typesetting Ltd**
Index **Indexing Specialists (UK) Ltd**

# Contents

# Chapter 1
# Introduction

Everything in the world is a subject for a drawing; yet what you draw is not important. That you enjoy drawing, and feel you are learning more about the visual world as a result, is of the utmost importance. This chapter explains simply and clearly some of the underlying principles of drawing. It helps you to see every subject with a fresh eye and, above all, it aims to remove the mystique which, sadly, surrounds this fascinating and rewarding activity.

There is nothing magical, for example, about understanding perspective, about 'measuring' the subject, or about drawing negative space. They are all 'learnable' principles which, once mastered, will help you tackle any type of subject with confidence and enthusiasm. Although such fundamentals are important, try not to treat them as 'musts', to be slavishly followed. This chapter is designed to help you, and to remove some of the frustrations of learning to draw – it should not be treated as a textbook, with hard and fast rules, to be first learned and then obeyed!

Drawing is a subjective occupation. The best artist is the one who understands the principles and rules, but who interprets rather than copies them. Composition is a prime example of this. Convention dictates that a pictorial composition must be harmonious; should not contain any discordant elements, such as a figure looking toward the edge of the picture; and should avoid absolute symmetry at all costs. Yet, we only have to look at some of the Old Masters to know that such rules can certainly be bent, if not broken.

This book is largely about materials, about the marks and effects which can be achieved with a whole variety of drawing media. But, without a basic understanding of drawing, the most sophisticated tools in the world will not enable you to produce a good drawing or, more importantly, the drawing you want to produce.

# Introduction

Making the first mark on a pristine sheet of paper is rather like being the first person to trample across a perfect patch of freshly fallen snow – it seems such a shame to spoil it! When learning to draw, the problem is even worse, because most of us have such grand and preconceived ideas of what the finished picture will look like that we are almost doomed to disappointment, even before we begin.

It is therefore a good idea to regard drawing as a process, a way of thinking and recording rather than a means of producing a perfectly rendered picture at every attempt. If getting going becomes a real stumbling block, and the thought of marking the paper is actually inhibiting, then try warming up with a few quick, throw-away sketches of the subject. This is a tried and tested method for overcoming tension and inhibition, and an excellent way of getting into the right mood.

The secret of successful drawing depends upon careful observation and the ability to put down on paper what you can see. So, before starting, take a good look at what is in front of you. Decide how you are going to approach the subject, and where it will be placed on the paper.

No two artists approach a subject in exactly the same way. The sequences on this page show two different approaches. In the first, the artist develops the whole subject concurrently, starting with a rough outline, then working across the image, gradually bringing up the whole drawing at the same pace. The second sequence shows a different approach. Having decided on the scale and position of the subject on the paper, the artist starts drawing in one place and works across the image, bringing each area to a state of completion before moving on to the next.

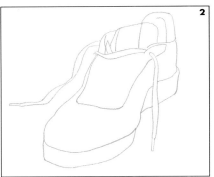

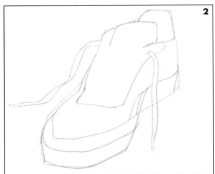

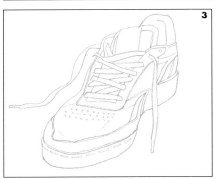

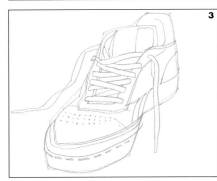

## The 'Growing' Drawing

1  Here the artist starts in one place – in this case the top of the shoe, making sure this is in the correct position on the paper, and leaving plenty of space for the rest of the subject.

2  From here, the lines are extended to show more of the shoe – the finished drawing 'grows' outwards from its starting point.

3  The artist completes the work by putting in remaining undrawn areas and details.

## Developing the Subject

1  For this traditional approach, the artist starts by establishing the main lines of the subject. At this stage, the drawing is kept fairly sketchy and loose to allow for redrawing and correction as the image develops.

2  From the initial sketchy construction lines, the artist works into the subject, using the line to describe the form of the shoe.

3  Finally, the drawing is completed with further line and detail.

## Outline and Internal Contours

Unless we are familiar with an object, an outline drawing of that object will not necessarily tell us what we are looking at. In the outline drawing (below left), we only recognize the subject as being a model of a hand because we know what a hand looks like, and we know that such an outline is likely to be that of a hand. But we need the added information of the second drawing to really know and understand what we are looking at.

The first drawing contains a flat shape; the second drawing describes a three-dimensional form. By drawing into the subject, the artist has turned a silhouette into a solid object.

These internal lines are similar to the contour lines we see on maps. Just as geographical contours describe the form of a hill by mapping out the relief pattern of its surface, so an artist draws contours to describe the form of a subject. The artist, however, must look at the subject to decide where the internal lines should be; they cannot be placed scientifically, at regular intervals, as with maps and diagrams. The hand, for example, has natural contours – the finger and wrist joints, and the wood grain which runs lengthwise down the fingers, hand and arm.

Internal lines are as important as the outline. So don't automatically start by drawing the outline and then filling in the rest. Ideally, you should try to develop the two together, looking carefully at the subject to see how the inside lines and outside lines combine to describe the form. However, there is no reason why you should not try to draw from the inside, and leave the outline to last.

Light and shade can also be exploited in a drawing to give a sense of form to an object (see page 10), changing it from a flat shape into something real and solid. But, remember, the areas of light and shade are not independent of the internal contours. They are directly related to them.

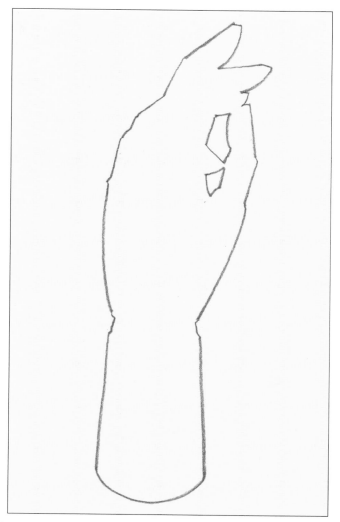

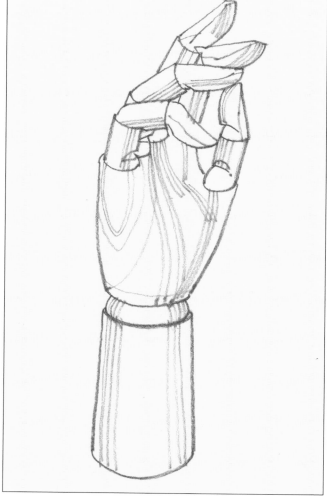

# INTRODUCTION

We are able to see three-dimensional objects because of the light which falls on them. Without light, and the shadows it creates, all objects would be seen as flat shapes. Strong, directional light casts harsh, defined shadows on and around the objects; it also creates bright highlights and reflections. The effect of diffused light is more subtle. The apple illustrated here was drawn in the artist's studio, with a strong window light falling from the top left-hand side, hence the highlights on the top, and the dark shadow across the right-hand side of the fruit.

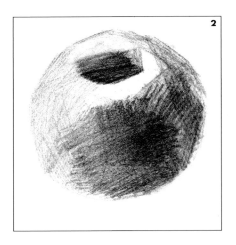

## Tone
To indicate light and shadow on an object means picking out the pale and dark areas. These darks and pales are known as 'tones'. The tonal range runs from black to white, and includes all the greys in between. To pick out the tones, or values, you should ignore the local colour as much as possible, and this can be difficult – especially if the subject is complex or highly patterned. This apple was actually red and green, but the artist was concerned only with the tonal, monochrome effect of the light and shadows, and chose to illustrate this in black and white. Any other single colour could have been chosen.

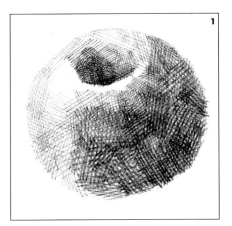

## Types of Shading
These are various techniques for blocking-in shadows. Probably the most common way is to build up a shaded area with a series of parallel lines, a technique known as hatching. When the lines are drawn close together, the tone is dark; widely spaced hatching produces lighter tone. Whichever method you use, it must have this flexibility – you must be able to vary the tone.

**1 Cross-hatching.** Shading built up in patches of tiny crisscross hatching. The cross-hatching becomes finer and more spaced towards the lighter areas.

**2 Scribbled hatching.** Regular parallel lines are unsuitable for the rounded form of the apple, so the artist adopted a looser type of hatching.

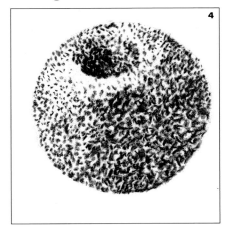

**3 Blending.** Soft shadows, blended with the finger, eraser or cloth, are only possible with soft drawing materials. These include charcoal, pastel, conté and soft pencil.

**4 Stippling.** Tiny dots can be built up to depict shadows – the denser the dots the deeper the shading.

## Colour and Surface Texture
Texture and local colour are factors to be considered when assessing the tonal values of an object. For example, a matt surface will have less tonal contrast than a shiny surface, which often contains bright reflected highlights. Local colour, too, affects

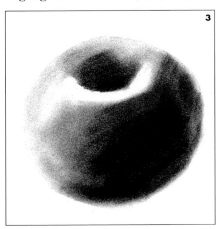

tone. Two identical objects, one light and one dark, will not be the same in a monochrome drawing – the lights and shades on the darker object will be tonally darker than those on the lighter.

## Describing Form
When rendering shadows, you can often give a further feeling of three-dimensional form to the subject by paying close attention to the direction of the strokes as well as to the tones which the strokes represent. In other words, be logical about the direction of the shading – draw with the form, not against it. For example, the hatched lines on the apples are taken round the curved shape of the fruit.

## Planes

Objects with gradually curving sides, such as spheres and cylinders, are simple to draw: the shapes are regular, and light and shade are evenly distributed, making it easy to both recognize and describe the form.

Not all subjects, however, are so straightforward. Natural forms have always been favourites of the artist, but they are inevitably irregular and often complicated. Plants, flowers, animals, birds and human figures are fascinating and challenging subjects, but they are notoriously complex and irregular when it comes to drawing them. Light falls on their surface in an unpredictable way, making it difficult to see, let alone draw, the subtle areas of light and shadow.

The best approach is to find a way of simplifying what you see. Try to ignore distracting detail and small surface irregularities, and to break the subject down into basic areas of light and shade. These simplified areas are called 'planes'.

The illustrations here show a cylinder and a human face, simplified into planes of light and shade. The lightest planes are those areas which receive direct light; the darkest are those turned away from the light. The greys, or mid-tones, describe other planes in varying degrees of light and shade. On the face, the light is falling from the top left, catching the forehead, the cheek, the nose, the convex area between the nose and mouth, and the lower lip. These are the lightest areas in the drawing, and the artist depicted them with the bright, light tone of the paper. The darkest tones, down the right side of the head and neck, are drawn in black.

By simplifying the face in this way, the artist has tackled the problem of form and structure before attempting to create a realistic image. But, with this basic, solid structure established, the artist is then free to develop detail and to blend and break up these large, rather crude planes into softer, more blended areas. The technique can be adapted to any subject, and will help you to draw both simple and complicated forms.

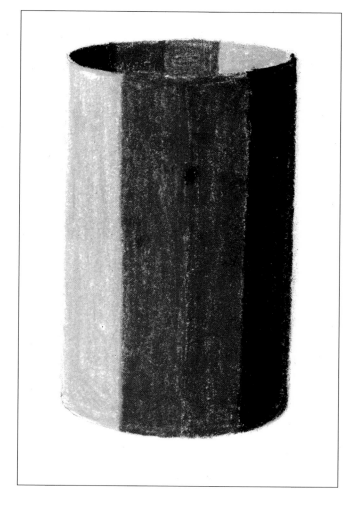

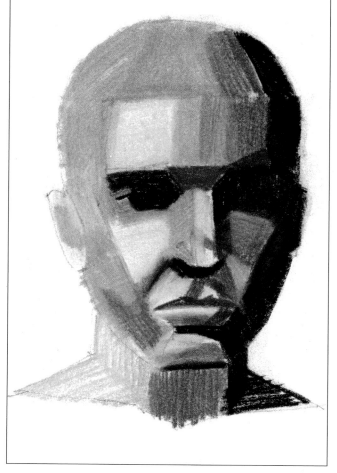

## INTRODUCTION

The best way to learn to draw with accuracy and with ease is to practise, and that means to sketch at every available opportunity. There is absolutely no substitute for sketching, and pastels are an ideal medium. They enable you to make quick colour line drawings and to shade your sketches in a matter of moments. Indeed, the more proficient you are at drawing the quicker you will become and the more sure your results.

Try to take your pastels, or at least a pencil and notebook, with you whenever possible. Preliminary sketches can later be turned into more detailed drawings. If you see a subject that inspires you, make notes on the colours, shapes, direction of light and other details so that you can recreate the scene as nearly as possible.

There is no shortage of subject matter, and one subject which will serve you well is the human face. While you may be able to practise drawing the human figure and the way it moves from a lay figure this will give you no clue at all about people's facial features. Observe people carefully, for the human face also has proportions which must be considered and features will look odd if not drawn in correct relation to others.

One good source of reference material is the television. Think of the number of faces that can be sketched in just one evening sitting at home. Many of them flash on to the screens for just a few seconds, but interviews and news programmes give you the chance to study faces for longer.

Days out at sporting events, walks in the country, visits to wildlife parks and nature reserves and even visits to art galleries can all provide you with sketching material and inspiration to practise your drawing techniques.

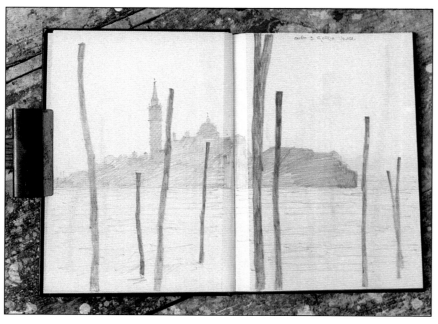

Look at buildings and work out the perspective and vanishing points and areas of shadow. Drawing is a process of ever learning, and trying, and the more you sketch the sharper your eye and the more successful your art.

# INTRODUCTION

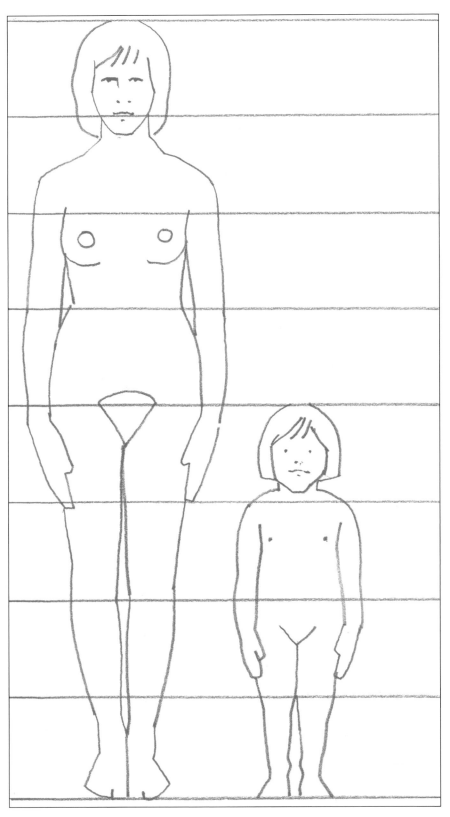

## Proportion

Everyone subconsciously knows the proportions of the human figure, and consequently, if you get this wrong, the mistakes will be glaringly obvious. If the proportions are not right, if you have drawn a figure with a too-large head or a too-long arm, no amount of careful rendering and detail will disguise the monster you have created! And it is a sad fact that the longer you work on a drawing the easier it is to get used to an error in proportion, and carry on in happy oblivion. It is usually somebody else, coming fresh to the drawing, who notices that something is wrong.

One way to avoid this problem is to frequently stand back from your work to check that all is well. Prop the drawing upright to avoid a foreshortened or distorted view.

Generally speaking, the head of a standing adult fits into the height of the rest of the body about seven times; a child's head is considerably larger in proportion to the body, depending on the age of the child. Obviously, this guide is variable, but it is a good general principle to follow.

Arms are always longer than one imagines. An adult standing with arms outstretched measures approximately the same from fingertip to fingertip as from the top of the head to the soles of the feet. When the arms are relaxed, as in the drawing here, the hands hang a considerable way down the thighs.

A seated figure is more of an unknown quantity. Before starting work, imagine a line drawn across the picture from the top of the head to a point parallel to the feet. As a rough guideline, the head takes up about a quarter of the line. Naturally this proportion varies considerably according to different postures and chair heights, so check the proportions of your particular subject, taking the head as the basic measuring unit (see page 25).

## Mass and Volume

The human figure is a solid, single form. But it is also a complex form. The head, torso and limbs can all be seen as separate elements, and each of these is made up of several forms. By analyzing the subject and breaking the figure down into a series of simple cylindrical forms, as the artist has done here, you will make the task of figure drawing much easier.

For this initial stage, forget about line, surface rendering and whether or not your drawing looks like the subject. The main thing is to establish the figure as an arrangement of solid cylindrical forms, with each cylinder representing a mass or volume of the body.

The torso is the largest volume in the figure. In this illustration the torso is upright, the weight of the figure being borne squarely by the chair. Often, however, the torso is at an angle – this is especially the case with standing positions when one leg carries most of the weight of the body. When the weight of the figure is unevenly distributed in this way, the torso leans to correct the imbalance and to prevent the figure from falling over. The head will tend to tilt in the opposite direction.

Stand in front of a long mirror and watch the effect on your body as you shift your weight from one leg to the other. Any change in one part of your body is reflected elsewhere. Observe yourself in a number of positions, and notice how a simple, and seemingly local, act of lifting an arm affects the slant of the shoulders and the angle of the torso. Imagine each of the body's cylinders has an axis, a centre rod, and try to determine how the direction of each axis is affected by your change of position.

The 'cylinder' approach is an excellent way of starting a figure drawing. When you have established the main volumes in this way, the robot-like construction can be rubbed down so that it does not necessarily impinge on your finished drawing. You are then free to concentrate on the visible aspects of the subject, converting the broad masses and volumes to a living, recognizable human being. Without understanding the volumes and three-dimensional composition of the figure, there is always a danger of merely copying the surface.

Although useful, the approach is not a rigidly formal one. It is designed to encourage an understanding of the basic volumes and structure of the figure, not to hamper the drawing by imposing rules. Drawing is not a science. The method outlined here is helpful, but should not be regarded as a technical exercise. The cylindrical diagram may look scientific and unchallengeable, but it is just one artist's interpretation of the subject.

Another artist might analyze the forms in a completely different way, perhaps splitting the torso into two cylindrical forms – one to represent the chest cavity, the other the abdomen – and so on.

# INTRODUCTION

## Portraits

You first have to decide what type of portrait you want to draw. Do you want to concentrate on the face alone or is it to be a full-length portrait? Do you want to portray the person in their favourite place – in a garden maybe, or curled up reading a book? Do you want a coloured background or will you show your sitter surrounded by a few prize possessions, giving a clue to their character? Will it be a formal studio portrait or an action portrait in the fresh air, sailing or biking? Your choice will be influenced by what you like to draw and how complicated you want your portrait to be.

Whatever you decide, remember that the closer you are to a person the more important it is to get the individual features of the face right. If, for example, you draw a person in their sitting room, it will contain many clues to that person's character from its decor, and the possessions and nick-nacks scattered around it.

## Your Model

There are many ways of arranging a model for a portrait. The pose can be informal – sitting on a sofa or lying on the grass outside. Alternatively, the

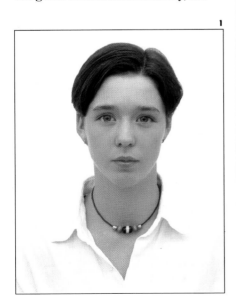

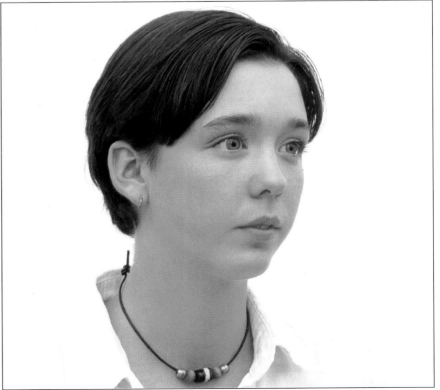

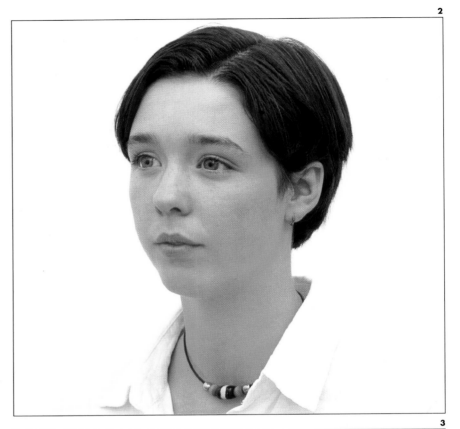

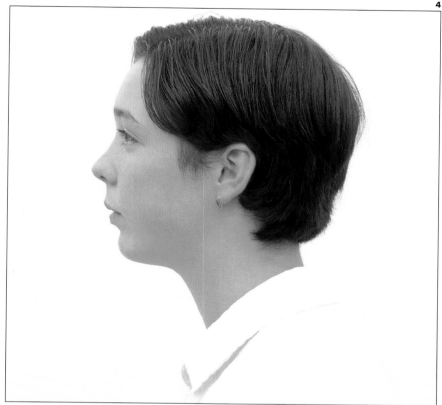

**4**

## INTRODUCTION

*The photographs on this spread illustrate the substantially different shapes the human head takes on when the viewpoint is changed. Straight on (1) you see an oval outline, but a step to either side (2&3) flattens the oval towards a circle. In addition, the bone structure of the forehead and cheeks becomes apparent. A step further and you are into full profile (4&5) where the structure of the face is at its most pronounced. By viewing your subject from below (6) and above (7) the effect is different yet again.*

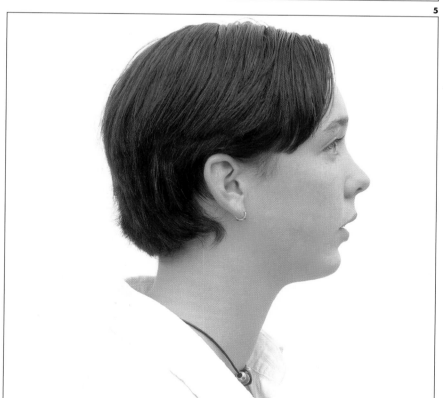

**5**

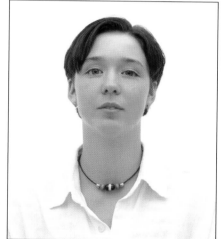

**6**

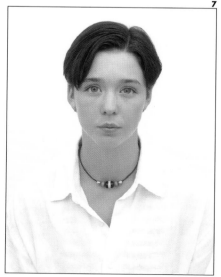

**7**

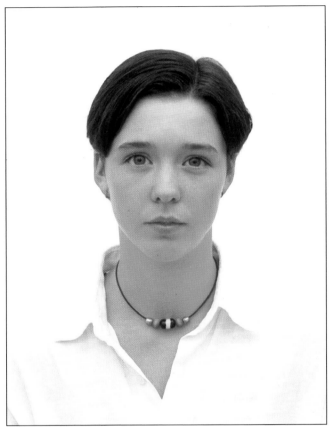

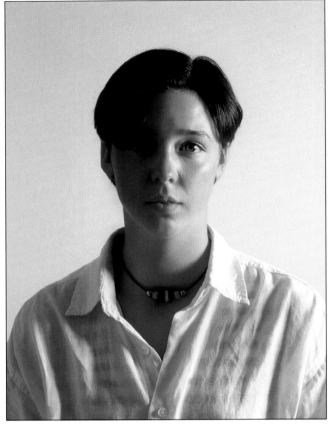

sitter can be posed to make an interesting composition, maybe with the face in profile or the torso twisted. Whatever pose you decide upon, you have to be aware of the comfort of your model if you want him or her to maintain the position for any length of time. This can also be applied to the expression on the face. It is difficult, for example, to hold a smile for any length of time.

It is a good idea, once you have arrived at the perfect pose for your model, to take a polaroid photograph so that the model can easily return to the pose and, if necessary, you can complete the portrait even if your sitter gives up on you!

## Lighting

Lighting is very important, as you will discover. You need to take into account the type of light you want: natural or unnatural, its direction, its

strength, and also its colour and depth. The lighting you choose will depend on the type of portrait you are composing or the character you are trying to portray. Experiment with lighting on your own face by using a hand mirror. Notice the shadows cast by your features. Stand close to the window and then move back from it, into a dark corner of the room. Try with a strong overhead unnatural light and then with a spotlight trained on the face from one side.

Natural light from a window is considered kinder to a face than an artificial light source. Daylight is more mellow, resulting in no ugly shadows being cast over it. The density of natural light is usually more flattering than harsh artificial lighting.

If your model sits facing the main source of light, his or her face will appear flatter and less sculpted because there are no shadows in the

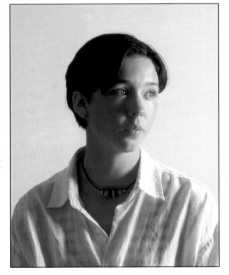

eye sockets, around the nose or mouth. It is best to draw in a gentle general light with more directed light coming from one side. You can make your portrait more dramatic by directing strong light more obliquely

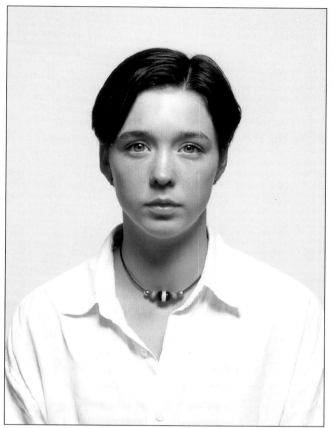

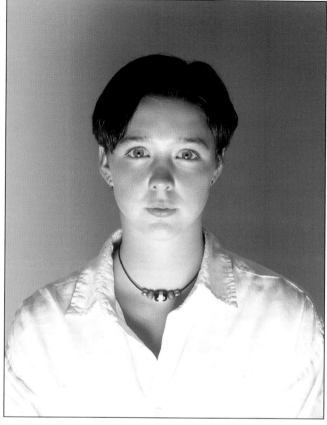

*The photographs on this spread show how, through the use of directed interior lighting, a vast range of different effects can be achieved. Lighting can be used in a wealth of ways – not only to create atmosphere. With a bit of care and attention you can use harsh lighting to pick out the bone structure in the face to make the sitter look older or thinner or to create a melodramatic effect. Softer lighting tends to have the opposite effect, potentially taking years off your model.*

to extremes of contrast. Bright light from above produces cavernous dark eye sockets and dark shadows cast by the nose and lips – appropriate for portraits of historical villains maybe, but not very flattering to your greatest friend!

Experiment with colour too. If nature does not oblige with warm sunlight or cool moonlight, place coloured filters over a lamp. A figure basking in golden sunlight will give a very different impression to one seen in the rosy glow of a fire.

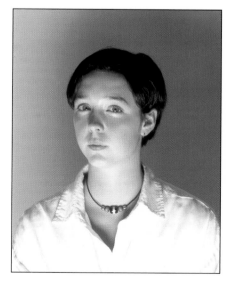

## Getting Ready to Draw

Having organized your model, you need to consider the practicalities of drawing them. You need to be seated or standing so that you can see your model by looking across or beyond your support just by moving your eyes. It is hopeless to arrange your drawing gear and then your model in

from the side so that one side of the face and body is in deep shadow. These effects are the same whether you use natural or artificial light.

Bright, harsh light flattens the subtle curves of the face, reducing it

such a way that you have to come out from behind an easel, stand up, or swivel around in order to see them. Whatever medium you are using – and these are individually explored in the coming chapters – make sure that

# INTRODUCTION

you have everything you need close to hand before you start. It is distracting for you and your model if you have to keep wandering off to find things.

## Proportions of the Face

The proportions of the face stay the same whether the sitter is facing you head on, half turning, or in profile. Seen head on, there are a few general points worth noticing: the eyes come about halfway down the head, the ends of the eyebrows align with the tops of the ears, and a line through the base of the nose runs through the base of the ears. A vertical line can be taken through the inside corner of the eye to the outside width at the base of the nose. Of course, faces vary enormously, and these proportions are only a rough guide. However, by knowing about them, you can see how the face of your sitter varies from them and this will help you to capture their likeness. The features in a baby's face, for instance, appear crowded in the centre of the face. By adulthood, the features have spread out.

## Applying Perspective

If you are looking at the face from above or below, then the proportions change. Sketch a willing model with face upturned and notice how the area between chin and nose now dominates. Notice the rounded planes – over the top of the cheekbones, the brow and the hairline. Now sketch the face from above. The brow and nose now dominate over a reduced chin.

## Getting a Likeness

This is always the aspect of portraiture which unnerves the artist. Yet it is a case of careful, objective observation. Look at the shape of the face – is it round or square – and then the proportions. You can fix these proportions by measuring with your thumb along a pencil in your outstretched hand. A good exercise is to take a photograph of a friend, turn

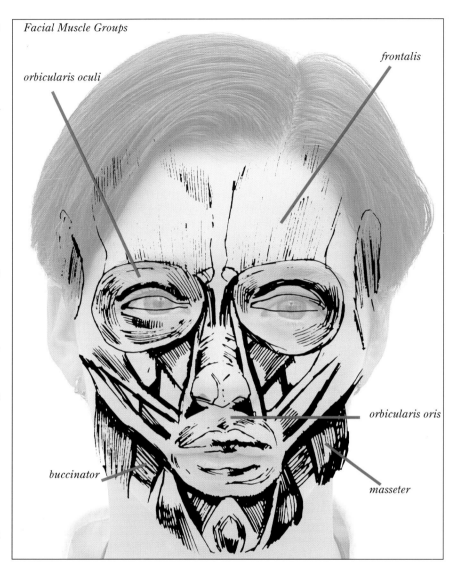

*Facial Muscle Groups*

*orbicularis oculi*

*frontalis*

*orbicularis oris*

*buccinator*

*masseter*

it upside down and then sketch it. This will force you to look at it objectively as a series of lines and interlocking areas of light and shade. The results are often surprisingly good.

## Sketching the Face

You will learn a lot by sketching faces. Sketch any faces you can find – photographs in magazines, from photo albums, or willing family and friends. By doing this you will build up a gallery of heads of different shapes and sizes, heads with and without hair, faces with glasses, beards and moustaches, tired faces,

**Above and Opposite Page:**
*Beneath the skin lie the bone and muscle structures. It is these which work together to give the face its contours and so establish the general features.*

old and young faces. You will notice how smiling faces push up the cheekpads against the eyes, half closing them. You will observe the texture of skin – from shiny, tight, baby skin to sagging, wrinkled octogenarian skin. All this and much more you can glean from watching and sketching people around you.

## Modelling the Face

Learning to model the face takes practice. We tend to forget the face is a series of rounded planes. The brow is rounded, the cheeks, the eyeballs in their sockets, the bridge of the nose, the mouth – all are curved. If you can remember to sketch these as curves and rounded planes with appropriate shadows, then you are halfway to achieving a realistic image.

You will find shadows and shade where the light is obstructed. If the light comes from above, a fringe will cast a shadow, as will the brow, the nose, the pads of the cheeks and the lips. Areas of highlight will appear on the brow, the bridge of the nose, the tops of the cheeks and the chin.

With a soft pencil, and by using a photograph of a face, draw the shape of the head and then map out the areas of tone without 'drawing' the features with lines. Shade in the areas of dark tone and mid-tone, leaving the highlights white. You have to be strict with yourself. When you have finished, you will find the facial features have emerged through these patterns of tone.

## Body Shapes and Clothes

A portrait is rarely just a face. The body of the sitter, even if only part of it is viewed, is equally important in building up a character, as are the clothes. If you have trouble with getting the proportions of the body right, try seating a figure in a chair. Draw the chair first and use it like a grid to place the main lines of the body in it.

Some artists, such as the seventeenth-century Spanish artist Velázquez, delighted in painting the details of their sitter's clothing.

Velázquez had a talent for painting fine lace and brocades as well as the fine black woollen cloth fashionable at the time.

Clothes help to define the character and give shape to the body. The curved edge of a cuff will describe the plumpness or angularity of a wrist. However, you do not need to work the body or clothes to the same degree of finish as the face. Some artists just fade out the detailing at about the waist, allowing pencil sketch lines and the paper or canvas to show through. Alternatively, you can block in the clothing in much bolder and broader strokes.

## Hands

It is often said that hands are as expressive of the character of a person as is the face. Hands can offer another point of interest in composition, balancing the face. Look at people's hands and notice how they hold them. Take a week when you only sketch hands – on the bus, at work, from photo albums and magazines.

## Skin Tints

There is no magic recipe for mixing skin colour in pastels because there are so many different tints of skin from 'white' to 'black'. However, as a general rule, you should block in the facial area with a mid-tone flesh tint and then work down to the deepest shadows and up to the highlights from the mid-tone.

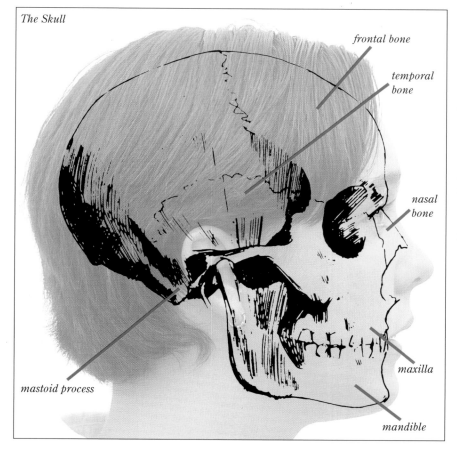

*The Skull*

frontal bone

temporal bone

nasal bone

maxilla

mandible

mastoid process

# INTRODUCTION

## Planning the Picture

When we talk of 'composition' we are really referring to the way the subject is arranged on the paper. This may be a single object – a vase of flowers, or a figure. Or it might be an arrangement of objects, or a complete scene.

Whatever you are drawing, it is important to give some thought to the composition before you start.

These still-life drawings illustrate just four possible arrangements of the same subject, and there are an infinite number of other possibilities. Notice how the background plays an important part in each one. The basic division of the drawing into the blue and brown shapes is just as important as how the mugs and coffee pot are arranged. The artist has avoided a horizontal division, preferring a more interesting and unusual solution in this case.

No subject fits conveniently into a rectangle or square – the shapes we generally work on. When we look at the subject, what we actually see is an amorphous shape with an indistinct outline – and our eyes can only focus on one part of that shape at a time. The rest of the image is blurred.

The most immediate problem, therefore, is defining the edges of the composition, finding the most suitable shape for the subject and fitting the subject into that shape. This applies even with a figure study, an isolated drawing which does not actually touch the edges of the paper. It is still necessary to place the subject properly on the paper, leaving enough space around the figure to prevent it looking cramped, but not so much that the subject looks small and lost.

An excellent way of looking at the subject through 'rectangular eyes' is to cut the shape from a piece of card. This can then be moved around until you find exactly the composition you want. In this way you can actually see the shapes of the space around your subject – the blue wall and brown table in the case of the illustrations on this page.

Scale, too, is an important consideration. Variation of scale within a composition is usually more interesting than one which has no contrast between distance and foreground. This is especially true of landscapes, which can be very dull if everything is small and distant.

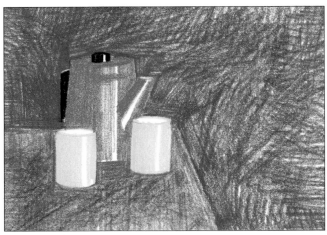 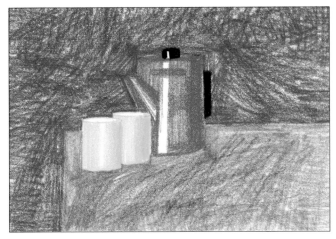

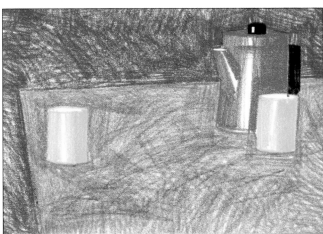 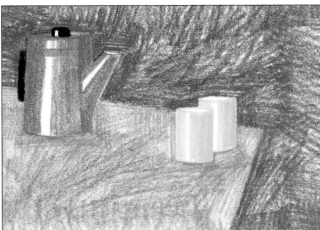

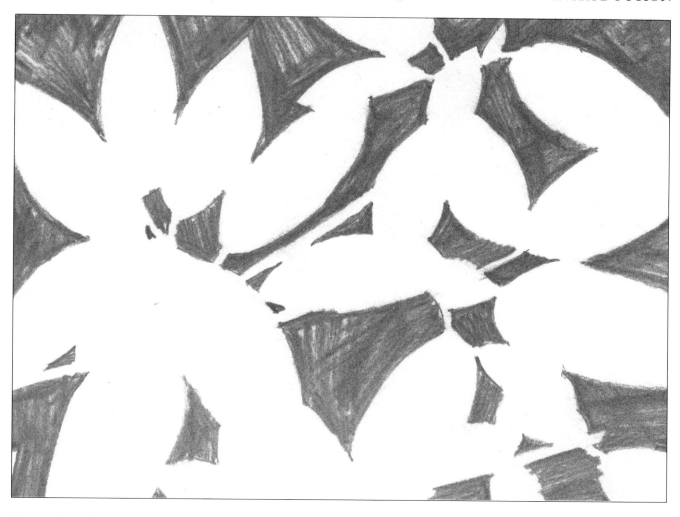

## Negative Shapes

When planning a composition, remember to include in your calculations the spaces around and between the subject. If these are not taken into account, your drawing will, at best, lack cohesion and a sense of design. At worst, it will be wrong, because if the 'negative' shapes are inaccurate, this will be reflected in the rest of the drawing.

The leafy twig illustrated here was done not by drawing the shapes of the leaves, but by drawing the shapes of the spaces between the leaves – the negative shapes. By working in this way, the artist has successfully created a satisfying composition, with every area carefully considered and brought into the overall design. Notice how the subject is extended to the edges of the paper, the straight edges of the support thus forming part of some of these outer shapes.

Drawing the negative shapes forces an awareness of the composition as a whole. It also discourages a tendency to draw what we know rather than what we see. For example, we know what a leaf looks like, so why bother to check that we have drawn it right? However, because we have no such preconceived idea about the shape of a space, it becomes necessary to look very carefully at what we are drawing. The purpose of the exercise is not to produce a drawing in which the negative shapes are as important as the positive ones – in this case the leaves. Rather it is a device for drawing the positive shapes correctly in relation to each other by drawing the spaces between them correctly.

Practise the technique. You will be surprised how much easier it is to make correct drawings once you become aware of negative shapes. Chairs, tables and stools are ideal for this type of exercise, because their legs and crossbars create a variety of geometric patterns of empty space. Other good subjects are winter trees, with their twisted and splayed branches and spindly twigs; household objects; and groups of figures.

# INTRODUCTION

## Linear Perspective

Imagine standing in the middle of a completely straight road, looking into the distance. You will notice that the edges of the road appear to come together and disappear at a spot on the horizon. The scene demonstrates perfectly the principle of linear perspective – that all such parallel lines on the same plane appear to get closer as they recede into the distance. The point at which they appear to meet is called the 'vanishing point'. The practical applications of linear perspective are important,

because, if the perspective of a drawing is wrong, this distorts the whole composition.

If two sides of an object are visible, two vanishing points are necessary; more rarely, three sides of an object can sometimes be seen, in which case three vanishing points are required. In the drawing below, two 'sides' of the ship are visible, and the artist has plotted the two vanishing points.

## Aerial Perspective

Objects appear to get fainter as they recede into the distance. For example,

hills and mountains look bluer and paler, the further away they are. This is because the intervening atmosphere interferes with our perception of them.

For the artist, aerial perspective can provide a useful means of indicating space. By making distant objects fainter, and by drawing with finer lines, it is possible to create an illusion of recession. In the bridge drawing below, the artist used a soft pencil for the heavy foreground lines; for the distant objects, a hard pencil was chosen to create thin, pale lines.

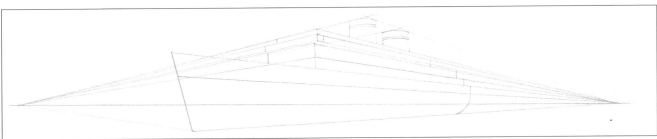

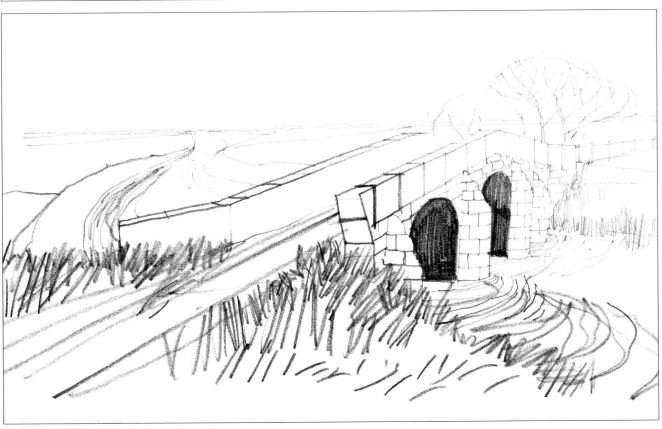

## Measured Drawing

By holding the pencil upright at arm's length, you can use it as a measuring device to help you to establish the correct proportions of the subject. Start by choosing one 'distance' on the subject as your measuring unit. Use the top of the pencil to mark one end of this unit, and your thumb to mark the other end. Everything else can then be plotted accurately in relation to this one measurement.

For the tulip drawing below, the artist first took the measurement of one bloom, and worked out the position and size of the vase and the other flowers in relation to this chosen unit. For example, the height of the bunch of flowers was exactly six times that of the measured tulip head, and this was duly plotted in. Before drawing a single line, the composition was thus plotted out in some detail – the position of each element was indicated with a series of marks. In this particular drawing, the artist worked in coloured pencils, so each mark was plotted in an appropriate colour – red flowers, green leaves, and so on.

When drawing a figure, the obvious measurement to start with is the height of the head. Generally, however, it does not matter which part of the subject you choose, as long as it is consistent and easily visible.

Of course, the literal measurement of the chosen unit has no bearing on the size it is on the paper. If this was the case, you would have no choice at all in the size of your drawing! It is the relative size which is important.

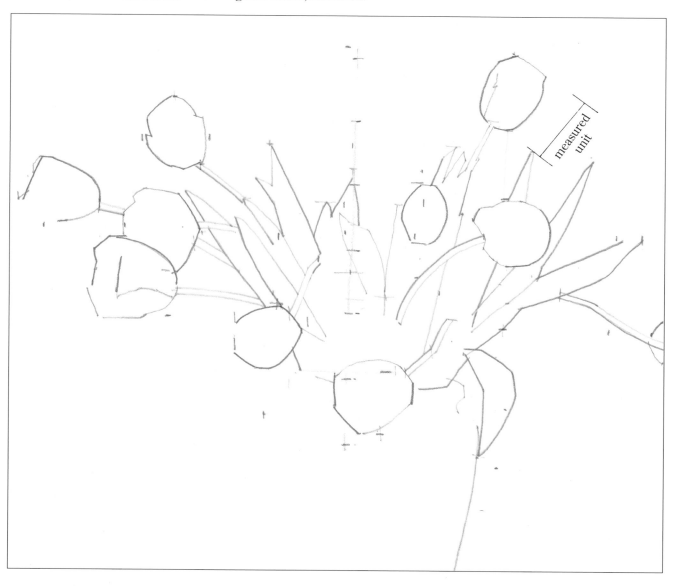

# INTRODUCTION

When artists speak of colour they use specific terms and categories to describe exactly what they mean. It is helpful to have a basic understanding of these terms so that you can develop your use of colour to its full potential.

There are three colours, or hues, which cannot be mixed from other colours. These are red, blue and yellow and are known as the primary colours. All other colours can be mixed from varying amounts of these three primary colours.

If you mix equal amounts of two primary colours you produce a secondary colour. Thus red and blue produce violet, red and yellow make orange, and blue and yellow produce green.

By mixing all three primary colours together in varying amounts you can produce what are termed tertiary colours. These are a range of more subdued colours such as burnt orange and olive green in addition to numerous browns.

You will probably find it useful to make your own colour wheel or chart to see how all these colours mix in practice.

Colours that are near to each other on the colour wheel, for example red, orange and yellow or yellow, green and blue, are termed harmonious colours. Those that are opposite on the wheel, for example blue and orange or yellow, and violet, are termed complementary colours. When two complementary colours are mixed together they produce a neutral grey colour. Much of the theory of colour revolves around the use and juxtaposition of harmonious and complementary colours.

Artists also speak of the temperature of a colour. Those based around orange on the colour wheel are considered to be warm colours, while blues and greens are felt to be cold or cool. A skilful use of warm or cold colours can create a strong visual effect.

The lightness or darkness of a colour is measured by its tone. When a hue is mixed with white to make it lighter the resulting colour is known as a tint, while a hue mixed with black to make it darker produces a colour known as a shade. It is an interesting exercise to see how many tonal values you can give to one colour by adding gradated amounts of it to white or by adding gradated amounts of black to the colour.

Learning to mix colours is part of the fun of pastel work and becoming familiar with just some of the infinite range of hues and tones is a major step towards discovering how to use them to best effect.

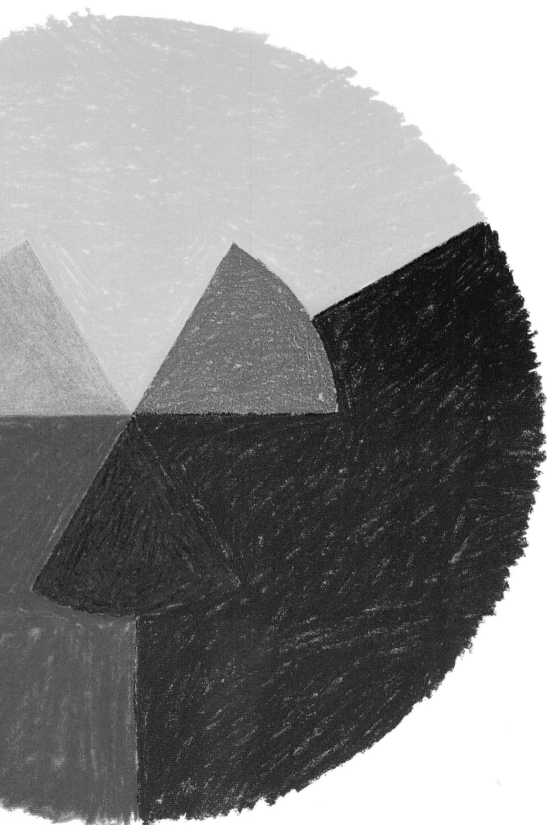

**The colour wheel**
Mixing secondary and tertiary
colours with pastels requires a
slightly different technique
from paints. The pigment is
applied dry and the colours
need to be built up in layers and
blended, or mixed visually from
a distance. A huge range of
tints is available and some very
subtle tones can be achieved.

# INTRODUCTION

Volumes have been written on the subject of colour theory, but if you have at least some practical experience of the way colours work visually then you can approach your subject with some confidence.

Colour can be used to establish distance and movement within a picture and the coloured squares within squares shown here demonstrate clearly how our perceptions can alter quite radically when two colours are juxtaposed. Try creating a series of squares to experiment with harmonious, complementary, warm and cold colours and tones to build up some

colour reference of your own.

The use of one colour always has some effect on another in the same picture. When complementary colours are used next to one another they appear to make the other colour look brighter. Thus you can enrich the colour of an object by casting its shadow in its complementary colour.

An orange, for instance, will look even more orange if it is casting a blue shadow.

The natural, or local, colour of an object can also be tinted by colour that is reflected on to it. This happens when a bright, dominant colour is placed next to it. If you hold a

buttercup under someone's chin then you will see the effect of reflected colour.

Remember that all colours change according to the light conditions both indoors and outside, so always observe carefully before you start to draw your subject.

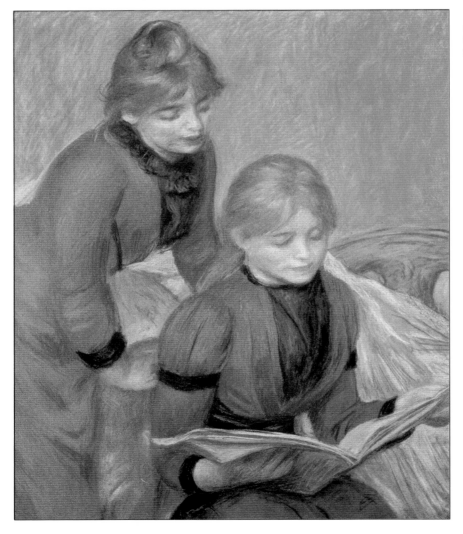

*In* The Lerolle Sisters, *Renoir (1841–1919) boldly juxtaposes complementary colours to intensify both the orange and blue tones.*

It is generally accepted that cooler, darker colours recede or move into the background and warmer, brighter colours advance or move into the foreground. The two columns of squares show pairs of colours side by side and appear to bear out this theory. In the left-hand column the inner squares advance and in the right-hand column the inner squares recede.

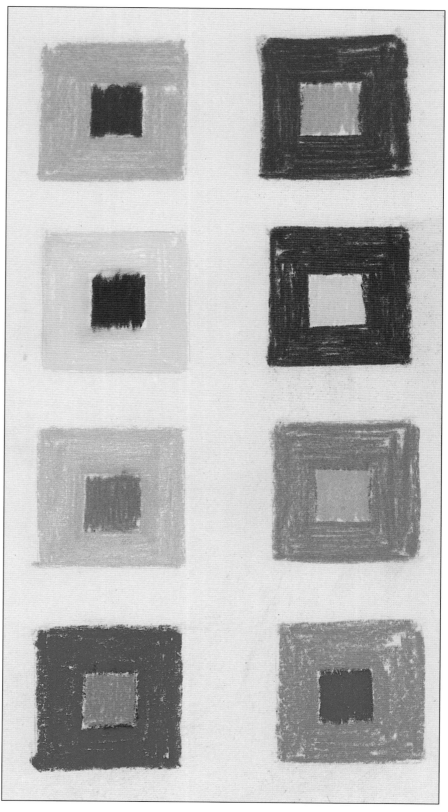

## INTRODUCTION

There is no need to buy a large number of pastels to have a wide range of colours and tones to hand, for the art of pastels lies in mixing and blending.

If you intend to specialize in landscapes or portraits, then boxes of a dozen or so pastels are available with the appropriate colours and tones already selected. You can also buy a box with an assorted selection. It is far more satisfying, however, to choose your own and to spend some time just working out a few of the new colours this will enable you to mix.

Here the artist chose to make a limited palette of ten colours, and shows that by mixing just two colours together you can achieve numerous new ones. Those illustrated here are just some of the possibilities. The ten pastels he chose were:

Poppy Red
Crimson Lake
Mauve
Cobalt Blue
Yellow Ochre
Lemon Yellow
Lizard Green
Burnt Umber
Vandyke Brown

These colours form a useful base from which to work, but you may wish to make your own selection. Every artist has different colour preferences and requires a palette suited to expressing their own style and choice of subject.

You can also choose to limit your palette entirely to one colour. Working in monochrome does not limit you to black and white, however, for you can choose to draw in tints of any colour. You might wish to try the colours of black, white and red that were used to such effect by Leonardo and other Renaissance painters or to use a range of browns and try to reproduce the sepia effects of old photographs.

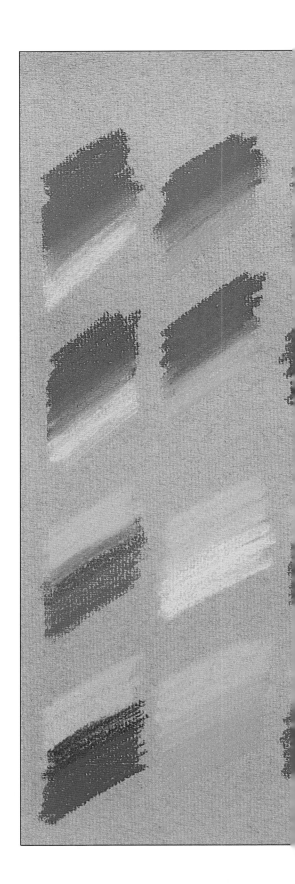

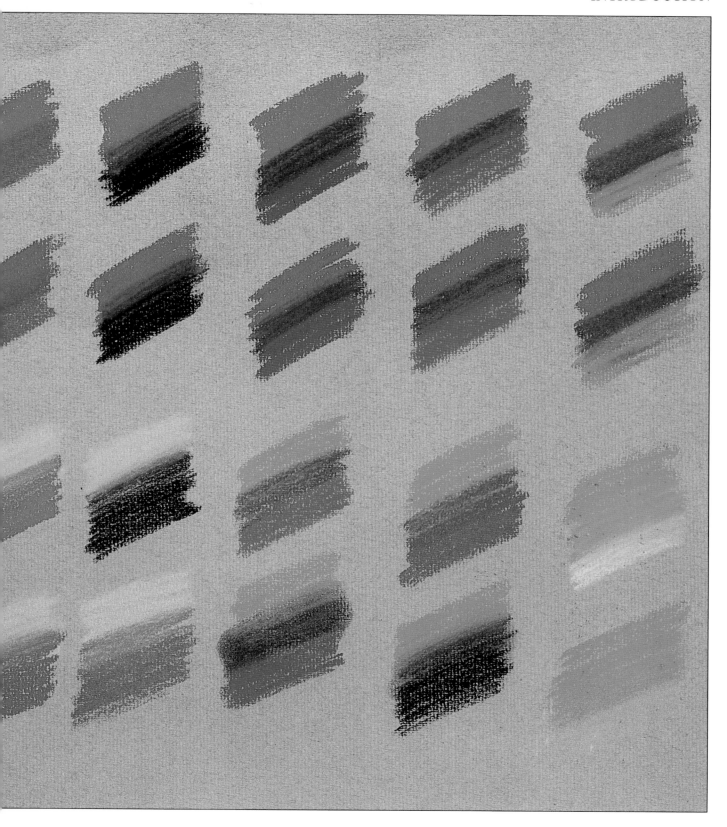

# Chapter 2
# Equipment

Learning to draw is very much a matter of learning how to exploit the materials. In the practical sections of this book, the materials – the actual drawing media – are described and discussed in detail. Pencils, pastels and charcoal, for example, are clearly illustrated, with demonstrations of the marks they make and the techniques to which they are best suited. There are, however, certain materials and items of equipment which are common to all, or many, of these groups. This chapter takes a look at a few of these – some are helpful, some useful, and some essential.

Choosing the right paper for a particular material can be confusing and time-consuming. In this chapter we suggest suitable supports for the various media. This is done gently, usually without too many absolute prohibitions – although obviously there are a few 'definitely nots'!

Erasers, pencil sharpeners and easels are also discussed here. Generally, the recommendation is to resist the temptation to go out and spend money on equipment before you really know what you want. Easels, for example, are a relatively expensive item. Although undoubtedly useful, an easel is not essential (the step-by-step drawings in this book were actually done without an easel). By all means buy an easel, but wait until you know what your requirements are – whether you like working small or large, indoors or outdoors, and so on.

Sketching and drawing are compact, portable activities – that is one of the great attractions. But work mounts up, and pieces of paper accumulate at an alarming rate. It is useful to have storage space for your drawings and sketches – plan chests, folders and filing systems are all practical possibilities and well worth thinking about.

Indoor drawing calls for good lighting. Not only should you have adequate illumination for the subject, but the paper too should be well lit. Whether you are working by daylight or artificial lighting, try to avoid the light falling in such a way that your hand casts shadows on the paper.

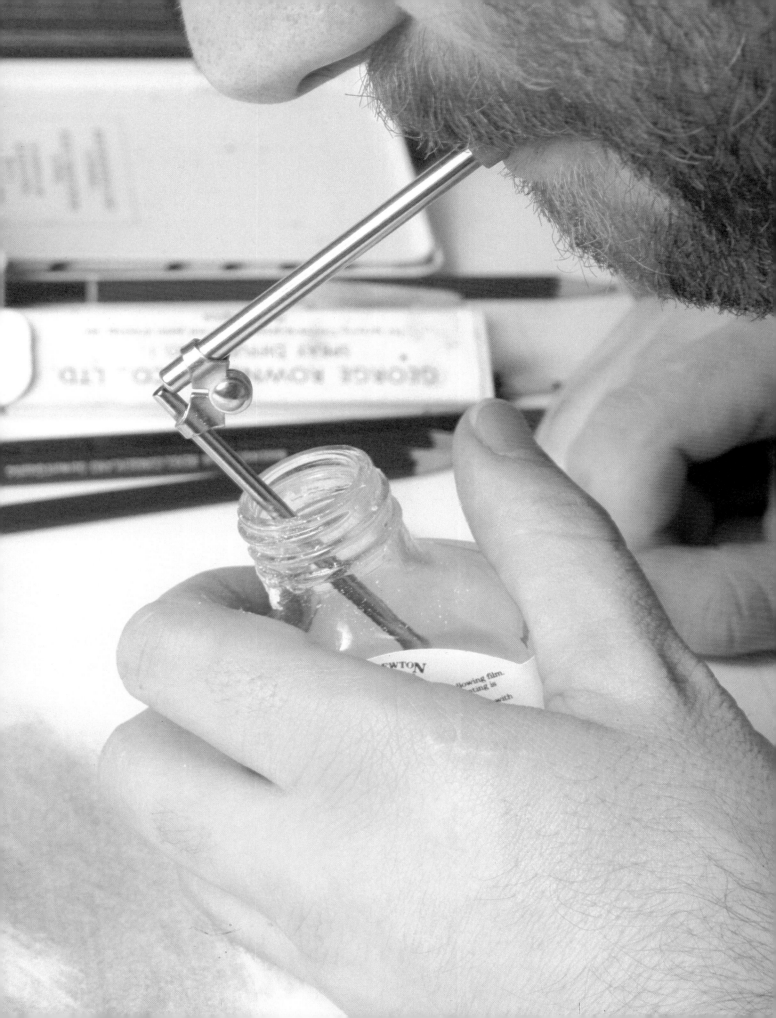

# Equipment

All you actually need to make a drawing is a piece of paper and something to draw with. The basic requirements are that simple. Of course, most artists possess a far wider selection of materials and equipment, many of which were bought for a particular job, and which have accumulated over a period of time.

It is almost always a mistake to go out and buy masses of materials in one go, especially for the beginner. Far better to start off with the minimum, adding to this gradually as you become more involved and confident. An art shop is rather like an Aladdin's cave, full of colourful and tempting things. But not all of these are suitable, and some are very expensive. So start off with a few basics. Some of these, such as fixative and erasers, are essentials. Others, like easels, a ruler and sticky tape, can make life much easier.

## Sketchbooks

These come in a wide range of sizes and types. The most useful size is one which fits into a pocket or bag and can be carried around. Sizes start at around 7 in×5 in (17.8 cm×12.7 cm), going up to 25 in×20 in (63.5 cm×50.8 cm), and larger.

Hardback sketchbooks are durable and easy to keep and file away (they have a spine, so can be labelled and stacked on a shelf for easy reference). Daler hardback sketchbooks have 80 pages, perforated for easy removal. Spiral-bound pads with a stiff card backing are useful for outdoor sketching: used sheets can be flicked over quickly, ready for the next drawing.

Type and quality of paper varies. Most drawing pads and sketchbooks are made from cartridge paper, but other papers are available. These are made and sold mainly for watercolour work, containing Bockingford, Saunders and other types of quality paper. But they can also be used for drawing. For pastel and other colour work, Ingres drawing pads are made with an assortment of coloured papers.

## Knives, Blades and Sharpeners

For the best results, all pencils should be kept well sharpened. Artists who work a lot with pencils use electric sharpeners to save time, otherwise a standard sharpener will do. Some pencil products are the wrong size or shape to fit a normal pencil sharpener – these include rectangular studio pencils, which have to be sharpened with a knife or blade; and the new, chunky water soluble coloured pencils (featured on page 244) which come with their own sharpener.

Craft knives and surgical scalpels, with interchangeable blades, and shielded razor blades are all ideal for pencil sharpening.

## Drawing Board

A board to rest paper on really is an essential. This can be bought from an art shop – these are usually wood or laminated wood; some boards are reinforced with metal ends. Alternatively, you can make your own from offcuts, providing you choose an absolutely smooth surface. The size

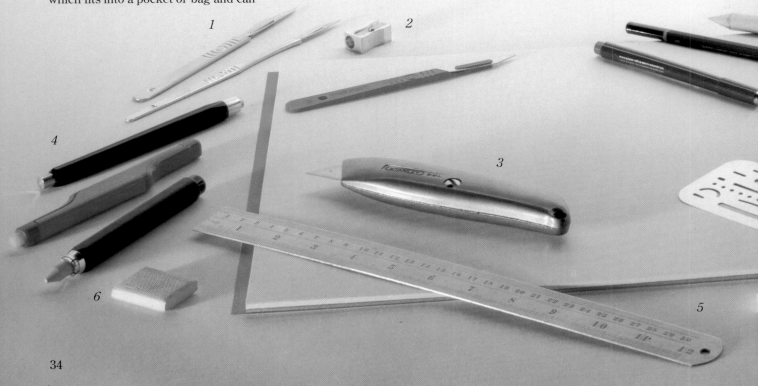

obviously depends on how large you are likely to work, but a practical size and weight would allow you to carry the board around with you easily.

## Erasers and Eraser Shields

Ideally, do as little erasing as possible. Continual rubbing out can become a bad habit, undermining your confidence and hindering any possible improvement. As your dependence on rubbing out increases, a line ceases to be a committed mark. It becomes merely a tentative suggestion, a mark which can be easily rubbed out if it is wrong. This 'let out' is not good for the beginner, who should experiment extensively, learning to observe as well as trying out new ideas and materials rather than being concerned with the final, perfect mark.

Some erasing, however, is inevitable, and sometimes erasing is necessary to achieve a certain effect. The drawing on page 220 is a good example of what can be achieved with creative rubbing out!

The soft kneadable eraser is the most useful type. It can be moulded to any shape, and does not mark the paper. Especially effective with graphite and charcoal materials, the kneadable eraser is ideal for rubbing back and lightening initial construction lines of a drawing. It is also widely used for creating sharp highlights in an otherwise dark or tonal drawing.

Both the traditional India eraser and the plastic eraser are harder than the kneadable type, but they are fine for removing lighter pencil marks. The plastic eraser is excellent on tracing and layout papers.

Removing ink is rarely entirely satisfactory, but the specially designed plastic ink rubber contains oil, and this makes it possible to remove specks and small areas.

An eraser shield can be invaluable for fine, detailed drawings. The tiny cut-out shapes can be neatly erased; the metal or plastic template protects the rest of the drawing. By moving the template around, it is possible to create any shape you require.

1  *Scalpels*
2  *Pencil sharpener*
3  *Craft knife*
4  *Eraser, lead and strip holders*
5  *Ruler*
6  *Putty eraser*
7  *Erasing shield*
8  *Drawing pad*
9  *Tape*
10  *Ink and pencil eraser*
11  *Sketchbooks*

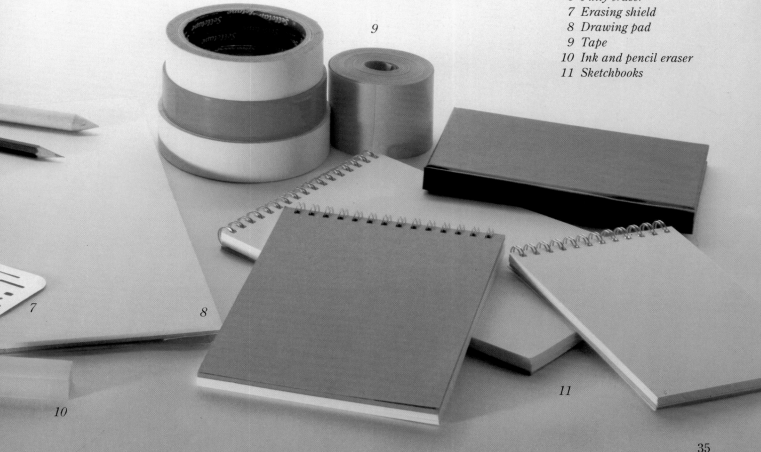

# EQUIPMENT

## Fixative

Any drawing which is liable to smudging should be given a spray of fixative to preserve the sharpness and crispness of the image. Pastels, conté, charcoal and other soft, crumbly materials should always be fixed as soon as the drawing is finished. Often it is a good idea to apply a light spray of fixative at certain stages during the work – this minimizes the chances of accidently smudging the unfinished drawing with your sleeve or hand.

Fixative is supplied in aerosol cans, which are easy to use and store. Otherwise it can be bought in glass or plastic bottles. This is a cheaper alternative, but you do need a metal blower to spray the fixative onto the drawing. Both methods are equally satisfactory.

Fixative does tend to darken the colours of the drawing, sometimes quite severely. Pastels are particularly vulnerable, because the light, bright colours absorb the thin varnish and this can affect the tonal values of the whole drawing. Many pastel artists spray their work from the back for this reason – this method is slightly less effective because it can leave loose particles on the surface of the picture, but there is far less risk of altering the work.

To fix a drawing, hold the can or bottle at right angles to the paper, at a distance of about 12 inches (30 cm). Spray lightly, moving backwards and forwards across the paper as you spray. Do this until the whole drawing area has been fixed. If you spray in one spot too long, the fixative can run or stain the drawing.

1 *Soft brush for lifting powder*
2 *Aerosol fixative*
3 *Plastic eraser*
4 *Putty eraser*
5 *Bottle fixative*
6 *Masking fluid*

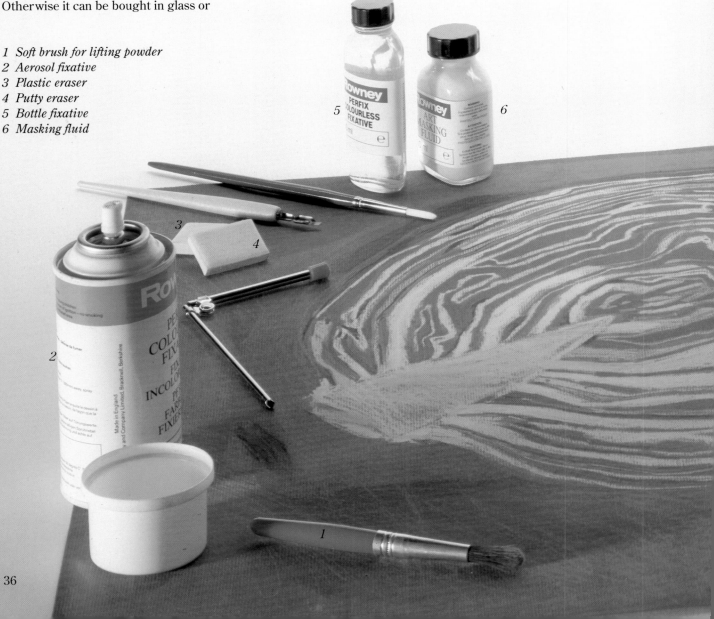

## Easels

Drawing and sketching easels are essentially lightweight, designed to hold your board or pad at a convenient height and angle as you work. They are collapsible and portable, making them ideal for outdoor work.

A watercolour easel can be tilted to a horizontal position – this is useful for mixed media work, or if you plan to add washes of colour to your drawings. The horizontal position prevents the ink or paint from running. Lightweight box easels are also good – ideal for drawing expeditions because they have a box or drawer for materials. For working at home, a table easel, which stands on any flat surface, is useful and takes up very little space when not in use.

It should be said, however, that an easel is not obligatory – certainly not the first item of equipment you should rush out and buy. It is obviously easier to see what you are doing if the support is propped up, and the majority of artists prefer to work in this way because it allows them a full and undistorted view of the drawing as it progresses. But other artists work quite happily with the drawing board rested on their knees or propped at a slight angle on the table. For instance, the step-by-step projects in the last chapters of this book were done on a drawing board on a flat table top. The artist propped this upright at intervals in order to stand back and assess the work.

Nor should the lack of an easel prevent you from working outdoors; you can quite easily fix a strip of fabric tape to a drawing board (pin each end of the strip to the centre of the short sides of the board) and wear the board around your neck for support. A folding canvas stool is another excellent piece of equipment for outdoor sketching.

*Easels (left to right)*
1 *Metal folding sketching easel*
2 *Wooden folding sketching easel*
3 *As 2, but with box rest brackets*
4 *Folding sketch box easel*

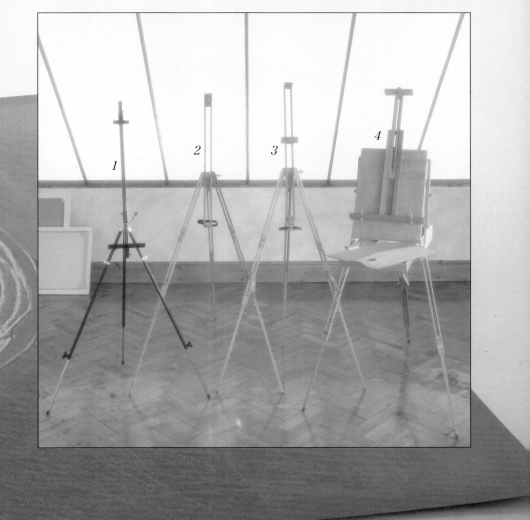

# EQUIPMENT

The paper you choose for your drawing plays an important role in the success of the finished work. Not only is choice of colour and tone crucial when using coloured drawing materials such as pastel, but the texture and surface of the paper dictate the character and appearance of the marks made upon it.

Traditionally, drawing papers are white or off-white but, as you will find in the practical demonstrations in the final chapters of this book, the barriers are not rigid and there are no hard-and-fast rules. Common sense is the governing factor as far as colour is concerned. Obviously, a deeply toned paper is unsuitable for delicate pencil drawing; similarly, pastels and other coloured media often look better if the paper tone is chosen to match the colours in the subject.

How to choose a support for a particular drawing material is discussed in more detail overleaf.

## Choosing Your Paper

Artists' papers are confusingly named, but the categories are actually quite simple. Basically, they fall into two groups, machine-made and hand-made.

Most papers are machine-made. These can either be 'hot-pressed' (HP), 'not' (meaning 'not' hot-pressed), and 'rough'. Hot-pressed papers are generally fairly smooth, whereas 'not' papers have a definite texture, or 'tooth'. Rough, as the name suggests, is extremely coarse and generally used by watercolour painters, but it is good for certain types of drawing, such as brush with ink, and mixed media.

Hand-made papers are expensive and are usually made from pure linen rag. One side of the paper is given a coat of size, and this is the side to draw on. If you cannot recognize the correct side by its slightly smoother texture, it can easily be identified by the manufacturer's watermark.

Cartridge paper is the most widely used drawing paper, but Bockingford, Saunders, Arches, Cotman, Kent and Hollingworth are among the quality papers to look out for.

The 'weight' of an artists' paper refers to its thickness. A 60 lb (128 gsm) paper is fairly thin; a 140 lb (300 gsm) paper is thick. Lightweight papers will buckle when wet, and will remain buckled even after they dry. This is worth remembering if you want to use washes of colour on your drawing, or if you are working with water soluble pencils and intend to

5

4

3

2

1

dissolve the colour with a quantity of water (small areas of water or wet colour will not normally affect the paper). Choose a heavy, good-quality paper – preferably in a gummed pad – to avoid this disappointing problem.

## Toned and Tinted Paper

Coloured and toned drawing papers are widely available and usually come in an extensive range of colours and neutral tints. Quality names include Canson, Ingres and Fabriano, but there are many more. Each paper type is characterized by its particular surface texture. Some have a fine, regular 'tooth'; other papers can be identified by barely discernible grooves.

Cheaper tinted papers include sugar paper, available in grey and other neutral colours. This is a longtime favourite with art students and beginners. Its popularity is partly due to its low price, and partly because its sympathetic mid-tones are ideal for many techniques and materials.

## 'Tooth' and Texture

The texture of your paper – how rough or smooth it is – is important. Crumbly materials, such as charcoal and pastel, need a support with enough surface texture to hold the colour. Pen and ink, technical pens and other delicate drawing tools are best on smooth paper or board.

## Special-purpose Papers

In addition to the standard drawing papers, there are several specialist products on the market. Many of these, such as the exotically textured Japanese papers, are not suitable for the inexperienced artist. But others are more functional.

Smooth board, including Ivorex and Bristol board used mainly by graphic and technical artists, are ideal for drawing when an even, precise finish is required. Other types of board are simply drawing papers glued to a stiff card. Being rigid and easy to handle, these are convenient for outdoor work.

Special papers for charcoal and pastel are also available (see overleaf).

1 *Sugar paper*
2 *Sugar paper*
3 *Bockingford Medium 140 lb*
4 *Hollingworth Rough 140 lb*
5 *Whatman Rough 140 lb*
6 *Whatman HP*
7 *Bristol board*
8 *Cartridge paper*
9 *Pergamenata (vellum type)*
10 *Hollingworth Smooth*
11 *Pergamenata (vellum type)*

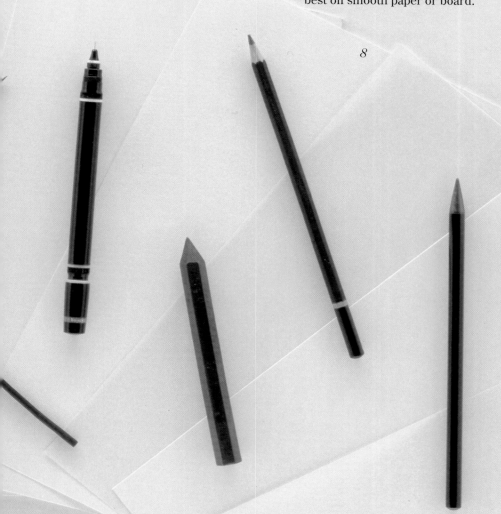

# EQUIPMENT

The supports used in the projects in the final chapters of this book were the choice of the artist, selected in order to demonstrate techniques and materials as clearly as possible. You will probably find it helpful to follow our artist's example, but do not let this deter you from making your own experiments later on. Even when learning to draw, the task can be made more exciting and adventurous by trying out different surfaces and comparing the results.

## Charcoal and Chalk

When using charcoal and chalk, the paper should be matt and have a slight 'tooth' or key, otherwise the dry, powdery medium will not adhere to the surface of the paper. Very smooth or shiny supports are unsuitable because the charcoal and chalk slide around.

When working with charcoal and chalk – using the charcoal for the dark, shaded areas, and the chalk to depict illuminated planes and highlights – choose a tinted paper. Ideally, this should be a medium or middle tone, so that both lights and darks show up well. Canson, Ingres, Fabriano, Montgolfier and the inexpensive sugar papers are all good for charcoal and chalk. A special 'charcoal' paper is also available. This is heavy with a coarse texture and toned or coloured finish.

When working with charcoal alone, choose a paper of any colour provided it is pale enough to enable the dark lines to show up.

## Colour Sticks

This broad category includes traditional conté as well as the waxier studio sticks and crayons. Again, a slightly textured paper is required if the various sticks of colour are not to skid around. For traditional conté colours – sanguine, grey, bistre and brown – choose a medium-toned, neutral-coloured support, such as sugar paper or one of the more subdued tinted papers. When using the full range of conté colours, use tinted, white or off-white paper. Studio sticks and wax crayons are best on light-toned or white paper.

## Pen, Brush and Ink

Ink can be used on any paper surface, depending on the effect required. This can either be very smooth or shiny, or extremely coarse. Pens are best used on fairly smooth surfaces; the technical pen should never be used on coarse or textured papers because these clog the fine tubular nibs. When drawing with a brush, however, the possibilities are wider. Try using very textured hand-made watercolour papers – supports not normally favoured for drawing. These produce unusual and exciting textures, including areas of flecked colour and broken lines.

*6*

*5*

*4*

*3*

*2*

*1*

## Pastel

Soft pastels are at their best on good-quality tinted paper. Choose one to match the subject. Light pastel tones on a dark neutral paper can be most effective. Special pastel papers, similar to fine sandpaper, can be bought at art shops. Alternatively, try the finest graded sandpaper available at your local hardware store. The advantage of these gritty surfaces is their capacity for holding dense quantities of pastel, and this makes for exceptionally intense colours.

## Pencil and Graphite

Choice of paper here is wide, depending on the scale of work and the effect required. Generally, a smoother paper is good for small, detailed drawing; coarser surfaces for large-scale work. Otherwise almost any medium-textured drawing or watercolour paper is suitable. Exceptionally smooth and shiny surfaces are not recommended.

## Coloured Pencil

Again, a medium-textured paper is desirable when using coloured pencils. The water soluble variety call for a heavy, good-quality support to withstand wetting. Coloured and dark-toned papers are generally unsuitable because the pencil tones have neither the strength nor the opacity to stand out. Light-toned papers, however, are worth experimenting with and should be selected with the subject in mind.

## Markers and Fibre-tip Pens

Hundreds of these modern, disposable writing and drawing tools are now available in stationers, artists' supply shops and high street stores. Some are waterproof, others water soluble. Choose the surface to suit the product – trial and error is probably the best way. Generally, medium-textured drawing paper is the best bet.

Wedge-tipped markers and certain felt-tipped pens bleed when used on ordinary, absorbent drawing paper. To avoid this, use special marker paper available from graphic and fine art suppliers. This is sealed, either on one or both sides, thus preventing the colour from seeping through.

1 *Ingres*
2 *Ingres*
3 *Canson*
4 *Canson*
5 *Pastel paper*
6 *Canson*
7 *Canson*
8 *Canson*
9 *Turner Grey*
10 *Greens 'Camber Sand'*
11 *Ingres*

41

# Chapter 3
# Charcoal and Chalk

This is the perfect medium for beginners. It is much better to start drawing with charcoal and chalk than with a normal pencil. The medium is popular in many art schools for initial drawing lessons because it encourages students to think about the whole subject and not to become lost in detail. In the same way, it will help you to think big, to concentrate on main features, to treat subjects in broad terms, and to think about lights and darks from the moment you make your first marks on the paper. Why not pin up a jumbo-sized piece of paper to the wall, right now, take up charcoal and chalk, and sweep some broad marks on to the surface, perhaps sketching out an arrangement of large, simple objects on a life-size scale . . .

Without worrying about detail or over-specific outline, try to indicate – straight away – where shading appears on the objects, contrasting this with lighter patches. Then draw in some outlines later, using the shading as the starting point. You do not necessarily have to start with an outline sketch.

You may have discovered by now that the medium is messy! Smudges are almost inevitable, but do not worry about this; in fact it discourages another initial fault of beginners – to rely totally on an eraser to make their drawing absolutely neat. Work that is too neat becomes dead, especially if it is overworked. Charcoal, or charcoal with chalk, is essentially a lively way of operating.

You should think positively about what choice of paper to work on. Black and white on toned paper makes you look for the lights and darks of the subject. These are important. A drawing without tonal contrast looks flat and uninteresting. Tones are something we have to learn to look for: they will not appear automatically as you draw (for instance, there may be more than one shade in a shaded area). The local colours or tones of familiar objects are what our eyes see without 'thinking'. Tone is something which we look for only if we have to make an interesting, contrasting picture. Therefore it is advisable to get into the habit of 'tonal thinking', looking for lights and darks rather than detail and colour. You do not even have to make recognizable forms at first – turn your subject or composition into an arrangement of flat shapes of greys, black and white as a good initial exercise.

Charcoal and chalk can be used, of course, for linear drawing as well as for shading.

# Materials
## CHARCOAL AND CHALK

Charcoal, made for centuries by the controlled and partial burning of wood, is one of the oldest drawing materials in history. It makes bold, black marks which can then be lightened if necessary by erasers. The longer the process of carbonization of wood the softer the charcoal is. Charcoal for artists comes mainly from the vine – producing the finest quality – and the willow, which is the more common. The products are marketed usually in a form known as stick charcoal – sticks about 6 inches (15 cm) long, boxed in sets. You can buy sets of thin, medium or thick sticks, and some can be purchased individually. The sticks can be sharpened to a point by rubbing on fine sandpaper. Charcoal pencils, where a strip of reconstituted charcoal is encased in wood like a normal pencil, are also available on the market. Although they are cleaner to use, they have to be continually sharpened to reveal the charcoal point.

### Compressed Charcoal
You can also obtain compressed charcoal, made from charcoal powder pressed with binding medium, which breaks less easily. This usually comes in shorter sticks. They are suitable for blocking-in more definite areas of tone. Their marks are bolder, and less easy to tone down or rub out.

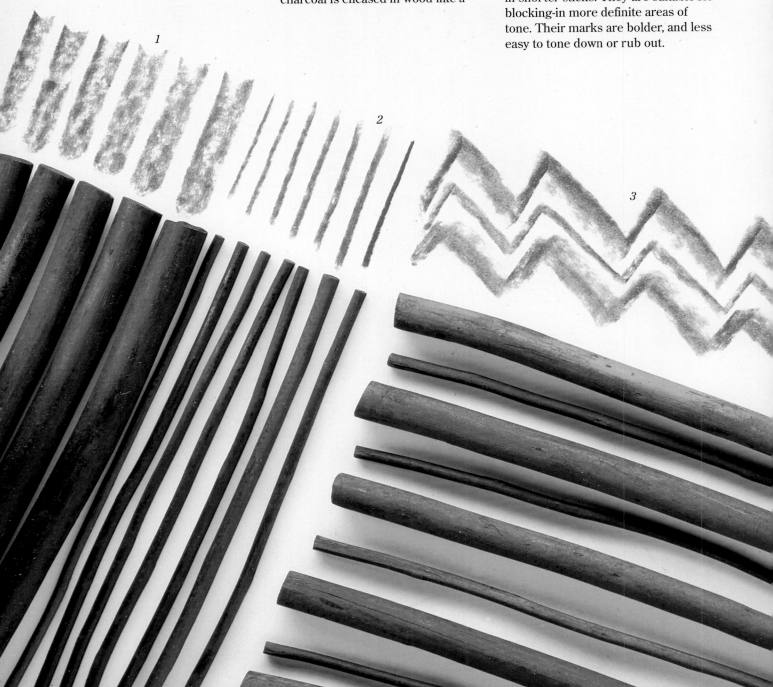

## Chalked Highlights

Chalk (calcium carbonate) is often used with charcoal, and the cheap blackboard variety is perfectly suitable. White pastel, conté, or pastel pencils can also be used, but many artists stick to chalk as a traditional way of picking out highlights in a charcoal drawing, or for mixing with charcoal to establish a mid-tone.

## Paper Choices

To get the best use of the light and dark tones of white and black drawing materials, you should choose tinted paper. Our artist has done this in the chalk and charcoal drawing on page 48. Several types of tinted paper are available. Canson or Ingres come in a good range of colours, have good quality and also possess a matt surface suitable for the medium. Sugar paper, which also has a matt surface, comes in warm and cool grey, and is inexpensive. As a general rule, avoid smooth, shiny surfaces. Your chalk and charcoal will just slip around and not adhere to the surface at all. When using charcoal alone – for a line drawing rather than a tonal picture – any fairly textured surface will do, and you will find white and off-white suitable. Charcoal is sympathetic to the textures and grains of paper, allowing them to show through. For this reason, watercolour papers are good supports – their pitted surfaces create a lively textured drawing. For the beginner, however, this can be difficult to deal with; it might be better to avoid very textured papers. But experiments will pay off. Because charcoal is good for large-scale work, rolls of cheap newsprint or lining paper can be useful as supports.

## Blending Tools

Charcoal tones can be blended or lightened by erasers. A kneadable eraser is ideal because it is softer and picks up the charcoal powder, producing a cleaner mark. Torchons, brushes, pieces of tissue, rags – all of these can be used to create lightened effects on charcoal.

It is absolutely essential to fix a charcoal drawing. If you fail to do this, the lines and tones will become blurred.

*1 Thick charcoal*
*2 Thin charcoal*
*3 Assorted charcoal*
*4 White chalk*

4

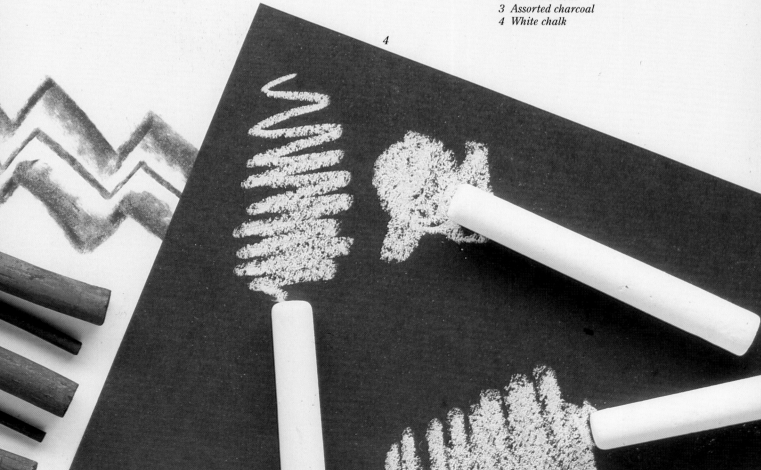

# Techniques
CHARCOAL AND CHALK

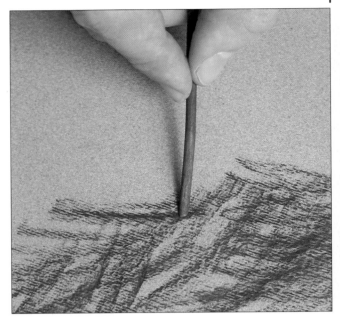

## Soft Blending

Charcoal is one of the most adaptable of all drawing media. With it you can make lines of any thickness and density. You can create areas of heavy shading, and you can also describe form by means of delicate, graded tone. Charcoal, however, is naturally grainy and makes an uneven, textured mark or line, especially when used on coarse paper. If you want a flatter or smoother finish it is necessary to blend the charcoal – usually with the finger, a torchon, or a piece of tissue or cloth. Before embarking on a drawing, it is worth devoting a little time to practising this technique, and to discovering the sort of effects which can be achieved.

To create an expanse of blended tone, first build up an area of lightly scribbled marks, making these as even and consistent as possible (*1*). Do not press too hard with the charcoal – if the mark is too ingrained, it will be difficult to blend. Use the tip of your finger, lightly rubbing the surface of the drawing to blend the marks together (*2*). The finished effect (*3*) is a deep, soft shadow which can be made darker by repeating the process until the required depth of tone is achieved, or lightened with further blending.

Remember, blending simply means smoothing or rubbing and need not be confined to large areas – you can be selective, picking out small patches and details, or even blending a single line if this is the effect you want. Chalk and charcoal with chalk can be blended in exactly the same way.

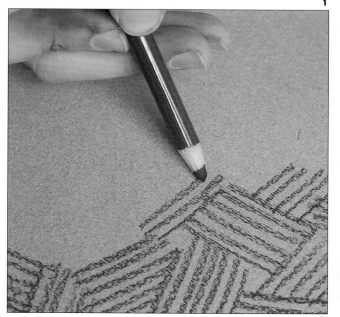

**1**

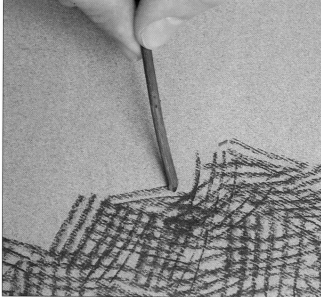

**2**

**3**

## Hatching and Cross-hatching

Drawing is essentially about line, about creating form and movement with charcoal, charcoal pencil, chalk, or any other drawing instrument – all of which produce a line. With soft materials it is possible to blend lines to achieve a solid area of tone, as the artist demonstrates on the opposite page. But it is also possible to create tone with line alone, using the traditional method of hatching and cross-hatching. By building up a series of hatched lines on a selected area you can suggest solid tone and colour, making this darker or lighter by varying the closeness of the lines. For a formal, graphic effect, keep the hatching regular and even; use free, scribbled lines for a looser, more sketchy look.

The pictures here show the artist creating hatched effects using both charcoal and charcoal pencil. Charcoal pencil (1) produces a harder line than charcoal, making it possible to control the tone to a large extent. Here the artist is using adjoining patches of neat parallel lines, allowing the amount of light-tinted paper showing between the black marks to dictate the shade of the final tone (3). The thick, soft line of stick charcoal is less suited to controlled hatching and here the artist adapts the marks accordingly. Instead of a regular pattern, the strokes are laid freely in loose hatched and cross-hatched areas, creating a slightly patchy mesh of tone (2). The colour of the paper affects the final tone, so experiment on both white and tinted supports.

# Drawing Form

## CHARCOAL AND CHALK

We know what a sphere, a cylinder or a box is supposed to look like, but we 'see' these objects only with the help of light and shade. Otherwise they would appear as flat shapes. In other words, we see form in terms of tone. This is not a problem in everyday life; we have expectations of what familiar objects should look like, but the artist has to 'create' form on the flat paper – one of the fundamental problems of drawing.

The objects here have been chosen for their simplicity – even though they are the key to much of what you will eventually draw. You may not have all these precise objects to hand but you should be able to find something similar from around the house.

Chalk and charcoal are excellent drawing materials to start with. They cover the entire range of tone; the charcoal can be used heavily to represent deep black, and the chalk similarly for the white end of the spectrum. Because they are a broad, chunky medium, they will encourage you to deal in broad terms – looking for the basics instead of getting carried away by irrelevant detail.

Grey or tinted paper, instead of white, is crucial for this type of drawing. From the mid-tone grey you simply need to make the darks darker and the lights lighter.

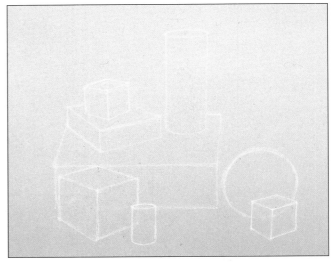

**1** The artist uses white chalk to mark in the outlines of the objects. The lines are lightly drawn, so the final drawing will not be dominated by outlines. It is important to think about composition right from the start. The whole area of this grey Ingres paper, measuring 22 in×30 in (56 cm×76 cm), should be used; if the objects are too small, they will be dwarfed by surrounding space.

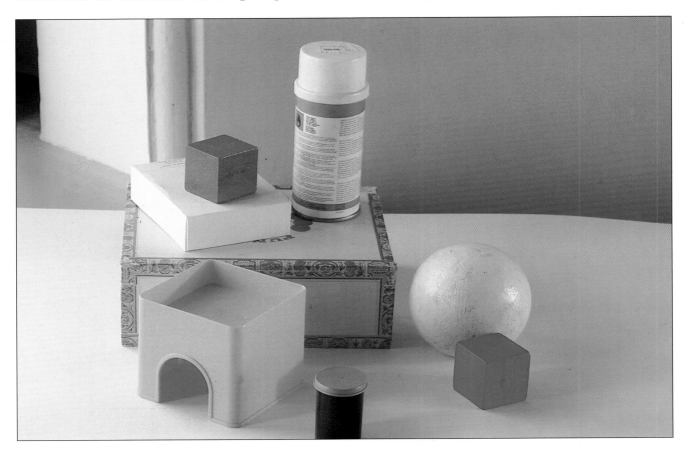

**2** A stick of charcoal is used to block in the darkest shadow areas of the subject. When drawing objects which are different colours and contain patterns or letters, it is often difficult to discern areas of light and dark. Therefore, you will find it helpful to look at the subject through half-closed eyes. This blocks out some of the local colour, making the highlights and shadows more distinctive.

**3** Here is an example of the torchon (described earlier) being used to blend the charcoal. The cylinder is dark on one side and light on the other, and is smoothly graded from its lightest to darkest areas. Therefore the shadow area must gradually fade, and the torchon is rubbed onto the charcoal to lighten it and help the blending.

**4** At this stage the artist has established the main shadow areas. For the darker shadows the artist has used the charcoal relatively heavily to obtain black or dark grey. Because charcoal tends to crumble you might find it easier to build up the very deep tones gradually, when first drawing. The artist has used a second, slightly lighter, tone of grey for the mid-, or 'in-between', shadows. This is done by using the charcoal lightly and occasionally applying the torchon to soften areas which look too dark.

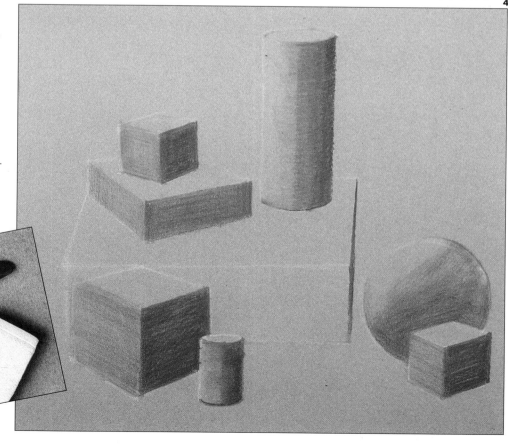

**5** The artist has given the blocked-in charcoal a light spray of fixative before moving on to this next stage.

A directional light is falling on the objects, which means that the top surfaces are light planes and the shadows are cast clearly to one side. The light therefore helps to describe the volume and form of the cubes, sphere, cylinders and boxes. In this illustration, the artist is picking out the most obvious highlights and blocking them in with fairly dense white. A chalk pencil is being used to obtain a good crisp line on the edge of one of the boxes, but do not worry if you do not possess one. By using the edge of a stick of ordinary chalk you will be able to achieve an equally precise mark.

**6** All the white planes and highlights have now been established. The artist has used the chalk loosely to suggest the table top, deliberately seeking to achieve a broken tone by the free criss-cross of the marks. This has allowed the grey paper to modify the white, to avoid a densely bright table top which would have competed too much with the objects.

The treatment of the objects has reflected the nature of the objects themselves. They have very smooth surfaces, so the chalk and charcoal have been smoothly applied and blended when necessary with the torchon.

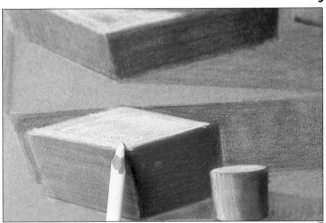

**5**

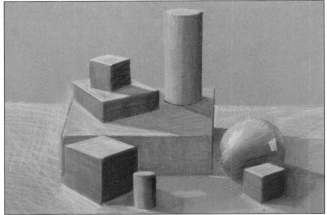

**6**

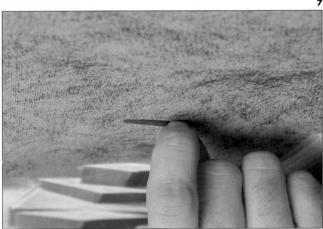

**7**

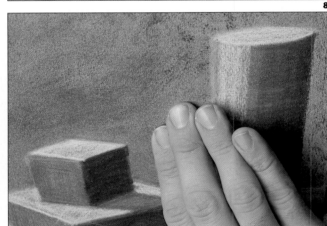

**8**

**7** The artist blocks in the background. Because this is such a wide expanse and the artist does not want it to be too dark or dense, the area can be covered rapidly by using the side of a stick of charcoal. This method inevitably produces an uneven texture which can be blended later, but it has the advantage of enabling the artist to control the tone – layers can be built up fairly quickly to obtain just the right degree of darkness. Cover the required area as quickly as possible even if it is too light, and then add second and third layers and so on. This way the result will be more even than by trying to establish the correct tone straight away.

**8** The fingers are used to blend the background to a smooth finish. Again, the artist works quickly across the whole area, rubbing gently but briskly with the fingertips and causing the granular texture to give way to a flatter tone.

Textures can offer a choice between a picture which aims at harmony or one that seeks contrast. The background here did not necessarily have to be smoothly textured like the objects. The artist took a personal decision to aim for harmony. An alternative would have been to create contrast by allowing the slight coarseness of the initial background tone to remain – thus emphasizing the smoothness of the subject.

**9** The forms in this finished picture are simple, abstract ones, but the treatment of them is exactly the same as it would have been for something more complicated. The rules are the same. After all, even the human body is in fact an arrangement of near-cylindrical volumes. An arm or a leg would require the same treatment of light and shade and similar blended degrees of tone as the cylinder in the picture. The cubes and boxes, too, are the basic underlying forms which will need to be represented in many more complex pictures. A house, for instance, consists of a combination of these. The same principles apply to organic shapes such as flowers and plants – they have a definite structure and can be simplified into basic shapes and forms in exactly the same way as the more obvious geometric objects. Dealing with amorphous shapes like foliage or clouds, human hair or animal fur – things which do not apparently possess precise form – can present what appears to be a daunting problem. If you can only get into the habit of looking at, and treating, these as arrangements of simple mass and volume you will start to solve the difficulties.

One essential final touch for a drawing with charcoal and chalk: give the picture a spray of fixative and allow this to dry.

**9**

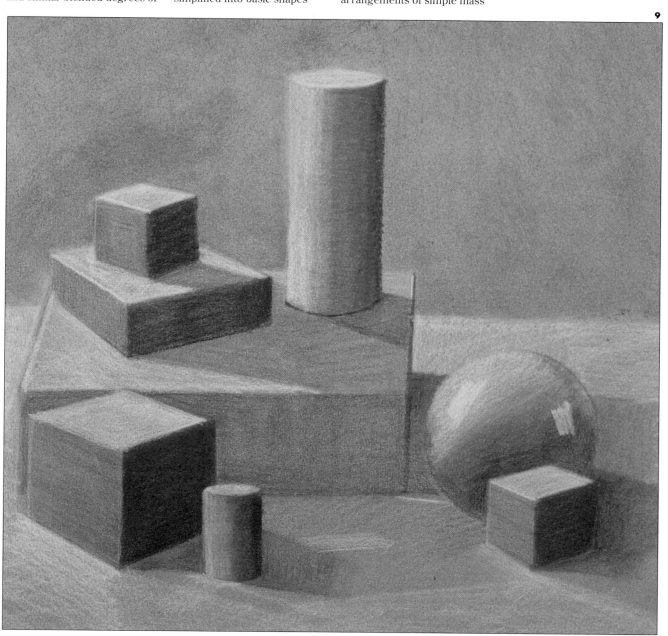

# Sheep's Skull

## CHARCOAL AND CHALK

The subject here is more complex than the previous geometric forms. But the approach is still simple, seeking out the basic elements of the image. The sheep's skull – placed in the barest of settings with a piece of curved paper forming a background free of clutter and horizon – provides a less rigid exercise than the previous project. It is a more complete enterprise that is potentially more interesting, as there is more scope for personal interpretation.

You are invited to introduce new aspects now into your drawing. In this demonstration the artist looks for the graphic qualities of the subject – the effectiveness of the shapes themselves in an almost abstract sense. There is also an opportunity to be selective about areas of light and shade, rather than making an academic rendering of everything before you. The secret is to keep the selection to a minimum. Experience has taught the artist when to stop. The subject offers a challenging chance to try your hand at drawing line, exploiting all the different thicknesses and types of line, each doing a specific job. Here, for instance, the artist has used stronger line for the major shapes and outlines, tapering into a fine mark for the internal contours of the skull.

The project involves an indication of local colour, and the use of texture, to enhance the nature of the subject and its bony substance. The lightest areas of the subject, the horn and the lower part of the skull, are appropriately lightened with white chalk in the drawing, as is the light coloured background. The artist has deliberately made the shadow much darker than the reality, in order to improve the strength of the composition and emphasize the light source, and thus the solidity, of the subject.

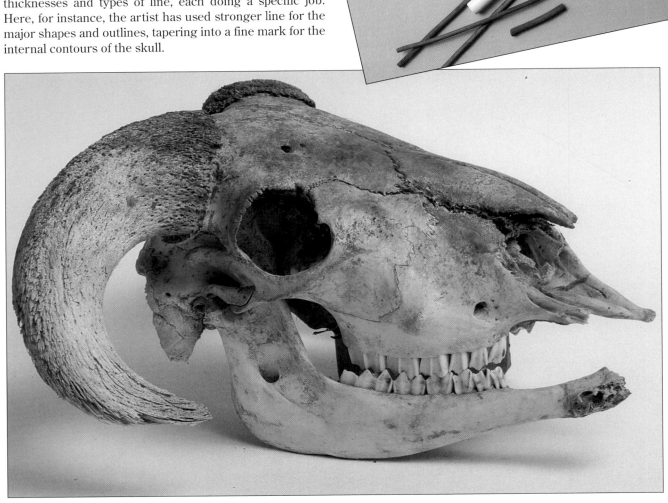

**1** Working on grey Ingres paper measuring 22 in×30 in (56 cm×76 cm), the artist starts by making a line drawing of the subject in charcoal. The artist draws into the form – outlining not only the outer shape of the skull, but also the forms that appear within it. For instance, in this case the outlines which make up the contours of a cheekbone are described.

When using line to depict a three-dimensional object, it is important to be sensitive to the subject as a whole. The line is therefore kept light but varied in strength and thickness. Remember that, if the line is too regular and harsh, the subject will look flat, however accurate this line might be.

**2** The outline continues, with the charcoal moving into the jaw and teeth. The artist draws the individual outlines of the teeth because in this case they are an integral part of the main structure. Again, the line is kept fairly light. The artist looks carefully at the subject, referring to it constantly before committing a mark to the paper, to retain a linear quality and keep adjustments

to a minimum. But this should not inhibit you into making an over-tight drawing. The line does not have to be absolutely perfect first time.

The necessary alterations here have been made by re-drawing rather than erasing. For this picture, a clear image is required, and erasing would break up the surface.

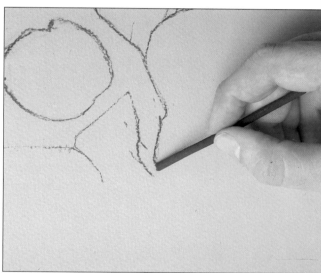

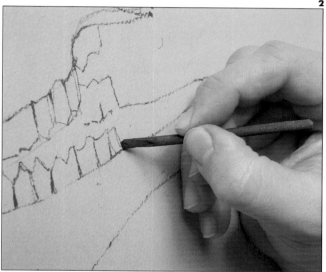

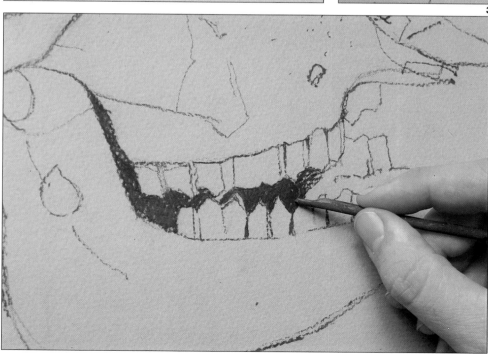

**3** The space between the teeth is drawn in, to make a flat, black shape. The artist is trying to keep the light and shade to a simple minimum to preserve the linear aspects of the drawing. Just enough light and shade is required to suggest the form. The black shape is sufficient, immediately suggesting the depth that would exist behind the teeth and within the skull; the artist has not created any degrees of tone in this area. In blocking in this shape, the artist takes special care not to destroy the jagged, bony structures of the teeth.

**4** The line drawing is complete. In effect, the lines on the contours resemble contoured hills on a map – they describe three-dimensional form on a flat diagram and they also build forms within forms. Now that the lines have been drawn it is easy to see how the artist has varied their thickness and strength to suit their purpose. The outlines are strong while the shapes of the bones within the skull are lighter. Thus, the form has been described largely by means of line, without any strong directional light which would create the shadowy chasms that depict form. In fact a light did shine on the skull but the artist ignored it, relying on simplified shadow and line to create a solid image.

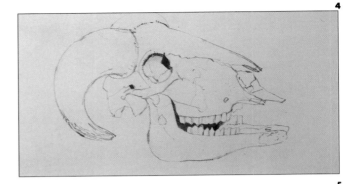

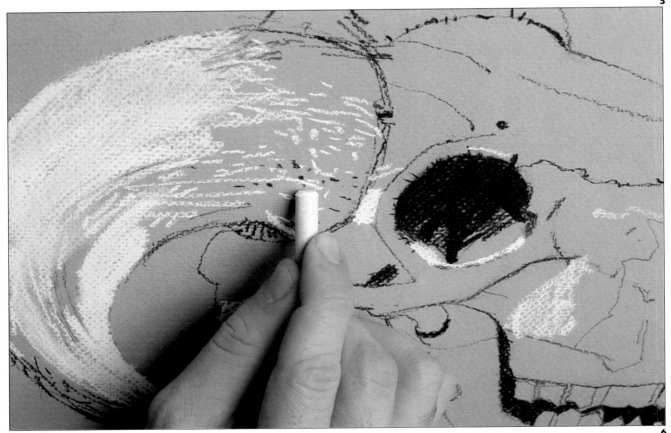

**5** The white chalk is being used to pick out the highlights and obvious light planes on the skull, such as the raised edge of the eye socket and the tiny triangular planes on the face. Here a lot of white has been used on the horn, an important and striking characteristic of the subject. Flecks of white provide an effective way of depicting the horn's porous texture.

**6** The light and dark tones are now in place, but in fact the image looks inevitably weak. This is because the skull is still predominantly composed of the grey-coloured paper and is therefore still very much part of the background. The picture as a whole has not yet taken on a three-dimensional aspect. The artist is ready to unify the image and develop the background.

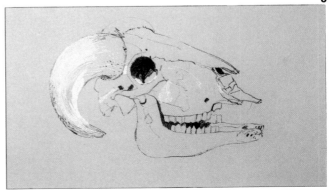

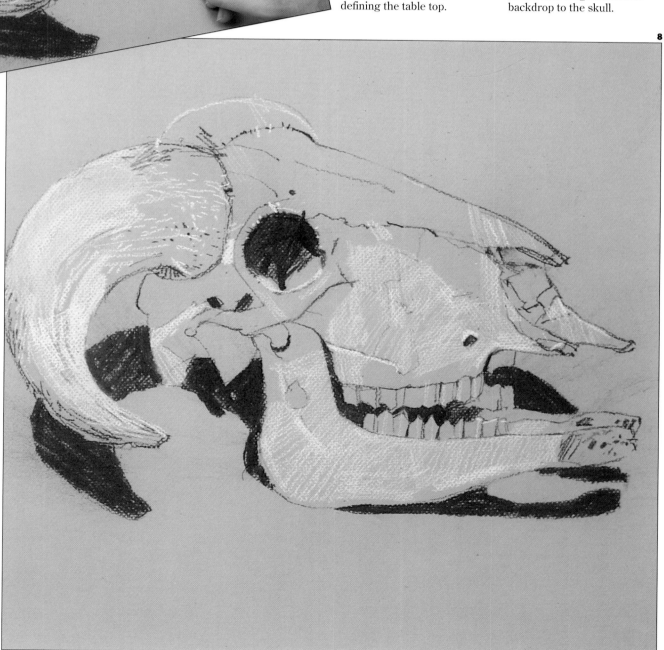

**7** The artist uses light hatching strokes in white chalk across the main areas of the skull. This represents the local colour of the subject – the light-toned bone. The purpose here is to make the skull stand out from the background. In a further step towards this end, the shadow is blocked in, as an emphatic dark shape, so defining the table top.

**8** A final step has been taken to defeat the two-dimensional flatness of the paper and lift the picture into form and space. The artist had lightly scribbled in a texture with the side of the chalk. These areas of flat paper have therefore been broken up, suggesting substance rather than space – in this case a light-coloured backdrop to the skull.

# Old Telephone

## CHARCOAL

Although charcoal is considered to be a very loose, quick and easy medium, often associated with simple sketches, it works surprisingly well in rendering more detailed images. The artist loved the classic style of this 1930s bakelite telephone and decided to use it as the basis for this composition. The other objects in the group were carefully selected to be in keeping with the style of the telephone, down to the old-fashioned fountain pen. Even the telephone number jotted down on the pad is an old-fashioned, lettered London exchange. When composing your still-life it is always important to pay attention to small details; in this case a jumbo pen bearing the logo 'I ♥ New York' would have ruined the credibility of the period feel!

For purely practical reasons the artist used photographs as reference for this drawing. Due to the pressure of time, he decided to take several shots of the group from different viewpoints so that he could choose the best one later on and complete the drawing at his leisure. In the end, his final composition was based on a rough sketch which comprised the best elements from each photograph.

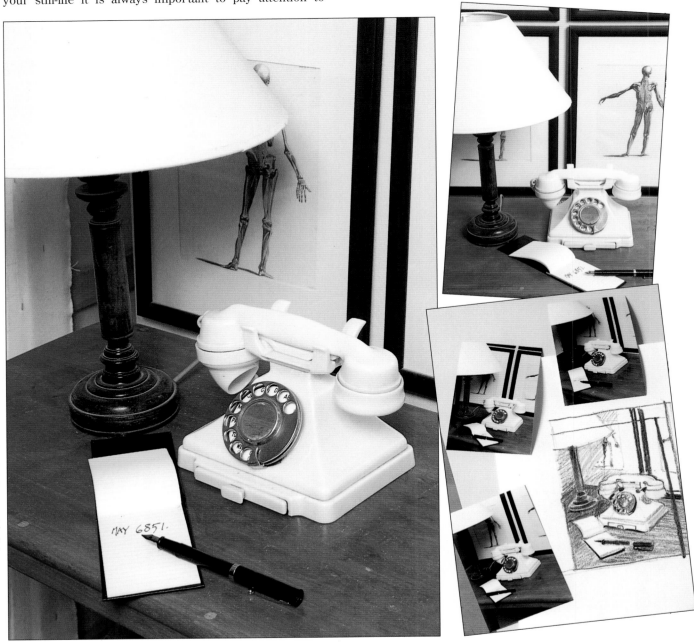

**1** A grey Ingres paper has been chosen for this project because its colour will become an integral part of the drawing. Apart from forming a useful mid-tone against which to judge the strength of the lights and darks in the image, a tinted paper also prevents the 'whites' – such as the lampshade, telephone and notebook – from appearing too stark and disrupting the tonal harmony of the drawing. Using your thumbnail sketch as a guide, start to lay down the initial outline drawing. Keep the charcoal lines light and loose at this stage – notice here how the artist holds the charcoal pencil from beneath, his hand well back from the drawing point.

**2** As you sketch in the main elements of the drawing it is always worth standing back as you complete each one, just to make sure that you are happy with its shape and position. The beauty of charcoal is that alterations and corrections can be made simply by gently rubbing the lines away with your fingers.

Any pale marks which are left will be absorbed into the drawing as it progresses.

**3** You are probably wondering by now why the artist does not appear to be using a charcoal stick. In fact he is, but it is enclosed in a stub holder. This is a handy device which can be adjusted to take virtually any thickness of charcoal stick. Willow charcoal can be quite fragile and prone to breaking if you apply too much pressure on the stick. With a stub holder this problem is avoided and you have greater control over your work. In addition, a stub holder keeps your hands clean and thus reduces the risk of accidental smudging. Once you have sketched in all the elements of the drawing, start to fill in the background and add the darkest areas – the picture frames and the lampstand.

**4**

**4** The table top is very similar in tone to the lampstand, so work carefully here to keep it just a shade lighter and prevent the lampstand from becoming 'lost'. At the same time, indicate the contrasting texture of the grain of the wood on the table top. If you are using a stub holder do not be tempted to hold it too tightly or you will lose that naturally loose and spontaneous feel that charcoal affords.

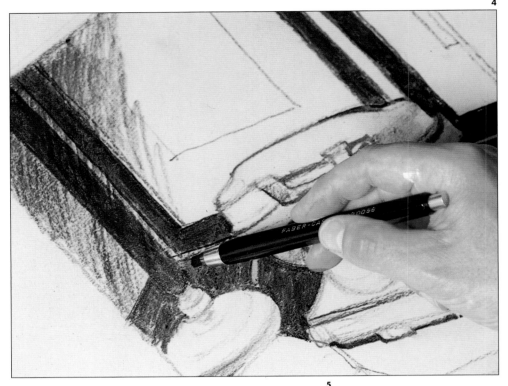

**5**

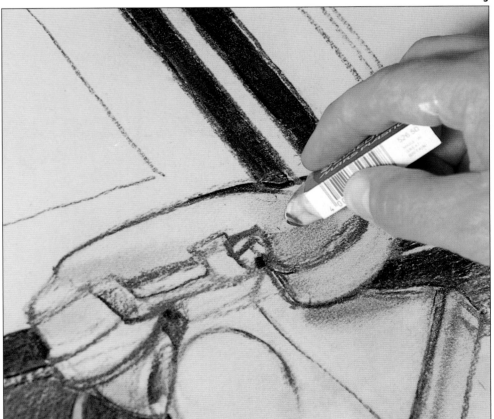

**5** At this point it is a good idea to fix the whole drawing. This will allow you to continue working on the piece without smudging what you have done so far. When the drawing has dried, start to develop the three-dimensional form of the telephone. Add the shadow inside the mouthpiece, softening the charcoal mark with the tip of your finger. Then, using a kneadable eraser and without applying too much pressure, gently smudge some of the charcoal lines on the handset to create the softest of tones in the shadow areas. Do the same with the shadow cast by the handset onto the body of the telephone.

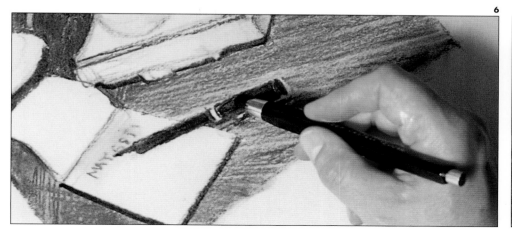

**6**

**7**

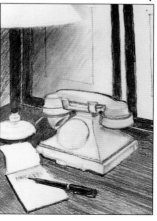

**6** With the charcoal stick, lay in the foreground area of the table top. Use closely hatched strokes, but work lightly and loosely to give an impression of the grain of the wood. Write in the telephone number on the notepad, then fill in the fountain pen with a dense, dark tone, leaving the metal details white.

**7** Before you continue any further, this is a good point at which to step back and take an overall view of your drawing so far. Referring back to the original reference you will see that more shading is needed over the left-hand corner of the picture where the lampshade throws a shadow. Work this part of the background up with light hatching strokes, but be careful not to make it too dark as it will throw the picture off balance. Notice how this area of darker tone throws the telephone into relief and brings it forward in the picture plane.

**8** Once you are happy with the background it is important to fix the whole drawing again to prevent any smudging as you work on the final details. Sketch the figure in the frame on the wall, then resume work on the telephone. Sketch in the central circle and the finger holes on the dial.

**8**

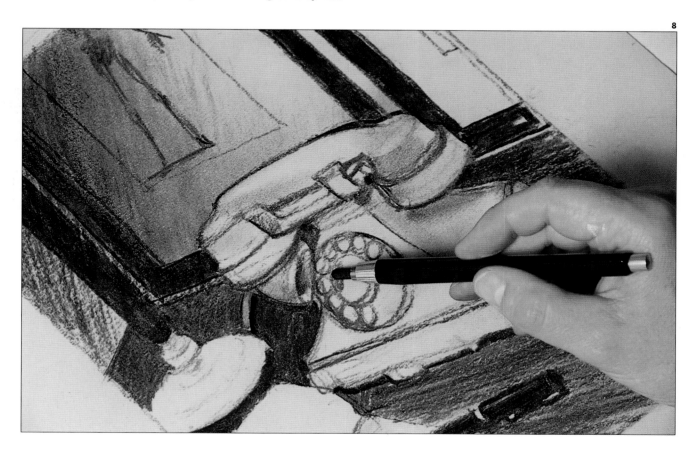

**9** Fill in the circle of the dial but do not worry about the letters in the finger holes, as such fine details tend to 'leap out' and distract attention from the rest of the picture. Now that the darks and mid-tones are established, it is time to bring the drawing 'into focus' by picking out the highlights. Here the artist is using a stick of white chalk to render the highlights on the shiny surface of the telephone.

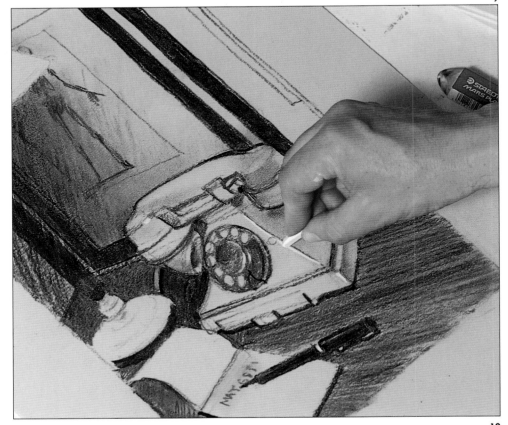

**10** This detail from the drawing shows how the addition of a few well-placed highlights can really make a picture 'sing'. Fill in the base of the lamp with charcoal, carefully following the lines you originally sketched in. Then use the white chalk to pick out the highlights on the base, pressing hard with the stick to make them quite strong. If you refer back to the original photograph you will see that the highlights on the lamp base are clear and sharp, whereas those on the telephone are softer and more subtle.

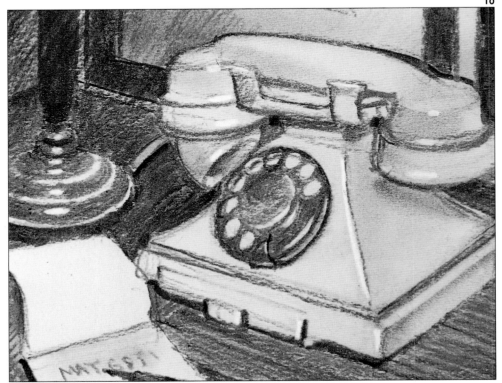

**11** At last you can stand back and assess your finished drawing. If you are not completely happy with it, now is the time to do any final 'tweaking'. However, do not be tempted to overwork any details, as this could easily spoil the overall effect. Bear in mind that the main appeal of charcoal lies in its loose, sketchy quality – so try to work quickly and with spontaneity. Even in a drawing like this where there are several elements involved, the actual rendering should have taken you hardly any time at all. Finally, do not forget to fix your drawing, otherwise it could be reduced to one big smudge before you get a chance to frame it and hang it on the wall!

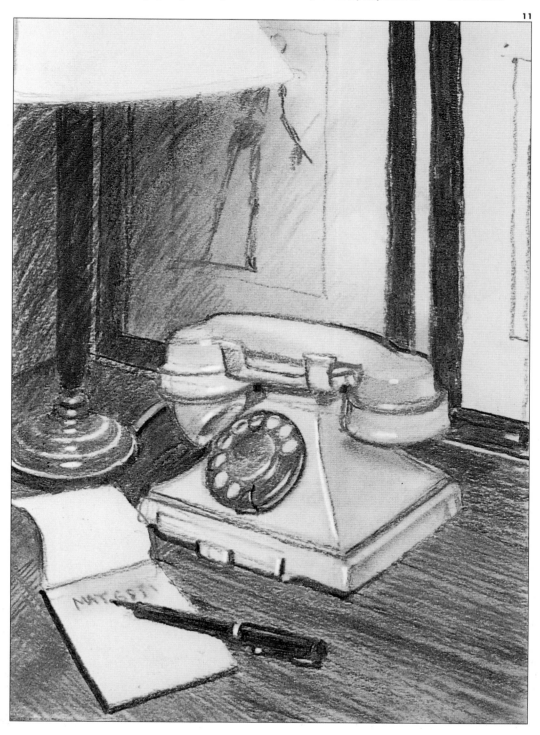

11

# Country Lane

## CHARCOAL

Most people seem to have a romantic, idealized view of the solitary landscape painter, sitting in the open countryside with his trusty easel and palette, at one with Mother Nature. In reality, working out of doors is not always a practical option. Even in the sunniest of climes, the weather can change from day to day and as the sun moves across the sky the shadows and colours will alter from hour to hour. Do not get us wrong, for there is nothing more pleasurable than sitting in the open and feeling a part of what you are actually drawing, but your time will be limited to certain parts of the day and, depending on the complexity of your composition, might mean that the project could take weeks. In days gone by artists had no choice but to work in the open, or from sketches made in the open, but with the invention of the camera the artist's life has changed dramatically.

In fact the camera allows the artist a great deal of freedom and spontaneity. The artist chanced upon this scene while out walking in the country and felt it would translate into a painting. Unfortunately he was not carrying his paints, but he did have his camera with him, so he was able to take several shots of the scene and add them to his own personal library of landscapes. Thus, when it came to choosing a subject for this charcoal project he had a wealth of images to choose from. This particular one seemed to lend itself well to the medium of charcoal, partly because it contained very little colour and so could easily be translated into a monochrome rendering without losing any of its beauty, and also because it contained certain details that could be executed in the loose style of charcoal without losing any impact.

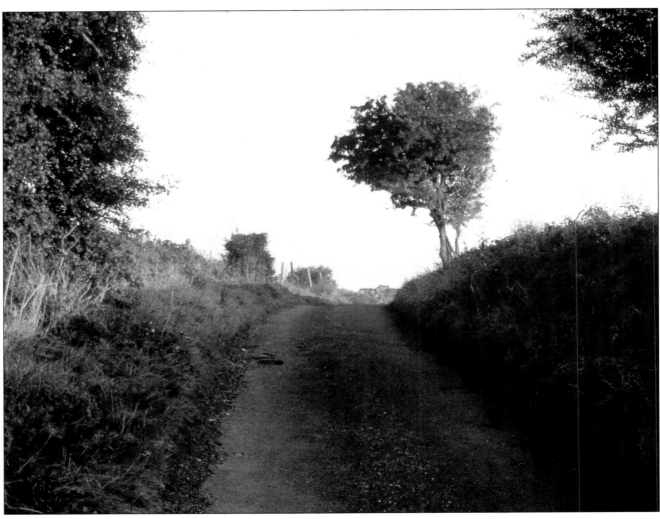

**1**

**1** As this is partly an exercise to prove that you can create an entire image with just one stick of charcoal, your best bet is to go for a nice, extra thick, weighty one. This will give you the best of both worlds, enabling you to cover solid areas quickly using the side of the stick and to draw fine lines and details with the sharpened point. Map out the rectangle in which you will be working and then refer back to the original image and start to loosely sketch in the main elements of the composition. In keeping with this fluid medium, try to relax and work loosely. Hold the charcoal stick lightly between your thumb and forefinger and let the point glide over the paper. It is also a good idea to make practice strokes on a piece of paper before starting your drawing.

**2**

**2** As you work, you will soon get used to the feel of charcoal and enjoy the way it glides softly over the paper. Do not worry about detail and tight outlines; just start by loosely mapping in the areas that will contain the darkest shading – the bushes and the foliage of the tree. Do this by using the side of the sharpened end of the stick.

**3** The bushes at the back on the left-hand side are much smaller, so this time you are going to use the sharpened point of the stick to create finer marks. Following the contours of your original reference, block in the bushes, applying slightly more pressure with your stick of charcoal, and at the same time adding some more detail. One of the advantages of charcoal is that if you make a mistake you can easily erase it with the tip of your finger, leaving an almost clean surface underneath.

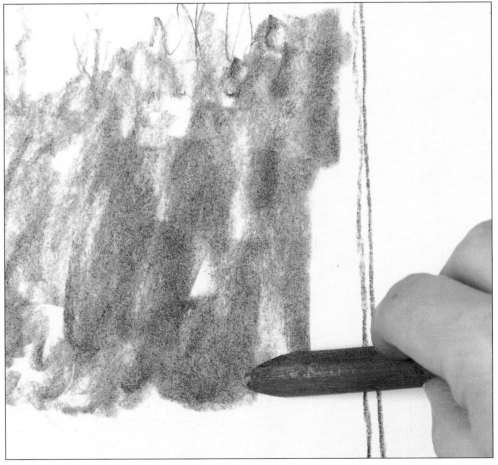

**4** Moving down to the right-hand side of the drawing, loosely fill in the rest of the bushes. To do this use the whole side of your stick, which allows you to cover large areas quickly. Remember to keep the pressure fairly light as charcoal is a soft medium and if you press too hard you will end up with a lot of loose 'dust' on the surface of the paper. Not only that, the fragile stick will probably snap!

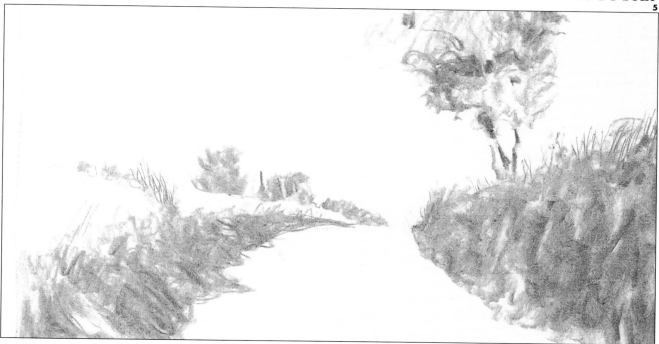

**5** Now that you have mapped in all the major dark tones of your drawing, switch to the sharpened end of your stick once more and 'tickle them up' by adding a few extra details such as the individual branches growing through the tops of the bushes. To prevent smudging, keep your hand above the paper at all times, and from time to time gently blow off the excess charcoal dust from the surface.

**6** By now you will probably have realized that charcoal is a pretty messy medium! Therefore at this stage it is a sensible idea to spray fixative over the whole drawing to prevent smudging of your work and allow you to add some more detail. Tape your drawing to the drawing board and set it upright against a wall. Holding the canister of fixative 18 inches (45 cm) away from the drawing, spray *lightly* from side to side. Do not overspray – if the fixative runs it will ruin your drawing. When the fixative has dried, use the sharpened end of your stick to introduce the branches of the tree on the left.

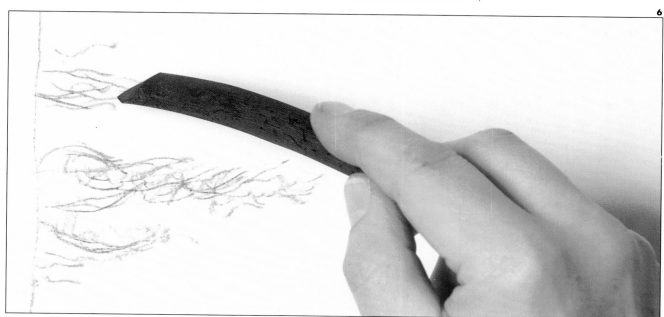

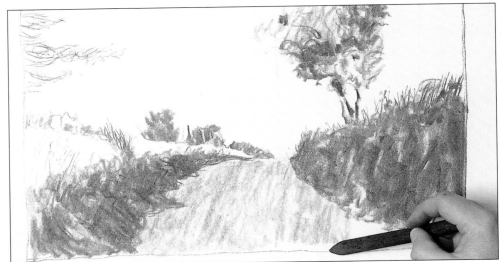

**7** With the side of the sharpened end of the stick block in the first layer of the lane and add a little more detail to the tree on the left-hand side. This is again a good point at which to spray the whole drawing with fixative.

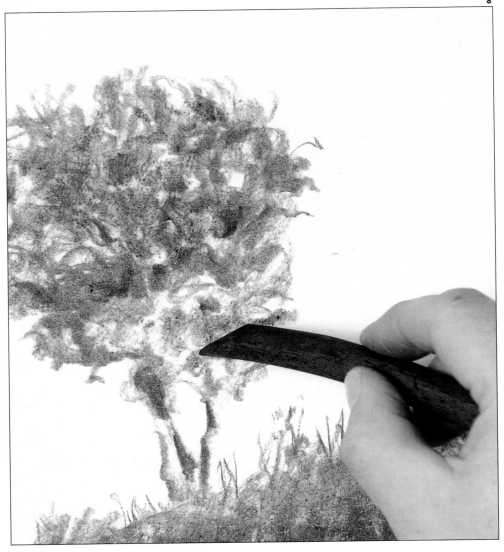

**8** From this stage on you are going to be bringing into focus all the individual elements of your drawing. Using the sharpened end of the stick, start by adding more tone to the tree on the right. We use the word tone as charcoal is not suited to minutely detailed work, which is why it is also a very fast way of working. Use short, irregular strokes to indicate the texture of the foliage. When you are satisfied with the result lightly spray the area with fixative.

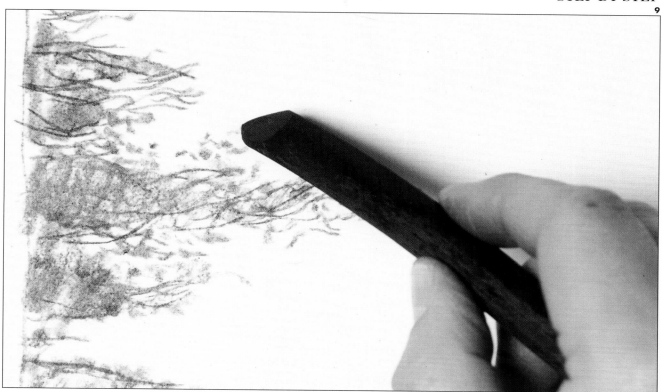

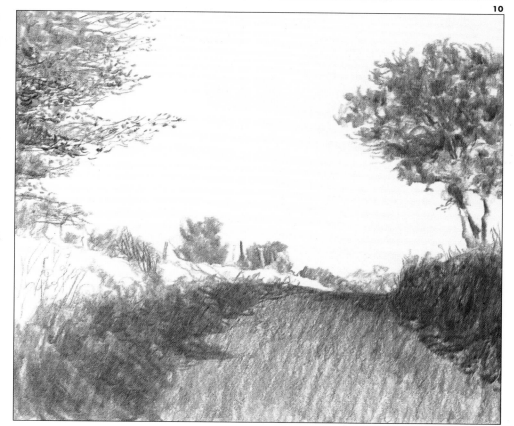

**9** Having completed the main focal point on the right-hand side you can now move over to the left. Originally the tree on the left was rendered quite simply, with only a few odd branches indicated, but, to give a sense of balance to the overall image, these branches will need to be extended. Using the sharpened end of the stick, work up the branches and indicate the leaves with scribbled marks. Spray once again with fixative.

**10** Now take an appraising look at your drawing so far and decide which areas you need to work up next. By this point the bushes and the lane will have shrunk into the background so they will be your next line of attack. Re-sharpen the tip of the charcoal stick on a piece of sandpaper, then work over the bushes and add another layer of tone to the lane.

## CHARCOAL/COUNTRY LANE

**11** You can now start adding all those little finishing touches. In fact adding is the wrong word, because what you will be doing is knocking back. Using a putty rubber you can lighten tones such as those on the tree by applying gentle pressure and executing a sort of dabbing technique. This will remove the fixative as well, but be careful to avoid pulling the surface off the paper.

**12** Returning to the left-hand side, the bushes need just a little more detail. Using the sharpened end of the stick, add a few extra squiggles, but do not overwork the details as this defeats the object of working in such a broad and expressive medium and can actually spoil the drawing by making it look rather lifeless.

**13** At this point your drawing looks very finished, but stand back and use your own judgement as to whether or not it could be improved upon. In fact at this stage it is often a good idea to leave the drawing for a while. When you come back to it with a fresh eye you will spot any mistakes instantly. In this particular case the artist felt that the tones of the bushes and the lane could be darkened up a little to achieve a better balance of tones.

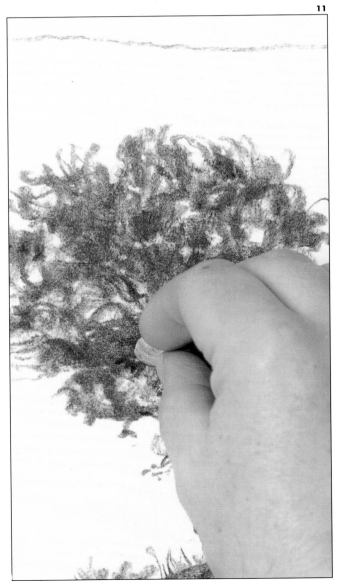

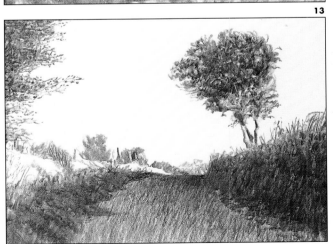

**14** On further reflection the artist felt that the lane itself looked decidedly dull and flat. To correct this he decided to use the knocking back technique, gently pressing over the area from left to right with a putty rubber to give a slightly graded tone and create the illusion of a shadow.

**15** Now it really is time to stop. Any more work would be totally unnecessary and, after all, part of the fun of charcoal is the speed at which you can go. Even in this example, where the artist did in fact pay some attention to detail, the actual rendering of the drawing was still very fast. All that remains now is to spray the whole drawing with fixative so that it can be stored away without it getting smudged and ruined. So, whatever you do, avoid a tragedy and always spray your drawing, even before you stand back to admire your work.

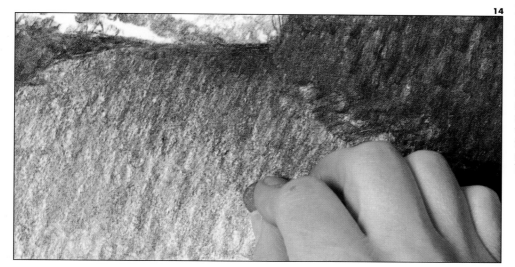

14

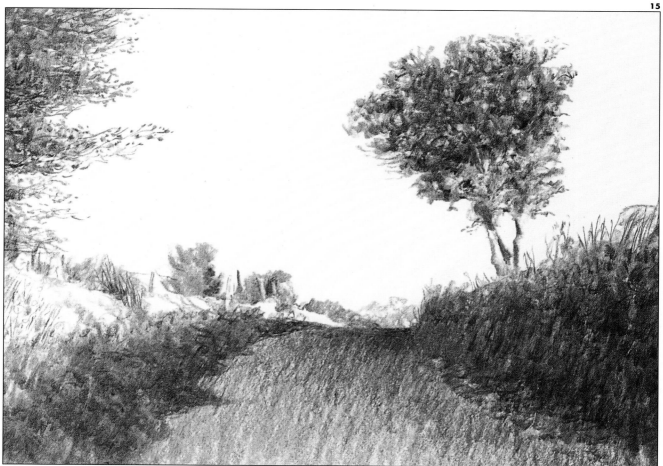

15

# Silhouette

## CHARCOAL

Although you cannot beat working with a live model, unfortunately we are not always in a position for this to be a practical option. Friends are often too shy and relations often too busy. You can pay a professional model, but this is not cheap. As an alternative, try your local art school or evening classes which will be less expensive. Television provides plenty of models and if you have a video you can freeze frame your chosen model in the position you want to draw. For our project here, we used a photograph from a newspaper which caught the artist's eye. Newspaper images are invariably soft-edged – due to the quality of the paper – and charcoal sticks produce an attractively soft line which can be altered in tone through pressure. When working in monochrome it is impossible to add highlights, so the way around this is to use the white paper by letting it show through the drawing. So you will need to work out at the beginning where your highlights will be.

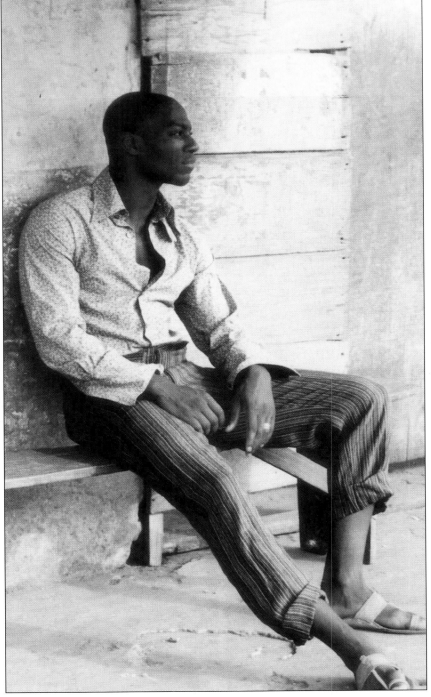

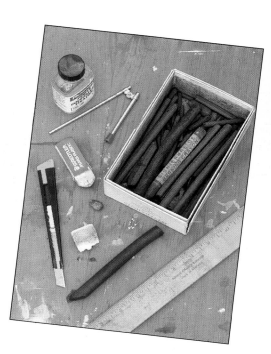

**1** Throughout this whole project you will only need to use one stick of large willow charcoal with one end sharpened to a tip with a razor blade. The paper is 120 lb (260 gsm) cartridge paper 23½ in × 16½ in (60 cm × 42 cm). With the fine end sketch in the basic shape of the head and all the outlines such as the collar and the lips.

**2** Still using the fine end of the stick, add the eye and the ear. Switch round to the broad edge of the stick (the side) and add the basic areas of tone such as the hair, the back of the neck, the jawline and the shadows of the collar. Still using the side of the stick, lightly suggest the tone on the side of the chin and the lower neck.

**1**

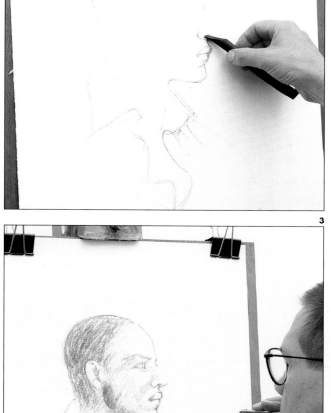

**2**

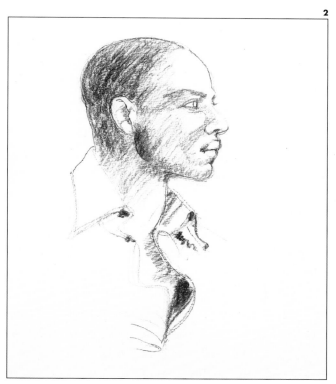

**3**

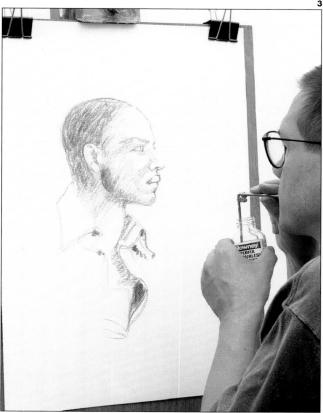

**3** At this stage it is a good idea to fix the drawing. Here the artist is applying the fixative using an instrument that resembles a blow pipe, which is held in the bottle of fixative as shown. The advantage to this is that it cuts out all the terrible fumes which an aerosol (even a CFC-free one) creates. Fixing the portrait at this stage will allow you to superimpose sharper marks which will not be softened by the charcoal already on the paper. It also stops you smudging the work with your hand.

**4**

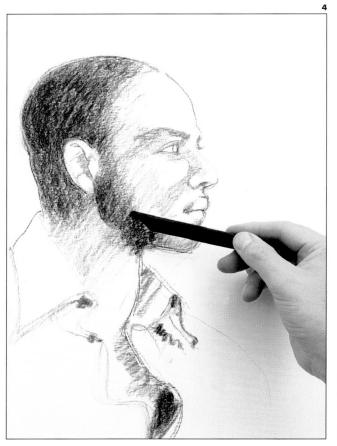

**5**

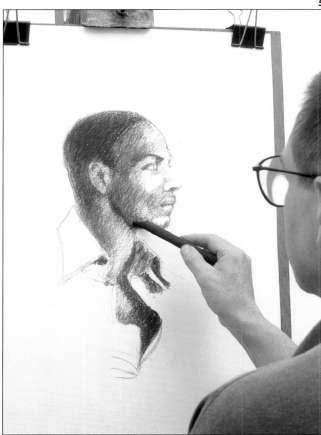

**6**

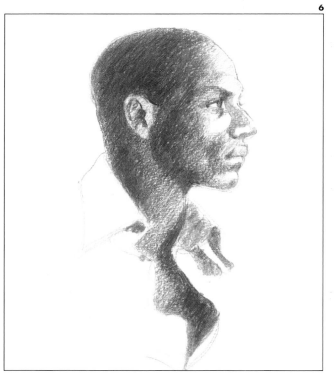

**4** Using the side of the fine-pointed end of the stick, which produces a sharper, blacker mark, add another layer of tone onto the hair. Now hold the stick lower down – which will give you a much freer stroke – and go over the hair and the side of the cheek again.

**5** Continue by working up the dark line of the jaw, the cheeks, the shadows which fall under the collar of the shirt, the neck and the forehead. Do this by gradually building up the tone in layers and switching the stick from the fine end to the side to vary the strokes. At this stage fix the whole drawing again.

**6** Work over all these areas once again, gradually building up the darks. Refer back to the reference and when you are happy with the result move on and add all the finer details of the face. Using the side of the pointed end of the stick, start to work up the mouth and the shadows around the nose. While working on the nose switch to the tip of the stick and re-define the outline of the nose to accentuate its contour. Move back to the side of the point and go over the darker areas once more. Switch back to the point and tighten up the lines of the inner ear and eyes and deepen the lines under the eyes and eyelashes.

**7** Before any further work is done, fix the whole drawing again to avoid smudging. Using the wide edge of the charcoal, add the shadow on the collar and go over the larger areas of shadow again. With the pointed end of the stick suggest all the smaller, finer details such as the eyebrows and the contours of the inner ear.

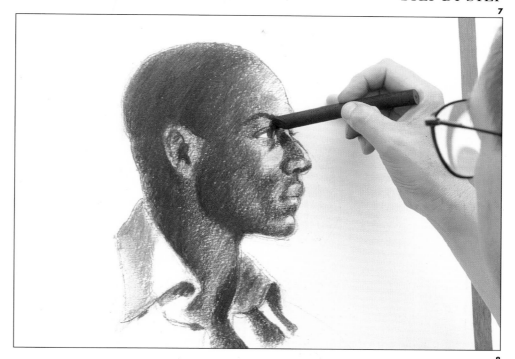

**8** If you do not mind getting messy, smudge the charcoal over the highlighted areas with your fingertip to blend them in with the rest of the picture and soften the edges; otherwise you can use cotton wool. Now fix the whole drawing again.

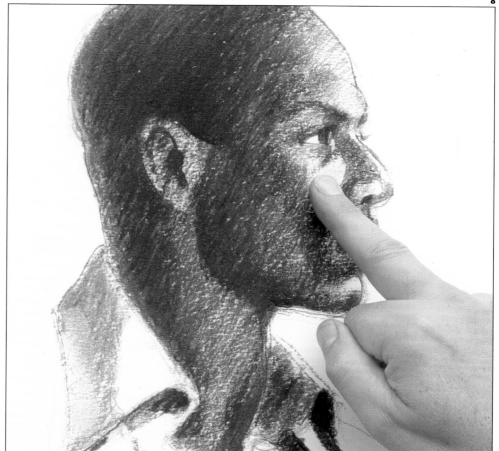

**9** When the fixative has dried, go over the dark areas once again using fairly loose strokes. You can use either the side of the stick or the pointed end, which should be well rounded by now. At this point you may want to neaten up the edge of the nose if it is looking a little untidy.

**10** Because some final adjustments are needed in the details, sharpen the end of the charcoal stick again with a razor blade. Break a small piece off a putty eraser, roll it into a point and use it to go over the portrait picking out the highlights. Now go over the dark areas once again. Add the two dark areas in the eye socket and on the side of the nose, picking off the lighter areas with the 'mini' eraser. Darken the eyebrow and generally tidy up the whole picture, tightening details where necessary.

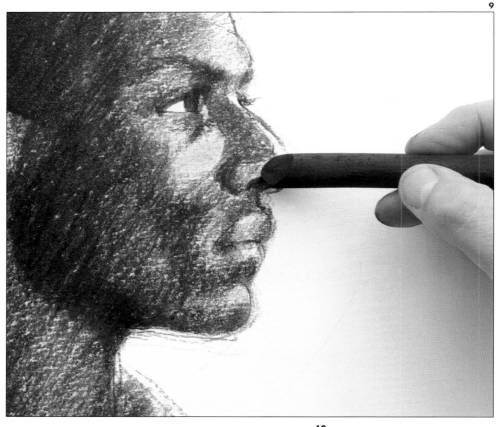

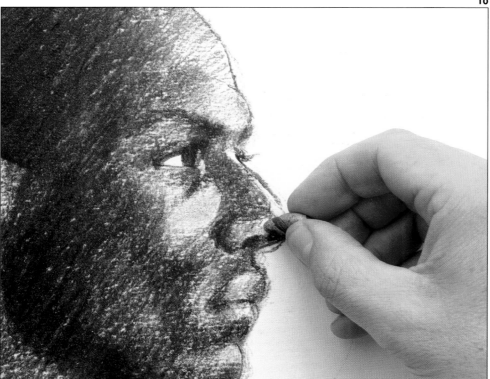

**11** One more vital thing before stepping back to admire your work, or moving it, is to spray the whole drawing with fixative. It is amazing how many people forget to do this and end up with just one large smudge across the paper. So be warned.

Back to the subject of the drawing, we hope that you have enjoyed working in charcoal and the freedom and the speed that a single stick can give you. Although here we have worked up this portrait to a highly finished state, you can also achieve some dramatic results by employing much looser, bolder strokes.

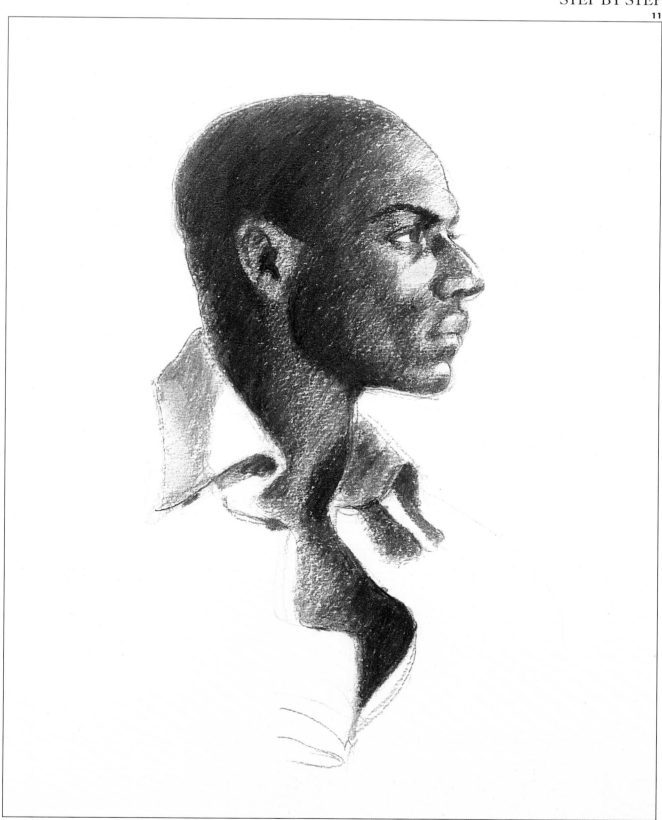

# Chapter 4
# Colour Sticks

Now is the time to move on to colour, and to start with we shall keep our emphasis on a bold and broad approach. To help with this, we have chosen materials which can be brought together under the general term 'colour sticks'. These are chunky, broad materials which encourage an open approach and discourage overworking, rubbing out and detail. Conté, studio sticks and wax crayons belong to this category. Although they call for bold marks, they are easy to use. They require less expertise, for instance, than soft pastels and oil pastels – see Chapter 6.

Again, you are advised to work on a grand scale, on white or tinted paper, the bigger the better. Our artist operated on a large scale in all four demonstrations, and there is no reason why you should not go even bigger, pinning the paper to a wall if your board isn't big enough – don't be restricted by standard-size equipment. Small supports and boards are fine for certain pictures, but remember that they tend to dictate the way you work. On a large scale, you can work freely, drawing from the elbow, keeping the lines flowing and uninhibited. For the same reason, give yourself plenty of room in your workplace.

Be adventurous with the outline, combining line and colour rather than outlining a shape with one colour and filling it in. The lessons learned about tone in the charcoal section also apply here – colours, too, have tones. It's great to have a lot of colours available – and most of these materials do come in wide ranges of colour. Remember to be selective, however. Choose the colours you need for your subject before you start. You can establish a harmonious colour theme in this way; and, once you start, you won't want to stop and look for what you need – a habit which can all too often lead you to pick up a compromise colour.

These chunky materials encourage you to use the whole of the paper. Make use of this. Don't start in the middle and work on a fiddly scale, thus losing the benefit of the materials. Notice that the lobster, in one of the demonstrations, fills up almost the whole support. In the first illustration there is more space but it plays an active role in the composition. The still-life arrangement depends on the top half being fairly empty, with folds of material leading the eye down to the lower half, where the focal point is the statue head.

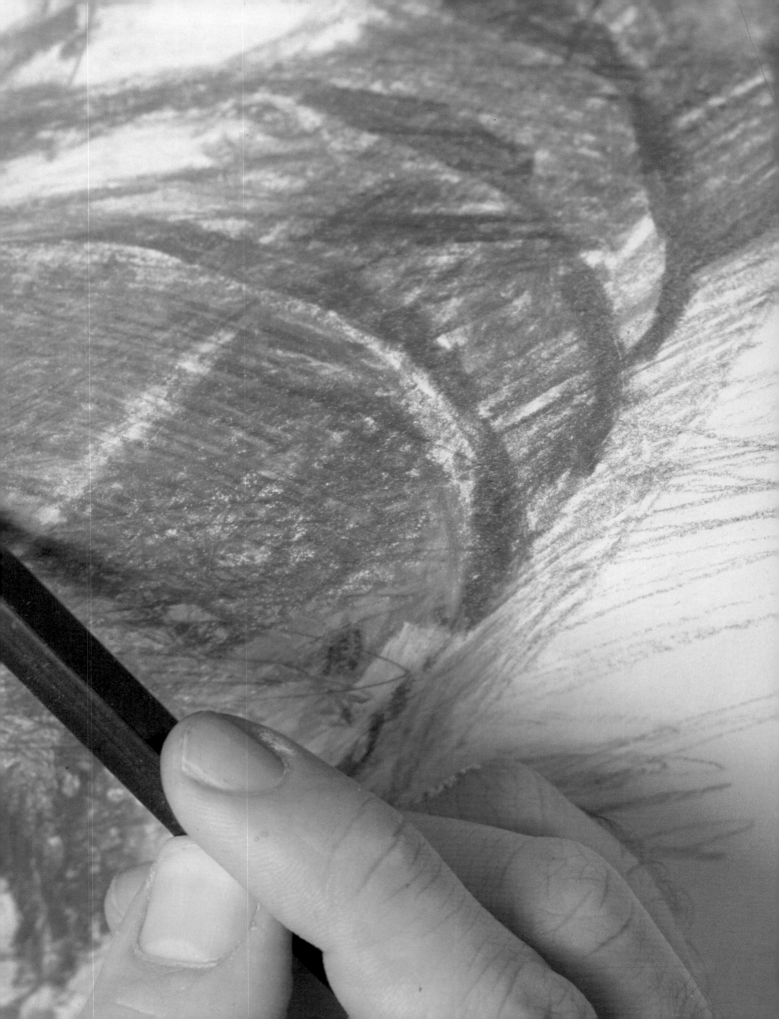

# Materials
## COLOUR STICKS

The range of new and old materials in the form of sticks is so wide that terminology becomes difficult. There is a vast array available – crayons, studio sticks, conté, and so on. These are the simpler, chunkier sticks, as opposed to the pastels which occupy their own chapter.

## Conté

These are small square sticks originally made from pigment compressed with clay and other ingredients. They are harder than charcoal and pastel. The traditional colours are black, white, sepia, sanguine and bistre. A range of greys has been added. Drawings done in these traditional colours often seem to have an antique look dictated simply by association. Leonardo da Vinci, for instance, used a red chalk similar to the sanguine conté.

Like charcoal and chalk, the limited range of these more traditional, subtle colours is good for tone-drawing on tinted paper. However, the development and refinement of artists' products never ceases, and conté sticks are now available in a full range of colours.

Conté can be bought in single sticks, in sets of the traditional 'Carrés' colours, or in the larger sets which contain a full colour range.

In a picture rendered in conté, the colours can be blended. When working with conté sticks, you can use the sharp edge, the broad edge or the broad end, giving you the choice of three thicknesses of line. Conté colours need fixing. Use matt papers with a key – Ingres, Canson, cartridge, or watercolour paper.

## Studio Sticks

Although they look similar, these modern materials are less manageable than conté because they are waxier, and they cannot be blended easily with the finger. They are more like coloured pencils without the wood. Studio sticks are good for the beginner because they defy a lot of detail, and their waxiness prevents them from being overlaid – the maximum is usually about three colours. You will achieve your best effects with studio sticks if you make

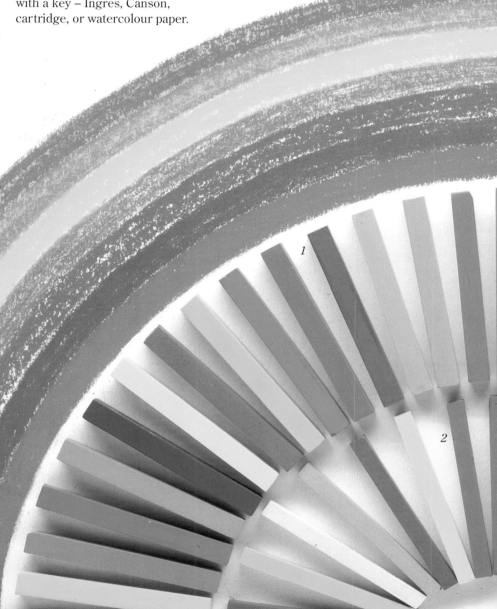

plenty of use of the white paper – see the illustration of the lobster. They can be used for three thicknesses of line, just like conté. Use smooth or textured papers, but remember that the papers should not be too rough.

Studio sticks do not rub out easily but they can be scratched back. They can also be dissolved with turpentine but it is difficult to control the tone and colour with this process, so experiment first. Unsuitable for small work, studio sticks are best for quick impressions. They break easily, so

build up colours in thin layers and don't press too hard. They are available from art shops in sets; on first use you might find them difficult because the outside of each stick has a waxy coating, so get rid of this by scribbling on rough paper.

## Wax Crayons
The cheaper varieties of these – the kind you would buy in a normal stationery shop – tend to be less refined than those of top quality, and they are not the best materials for controlled work. But, because they are inexpensive and easy to obtain, they are ideally suited for quick, or experimental, large-scale pictures.

Children's crayons are perfectly acceptable as tools for adult work; so, as well as searching the art shops for supplies, you could buy small sets of crayons from toy stores.

## Water Soluble Crayons
These chunky sticks can be dissolved with water. Practice is required, and the use of water makes the colour darker and more difficult to control. This type of crayon is good when you want to combine a line drawing with areas of 'painted' quality. It is another material not really suited to detail, so work on a large scale. Good-quality paper or card is needed, to withstand the wetting process.

1  *Studio sticks*
2  *Conté crayons*
3  *Water soluble crayons*

# Techniques

COLOUR STICKS

### Conté Crayons: Overlaying Colour

Less powdery than chalk and charcoal, conté colours can be mixed by laying one colour over another, allowing the underneath colours to show through. The sticks are square, which means you can obtain very fine hatched lines by drawing with the sharp edge of the end of the crayon, building up the colours in as many separate layers of cross-hatching as you need and allowing the colours underneath to show through.

In the illustrations on this page, the artist is using traditional conté colours – sanguine, black and white. The first colour, sanguine, is laid in neat cross-hatched patches on a tinted paper to obtain an even tone (*1*). To darken this, the artist works over the sanguine in black, using the sharp edge of the stick to make thin, controllable lines (*2*).

This combination can be worked into with other colours to alter the overall tone and colour as required. In the third picture (*3*) white is being added to lighten the final effect.

### Conté Crayons: Blending Colour

Conté is soft enough to blend colours by rubbing them together. This technique is especially useful if you want a small area of smoothly blended tone, such as the gently graded shadow and light on a shiny, rounded object (it is less suitable for large, even areas because it is difficult to get a flat colour). In the illustrations below, the artist demonstrates how to merge two colours to obtain a smoothly blended edge by first laying the colours next to each other (*1*) and then rubbing the join gently with the finger to merge them (*2*).

**Overlaying Colour**

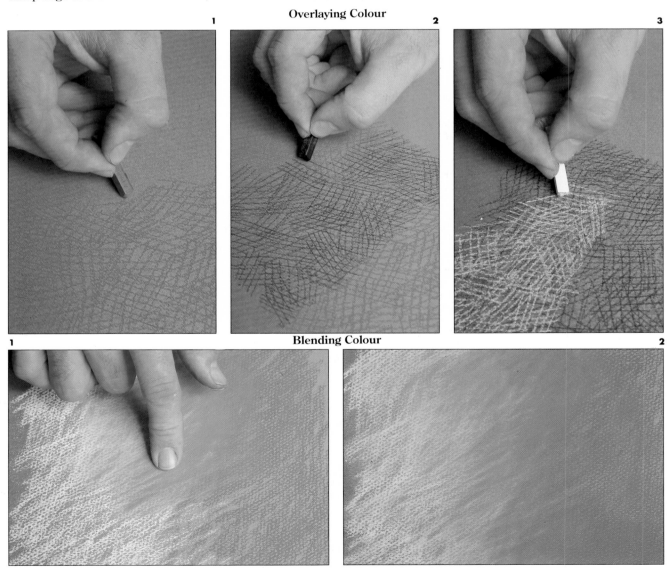

| 1 | 2 | 3 |

**Blending Colour**

1      2

## Studio Sticks: Optical Mixing

Studio sticks are waxy and heavy, without the crumbly, 'blendable' texture of conté, charcoal and chalk. Although they can be mixed by overlaying two or three colours lightly, subtle hues are limited because the waxy surface builds up, becomes shiny and resists further working. With studio sticks, two or three layers of colour are the maximum, and even then it can be difficult to control the effect.

One way round this problem is to mix colours 'optically' – in the eye rather than on the paper – by using small dots of colour to create exactly the shade you want. For example, greens can be mixed from yellow and blue dots. The shade and tone of the final green is determined by the proportions of yellow and blue, and how densely the dots are distributed on the paper. Different blues and yellows can be used to make an almost infinite range of greens. These can then be modified with small amounts of another colour. The technique is employed in all artists' media, including paints, but is especially useful when the materials themselves do not mix and blend easily. This includes studio sticks.

Here the artist starts with a scattering of light blue marks, working over these with bright red to create violet *(1)*. Green dots are added to neutralize this *(2)*. The brightness of the final colour *(3)* is determined by the amount of white paper showing between the dots. Mixed together on the palette, these colours would produce a dull grey. Here, the separate colours are visible and the result is a lively neutral.

COLOUR STICKS

## Studio Sticks: Laying Colour

Practice will enable you to control the colour and tone of waxy studio sticks to some extent. We have already seen how optical mixing can be used to combine colours on the support. This technique, however, is not suitable for all types of work, and you may not want your picture to be dominated by the flecked texture which characterizes optical mixing. In the pictures below, the artist demonstrates alternative ways of laying and mixing colour.

## Studio Sticks: Overlaying Colour

One of the best ways of mixing colour by overlaying is to hold the sticks lightly, drawing with feathery strokes, and pressing just hard enough to distribute the pigment evenly on the support. Work loosely, leaving plenty of white paper

showing between the marks (a slightly rough surface will provide a 'key' and hold the colour better than a smooth paper). Here our artist lays three colours – blue, violet and finally red *(1)* – to obtain a deep textural purple. The more colours you attempt to add the less white will be left showing, and the denser and more clogged will be the result. Generally, two or three are the most you should aim to use on any one area *(2)*.

## Studio Sticks: The Side of the Stick

To block in wide expanses, use the side of your colour stick *(1)*. The result is an evenly spread, mottled texture with flecks of white paper showing through *(2)*. You can also use this method to mix two or three separate colours by overlaying.

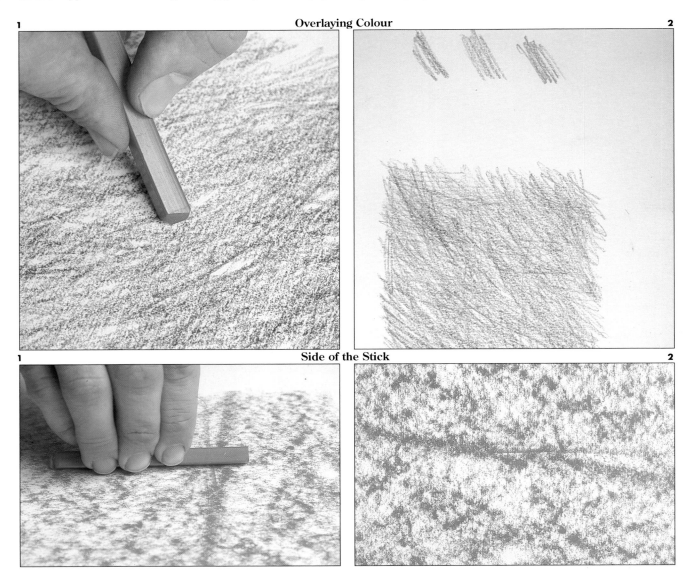

1        **Overlaying Colour**        2

1        **Side of the Stick**        2

## Texture

The conveniently squared shape of conté and studio sticks means you have a lot of choice when it comes to making marks and creating texture. Draw with fine, medium or broad strokes, depending on whether you use the sharp edge, broad end or side of the stick. The textures demonstrated here show just a few of those possibilities.

## Textural Marks

Long, broad flecks (1) can be used as a flat pattern. Alternatively, the direction of the strokes can be altered to indicate perspective. For example, if you wanted to render the surface of a receding road with a flecked texture, the recession and distance could be emphasized by directing the flecks towards the vanishing point of the road.

Feathery random strokes (2) are another useful method. They can be adapted to suit many surface textures, and are an excellent and quick means of turning a flat background expanse into an area of interesting broken texture.

## Sgraffito

Blocks of solid colour can be enlivened by scratching texture into the dense tone with a sharp blade or scalpel. The scratching, or 'sgraffito', technique allows you to make fine etched lines which reveal the colour underneath or the tone of the paper. Here the artist is using the tip of a surgical scalpel (1) to scratch away some of the blue top colour, thus allowing streaks of the bright yellow underneath to show through (2).

**Texture Marks**

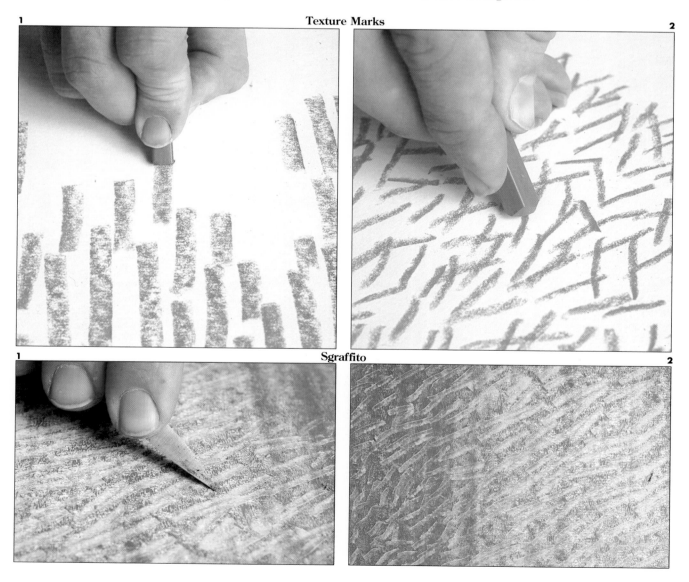

**Sgraffito**

# Still-life with Drapery

## CONTE CRAYONS

The cast of a head rests at the foot of a long, hanging drape, positioned near the simpler spherical form of an apple – a challenging arrangement which requires a systematic approach. The artist uses conté, which can produce darker lines the more heavily it is pressed. In order to achieve absolute control, however, the artist did not rely on different pressures. Instead, cross-hatching was used to build up the grades of tone. Fairly light cross-hatching was applied, and further layers were added where necessary to create darker regions. By adding light layer upon light layer you can retain total control and tackle quite complex compositions.

Because conté is softer and chalkier than modern studio sticks, it can smudge. Here, an experienced artist used fixative only at the final stage. However, there is no reason why you should not spray with fixative at each stage, between tones, especially after using white. Fixative is a varnish, so a light spray is sufficient. Too much will smooth the surface which will become shiny and resistant.

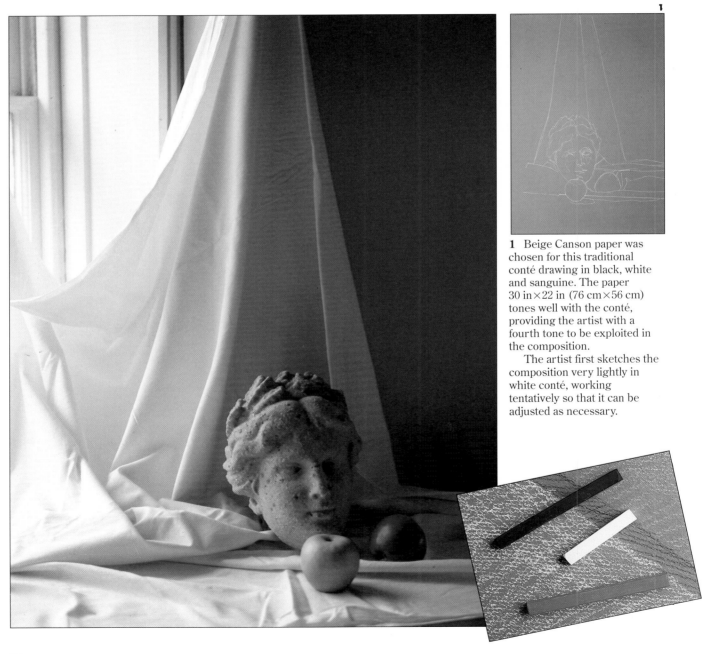

**1** Beige Canson paper was chosen for this traditional conté drawing in black, white and sanguine. The paper 30 in × 22 in (76 cm × 56 cm) tones well with the conté, providing the artist with a fourth tone to be exploited in the composition.

The artist first sketches the composition very lightly in white conté, working tentatively so that it can be adjusted as necessary.

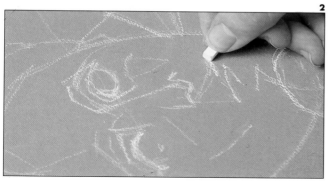

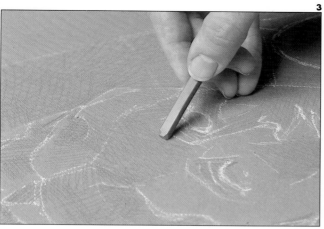

**2** It is now time to strengthen the white drawing so that it can act as a sound guide for the ensuing tones. The lines are drawn over again, using the sharp edge of the conté to achieve a narrow final line. Do not be afraid to draw boldly and to correct your drawing by going over the lines again. It is far better to have two or three clear lines overdrawn on the paper than to overdo the rubbing out which will make the drawing fuzzy. Once you start erasing, you are in danger of losing the clarity and sharpness of the background tone. By using the sharp edge of the stick, as the artist is doing here, you are further ensuring a crispness of image in this early stage.

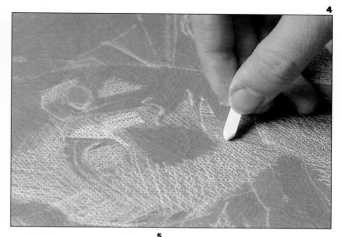

**3** Reddish brown sanguine conté is used to lightly hatch in the broad shadow areas on the face and drapery. The artist keeps the hatching loose and the lines far apart; if the work is done too densely at first, it becomes difficult to build up the colour and control the tone. This is the foundation for further blocking-in of the shadow regions. The edge of the square piece of conté is employed to keep the lines fine. The conté is turned over as each edge becomes worn.

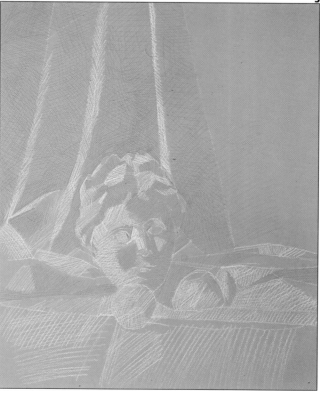

**4** Following the general areas of shadow, the artist now turns to the lighter regions. White conté is used – lightly hatching in the general areas of light. The strokes are kept loose, allowing for the brighter highlights to be added later in more dense and brighter white. At this stage the artist does not attempt to grade the white to suggest form.

**5** The broad areas of shadow and light have now been defined. It is important to note how they have been done – with extremely delicate, criss-cross strokes. Already the subject has been given a certain amount of form because of the strong directional light source, even though the sanguine and white areas at this stage are still flat shapes. The directional light has picked up the strong edges of the fabric folds and the contours of the face.

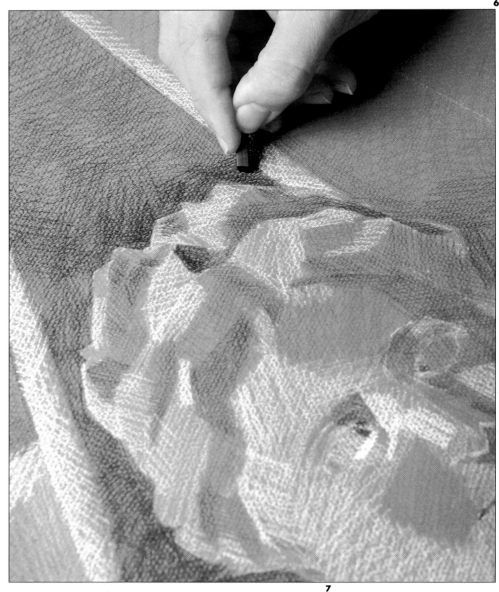

**6**

**6** Still working in the light criss-cross technique, the artist uses black conté to develop the shadows. The medium dark shadows are picked out first, and are depicted with one or two light layers of hatching being worked in over the underlying sanguine. The palest shadow areas are left to be represented by the sanguine. For the darker shadows, the artist applies further layers of cross-hatched black.

**7** The direction of the hatched lines can be exploited to describe form. In this illustration the artist is taking the direction of the cross-hatching round the curved shape of the apple to emphasize the form. A similar approach was used on the folds of the drapery where the strokes follow the long broad pleats.

**8** With the white conté, the artist works into the light areas, picking out the highlights, reflections and brightest patches. Again, this is done by further layers of controlled cross-hatching. On these narrower highlights the artist is using a single stroke of white to draw in a thin shape of elongated light behind the apple.

**7**

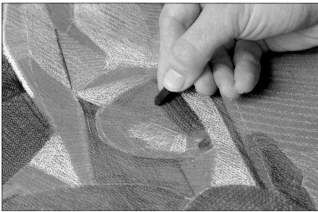

**8**

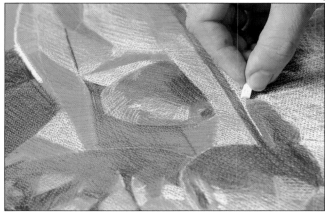

White

Sanguine

Black

**9** Because conté smudges easily, the finished picture is fixed.

The drawing was simplified – not graded like a photograph with an infinite number of tones. Tones were restricted to large simple areas, broken down into a lighter and darker version of each of the colours used. For example, black has been used deeply in some areas – such as on the right-hand fold of the drapery and behind and around the head. Elsewhere, black is confined to one or two layers of cross-hatching to represent the medium shadows. White is used to create an overall light tone except where the highlights were particularly bright, such as the reflections on the apple.

**9**

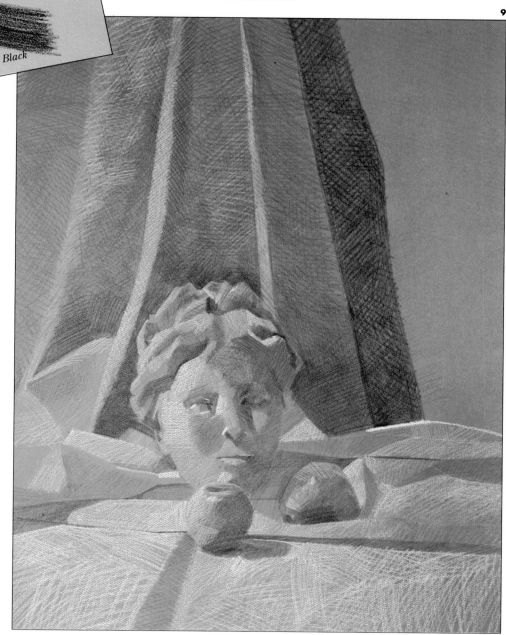

# Lobster on a Plate

## STUDIO STICKS

Studio sticks are an ideal medium for beginners. They are broad and chunky. One of the main hurdles when learning to draw is lack of confidence, and this tends to force the inexperienced into attempting detailed renderings. The studio stick, however, invites a bolder approach. The sticks e also available in a wide range of colours, allowing for colourful, adventurous interpretation.

These bulky sticks are used here to draw an object which at first glance seems exactly the wrong one for them – the complicated, organic twist of claw, tendrils and 'whiskers' which are typical of the lobster. The artist,

however, has decided not to carry out an intricate, academic drawing but to produce a big, sketchy image. The advantage of this is that it magnifies many of the shapes and colours which lie within the form of the lobster and which would be lost if the drawing was to real-life scale or smaller.

The artist has also decided to have no background in this picture. The lobster spreads itself across most of the support. For the drawing, it was set upon a white plate, the same tone as the paper, so that the backdrop would be white during the drawing.

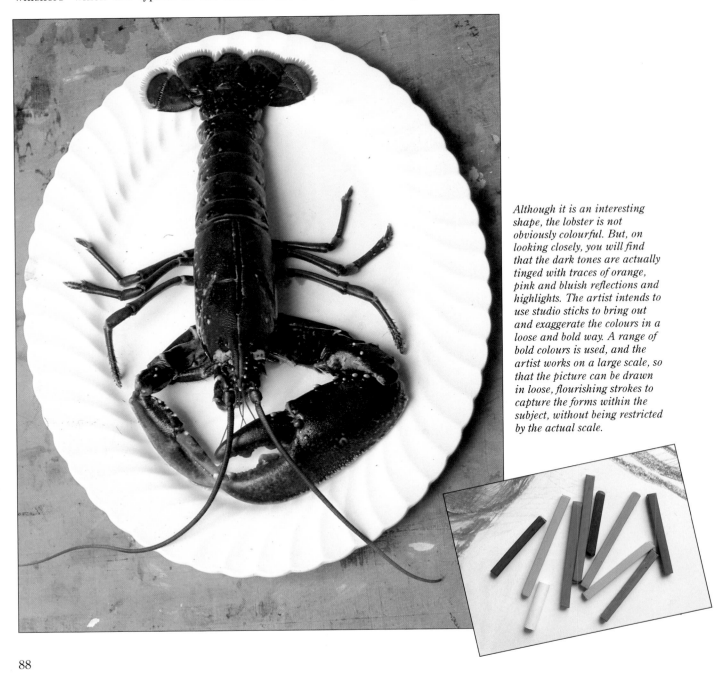

*Although it is an interesting shape, the lobster is not obviously colourful. But, on looking closely, you will find that the dark tones are actually tinged with traces of orange, pink and bluish reflections and highlights. The artist intends to use studio sticks to bring out and exaggerate the colours in a loose and bold way. A range of bold colours is used, and the artist works on a large scale, so that the picture can be drawn in loose, flourishing strokes to capture the forms within the subject, without being restricted by the actual scale.*

**1** The artist places the subject centrally and prominently on a large sheet of cartridge paper measuring 30 in×20 in (76 cm×51 cm). Using purple, black and brown – approximations to the obvious real-life colours – the artist sketches in the outline of the subject. The drawing movement is made from the elbow as well as the wrist, to capture the flowing curves of the tendrils. At this stage the drawing is fairly tentative and light.

**2** With black and brown, light cross-hatching strokes are made, in order to build up the dark local colours on the claw. Light and dark orange are also introduced to re-define the outline, lift the flat effect of the dark colours and capture some of the traces of bright hue present in the actual subject. The strokes are lightly applied with plenty of white paper showing through.

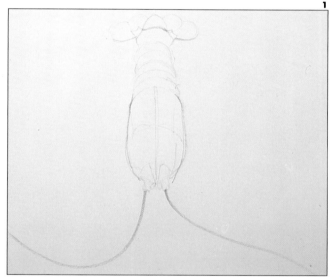

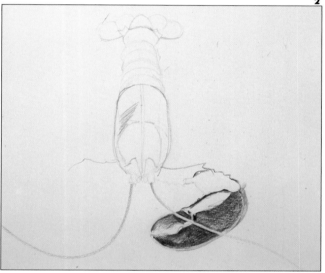

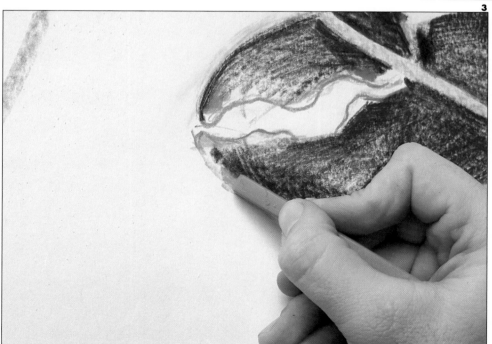

**3** The artist is combining line with solid tone, re-defining and re-drawing the outline of the subject as the work progresses. The lobster is being studied very carefully, so that bright colours can be picked out at this stage and introduced to the drawing. The fine wavy red lines on the inside of the claw are done with the edge of the stick. Here, the artist is using the broad side of an orange studio stick to create a wide solid wedge of colour. Notice how the dark areas of cross-hatching fade out towards the outline of the drawing. This means that the brighter linear colours do not lose their effect by being swamped. They have plenty of white paper around them to allow them to show up to full effect.

# STUDIO STICKS/LOBSTER ON A PLATE

**4** Further layers of colour have been introduced – hatched and cross-hatched to build up the tones in black, dark purple and brown. The tendril, which has already been lightly blocked in, passes in front of the claw. This has been preserved as a light negative shape. When using studio sticks it is difficult to make a lighter colour show up on a darker one, so areas which are light or white have to be left – the light tone of the paper providing the light tone. When drawing the claw, therefore, the edge is brought up to the outline of the tendril to leave a clean crisp edge. At this stage, the artist also strengthens the coloured outline to match the newly established darker tones.

**5** The artist now moves on to the rest of the lobster, having established, in and around the first claw, the basic overall tone and colour of the whole picture. The tones and colours are blocked in, in a similar way, lightly at first with a view to strengthening these later. With studio sticks you cannot be impatient when building up tone. If you use them too heavily at first, it makes further drawing impossible. They must therefore be built up slowly and lightly, especially as in this case when two or more colours are being laid on top of each other. The direction of the marks describes the form they represent. The head, for example, is simplified into directional planes describing the rounded form.

**4**

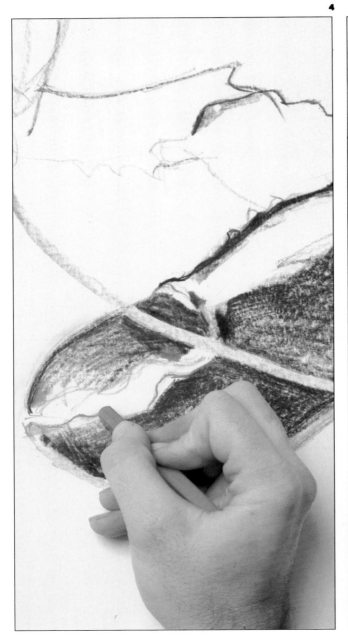

**5**

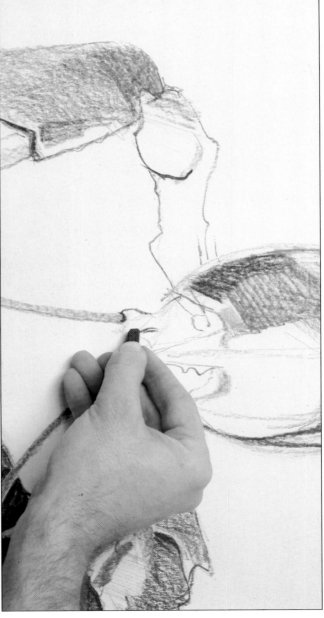

**6** The artist works vibrant warm tones into the dark and cool areas of local colour. Because the undertones were lightly applied, the white paper can still be seen, and the dark colour is not too dense to receive a further lighter tone. These dashes of colour are introduced sparingly, their object being to lift the image. Too much colour here would destroy the point of these dashes, and would work against the naturalistic effect being sought. Because the artist intends to continue to develop the local colour, the side of the stick is being used here, to keep the application light. This means darker tones can still be used over this to modify the effect of the yellow if necessary.

**7** So far the claws and the body have been blocked in, and already the lobster is looking very solid because the cross-hatching has been used to depict definite planes of light and shade. Notice that on the body of the lobster the artist has paid attention to the source of light. The light is not particularly strong or emphatic, but, without this highlight on the left-hand side, the body would look flat and formless. Similarly, light ridges have been left down the back of the lobster – another area where it picks up the light source – and light highlights on the claws and elsewhere have been applied.

**6**

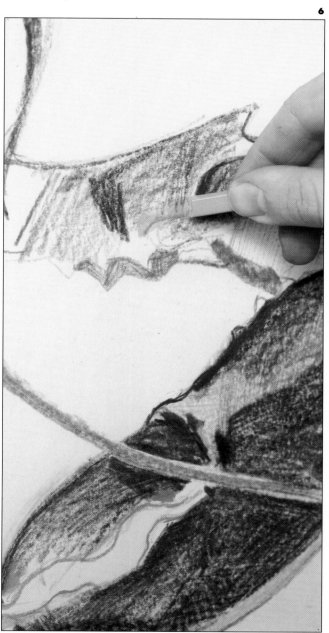

**7**

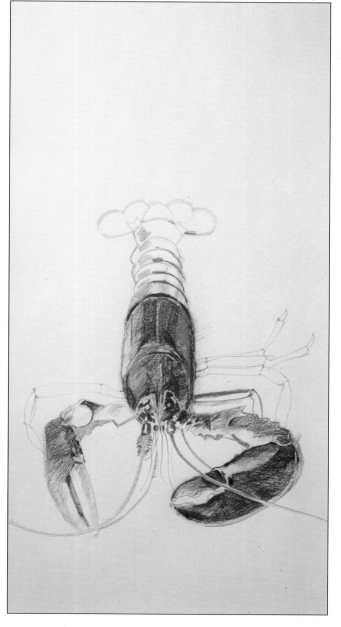

**8** With studio sticks it is often quite difficult to work from dark to light. You have to leave areas of light rather than working them over the top of darker regions, because the surface becomes increasingly shiny. However, you can scratch the surface to depict highlights – or, as in this case, you can switch to chalk.

**9** The artist chose chalk for highlights because its crumbly texture will adhere to the waxy surface of the studio sticks. Highlights have already been chalked in on the body, and here the artist is using chalk along the edges, in order to achieve a clean outline. The white chalk modifies the colour beneath rather than completely covering it.

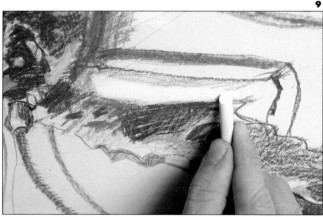

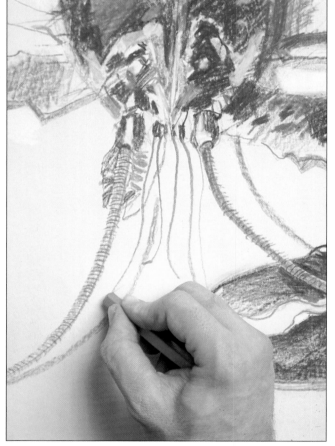

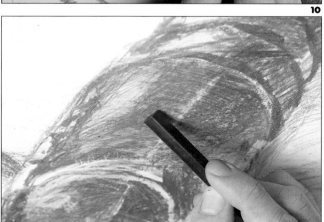

**10** The white chalk is receptive to further working with studio sticks. Here the artist re-defines some of the darker tones over the light highlights.

**11** Final touches are now added. The tendrils and 'whiskers', an important feature in the overall subject, are developed. The artist works round the two main tendrils in a dark purple with the edge of a studio stick, putting in their segments. Using brown, red and orange, the whiskers are added in free strokes.

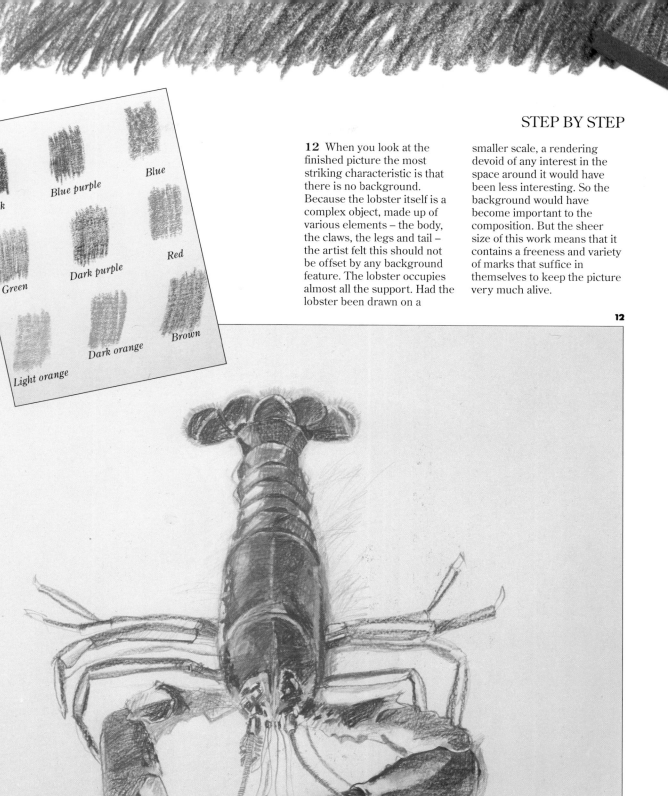

Black

Blue purple

Blue

Green

Dark purple

Red

Light orange

Dark orange

Brown

**12** When you look at the finished picture the most striking characteristic is that there is no background. Because the lobster itself is a complex object, made up of various elements – the body, the claws, the legs and tail – the artist felt this should not be offset by any background feature. The lobster occupies almost all the support. Had the lobster been drawn on a smaller scale, a rendering devoid of any interest in the space around it would have been less interesting. So the background would have become important to the composition. But the sheer size of this work means that it contains a freeness and variety of marks that suffice in themselves to keep the picture very much alive.

**12**

# Satchel, Hat and Coat

CONTE PENCIL

Within each of the projects chosen for this book we have tried to present you with a wide variety of textures to depict. This is not only to give you fresh challenges, but also, to show you that a still-life can be composed from any range of objects, whether indoors or outdoors.

For this drawing project we chose a small group of everyday objects – a folding chair, a denim jacket, a sunhat and a canvas satchel. The group has a spontaneous, unplanned feel, as though someone has just returned from an afternoon's sketching.

The artist is lucky to have a terracotta floor which provides an interesting background to many of his still-life compositions. It goes to show that you should always make use of what you have around you – even the floor!

The linear nature of conté pencils does not lend itself to rendering solid blocks of colour, but although the style of this drawing is quite loose and sketchy it is still possible to create the illusion of solid objects. This is why the colour of your chosen paper is so important, as you will find out in this project.

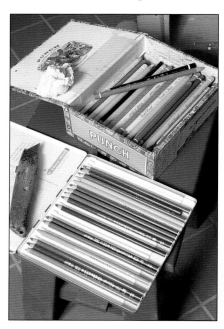

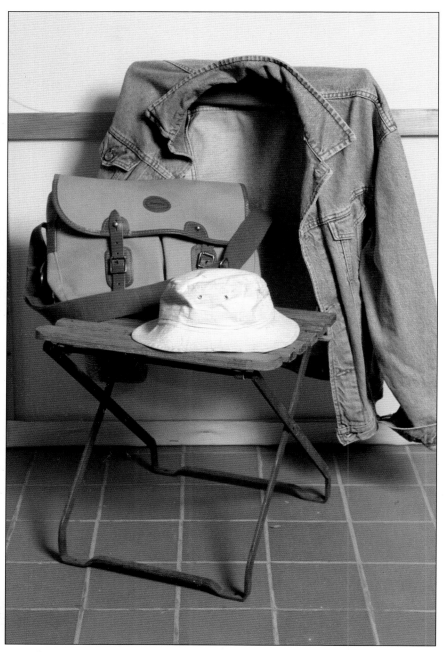

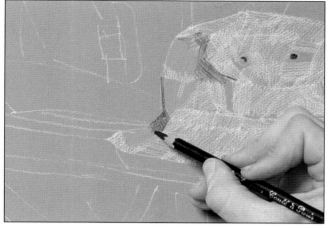

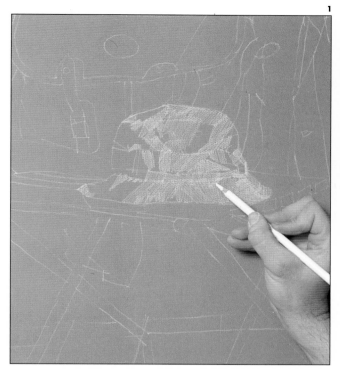

**1** When working in a dry medium like conté it is important to choose the colour of the paper carefully. This is because you will be using it not only as your background colour but also to enhance and bring out specific areas of your drawing. Conté pencils do not readily lend themselves to creating solid blocks of tone, so it makes sense to choose a coloured paper that will serve this function and relieve you of much of the hard work! The choice here was a mid-brown pastel paper which tones in with the bag, the canvas stool and the tiled floor. Draw the outlines of the group with a white pencil, which will show up against the relatively dark paper. Make the drawing quite detailed, mapping out such things as the shadows and folds of the material, as this will make your drawing much easier to build up. As you are already holding a white pencil, what better place to start than with the white of the hat. Following your initial drawing, start to fill in the contours of the hat using the technique of cross-hatching (see page 47).

**2** As you become more skilled at using your 'artist's eye', you will realize that a white object is never truly white but contains a wide range of tones, from light to dark. Often it will also contain hints of other colours; this is because white is highly reflective and picks up colours from surrounding objects. Here the colour of the canvas satchel is reflected onto the hat, so pale yellow and pale green pencils are required. Cross-hatch these colours following your initial drawing and referring back constantly to the actual object in front of you. Once you have completed the reflections, hatch in the shadows in black.

**3** With the black pencil, lightly indicate the main shadow areas, particularly inside the jacket. Use multi-directional cross-hatched strokes to bring a lively texture to the drawing. Just by doing this you will have already given a certain amount of form to the objects. Switching to a mid-blue pencil, move on to the denim jacket. With loose cross-hatching start to block in the folds and creases. At this point keep your hatching light as you will be returning to the jacket at a later stage; if the lines are too dense at first, you will find it difficult to build up colour and tone in a controlled way.

**4** Block in the lighter areas on the satchel with a yellow ochre pencil, using loosely hatched strokes that follow the form of the folds and indents. When you move around the picture like this, it is so much easier to get an overall feel for your drawing. Already all the individual elements are taking on form, and, by working in this way, you will be able to see more clearly which objects will need to be worked up more fully.

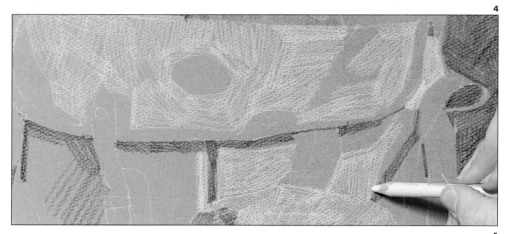

**5** Block in the strap of the satchel with a mid-green pencil, then use a light blue pencil to block in the highlights on the denim jacket. In this drawing there is no main focal point, so all the objects in the group must balance each other. This is why you have been working on the drawing as a whole, rather than concentrating on one element at a time. Besides, if you spend too long on one object it could put you off finishing the drawing, when you realize you still have four more objects to render to the same degree!

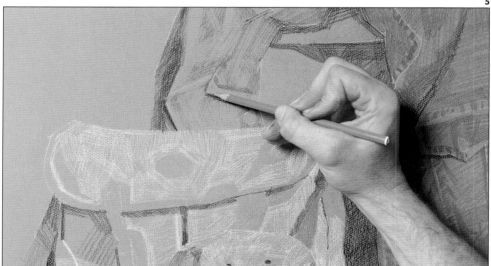

**6** Now block in the square-shaped highlight on the inside of the jacket with a light blue pencil. Draw the button, and the highlights on the edge of the collar, with the white pencil. With the black pencil, strengthen the main shadow at the back of the jacket. Then add the shadow beneath the collar and bring out the creases and folds in the material.

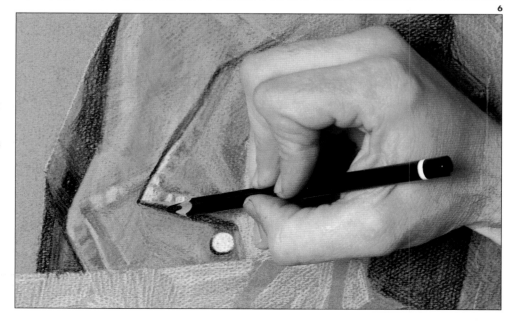

**7** Start blocking in the legs of the chair in black, using light cross-hatching strokes, and fill in the sleeve hanging down below the chair. Switching to a white pencil, loosely cross-hatch a white background in around the top half of your drawing. At this stage, stand back and take a good look at your work so far. It is incredible what a difference the white has made. Not only has it succeeded in defining the outline of the jacket, but it has also thrown the whole group forward in the picture plane.

**8** When filling in the precise shapes of the chair legs, you may find it useful to use the edge of a ruler as a guide, allowing you to hatch against it rather than being tempted to draw a rigid line along it which would create a hard edge. This is not cheating and means you can draw the strokes freely without worrying that they will go over the edges desired.

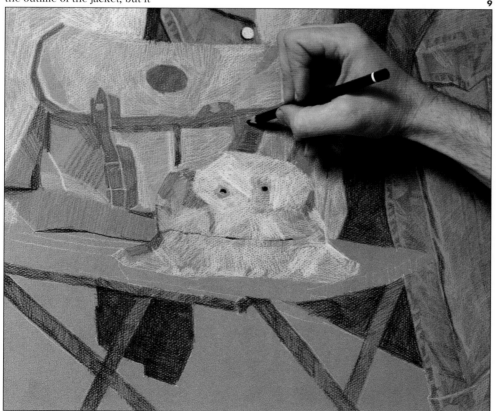

**9** Switching to a deep yellow, start to block in the darker areas of the satchel. You can do this with loose hatching, sometimes going over the paler areas, which will make the bag appear more natural, giving you a range of subtle tones rather than a solid, lifeless feel. Now it's time to tackle the leather trim, using a mid-brown pencil. These areas are more solid so block them in loosely, but this time use a little more pressure on the pencil. To bring out the sheen and density of the leather, switch to a dark red pencil and add some subtle patches to highlight the straps and then work up the shadow areas with black.

## CONTE PENCIL/SATCHEL, HAT AND COAT

**10** You are now on the final stages of all the objects. Using the black pencil for the last time, block in the shadow cast by the hat on the seat of the chair. Now take stock of your drawing and go over any shadows that you feel need to be strengthened.

**11** On looking at your picture as a whole – even though the floor tiles have yet to be tackled – the white background has created an uneven balance between the upper and lower halves of your picture. To rectify this, use a mid-grey pencil to loosely block in the lower half of the wall behind the chair, which is in the shadow. Now you can start on the tiles, using a mid-brown pencil. Use the ruler once again, this time to define the straight lines of grouting between the tiles.

**12** In keeping with the sketchy style of the drawing, there is no need to render the tiles perfectly. Never be tempted to overwork a drawing of this style. Instead, loosely block in the rest of the tiles as if you are almost scribbling. Hold the pencil right at its end to give you a really loose mark on the paper. To give an impression of light and shade falling across the floor, vary the tones of the tiles, making them darker immediately beneath the stool.

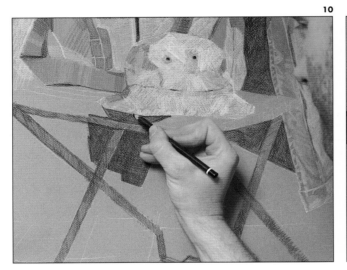

10

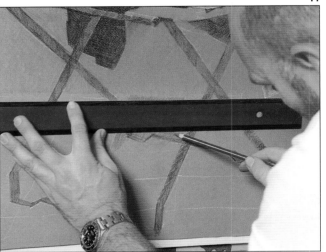

11

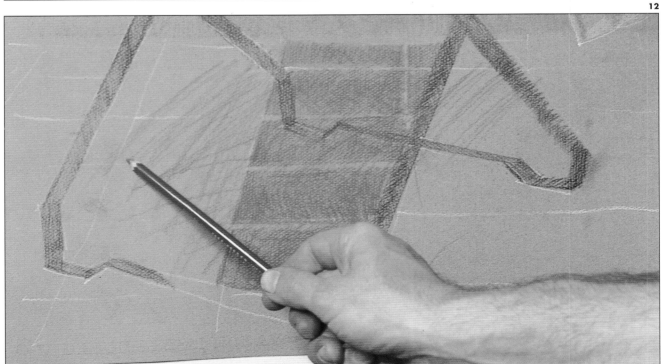

12

**13** Once you have completed the tiles, step back and take a final view of your drawing. If you feel anything needs going over do it now, but do not spoil the sketchy feel of the image by being tempted to overwork any specific areas. Now you can see what an important role is played by the colour of the paper; not only does it serve as the base colour for the floor, the satchel and the canvas seat of the chair, it also pulls the whole drawing together and creates a sense of harmony and unity. In addition, these areas of bare paper provide 'breathing spaces' in the drawing, enhancing its sketchy, spontaneous feel.

**13**

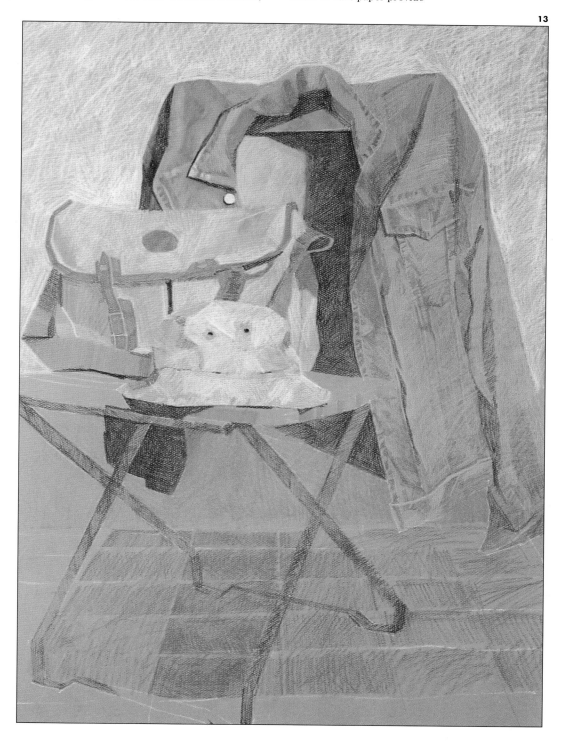

# Egyptian Man

## CONTE PENCIL

Sometimes you will come across people who just instantly strike you as good subject-matter for a drawing. In this case the artist was on holiday in Egypt, exploring the ancient monuments and generally soaking up the sights and sounds when he chanced upon this friendly fellow wearing the traditional *galaba* (smock) and turban. Although, as is common in many tourist spots in poorer nations, the man required money before he would pose for a photograph, it was (literally) a small price to pay.

It is preferable to work from life, but photographic reference can prove invaluable in a case like this. A hasty sketch could have been done at the time, but by taking photographs a much more considered approach is possible. However, to give the feel of a sketch done on the spot, conté was the chosen medium for the portrait carried out back home. This is because many artists do in fact use dry colour media such as conté and pastels to carry out sketches when working outdoors as they are, of course, colourful as well as clean, easy to carry and without the paraphernalia associated with some media.

When working with any coloured drawing medium the first thing you must consider is your paper – its type and colour. Your choice, of course, will depend on what you are trying to achieve. For a loose, sketchy picture you want a rough paper to break up the stroke. However, for this piece you will be hatching in places, and so you will need a paper with a smoother surface. The colour of the paper also affects the finished drawing. You can either go for a plain white paper (as used here) and let the drawing stand out against it, or use one of the vast range of tinted papers. However, make sure you select a colour that will complement your work. It is also useful to use a tinted paper in a creamy shade as the base tone for the skin. This makes it easier to model the face, adding shadows and highlights onto the base tone.

**1** Start the drawing by marking out the main areas of the composition using a very dark grey for the darker outlines and a red/brown for the lighter areas of the face. Keep your initial marks faint as you copy from the reference, re-establishing the marks once you are happy with the general proportions. If you do not feel confident with working by eye, then you can enlarge the reference picture on a photocopier and simply trace over it.

**2** Continue with these two conté pencils to establish all the very darkest areas such as the eyes, inside of the mouth and nostrils. Then use just the red/brown conté to hatch in the main shadow areas.

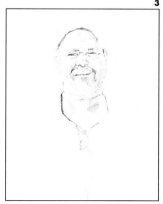

**3** Once the shadows have been established you can start to work on the mid-tones of the skin, hatching with a dark orange. Crosshatch over the darker mid-tone areas, and likewise crosshatch some light red over most of the orange. Keep your hatching very open (with lots of space between the lines) so that the colour beneath can show through.

# CONTE PENCIL/EGYPTIAN MAN

**4** Now work in further dark brown over some of the more shadowy areas you established in steps 2 and 3. Again use a loose hatching so that the colour underneath can show through.

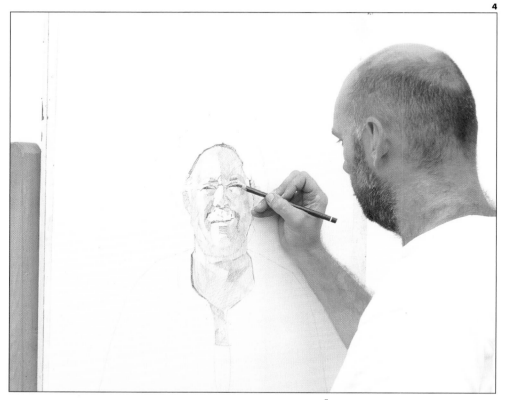

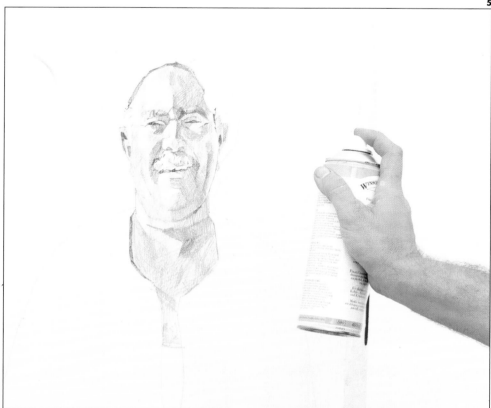

**5** Now that the basic features are in place, you must spray your picture with fixative to make sure that these initial marks retain their quality of line even after further conté hatching is superimposed. Wait a few minutes for the fixative to dry before starting work again.

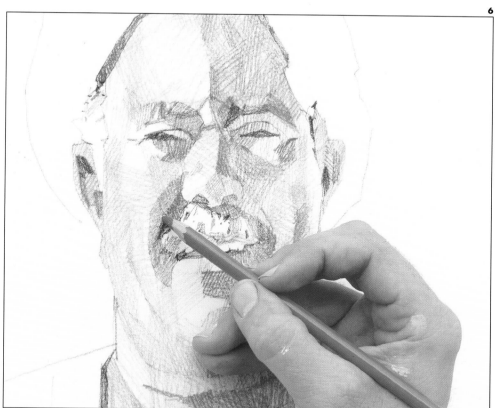

**6**

**6** To help give the drawing plenty of 'punch', you will need to introduce some strong colours. The deep shadows in the skin tones are the perfect place to do this as the strong colours will have a presence without being too obtrusive.

Start on the shadows by loosely hatching over some of them – for example the deep furrows that run from nose to mouth – with a dark red.

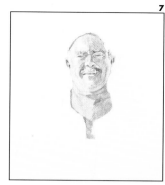

**7**

**7** You can also use a strong blue – the nearest conté equivalent to cobalt blue you can find – to loosely hatch over the shadowy areas in the flesh. The blue element in skin tones is particularly evident in shadows.

Continue the process of building up the skin tones by going over them with red/brown, orange and light red with a very open hatch. Then spray the drawing with fixative again.

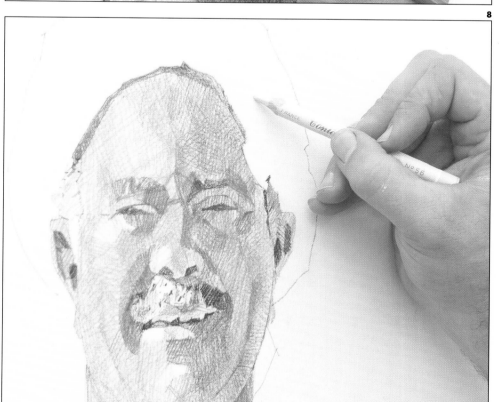

**8**

**8** Now switch your attention to the turban for a little while so that the drawing progresses as a whole. With a very pale blue lay a tight hatch (lines close together) to indicate the shadows in the folds of the turban.

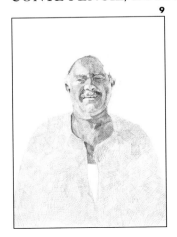

**9** Once the fixative on the man's face has dried you can return to subdue the shadow tones slightly by laying an open hatch of brown over them. The bold red and blue tones will still be evident, but the brown has the effect of knocking them back.

Switching once again away from the man's face, use a blue/grey conté pencil to lightly block in the *galaba* – the man's smock – with a combination of loose hatching and cross-hatching.

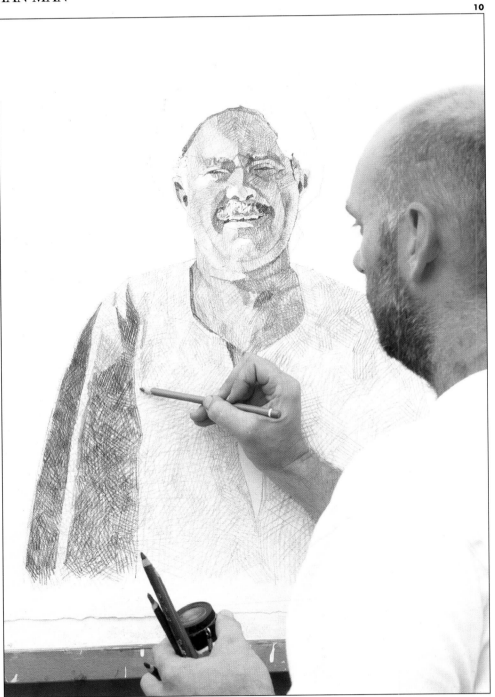

**10** Finally, to finish the picture, bring out the shadowy folds on the *galaba* with a cross-hatch of black, purple and red. Then switch to a mid-blue to add gentle hatching around the shadows to suggest the mid-tones.

**11** Stand back and give your drawing an all-over appraisal. If any areas require further work, now is the time to do it. Perhaps the shadows could do with being a little darker, or you may feel it necessary to add some highlights with white conté on the face. When you are finally happy with the drawing, spray it with fixative to prevent any chance of it becoming smudged.

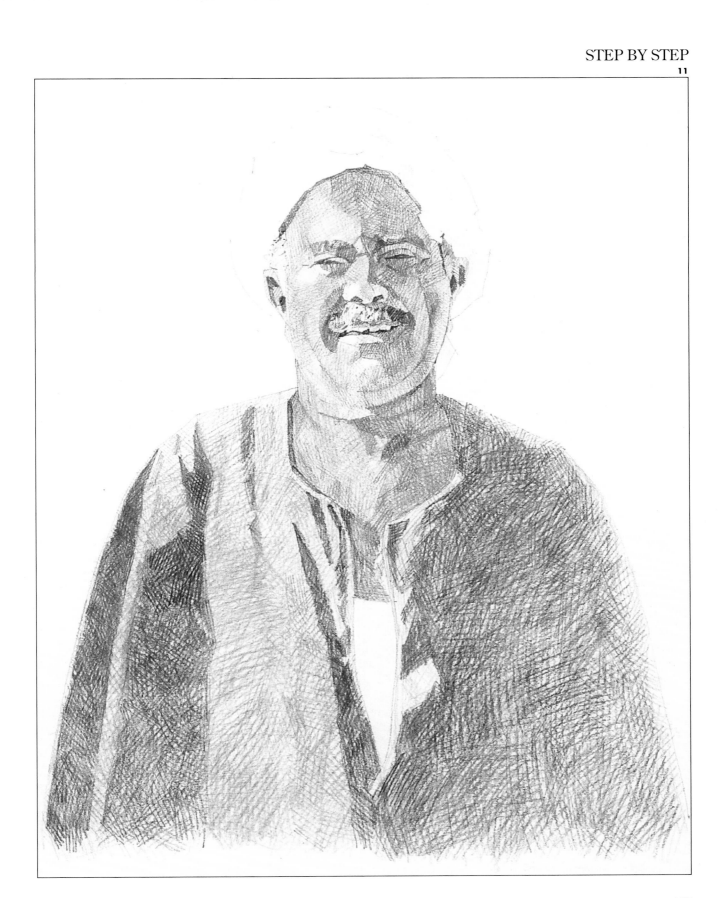

# Chapter 5
# Pen, Brush and Ink

This is a medium which was used by some of the great masters centuries ago and is still easily available, not only in its traditional form but also in a wide range of modern variations. When you sit down with pen, brush and ink, you may be working directly in the tradition of past artists such as Rembrandt (1606–69), who created drawings with brown ink and wash – some as preliminary sketches for paintings but many as finished pictures in their own right. Yet you are also working with a medium which allows for a great deal of experiment, for it embraces some of the latest materials.

This creative medium allows you to combine line with areas of colour and tone. It can be used in monochrome or in multi-coloured pictures. You can work with line alone, or you can use line with blocks of colour. Our artist demonstrates a line drawing with a technical pen; a bright circus scene with blocks of pure colour enlivened with dip pen and line; and a quick sketch made with an ordinary ballpoint pen.

You would be well advised to experiment with different pens. Get the feel of an old quill pen and compare it with modern fountain pens, ballpoints and technical pens. The medium can be used for finished works or for rapid on-the-spot sketching. Inks are now available in a huge range of colours, some brilliant or even fluorescent; they also come as concentrates.

There are various ways of exploring the possibilities and limitations of the medium. You can experiment with brush drawings, such as the Chinese 'boneless' style without outlines. You can start with line and add colour, or begin with blocks of solid colour and add line.

For the beginner, ballpoints and technical pens are ideal training tools. There are no precedents (no old master ballpoint drawings!), and therefore you can feel completely free to experiment. And the limitations of these tools can also be turned to advantage for quick sketching – they produce rather boring, unvaried lines in themselves. This means you can concentrate on getting down the information without worrying about how the finished drawing looks. You can work tight or loose, or combine these two approaches in the same work. The uncompromising lines will also force you to tackle directly some of the basic techniques of drawing, such as hatching and cross-hatching, to achieve a tonal effect.

# Materials

## PEN, BRUSH AND INK

These materials include the ordinary, everyday pens which can be bought in stationery shops and also some of the more technical types of pen. Even though there has been impressive technological development in this field, the old-fashioned quill has still not disappeared, and in fact is increasingly used by artists who like its characteristic, natural-looking line. The quill's direct opposite, the modern technical pen, is a rewarding challenge if you are a beginner seeking to explore some of the basic principles of drawing. Our artist chooses a technical pen to illustrate some of these principles.

1 Water soluble inks
2 Waterproof inks
3 Oriental brushes
4 Quill pens
5 Reed pens
6 Dip pen
7 Technical pen
8 Concentrates
9 Watercolour brushes
10 Mixing dish

## Technical Pens

The tubular nib of the technical pen produces a regular, ungiving line. This is suited to graphic, linear work, and our artist uses one in the still-life on page 112. Technical pens can be bought at art shops and graphic suppliers. You can obtain different nibs – sometimes called 'stylos' – from very fine to very broad. The number varies with the make. One manufacturer produces 19, another 12. The tubular nibs can clog and must be cleaned after use with a proprietary solvent cleaner. You can use special inks, made by the pen manufacturers and obtainable along with the pens, to help prevent this clogging. But, if a nib does clog, soaking in solvent cleaner can often save it.

## Dip Pens

These are the pens once associated with schoolrooms, where children made blots on their initial, scratchy efforts at handwriting. Dipping the pen into the ink and controlling the lines on paper was not easy for young schoolchildren at first, because the pen itself does not greatly restrict the flow of ink, and it responds to varied pressure on the paper. It is for these very reasons that the dip pen is popular with artists. The pen gives a varied and undulating line which can be turned to different effects. Most art shops have a range of nibs which are used in the same standard holder; and for tiny, extra-fine lines there are mapping nibs with their own small holders. You need a good supply of nibs. They don't last for ever, and with constant pressure they tend to spread.

## Ballpoints

These are cheap and easily available. Although they do not make interesting or varied lines, they are ideal for the quick sketch which is to be used as a reference for later work in the studio or home. They come in limited ranges of colour, usually red, blue, black and green.

## Fountain Pens

Fountain or reservoir pens are also useful for drawing. They offer a variable line – not quite as interesting as that of the dip pen, but you do not have to keep stopping to dip into the ink, so they are useful for sketching. Remember, however, that the nibs are not designed for drawing, and consequently they can be comparatively short-lived.

## Quills and Reed Pens

These earliest types of drawing materials have maintained their popularity over the centuries because of their ability to produce varied lines and often beautiful effects. Quills are available in art shops. You will need practice in order to develop their versatility. They require cutting frequently, to form a new nib, because the tip soon softens; use a sharp blade or craft knife for this. Reed pens can also be bought at many art shops and these make a hard, jerky line, capturing the linear effect of dip pens but on a completely different scale. You need to dip into the ink a great many times with quills and reeds, and you should experiment to collect the right amount of ink and to avoid flooding and blotting.

## Inks

The last few years have seen a big increase in the range of inks. Water soluble and waterproof are the main categories. Inks come in all colours.

Waterproof concentrates can be obtained in bottles, and they are very strong. The colours can be diluted as required, allowing for some degree of experimentation. They come in a very good range of colours. Some of these, however, are fugitive and fade quickly.

## Brushes

Any watercolour brushes can be used with inks. For line painting, sable has a nice, springy quality, but sable mixes and other hair brushes are also effective. Synthetic brushes are suitable, although they have less spring. Chinese and Japanese brushes have soft, pointed bristles, good for flowing, natural lines.

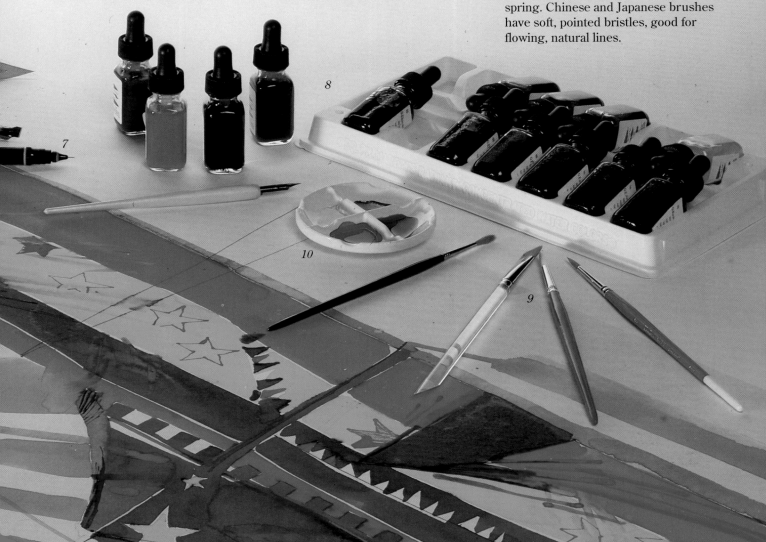

# *Techniques*
## PEN, BRUSH AND INK

### Technical Pen
The technical pen forces you to use line, and only line. Tone, texture and pattern must all be created from this single element, and you therefore need to be as resourceful and inventive as possible when using this piece of equipment. And the regular, mechanical line – so restricting in many ways – also has its compensations. For example, the rigid tubular nib can be relied upon not to flood and blot, and you can exploit this constant factor by extensively weaving the fine lines into a wealth of different textures and surface patterns. Here the artist builds up regular marks of cross-hatched tone *(1)*, using the smooth surface of white card to help produce the final, graphic effect *(2)*.

### Quill Pen
The old-fashioned quill pen differs from the modern technical pen in almost every way. Here, the problem is not one of how to make a mechanical line more interesting, but rather one of having a line which is uniquely interesting, but can also be too irregular and sometimes difficult to control! The quill needs practice, and you will have to dip into the ink frequently as you work. Do not attempt a neatly rendered drawing – instead, make the most of the natural, undulating marks which your feather pen produces. Here *(1)* the artist uses a scribbly line to produce an area of broken tone from the irregular hatching *(2)*.

**1**

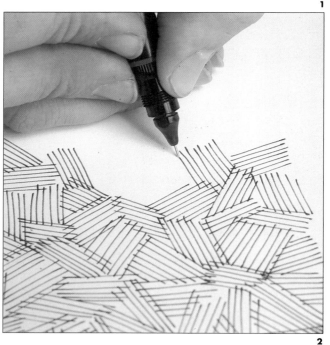

**1**

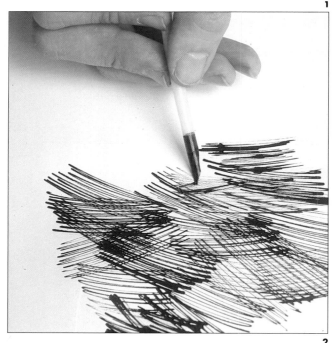

**2**

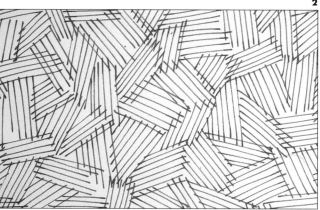

**2**

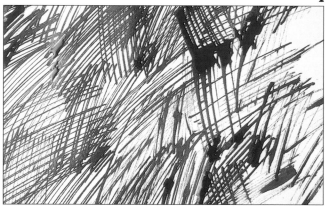

## Brush

Watercolour brushes make ideal drawing tools. The finer the brush the more delicate the line. But a word of warning – the artist who draws with the brush must be relaxed and well versed in the medium. Tension or uncertainty will be reflected in the quality of the lines, and the smooth, articulate flow which typifies the best brushwork will not be achieved. So spend some time getting used to the technique of brush drawing. Ideally, decide where you want to make the mark, and then apply it boldly and confidently – don't work cautiously, or hold the brush too tightly. Here, the characteristic tapering lines of the watercolour brush are used *(1)* to create an area of tone *(2)*.

## Ballpoint Pen

With ballpoint pens, you are not aiming for subtle drawing. This everyday, familiar writing tool comes into its own as a quick, convenient means of sketching when more conventional drawing tools are unavailable. Its techniques are confined to unexpressive line, hatching and scribbling, so get used to working within these limitations. Our artist uses scribble tone a lot when sketching with a ballpoint pen, usually starting with a loose, overall pattern *(1)*, and then building this up to the required darkness or density *(2)*.

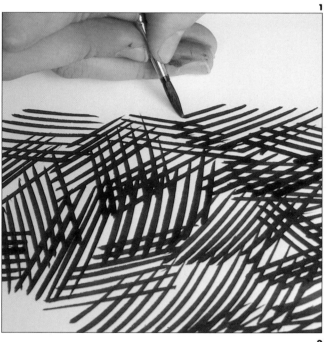

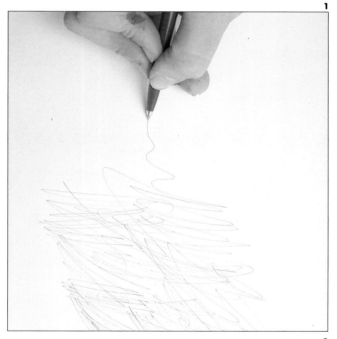

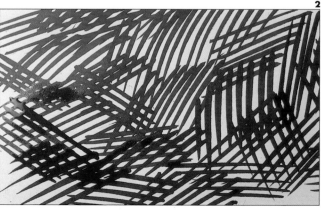

# Studio Still-life

## TECHNICAL PEN

The stark linear quality of the objects placed on plain sheets of paper and a sketchbook gives the artist an opportunity to use the technical pen for a task to which it is well suited – a simple graphic illustration. The arranged sheets of paper break up the composition into large shapes, already bringing the objects together into a coherent group. Notice how, in the finished picture, the abstract shapes formed by the paper and sketchbook have become a major feature. The artist has chosen to ignore the perspective of the sketchbook – preferring to present it as a rectangle. This sacrifices a feeling of space for a stronger compositional arrangement of shapes.

Because it is impossible to vary the width of line with a technical pen, the artist has employed other means to create an illusion of varied thicknesses. Occasionally, two lines are drawn very close together; if a particular line needs to be thicker or more emphatic, it can be drawn over several times to make it bolder. The artist has done this with the bottom of the jar, to indicate narrow shadow around the base.

Smooth white card has been chosen as a support, to avoid clogging the delicate tubular nib of the pen.

**1** Working on smooth white drawing card measuring 14 in × 18 in (36 cm × 46 cm), the artist starts by drawing the subject in a simple linear way. You would be advised to do a very light pencil sketch before you start drawing with ink and technical pen, to make sure you have obtained the right scale and position for the subject.

**2** The artist continues to make the line drawing, moving from object to object. Because the project is restricted to one type of line, the artist makes the most of the inherent textures and characteristics of the subject. For instance, the bristles of the brush are drawn in some detail; other areas are described with a single outline.

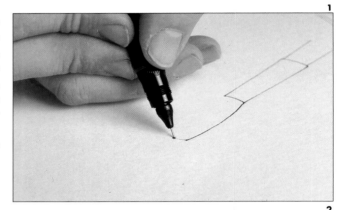

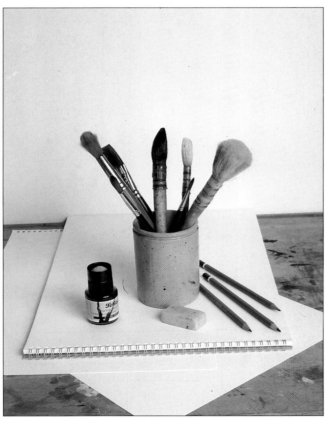

**3** There is no great variation of degree for the tones that can be drawn with a technical pen. Shading and tonal contrast are restricted to areas of solid tone, or tones built up by hatching and cross-hatching with regular lines. Here, solid tone is used to draw the ink bottle. The ink has been blocked in by using very dense hatching.

**4** The spiral binding of the sketchbook, on which the objects rest, is picked out with line. The regular wire curves are meticulously and systematically copied. The binding stretches across the foreground, giving scale and space to the sketchbook which is an important element in the composition, bringing the group together into an integrated whole.

**5** The artist has made a creative drawing within the very severe restrictions of the medium. Because with a technical pen it is not possible to vary the thickness of the line in any way, any detail or textural interest in the subject itself has been exploited to the full. This includes the well-observed patterns such as the wood-graining on the brush handle, and the tiny flecks of

texture on the earthenware pot. Even a slight irregularity in the eraser is faithfully included. Solid tone is used selectively and effectively on the ink bottle and the dark pencil ends. The artist has used just enough contrasting dark tone to lift the image. Too much would have looked fragmented.

**3**

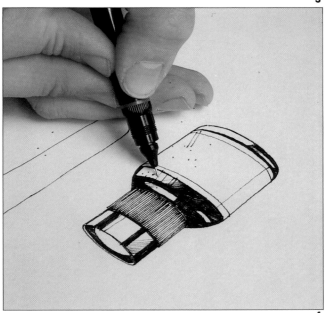

**4**

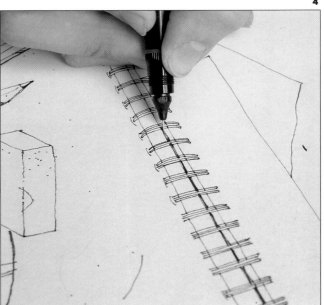

**5**

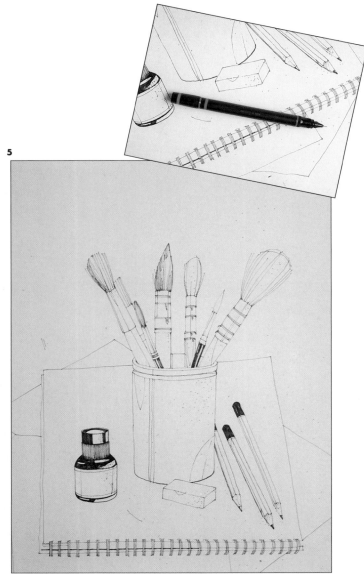

# Circus Scene

## PEN, BRUSH AND INK

For this bright lively scene, we combined some of the techniques of both a painting and a drawing. The tent, trees and awning are blocked in with a brush. But this is done loosely, to achieve a texture in which the brush marks are visible. The artist seeks to avoid flat areas, for the inks are being used as pure unmixed colour straight from the bottle and could easily look naïve if left in uninterrupted slabs. With the large area of foliage, the artist has even splashed the ink with water, creating light blobs and blotches, to prevent any dull flatness of tone and to capture the character of the mass of foliage.

The artist chose soluble rather than waterproof ink, because it gave greater flexibility. The colour could be dissolved once it had dried, and this was exploited to create the folds in the awning and the tent, and to develop the foliage. However, the soluble ink also presented certain problems. It was difficult to lay two colours next to each other, as the first would tend to dissolve the second and the colours would run. Sometimes this bleeding effect was desirable, but not always. So the artist had to leave a narrow area of white between the colours.

**1** The artist starts by making a light but precise line drawing of the subject on a sheet of heavy cartridge paper measuring 18 in × 22 in (46 cm × 56 cm). This drawing includes all the main forms and features. Remember, there is no correcting, so all the composition should be worked out in some detail at this stage. Starting with the trees, the artist begins to block in the colour with a large sable brush.

For this colourful circus, with its striking red and white tent, bright yellow umbrella, posters and fairground atmosphere, the artist chose four vividly coloured inks – scarlet, blue, green and yellow.

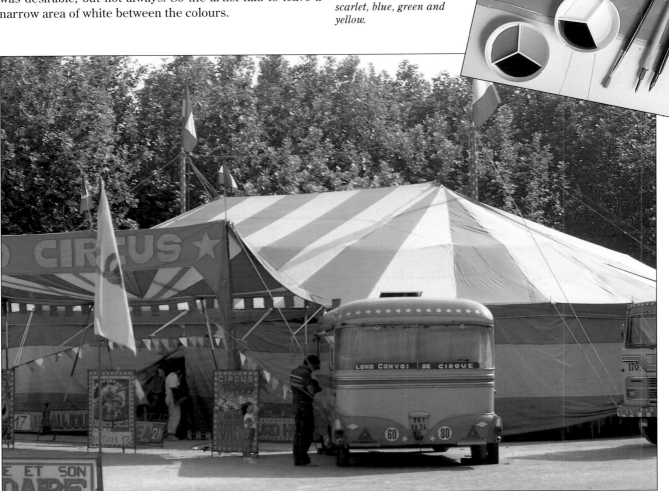

**2** The background foliage is blocked in loosely. Irregular patches of light and colour, visible in the actual trees, are reflected in the texture and tones of the ink. Some areas, where the colour is mixed with a lot of water, are very light. But darker shadows are painted into the pale tones. Don't overwork this stage – the looser the brushwork the more effective the treatment.

**3** With undiluted blue, the artist paints the banner around the star shapes. This is done very carefully – and bold graphic patterns, such as these stars, become a focal point in the composition, and will spoil the whole picture if badly done. Because the colours are soluble, a narrow white space is left between the green trees and the blue to prevent the inks from running.

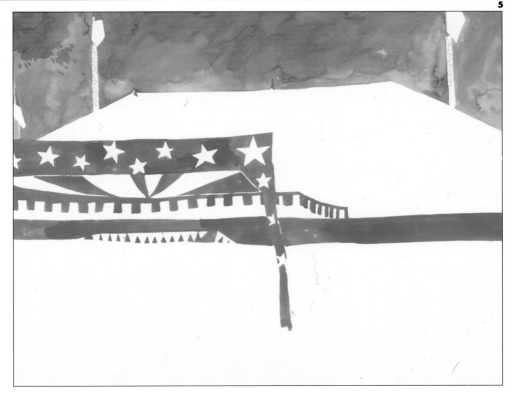

**4** Still working with undiluted blue, the artist draws in the decorative stars on the flag pole. These outline shapes echo the bolder white stars on the banner, and create an important contrast – a balance between drawn, linear elements and solid blocks of strong colour. An old-fashioned dip pen with a medium nib is chosen for these details.

**5** Already, with just two colours blocked in, the scene is taking on the atmosphere and character of the subject. The blue is taken carefully around the star shapes and the tiny triangular flags (these will be touched in later, when the surrounding blue is dry). There is no need to work slowly when painting precise shapes – indeed, this will often produce a shaky line. Instead, try to paint briskly.

115

**6** Turning to the wall of the tent, the artist uses strong, undiluted red, yellow and blue to block in the stripes. Here the centre stripe – the yellow – is being painted. A narrow band of white paper is left between the colours to prevent the colours from bleeding.

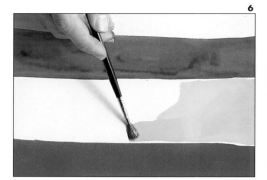

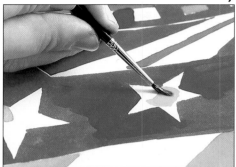

**7** The stars are now filled in with undiluted yellow. Because yellow is such a light colour, and because it is important to preserve the precise shapes of such graphic motifs, the artist fills in the centre of the stars only. This creates an irregular band of white paper between the yellow and the surrounding blue, thus preventing the blue from bleeding. This narrow band is scarcely perceptible, and in no way detracts from the bold, negative star shapes established by the dark blue outline.

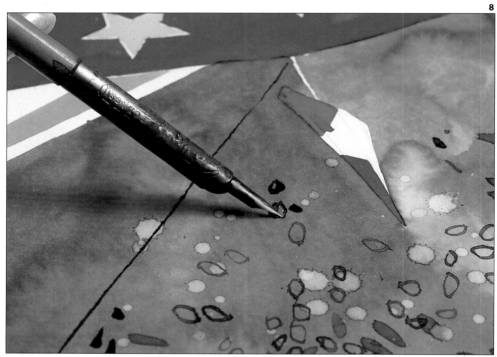

**8** The picture is almost complete, but the artist feels the need for a few linear shapes and details to break up some of the larger areas of colour. At this stage of a brush and pen work, you must be selective because indiscriminate scribbling can destroy bold graphic effects. The image here is already looking finished, and only a few linear additions are needed to pull the composition together. Here the artist uses a dip pen and undiluted green to loosely define some of the leaf texture.

**9** Further linear details are added. Here the artist draws the red stars on the yellow fabric. The colour bleeds a little as the scarlet ink slightly dissolves the underlying yellow. This effect is anticipated by the artist, who incorporates the runny lines into the picture, using a deliberately scratchy, irregular line for the stars rather than attempting to create perfectly even shapes. You can alter the thickness of the lines by altering the pressure.

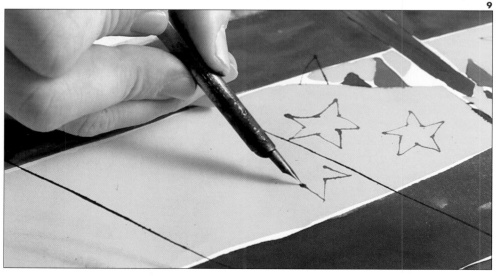

**10** The picture demonstrates a successful combination of bold colour and line. By first establishing the composition with wedges of pure, unmixed colour, the artist ensured a strong graphic image which could then be elaborated and developed with selected patches of line and texture. Such a strong, colourful design could easily have looked flat – bright colours used next to each other can lose their impact and effect if they are not modified in some way. In this picture the artist has exploited the white paper to separate the colours. This can be seen on the tent, where the red is contrasted with bold sections of intervening white, and between many of the other colours, where narrow ribbons of light paper tone fulfil a similar role. In other places the colours are deliberately drawn into each other with the brush – for instance, the artist indicated the folds in the tri-coloured foreground banner by dragging a brush loaded with clean water along the shape of the creases, thus pulling each colour out of its defined area and into the neighbouring colour.

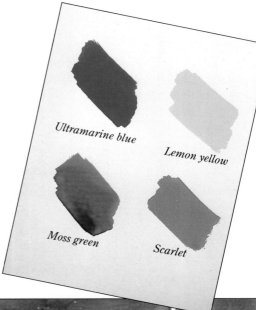

Ultramarine blue

Lemon yellow

Moss green

Scarlet

**10**

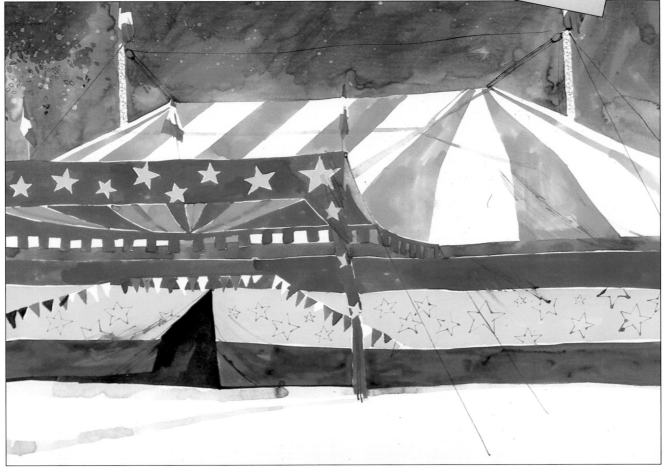

# Quayside Sketch

## BALLPOINT PEN

The artist is strolling by the quayside and suddenly sees a scene which can be used in a picture. The moored fishing boat, cluttered with interesting-looking tackle and other equipment, will be ideal as part of a composition planned for a later date. This is why you are recommended to carry a sketchbook as a matter of habit, and then all you need will be something to draw with – in this case a standard ballpoint pen. Such a pen might be all that is available at a moment like this; unfortunately it has definite limitations. You cannot vary the line, and the line made is not a particularly interesting one; the only way you can achieve solid tone is to scribble furiously, building up layers of hatching and cross-hatching. However, for a reference sketch such as this, the restrictions are not important. Your ballpoint pen has much to recommend it – not least being that you do not have to wait for it to dry, so sketching can be done quickly to record data.

The fact that you know you are not creating a work of art can also be liberating. This is likely to help you concentrate on rapidly getting down what you can see, without worrying about superfluous effects.

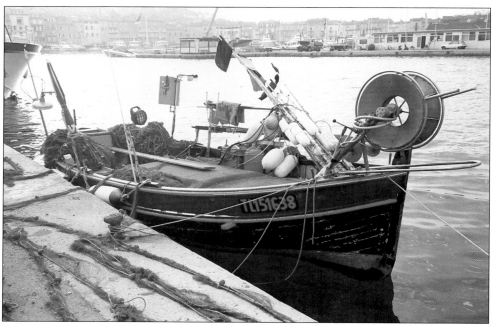

**1** An ordinary ballpoint pen and a cartridge paper sketch pad (10 in × 14 in, 25.4 cm × 35.5 cm) are the only items of equipment used for this rapid, on-the-spot sketch. Working quickly, the artist makes a start by roughing in the main feature of the scene – the boat – in a loose, linear manner.

**2** The object of the sketch is to record enough information about the boat to enable the artist to include the vessel in a more complex painting at a later date. Structure and detail are therefore equally important. Here the artist has established the main contours and form of the boat, as well as including some of the nautical equipment on board. When making quick sketches of this nature, the 'look' of the work is less important than the information it contains. Work rapidly. If you make a mistake or draw a wrong mark, merely draw over this with a heavier or more emphatic line.

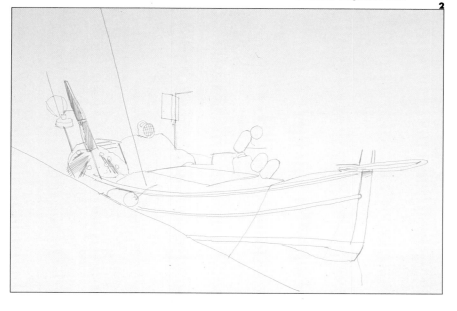

**3** Tones are established quickly by building up layers of scribbled hatching. In this illustration the artist describes the curved form of the boat with close parallel lines. Because ballpoint pens produce an even line and do not respond to added pressure, tone must be built up by varying the spacing of the lines.

**4** Here the artist indicates a rounded form with a graded shadow. This is simply done with regular hatched lines. On the underside of the form, where the shadow is darkest, the lines are drawn close together to produce deep tone; as the shadow gets gradually lighter, towards the top of the form, the lines are drawn increasingly further apart. Local colour too can be

indicated by tone. This is especially helpful when sketching a reference for a painting, as is the case here. By blocking in the dark grey boat in an equivalent deep tone, the artist is recording the tonal contrasts present in the quayside scene. In other words, the sketch will act as a reminder that the boat presented a dark shape against a lighter expanse of water, that

the reels and rigging on board stood out as dark shapes against a lighter background, and so on.

**3**

**4**

**5**

**5** The final sketch – completed in a matter of minutes – is one of many of the same subject made by the artist. As finished drawings, they look scanty, lacking in depth and strong tonal contrast. As sketches, they collectively contain enough material for the complex composition which the artist will paint in the studio.

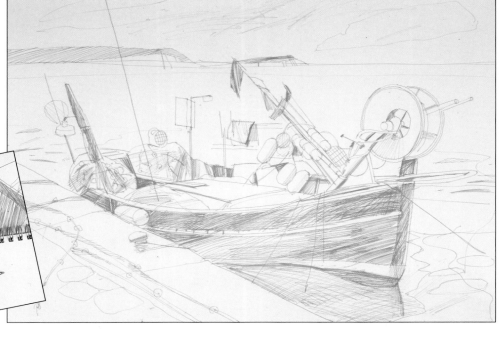

# Chapter 6
# Pastel

Where do pastels really belong? Some say they are really 'paints', and 'pastel painting' is often the term used for work done with them; but they are also linear tools, and therefore they have a rightful place in a drawing book. In many ways, they belong with the chunky materials such as the colour sticks, but, as they require more practice, they warrant a section of their own.

Like colour sticks, pastels are ideal for large-scale work and suited to a free, interpretive use of colour. They can be employed on a small scale but there is a tendency for this to have a 'chocolate box' look if you are not careful.

They come in two definite types – the familiar soft, crumbly pastels and oil pastels. And two completely different approaches are called for. With soft pastels, colours need to be built up; blended and overlaid to obtain the right tone and colour. In this respect they are similar to paints. You therefore need a large range of colours – several tones of the same colour can be used to obtain a realistic effect. Look at the pastels of Edgar Degas (1834–1917), a formidable experimenter with techniques and materials. You will see flesh tones built up with bold directional strokes of pinks, oranges, mauves and browns to achieve the subtle, translucent effect of human skin. This technique, however, definitely needs practice! An amateur's common mistake is to start by using the colour too densely, making it difficult to add further colours. When you have become used to them, pastels can be used to produce a beautiful finished painting with as much subtlety and detail as you may wish. Soft pastel needs fixing – a light spray with fixative after each stage will help stop the fine powder rubbing off as you work.

Oil pastels are another matter. Here, there are fewer colours, with a limited range of tones to each one. They are cruder, and it is difficult to achieve any subtle effects – usually a mistake to try. Oil pastels are best for large, bold work – an immediate effect if you want a lively, colourful and quick rendering of a subject. They are extremely handy for outdoor work for this reason. Oil pastels can be dissolved with turpentine to achieve a blend, but this is usually best kept to a minimum, for there is no point using oil pastels if what you really require is a smoothly blended oil painting. They belong to a quick, bold, instant approach – just right if you want to build up confidence in drawing with colour.

# Materials
## PASTEL

The so-called 'soft' pastels are made from powder pigment bound with resin or gum to hold them together in stick form. They can be square or round. Soft pastels come in three grades – soft, medium and hard. The harder pastels are mixed with extra gum or binder, which detracts from the colour brilliance; and this is why the softest pastels are the brightest.

When working with soft pastels you need a wide selection of shades or tints. The lighter the tint the more white chalk it contains. You can buy the sticks singly or in sets containing widely varying amounts, from 12 to more than 300 sticks. You can also purchase 'landscape' and 'portrait' sets in which the colours are biased towards either of these areas.

How the pastels are stored is important. Boxed pastels are laid on strips of ridged cardboard to separate the colours. Loose pastels become very grubby, rubbing off on each other until it is impossible to tell the colours apart. One good idea is to keep loose pastels in a box partially filled with grains of dried rice – the friction of the grains cleans the pastels and keeps the sticks sparkling and fresh.

Many artists make their own pastels, by mixing up the pigments and varying quantities of zinc white with distilled water and gelatine. Despite the wide range available, they still prefer to make colours to match their own particular requirements. The lighter shades are made by increasing the amount of white each time, so a very large range of tones of one colour can be achieved, to fit in with an individual taste.

### Choosing Supports

Supports for soft pastels are crucial. The colour of the support will become an important part of the finished picture, and should be chosen to match the subject. Papers with a matt or slightly textured surface are best for pastels. Smooth papers are less suitable, although vellum or calligraphy paper is good for delicate, light pastel work.

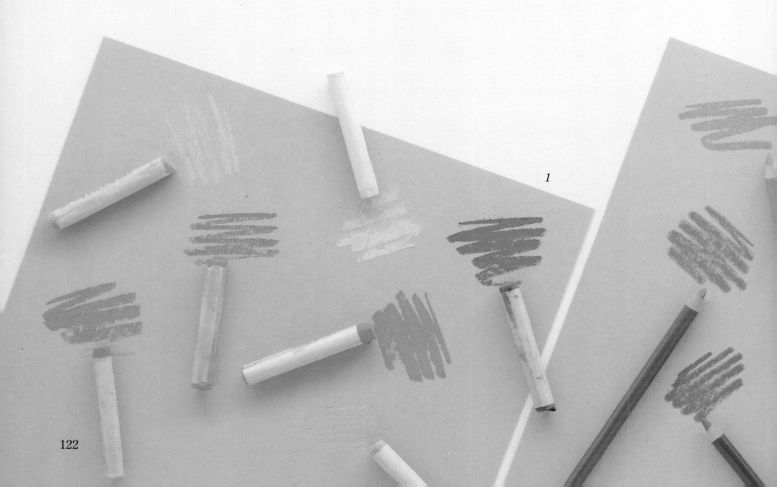

1

The paper must be of good quality in order to withstand the layers of pastel work. Tinted versions include Canson papers which have a slightly mottled colour, and Ingres which contain a faint linear pattern. Special pastel paper similar to the very finest grade of industrial sandpaper is available in art shops. Colours adhere thickly to this surface to give a strong, brilliant effect. Ordinary sandpaper can be used but produces a very definite effect which you may or may not like.

You need to fix the work, spraying each stage lightly and allowing it to dry. If you overdo this, however, you will create a shiny varnished surface which is unworkable. Fixing also alters the colours, so take care. Many artists fix from the back – spraying the back of the paper so that some soaks through. Some artists find this less effective, but it does hold the powdered colour to some extent and does not darken the colours.

Use a torchon to blend the colours – buy one or make your own by rolling a piece of paper to form a stick with a pointed end. Alternatively, you can rub with tissue paper or fine cloth for larger areas. You can also use a soft brush to lift the colour and a kneadable eraser to remove colour.

## Oil Pastels

These are heavy – more like oil paint than any other drawing medium – and they do not crumble like traditional soft pastels. They are therefore ideal for outdoor colour sketching. They come in bright colours, usually available in sets. There are fewer choices of tone, but oil pastels are best for bold line work with the occasional block of solid colour or texture. They are best used on a large scale. Use strong paper. You can blend the colours with turpentine. Limited colour mixing is possible by overlaying colours, but this is not easy to control.

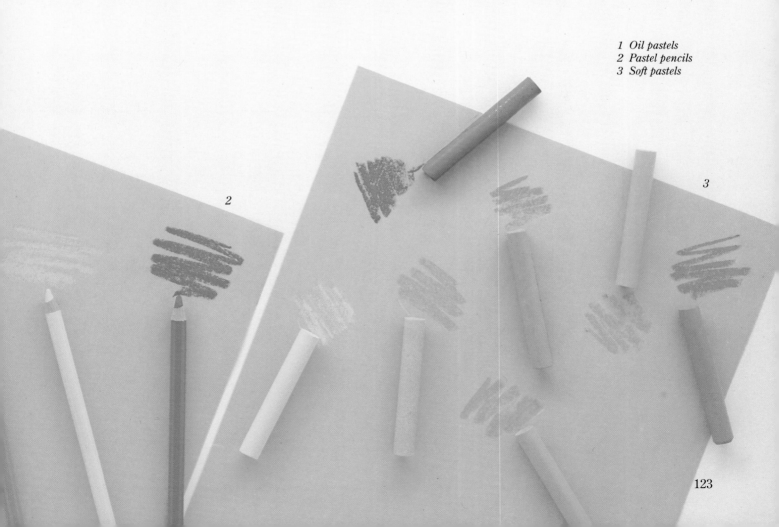

1  Oil pastels
2  Pastel pencils
3  Soft pastels

# Techniques
PASTEL

## Blending
The secret of successful soft pastel work lies in colour blending. With practised handling, pastels are as versatile as paint, carefully blended to produce a complete range of subtle tints and hues. These may be either areas of flat tone, or textured broken colour. Here the artist demonstrates one method of blending two separate colours to create a smooth, yet broken colour combination – an effect often used to depict skies and water. Bold white streaks are first drawn onto an expanse of flat blue pastel colour *(1)*. This is then gently rubbed to remove the harsh pastel lines and edges, thus merging the colours *(2)*.

## Mixing
Providing you apply the colour sparingly and lightly, pastels can be built up in several layers to produce beautiful and shimmering effects of mixed colour. Only by experimenting and practising will you find out how different shades and hues combine, and how many pastel colours can be laid over each other before the paper becomes clogged and unworkable. In the illustration here, the artist starts by blocking in an area of fairly solid purple, lightening this with thin white streaks *(1)*. Light red scribbling lends a pinkish tinge to the overall colour *(2)*. You might find it helpful to fix each colour with a light spray of fixative, allowing this to dry before moving on to the next colour.

**1**

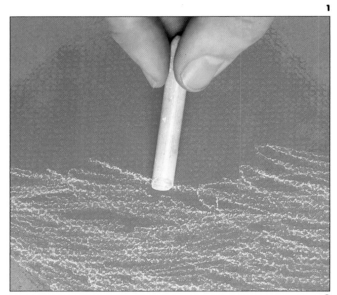

**1**

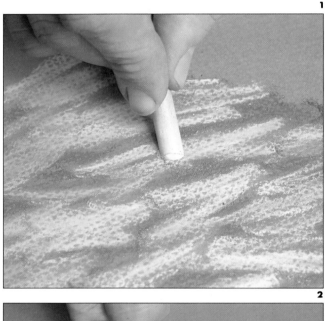

**2**

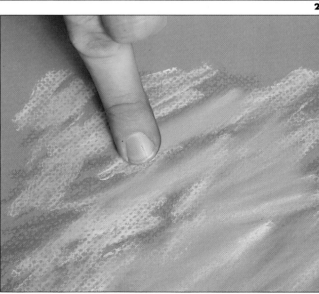

**2**

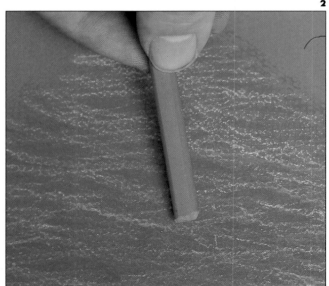

## Side of the Stick

Paper tone is an important element in pastel work, and this can be better integrated into your picture if you lay colour with the broad side of the stick. This method allows the colour to adhere to the raised parts of the matt pastel support, causing the paper tone to show through. With a particularly coarse support, such as watercolour paper, the effect is even more marked, and has a rough, granular texture. In the demonstration *(1)*, bright red is laid evenly on a darker paper; the final tone *(2)* is influenced by the deeper tone showing through.

## Scribbled Texture

Again, the tone of the underlying paper can be exploited by applying colour in scribbled or broken strokes. This basic technique may seem obvious, yet it is one of the most important underlying principles of all pastel work. Practise the method extensively, starting, as the artist is here, scribbling a colour on a tinted paper *(1)* to produce an area of loosely broken colour *(2)*. You can then develop this, lightly adding more colour and tone to achieve the exact combination you require. Keep the scribbles loose and wide apart to prevent the colour from becoming too dense, otherwise you will lose the light, airy quality which this approach creates.

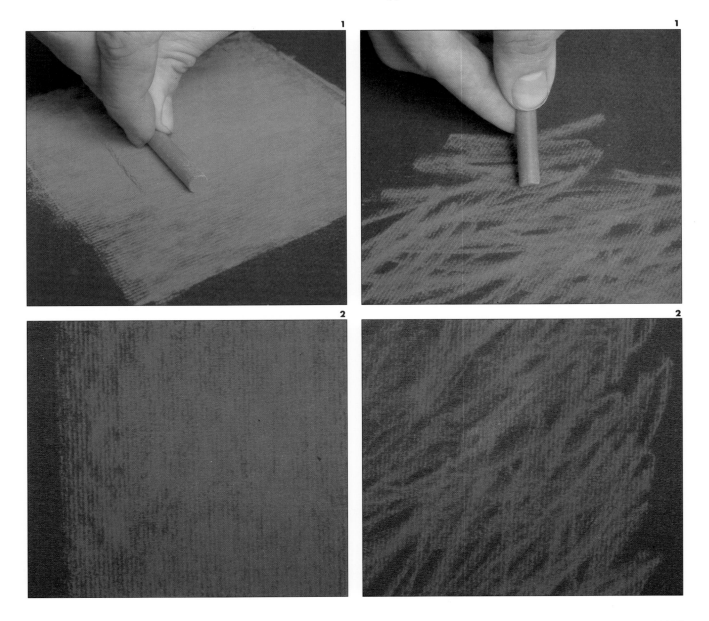

# PASTEL

## Texture

'Texture' is an all-embracing term which, to the artist, means the visual or tactile surface structure of the work. Thus, all areas of pattern or built-up marks fall into this very broad category. Try out as many textures as you can think of. In this way you will have at your disposal a store of techniques – a sort of visual repertoire – to fall back on, and your work will be more creative and lively as a result. Here the artist experiments with a texture of looped scribbles *(1)* starting with one colour and adding further colours worked in the same looped strokes *(2)*.

## Cross-hatching

Cross-hatching with pastel is unusual, simply because it is not strictly necessary. There are quicker ways of building up colour and texture when using pastels. However, hatching and cross-hatching does produce a crisp linear effect which can often provide a welcome contrast to the soft, smudgy nature of much pastel work. Use the pastel in exactly the same way that you would work with a pencil or pen, building up small regular lines *(1)* to produce an overall criss-cross texture. Here the dark red paper shows through, deepening the colour of the final effect *(2)*.

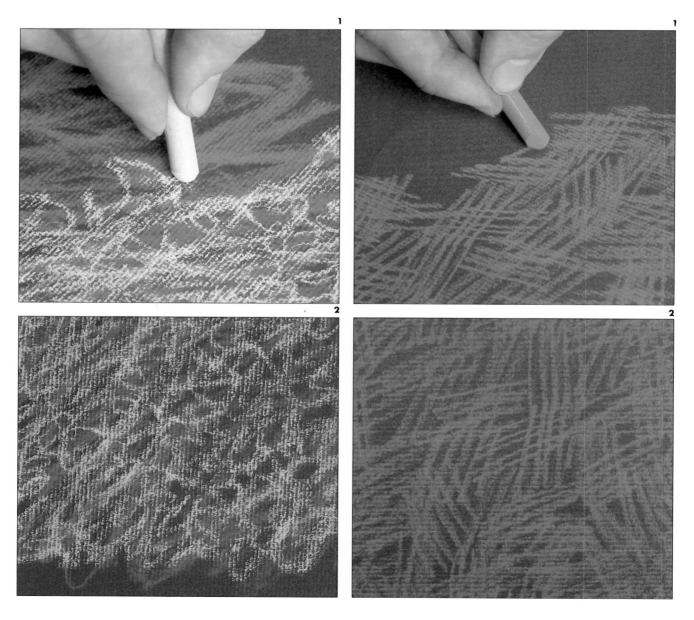

126

## Optical Mixing

All coloured drawing materials are ideal for mixing colour optically, and the small flecks, which mix in the eye rather than being blended together on the paper, can be easily and quickly dotted in with pastel. The soft, broad tip of the stick produces a largish mark, and the slight flick of colour, created naturally as you lay dots quickly, provides an irregular mark which prevents the pattern from looking too mechanical. Here *(1)* the artist combines light blue dots with bright red ones, using the tone of the paper as a third colour in the finished effect *(2)*.

## Oil Pastel and Turpentine

Oil pastels can be dissolved with turpentine or white spirit, enabling you to blend colours smoothly and completely. However, it is not a method which should be overdone. For full effect, limit these blended areas to selected parts of your drawing, and try blending the selected colours on a separate sheet of paper first – the strength and tone of oil pastels increase a lot when diluted with turpentine. Practise the technique by laying two colours next to each other *(1)* and using a brush or clean rag dipped in turpentine to dissolve and work the colours together *(2)*.

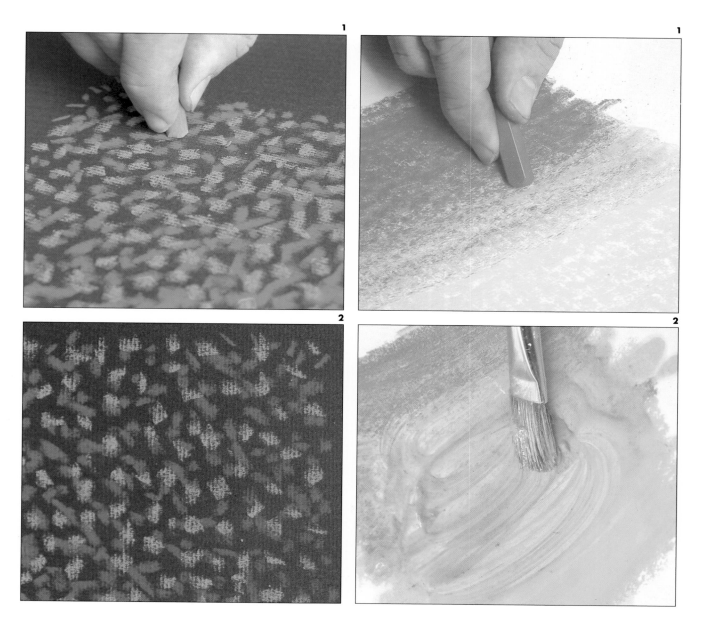

## PASTEL

### Drawing to a Shape

**1** Sometimes you may wish to have a shaped outline to a particular part of your picture, and there is a simple method of achieving this. A piece of paper torn randomly or cut to a specific pattern is used to mask off the area that is to be left. You then use the pastel in the usual way, making sure that you work it right over the edge of your mask.

**2** When you carefully remove the mask your chosen shape is revealed.

## Drawing to a Straight Edge

**1** If you are thinking of framing your work you may wish to have a straight edge to your picture. This can be achieved by holding a ruler or straight piece of thin wood or metal along the support as you are working.

**2** Remove the ruler and you will find a clear, straight edge. This technique can also be used for elements inside the picture, but take care not to smudge other areas of pastel.

# Red Cabbage

PASTEL

The drawing of the red cabbage, cut by cross-section, bears a resemblance to an approach sometimes used by designers, especially in fabric. The designers will look for something interesting, often in nature, and will then blow this up into an enlarged detail; turning it into a motif in its own right. The artist here has taken a similar approach, concentrating on the basic elements of the pattern produced by the cabbage. The result is a highly personal and yet surprisingly realistic portrayal of an everyday vegetable. The cabbage has been made larger than life. Its familiar patterns have been given a special meaning and the compact, compressed forms of its furled leaves are brought vigorously to our attention.

The drawing is very much an exercise in line. The cabbage is built up of lines. Even its solid areas are actually swollen lines. Some of these are thick, others fine and jagged, and each space between them – where the paper shows through – is also a 'line'. It is the tension between these, and the optical illusions of movement, that demonstrate the use of line at its most expert. The artist did not pick out all the cabbage's compressed leaves but aimed for a general impression.

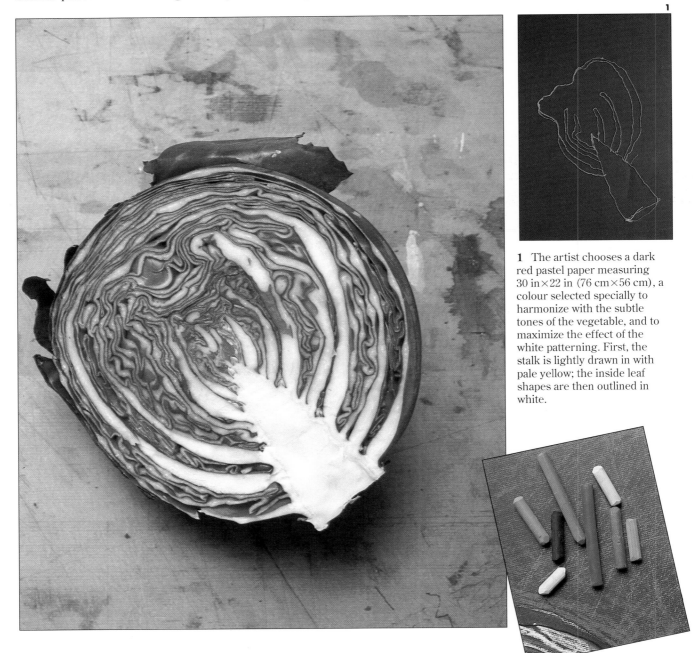

**1** The artist chooses a dark red pastel paper measuring 30 in×22 in (76 cm×56 cm), a colour selected specially to harmonize with the subtle tones of the vegetable, and to maximize the effect of the white patterning. First, the stalk is lightly drawn in with pale yellow; the inside leaf shapes are then outlined in white.

**2** Here the artist is filling in the solid white shapes visible on the cut cross-section of the cabbage. Because the patterns are too complicated to depict exactly, the drawing aims to capture the character of the subject – an impression of the effect of the tightly folded foliage rather than an accurate, map-like drawing with every leaf in the correct place.

**4** Swirling lines of mauve are added to the pattern. Again, the artist is not taking the subject literally, but using it as a starting-off point to make a creative interpretation of what can actually be seen. A tinge of mauve, just discernible on the lighter cabbage leaves, is exaggerated to provide this vibrant and colourful addition to the drawing. Although this is boldly applied with strong linear strokes, the artist intends to modify this as the work proceeds.

**3** The main white shapes are now blocked in. These show up clearly and cleanly on the tinted paper, helped by the fact that the slightly furry surface of the specialist support provides a key for the fine pastel particles to adhere to, so producing a dense effect without undue pressure being necessary. To retain the crispness of these colours, the artist gives the drawing a light spray of fixative at this stage.

Variety of line is important here. Organic forms and natural patterns are not regular or predictable and cannot usually be described with an even or mechanical line. When faced with such subjects, try to vary the line. Here, for example, the artist used the sharp edge of the stick for fine lines. To create an undulating line which varies from thin and spidery to heavy and swollen, vary the pressure on the pastel as you draw.

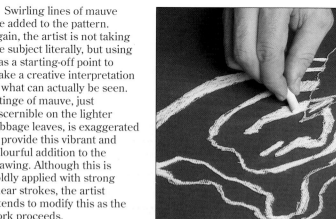

**2**

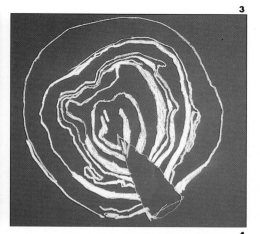

**3**

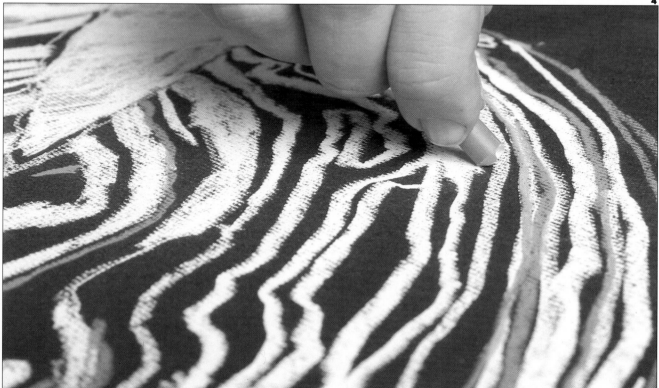

**4**

**5** Using alizarin and red, the artist works into the dark spaces between the leaves. This tone, just slightly lighter than the support, is scribbled in to form bold areas.
The alizarin covers up some of the brighter mauve tones – as the artist intended – although patches of the lighter colour are left showing through, to produce effects of colour, line and tone similar to those visible in the actual subject.

**6** To preserve the colour and maintain the sharp contrasts between the shapes, the drawing is once more sprayed with fixative. In your own pastel drawing, you may wish to use fixative more frequently than the artist does here. This is fine, providing you don't overdo it – a few light sprays in the course of one drawing should be all right. You must, however, wait for the work to dry before you proceed. Here the artist is introducing thin black and blue lines to the fixed drawing. These define the shapes within the main outline and emphasize the pattern of the folded leaves. The black also represents the deepest shadows, thus giving a feeling of depth and surface texture.

**7** Loose, jerky strokes keep the images alive and vibrant; the artist is careful not to become 'automatic' with the drawing, but constantly refers to the subject in order to maintain a fresh approach to the line and colour.

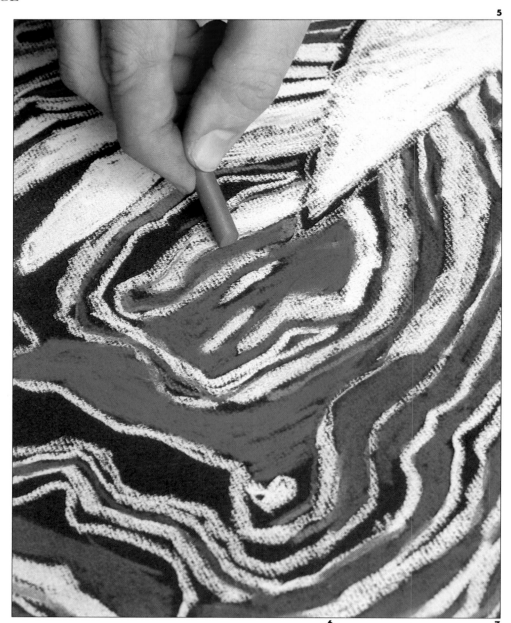

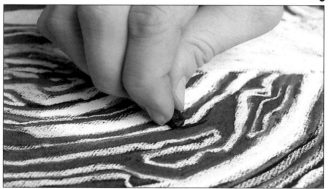

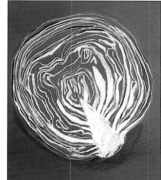

**8** The artist blocks in the background using the side of a stick of orange pastel. This is done lightly, allowing the dark red tones to show through and to act as a unifying colour in the composition. Finally, the finished work is given a spray of fixative to prevent the colours from smudging.

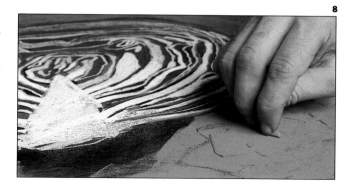

**9** The finished drawing shows us a convincingly realistic portrait of a cut red cabbage. Yet the artist did not stick rigidly to the subject. Nor are the colours accurately matched to the more subdued tones present in the real cabbage. Oddly enough, had the artist set out to depict every part of the vegetable in naturalistic detail, the likeness would have been disappointing and far less 'cabbage-like' as a result. The secret of the success of this pastel drawing lies in the artist's direct approach, one which aimed not at botanical detail, but rather at capturing the essence and character of the subject – in this case, the vibrant, almost psychedelic, nature of the leaf pattern.

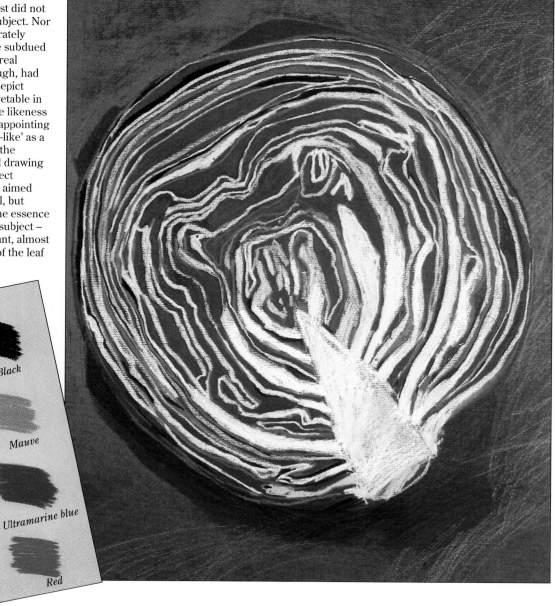

Alizarin

Black

Orange

Mauve

Pale yellow

Ultramarine blue

Red

White

133

# Swimming Pool

## PASTEL

For this drawing, the artist worked from a photograph instead of operating directly from the subject itself. For the beginner, this is an excellent method of working when confronted with the problem of water. The shapes and forms are never constant on the surface. The water is moving all the time. Many artists develop set techniques for coping with this, and base their works partly on what they see in the real world in each specific case, and partly on what they know from experience. For the beginner this can be daunting – but a photograph temporarily 'stops the world' and allows you to study the appearance of movement in a given instant. So take your camera along on some of your drawing expeditions. The artist here used a Polaroid camera which produced a photograph within seconds and allowed time for studying both the photograph and the real-life subject on the spot. After a while, you may become used to making quick drawings on the spot, and the camera will become less necessary.

Before starting work, look at the subject or photograph and select all the colours before you begin.

This saves scrabbling through a box of pastels as you work, often compromising because the exact colour is not immediately to hand. If you start off with colours to hand, you are also giving yourself a colour theme. The choice of paper is also an important prior task and should work as one of the dominant colours. Here, a subdued light blue was chosen, as a crucial part of the overall colour theme.

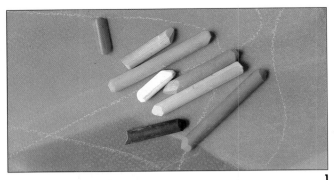

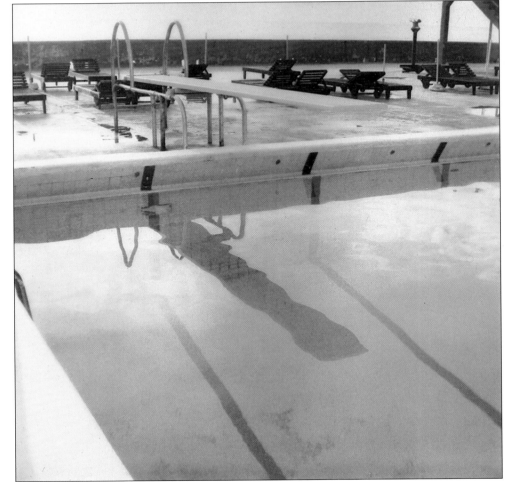

**1** The main part of this picture is the surface of the water, with its colours and reflections. So all the artist needs to establish at this initial stage is the visible edge where the water area starts.
This was drawn in with a white pastel. Then, using a dark blue-green, the main dark shapes – the shadow edge of the swimming pool and the reflection of the diving board – are blocked in with dark blue-green. The artist is working on good-quality light blue pastel paper measuring 20 in × 20 in (51 cm × 51 cm).

**2** At this stage the artist is concerned with blocking in the main areas of colour. These will later be modified and blended; but for the time being it is more important to cover the image rather than being concerned whether it actually looks like water or not. Some of the lighter water tones are loosely blocked-in, in light blue-green. White is used to establish the surface of the diving board, one of the lightest tones in the composition. The colour is put down quite emphatically, as a dense white, because the artist knows that in the final picture the diving board must stand out as bright white, and as work progresses other tones and colours will be related and compared with this.

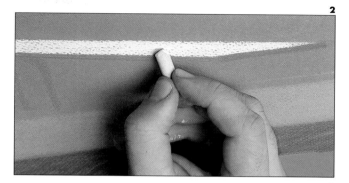

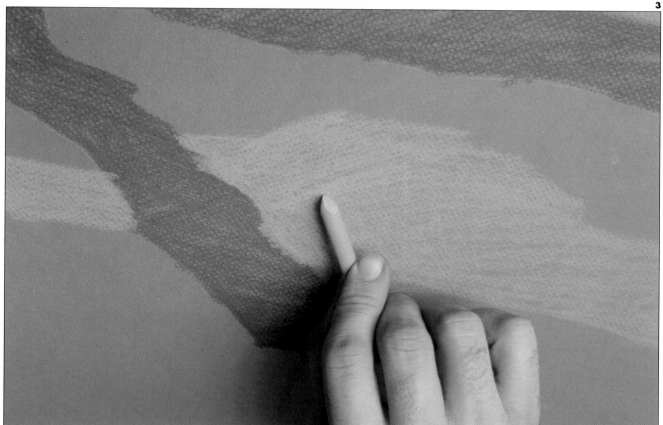

**3** The artist returns to the water, continuing to block in the shapes in terms of simple patterns and colours. The main problem here is that the shapes and colours do not really have crisp edges. They merge and blend. So to some extent these shapes have to be interpreted and simplified. It would be wrong to work this area too literally at this stage.

**4** Using bright blue, the artist picks out the medium tones in the swimming pool. Again, these are not exactly as seen. The shapes are more emphatic and the colours brighter than those present in the actual subject. In this illustration the side of the stick of pastel is used, making it quicker to block in larger areas.

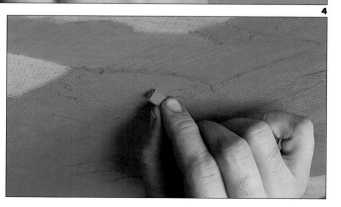

**5** The artist completes the blocking-in of the main colours, working from the selected range of blues. When the blocking in is finished, it is time to blend the colours to create a more accurate representation of the smooth water surface. Here the artist is blending the shapes of colour into each other by rubbing gently with the fingertips.

**7** Some artistic licence is being taken here, in order to make the water even more like water! The artist is very experienced in depicting water and its effects in this medium. So certain techniques have been developed. Here, thin wavy lines drawn loosely across the water describe the undulating surface and effectively and convincingly suggest the image.

**6** Here the distortion of a black painted line, seen through the water, is being rendered; this is simply a series of marks to indicate the broken distorted line. After looking carefully at the effect of the line through the water, the artist has noticed that it is visible simply as a definite but broken line. This is then drawn in light scribbly marks.

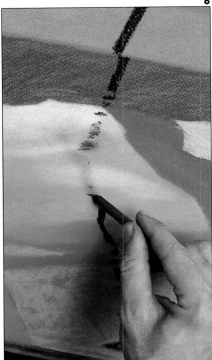

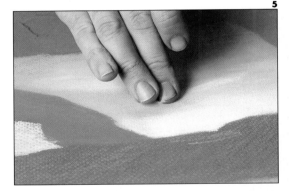

**8** Here is the final example of one way of depicting the surface of water. The image has to some extent been formularized; the artist has used well-developed techniques. It is not just a swimming pool surface that can be rendered in this way. All types of water, from fast-moving streams and seascapes to quiet pools, can be tackled with equal ease once you have looked at them carefully and decided how to approach the subject in a systematic and simplified manner. One of the problems here is that, because the artist knew that in the final stages the colour would have to be blended together, it was not possible to use fixative during the execution of the work.

**8**

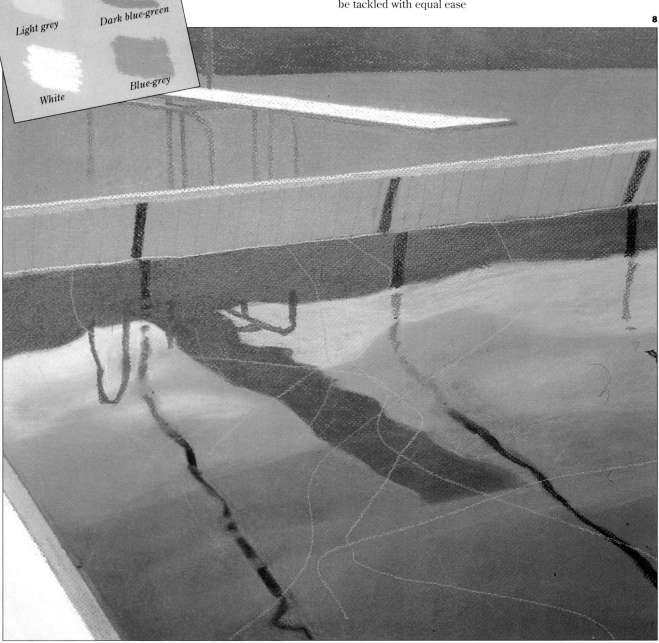

Bright blue

Black

Light blue-green

Ultramarine blue

Light grey

Dark blue-green

White

Blue-grey

# Bowl of Fruit

## PASTEL

One of the classic subjects for a still-life is an arrangement of fruit. The subtle variations in colour and different textures of their skins make them a challenge and a delight to draw. In the picture below, the fruit is piled high in a bowl, so that as well as a variety of shapes and sizes there is the added interest of shadow and masked outline.

There is an interesting selection of fruit here, each of which have typical features to portray. The shiny apple, plums, orange and lime all reflect bright highlights, while the pear and bananas are more subdued. All are rendered with a softly hatched technique. Strokes are all made in the same direction and blended together to create the texture, form and gradation of colour that is required.

A slightly looser technique is used for the heavy background material which serves as a contrast to the fruit. Colours are layered on top of one another and gently blended to form almost solid colour. The folds are worked in first to create shape and depth.

**Colours**
Yellow
Orange
Red
Red Violet
Violet
Green
White

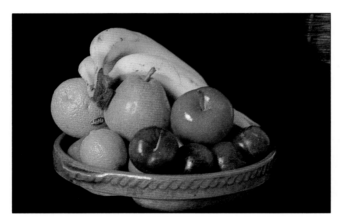

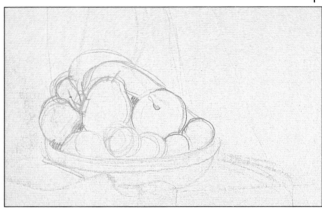

**1** The outline of the fruit is sketched in first in orange. Then the strong outlines and deeper areas of shadow between the fruit are defined in red.

**2** The most obvious colours for each fruit and the bowl are gently hatched in. For the background material a combination of a blue-green and red is used. The colours are very loosely mixed one on top of another to produce the heavy folds.

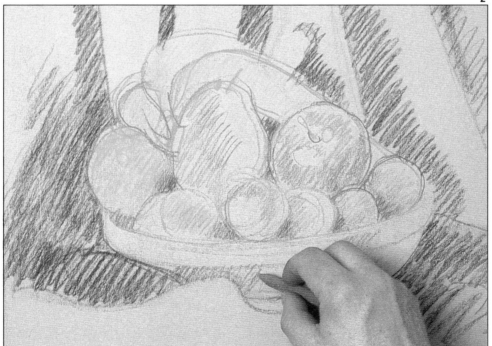

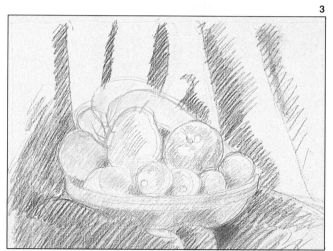

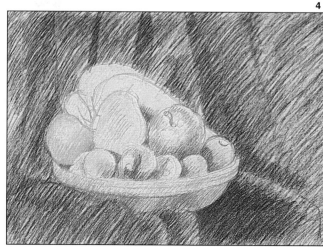

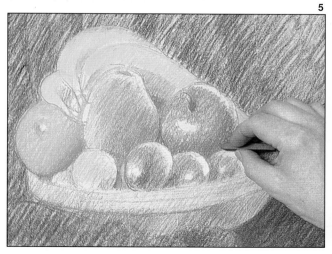

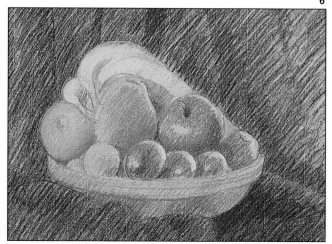

**3** The material on which the bowl rests is worked in. Areas of highlight are shown on the fruit so that the artist can avoid putting colour in these places by mistake.

**4** Further tones and colours are applied to the fruit, and the background material is beginning to be filled in as a whole.

**5** More layers of colour are added and blended, and the gradation builds up to give shape and form. The artist starts to work in areas of shadow to define the various elements of the picture.

**6** The composition is really beginning to take shape. The next stage will be to add detail to the individual pieces of fruit.

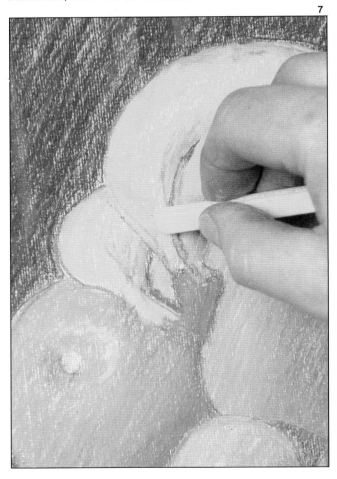

**7** Yellow and green are blended together on the banana. The texture of the skin must look real if it is to be a convincing likeness and the pigment is applied more thickly here than on the other fruit.

**8** Bright white highlights are added to the apple to show its shiny skin. Highlights are also added to the plums, but these are more muted to suggest the natural bloom on these fruits.

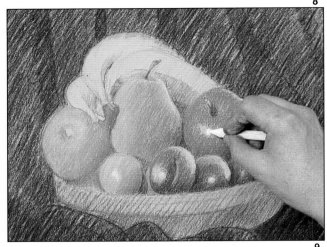

**9** Highlight is added to the orange which has a waxy, granular look. The pastel has not been applied too thickly and the texture of the orange is enhanced by the small areas of paper that show through.

**10** The edges of the fruit are carefully and thinly outlined in a darker tone to emphasize the shapes. Further layers of colour are still needed, especially on the material, to give more depth.

**11** Finally the shadows which the pieces of fruit throw on one another are added in, and the stalks of the bananas, pear and apple are defined. The draped material now has a heavy richness that perfectly complements the luscious bowl of fruit.

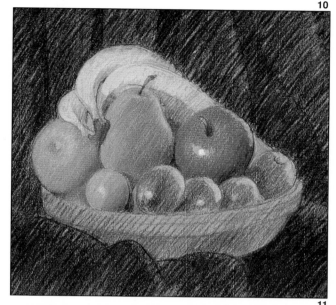

10

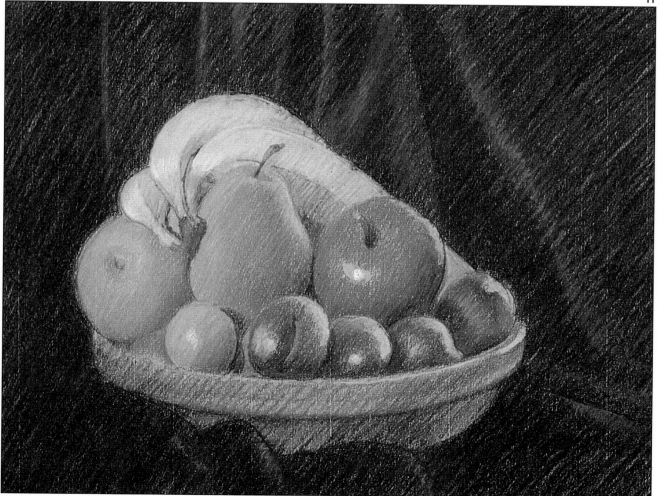

11

# Washbasin

PASTEL

A surprising number of everyday objects can provide interesting and useful subjects for a still-life. They can be really good practice, increasing your powers of observation and forcing you to see what is familiar in terms of light, shade, colour and texture.

At first sight a white washbasin surrounded by mainly white objects might not seem to offer much opportunity for colour, but the picture below demonstrates the number of subtle tones that can be found. There are odd splashes of bright colour too, such as in the toothbrushes and tube of toothpaste, and the chrome fittings are a challenge in tackling a shiny reflective surface. The artist has worked out an original composition by deciding to portray the washbasin from an unusual viewpoint.

With the exception of the shaving brush and toothbrush bristles the overall impression is of hard surfaces, yet this is achieved by using a soft technique. This allows the artist maximum control over detail and tone as the picture progresses.

**Colours**
Green
Violet
Red
Red Orange
Orange
Pink
Blue
Yellow
Yellow Ochre
White

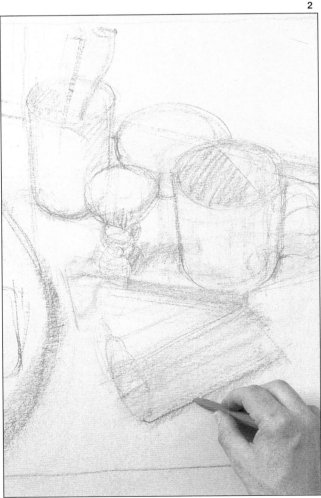

2

1

**1** The artist chooses an interesting viewpoint and makes a thumbnail sketch to plan the composition. White china has a bluish tinge, so blue is used for this initial drawing.

**2** Cylinder shapes are firmed up and start to look like functional objects. Their edges are delineated in red and orange to provide depth and contrast against the overall impression of blue. Areas of shading are added and shadows suggested inside the mug and toothmug.

**3** Before adding finer detail the pastel is sharpened to a point with a craft knife. The powdery pigment is kept safely and may be used later to tint a support for another picture.

**4** The shape of the soap is now established and the artist starts to provide some detail. The red part of the label is coloured in.

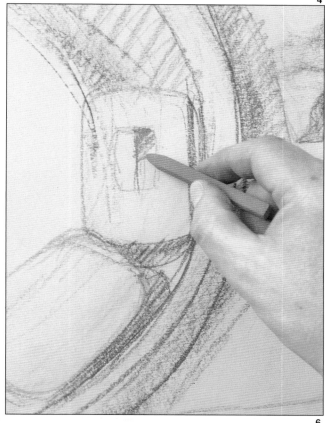

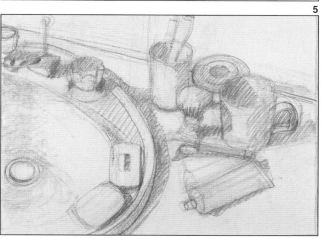

**5** All the shapes of the objects have now been drawn in quite clearly, and so have the areas of shadow which will need to be worked on. The artist was originally uncertain exactly where to position the tube of toothpaste.
Notice that he has decided to move it slightly to the front and it now helps to lead the eye into the picture.

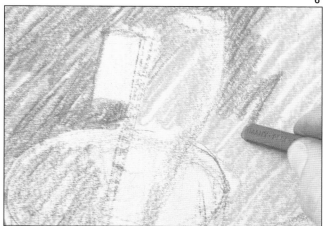

**6** The basis for the tiled splashback is now added in. A layer of orange is put down, then covered with a layer of bluish green, and the colours are mixed together. Further layers will be added later.

**7**

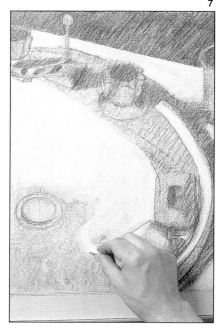

**8**

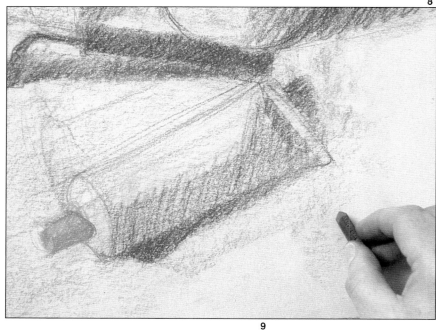

**9**

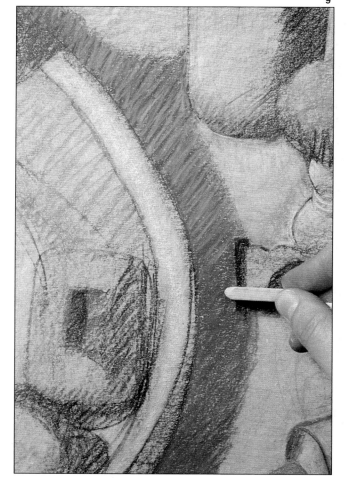

**7** The texture of the china basin is achieved by a mixture of bluish green and red making a brownish tone, then scumbling over with white. The same colours are used for the chrome fittings.

**8** Shading is added to give shape to the tube of toothpaste, and a first coat of orange is placed on the cap. Then the shadow thrown by the tube is worked in, the blue mixing with the orange and red that had been put in earlier.

**9** Lilac is blended into the shadow around the basin to soften its outline. This technique will also be used for the small shelf inside the basin where the soap rests and for the area behind the taps.

**10** The artist starts work on the mug, adding white around the rim to define its shape and to give an indication of white china. Close control is required and he rests his hand on a maulstick to avoid smudging other areas of the picture.

**11** All the elements of the picture are now ready for final detailing. A little yellow is added to the basin to take the brilliance out of the white colour and to help give shape. It is also used on other areas of the picture to add a little warmth and depth.

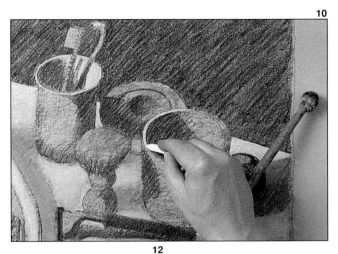

10

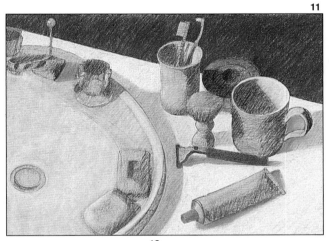

11

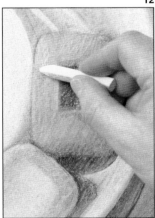

12

**12** Yellow is added to the soap before blending in the colours.

13

**13** After blending, the soap takes on a creamy, smooth texture and the shading denotes its moulded shape. The writing on the label is suggested, and the soap is complete.

**14**

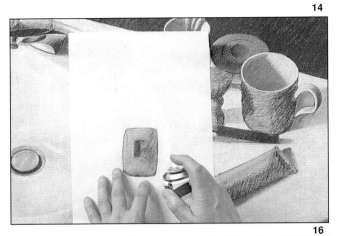

**15**

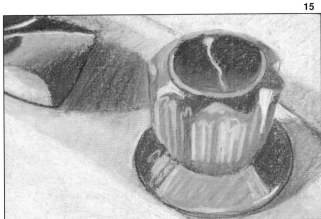

**16**

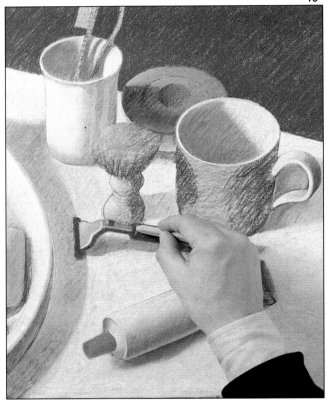

**17**

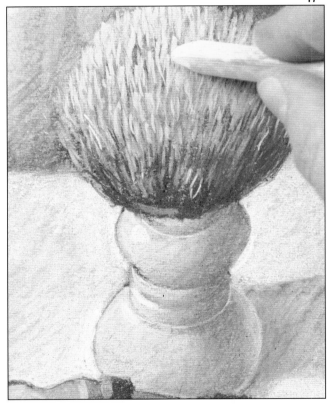

**14** The finished soap is protected with a light spray of fixative. To avoid spoiling areas of the picture that still need to be worked on, a mask is cut to fit round it.

**15** A little lilac is added to the chrome taps, plunger and plug to suggest their shiny surface. With white highlights, they reflect coloured patches of the items that surround them.

**16** The toothpaste tube is fixed lightly to avoid smudging it while working on the razor. Blue highlights are added to the razor to emphasize the shape of the handle and shaft.

**17** Now to finish off the shaving brush. The china handle is finished first and then the bristles are added in layers. Short strokes are used, keeping the colours lighter at the top. Again, a spray of fixative helps to preserve the final effect.

**18** The mug has a scumbling of white and is now ready for its delicate decoration to be added.

**19** Final decoration is added to the tube of toothpaste. To do this the artist makes sure that the end of the pastel has a sharp point, and rests his hand on the maulstick to avoid smudging.

**20** The finished picture. When tackling a subject like this it is as well to check that you have included all necessary details. For instance, it would have been all too easy to forget the grouting for the tiles on the splashback or the lines between the tufts on the toothbrush.

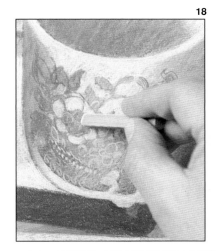

18

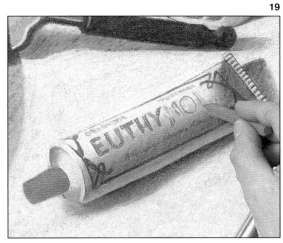

19

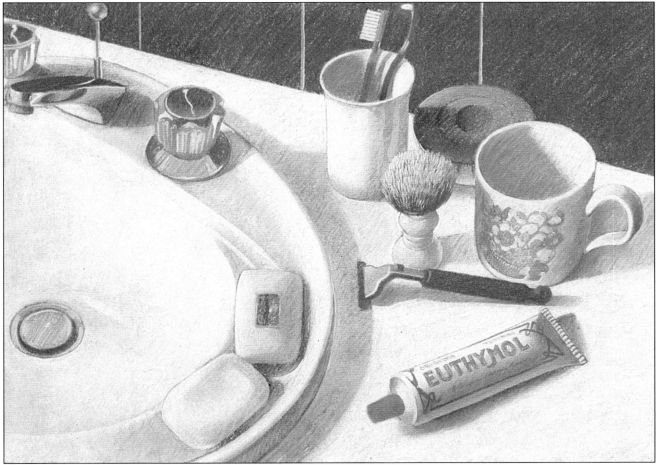

20

# Rural Scene

PASTEL

This rural scene is the sort of subject you spot when you are out for a walk or a drive in the car and immediately want to record on paper. It is a simple landscape consisting of nothing more than a view across countryside to a clump of trees and on to hills in the far distance. Yet it forms the basis of a very satisfying picture which can be worked on there and then or recorded for completion later at home.

A sketchy style has been used, as befits the typical circumstances in which a scene like this would be drawn. The pastels are used on end for drawing, and on their sides for large areas of soft colour. Colours are blended together, sometimes with the finger, to give a soft effect, and are worked in bands across the picture which increases the feeling of a wide expanse of space.

**Colours**
Phthalo Blue
Cobalt Blue
Blue Violet
Bluish Green
Phthalo Green

Burnt Umber
Light Yellow
Yellow Ochre

**Above** *Both linear and aerial perspective are considered in this picture. The viewer looks straight across to a vanishing point on the horizon, where the hills are faintly seen with a bluish tinge.*

**1** The scene is sketched directly onto paper, using blue to map out the different areas.

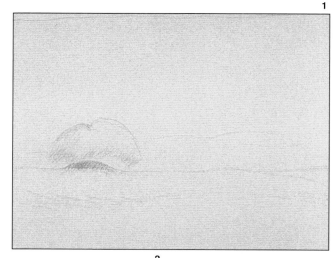

**2** A line of umber is blended in with the finger to denote the brow of the hill on which the trees are standing.

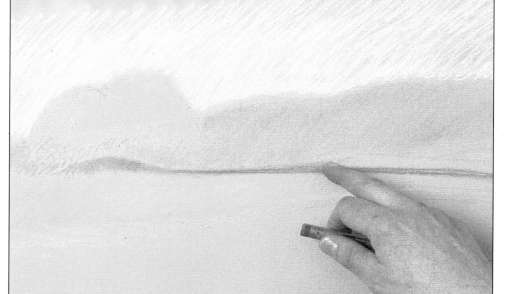

**3** The bottom part of the sky is hatched in white. The area of grass in front of the trees is added in yellow, while the hill behind is coloured green to suggest the bluish look of far distance.

**4** Now attention turns to the clump of trees. These are given a thin layer of umber pigment with the side of the pastel, producing a rounded sweeping silhouette. Although they are treated as a group, a suggestion of trunks is outlined and the hillock on which they stand takes shape.

**5** Using the ends of the pastels the fields in the foreground are coloured in loosely in blue and ochre, and the division between the two fields blended in green. Umber is used for the brow of the hill looking down on the valley and is applied by using the side of the pastel.

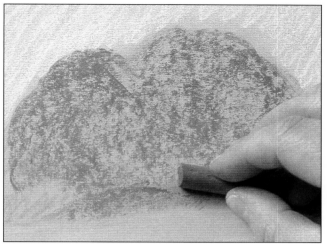

4

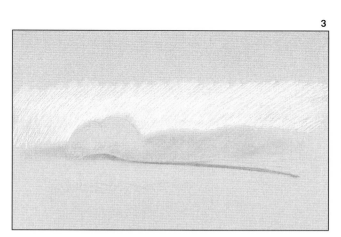

3

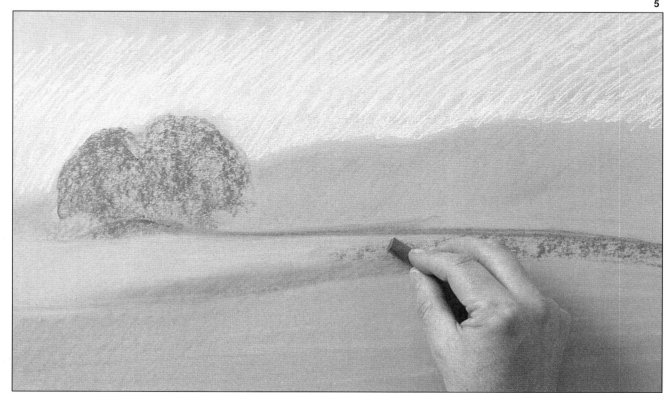

5

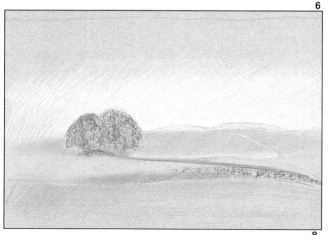

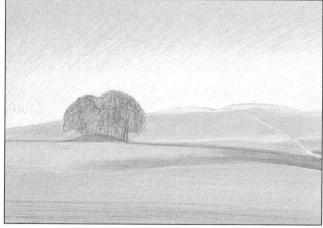

**6** The artist now turns his attention to the sky, putting in a layer of sky blue so that it just overlaps the white layer. Fields in the valley begin to take shape as the white road into the distance is put in place and pale blue tones are used for the hills approaching the horizon.

**7** Again using the pastel on its side, the artist sweeps in a broad expanse of bluish green for the distant hills.

**8** Small areas of pale violet are scumbled in to give shadow and depth. Notice how the colour of the support shows through and seems to add a slight natural warmth.

**9** A darker tone of blue is added to the sky, just overlapping the previous one and loosely mixed. The colours in the field are blended and details such as the line showing the brow of the hill are firmed up.

**10** Detail is added to the individual trees. Thin lines for trunks are drawn in with a bluish green pastel and random strokes are taken through the foliage. A sharp pointed pastel is needed for this as clear definition is needed to achieve the required effect.

**11** The artist now adds some detail to the foreground, drawing in long wavy lines quite evenly to suggest a furrowed field. These are done in a variety of colours, echoing the hills in the distance and bringing the various elements of the drawing together.

**12** This simple landscape was drawn fairly quickly, yet there is plenty of detail to satisfy the eye.

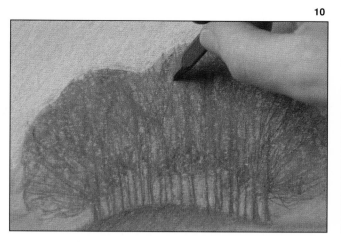

10

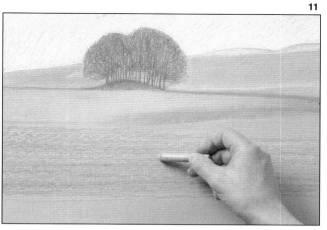

11

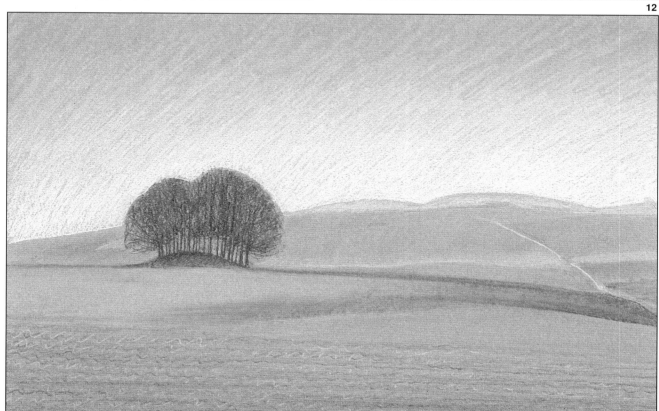

12

# Woodland Scene

PASTEL

What a difference there is when you stroll through woodland on a fine summer's day with the sun filtering through the trees from a walk through the same wood on a dark winter's afternoon when branches are swaying and cracking in the wind. What marvellous subjects to draw, and what opportunities to match a technique to the mood of the scene.

In the drawing shown here, the artist has chosen to illustrate a sunny day when the trees provide a cool retreat and the sunlight falls in dappled patches. He has used the technique of optical mixing, placing small spots of colour so that they merge and mix when seen from a distance. This has the effect of intensifying the colour so that it has a brilliant, shimmering quality.

The specific use of blue emphasizes the cool mood of the picture and also helps the feeling of recession and space established by the careful use of perspective. The eye follows the path down through the line of trees into the distance.

**Colours**
Yellow Ochre
Cobalt Blue
Cool Grey
Hooker's Green
Yellow Green
Intense Black
Silver White

**1** The artist starts by making a faint line drawing to indicate the various areas of the picture.

**2** Small dots of light ochre are applied to the areas where the dappled light will fall. Some are also placed on the tree trunk in the foreground to help build its form.

**3** Dots of light cobalt blue are added fairly randomly to the ground area, and to all the tree trunks. Already the colours begin to mix visually when seen from a distance.

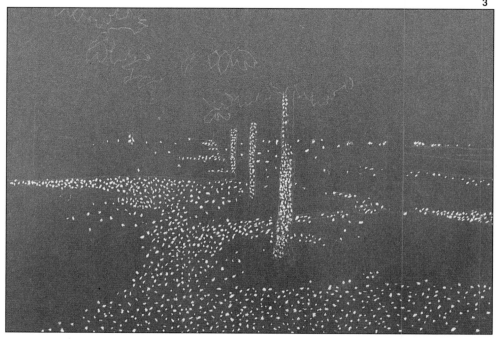

152

**4**  Black dots are laid in the dark areas of shadow. The Impressionist painters believed that there was no such colour as black in nature and preferred to mix very dark tones optically, but it is not advisable to be purist about this unless you have perfected your technique.

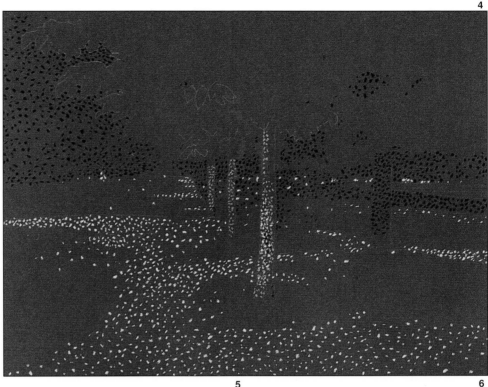

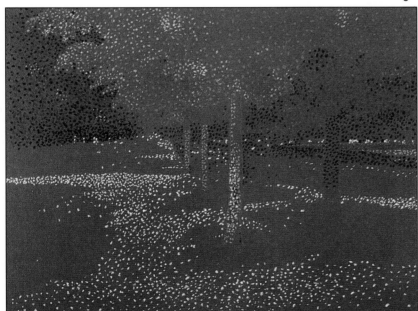

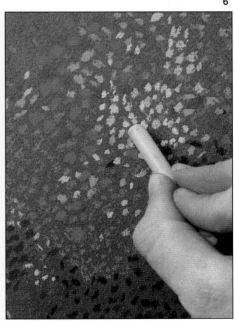

**5**  The artist starts to dot in the tones of the trees, using a variety of different greens. Those in the foreground are given a light tone to suggest sunlight playing on the leaves, while some blue is added to the dark green in the background to increase a sense of recession.

**6**  The general shape of the trees and their foliage is now in place and the artist concentrates on working on the trees in more detail.

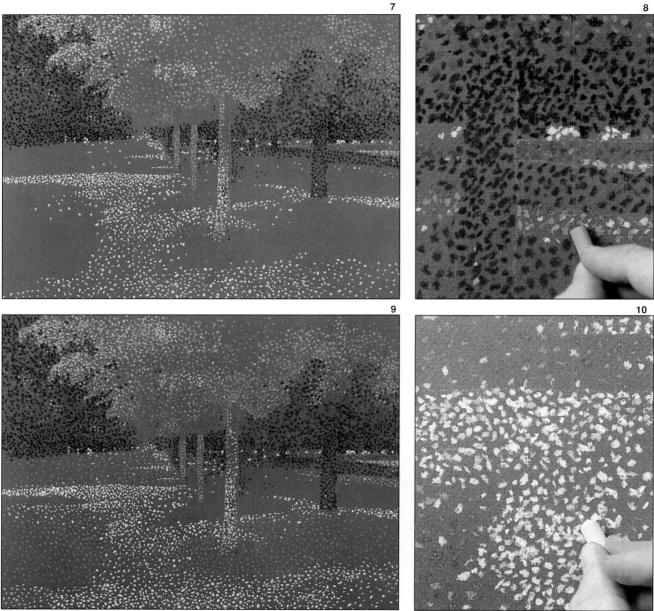

**7** This close-up photograph shows how the dots of colour are applied randomly with the end of the pastel to build up areas of light and dark foliage and to give general shape to the tree. From a distance the leaves are beginning to look as if they are about to stir in a gentle breeze.

**8** A bright band of blue is dotted into the middle foreground. This also helps to take the eye down the line of trees into the distance. This mixture of tones makes the blue appear very intense and vibrant.

**9** The artist starts filling in some of the foreground with blue. This ties the areas of light and shadow together, and the ground begins to show the effect of dappled sunlight.

**10** More dots of pale ochre are added to the foreground to increase the intensity. Notice that much of the colour of the support shows through, but this provides a further colour and depth in the picture.

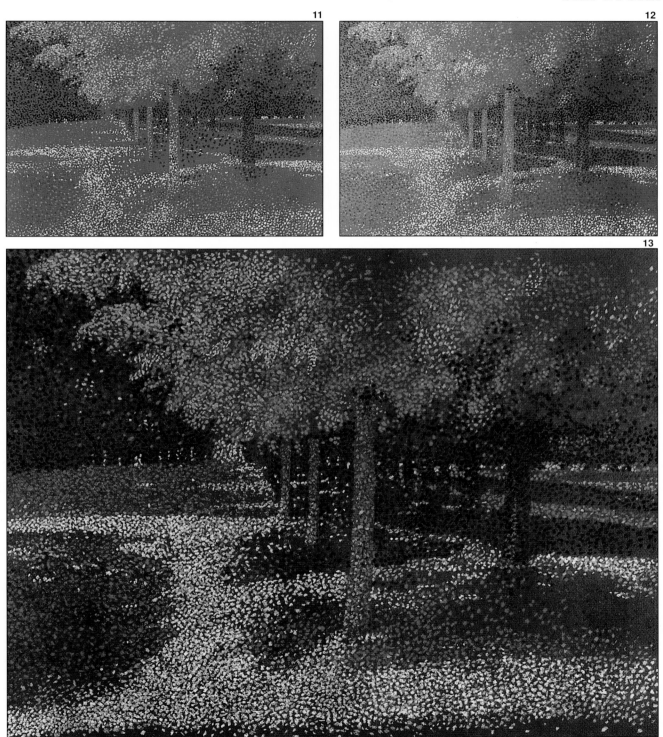

**11** Grey tones are added to path and foreground to build up texture in this area of the picture.

**12** Finally, touches of white are added to the light areas. These define the edges of the shadows.

**13** The final picture – sunlight dances under a cool canopy of trees.

# Fields of Tuscany

PASTEL

The reference for this step by step project is a small acrylic painting which the artist did while on holiday in Tuscany, Italy. It is a very quick little painting, done on hardboard, of a small farm surrounded by fields of grapevines.

When it comes to working in pastel, especially the hand-made, extra fat ones used here, such a 'tight' composition is unsuitable. The aim of this project is to show you how to loosen up a scene – be it from life, a photograph, or as here an earlier painting – to suit the bolder, freehand style that is so easy to achieve with pastels. In addition, because the original painting is such an accurate representation of the view, the colour scheme is predominantly green. Since you are going to be rendering this version in a loose, impressionistic way, the predominance of green could slightly deaden the finished picture, therefore the reference picture will be used as a compositional guide only.

It is possible to sharpen the tips of your pastels and use them in a similar way to coloured pencils for a very

tightly organized drawing; but half the fun of pastels is that you can use bold, sweeping strokes and blend colours together once on the paper. The best pastel drawings are often those that employ a loose, sketchy style, and the velvety texture of this medium is a delight to work with.

The best way to approach working in pastels is not to give yourself any steadfast rules. You will find that often your best drawings will be the ones that take you the least amount of time, as then your drawing style will be relaxed and confident. If you push yourself into drawing in a style which does not feel comfortable, then this will come across in the finished picture. Follow the step by step instructions here, but do not feel that you must obey them to the letter. If you want to change anything or treat a step in a different way, then by all means do so. This way, rather than working hard at learning how to use pastels, the pastels will start to work hard for you.

**1**  Start by blocking in the sky with a medium blue to produce a skyline and the outline of trees on the horizon. When depicting a landscape of this nature in pastels, often the best support to use is a heavy green paper as it can be allowed to show through the overlaid strokes and add harmony and unity to the picture. Obviously this is not a hard-and-fast rule, since different landscapes require a different base colour, but it is sensible to stock up on green papers as they are bound to be the most frequently used.

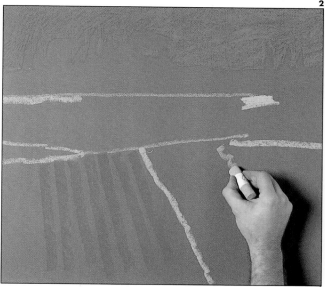

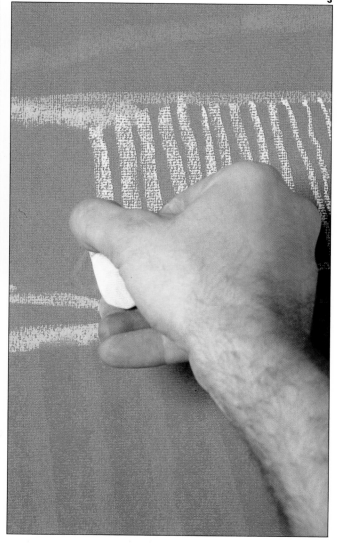

**2**  It is important to map out the various elements of the composition as early as possible to prevent you getting 'lost' later on and to stop you from getting the nasty shock of finding out you simply have not left enough room for the whole scene. Do this with bold, heavy strokes in only a few colours. Since this drawing is going to be more colourful than the original, make sure you lay down some bright tones early on to clarify this in your mind.

**3**  Gently outline the various bushes and trees with a light green. Keep the lines faint at this stage as you will be going back over these areas later. Then, using the end of a pale yellow stick, mark in bands down the central field to suggest the furrows running along it.

**4** Now go back to the trees on the horizon and start blocking them in with a dark green. Keep your strokes loose, making sure you do not allow the colour to become a solid slab which would be out of character with the rest of the picture. Note how the artist is holding his hand well away from the paper as he works; pastel smudges very easily, so it pays to be careful.

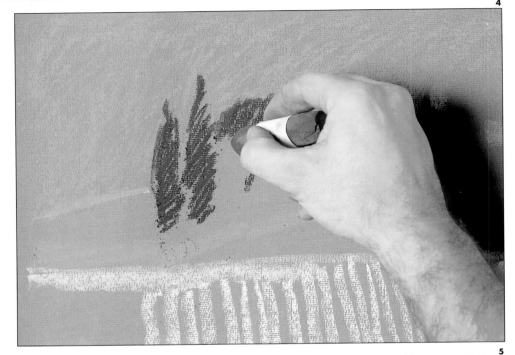

**5** Continue blocking in the trees along the skyline, then move down to the ones in the centre of the picture. Use varying shades of green to denote different tree types and to give a sense of light and shade. Most pastel pictures are built up in a very random way, with the artist rapidly switching from one part of the picture to another, trying different colours and techniques as he or she goes. This approach is especially suitable for a loose, impressionistic picture such as this, so, if you find yourself embroiled in one small section and getting nowhere, then leave it, tackle something else and go back to it later.

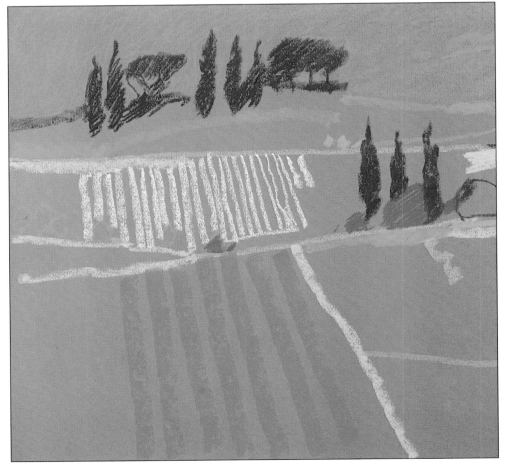

**6** Using the side of the stick, block in the field at the front right with a flesh tone. Then go back over it with stripes of light brown using the point of the stick. If you wished, you could then blend these two colours together with your finger to create a pleasant enough effect, but in this case leave it because we shall be going back to it later on for something much better.

**7** Continue by using several different green sticks to fill in the fields towards the back of the picture. This will create an attractive patchwork effect which is typical of farmed land. Now that much of the paper is covered, it is time to spray the whole picture with fixative. There are three reasons for doing this; it will darken down the colours slightly, prevent smudging, and, most importantly, allow you to add further layers of colour without muddying the ones underneath.

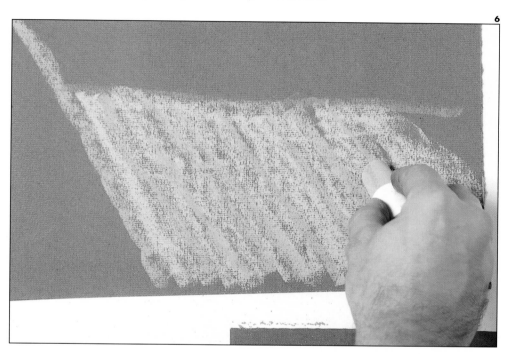

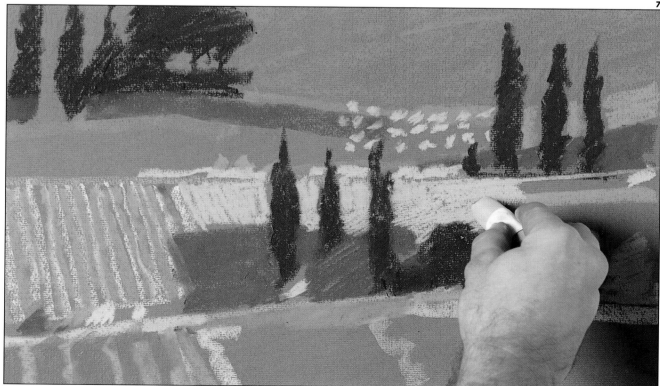

159

**8** Now that all the base colours have been fixed, you can start to work up the field of flowers at the front. Use a light pink to fill in the gaps left earlier between the stripes of dark red, and then, using the side of the stick, gently cover the whole field with a thin layer of purple. This will give you a very pleasant undulation of colour which can be further enhanced by adding bands of orange over the top with quick zig-zag marks.

**8**

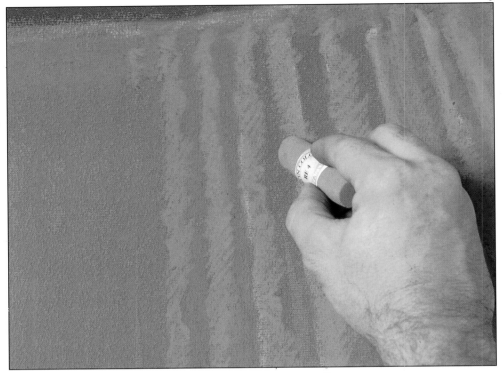

**9**

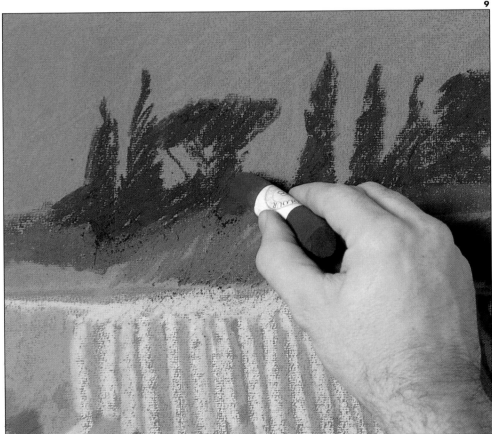

**9** Use some lime green to fill in any gaps in the mid-ground, and then switch to the trees on the horizon. This is where the blue sky and the green fields meet, so it is a good idea to introduce a hint of blue into the fields to create a link between the two. This way the sky and land become a united whole, and the landscape has a sense of atmosphere. You originally marked the trees in using dark green, so go back to them and strike in some dark blue.

**10** At this point the artist decided that his sky was too dark and was therefore darkening down the mood of his picture. Have a look at your own work so far. If the scene is looking like a bright summer's day then your sky is fine, but if it looks like an overcast day then it will require some attention. The solution is simple. Go over the entire sky with a light blue, not forgetting any bits of sky showing through the gaps in the trees. Once you have done this, again spray the picture with fixative.

**11** The field second up from the right has not received any attention yet, so quickly block it in with a dark brown, and then add some details over the top in a light green. Now that the paper is completely covered, you can start work on the finishing details. Cover the field at the front right with a scribble of light brown and then spray it with fixative.

**12** While the fixative is drying you can finish off the ploughed field in the centre of the picture. Using the side of the stick, lay a dark olive green all over it to neutralize the colour a little, then go over the lines again with light green, this time making them more 'hazy' by putting them in as gentle zig-zags.

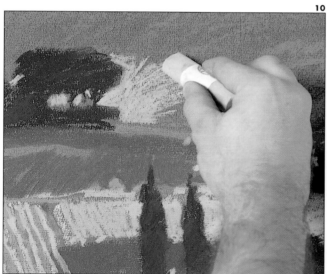

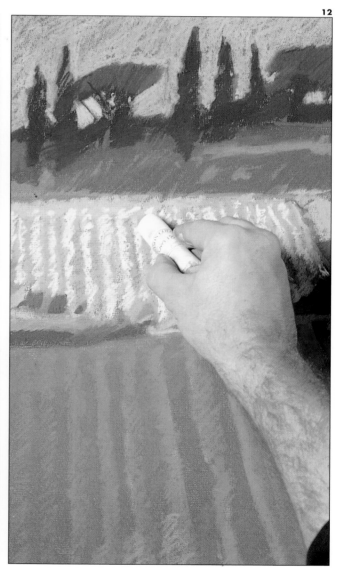

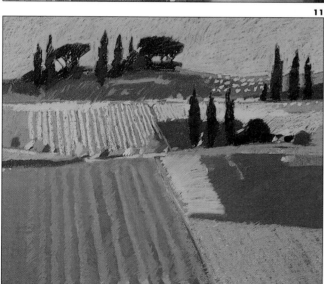

# PASTEL/FIELDS OF TUSCANY

**13** The fixative you sprayed on the field at the front will have dried now, so you can return to it for the finishing touches. The fixative was important in this instance to 'set' the colours so that a light shade can be put on top without it blending into the dark tones underneath. So now, using a light skin tone, draw in some furrows down the field, and then to avoid this looking too regimented add some scribbling down one side.

**14** The picture is basically made up of browns, greens and the blue of the sky, with the red field at the front to add impact and create an area of contrast which forms the focal point of the composition. The presence of this field can be further enhanced by adding violet zig-zag lines down it so that the viewer's eye will always be drawn to it first.

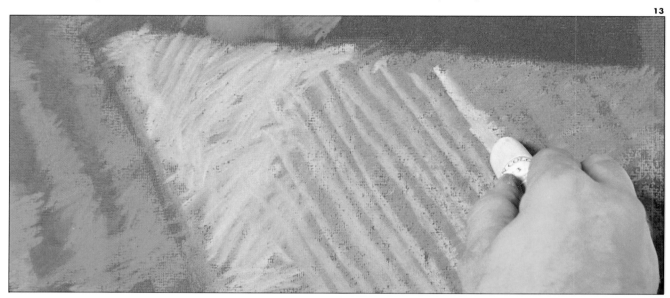

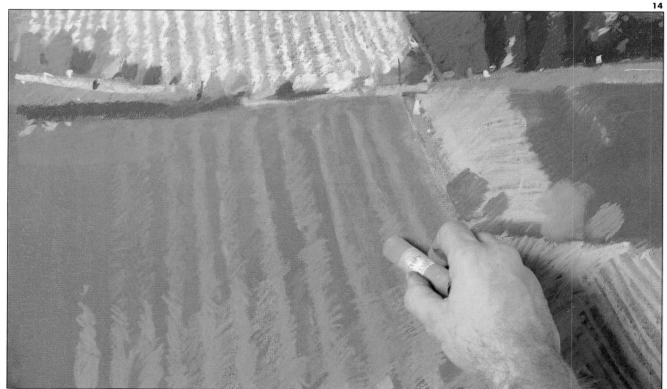

**15** A final spray of fixative and the picture is completed. In fact in this example the artist decided that, although he had lightened the sky once, it was still too dark. Therefore, he simply went back over it with a very light blue. Although it is sometimes worth going back and altering parts of your picture – always remembering to fix the area first – it is often preferable to work quickly and on the spur of the moment. Sometimes a picture can be ruined by going back over the same section again and again looking for perfection. Another important lesson to be learnt from this demonstration is the use of complementary colours in landscapes. The original scene lacked impact because it was all greens and blues, so the artist decided to liven it up by introducing an element of the predominant colour's complementary colour. Complementaries are pairs of pure colour from opposite sides of the colour wheel which, when placed side by side, enhance each other. The complementary of green is red, so the obvious way to liven up this picture was to add a field of red flowers. This is a very blatant example of the rule, but as you can see it does the trick.

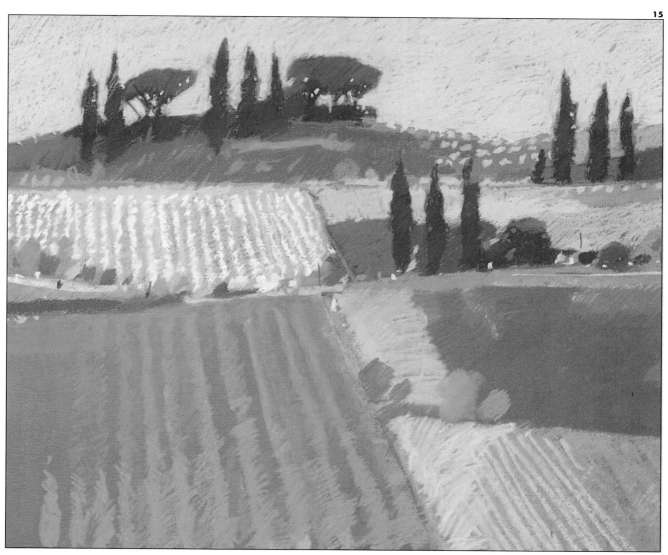

**15**

# Venetian Waterfront

PASTEL

For the artist water is an ever-changing subject with infinite moods and colours, and its inclusion in any picture can have a decided impact. When it forms the main subject it can provide a very strong image, allowing you to use your imagination to the full and express yourself in a variety of techniques.

The waterfront at Venice must be one of the most painted and photographed subjects in the world, but this rendering evokes an atmosphere that seems much removed from the crowded city so beloved of tourists. The gondolas are empty and tied up and the other side of the water seems a world away. It is an open image with a tremendous feeling of space. The water mirrors the sky and the dominant blues, greys and greens have been skilfully blended together with a torchon to create a cold, misty atmosphere.

**Colours**
Cool Grey
Intense Black
Prussian Blue
Green Grey
Coeruleum Blue
Silver White
Lizard Green
Hooker's Green

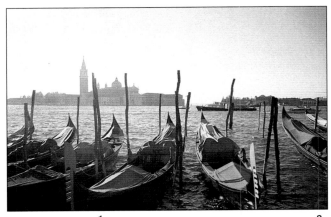

1

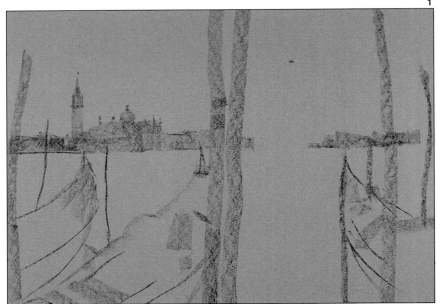

1  The artist draws in the subject in black, using the side of the pastel to block in the basic shapes.

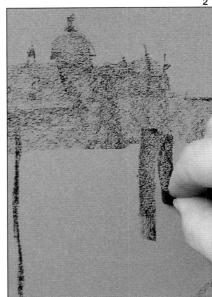

2

2  This close-up shows the loose, open look produced by laying colour with the side of the pastel. A certain amount of atmosphere is introduced from the outset.

164

**3** Thinner, sharper elements are drawn into the picture using the end of the black pastel.

**4** With the basic outlines established, the artist now sets to work on the sky, placing a layer of very pale blue over the whole area. He uses the side of the pastel in broad, sweeping strokes and the pigment overlaps unevenly, building up texture.

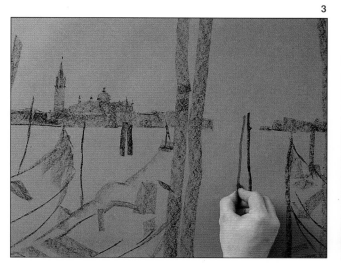

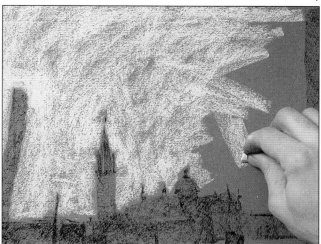

**5** The sky is now in place, and the next stage is to lay colour on the sea. The blue ground will provide added depth, and already helps the artist to visualize the sort of mood he wants to express.

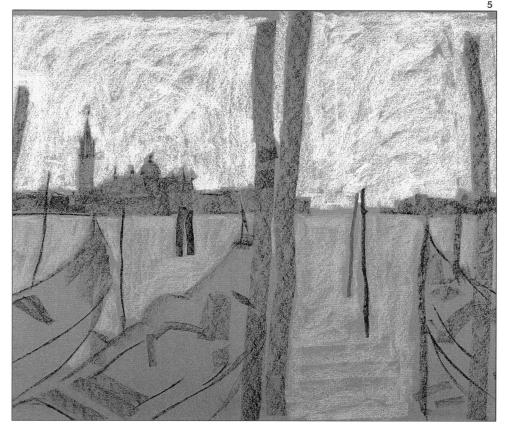

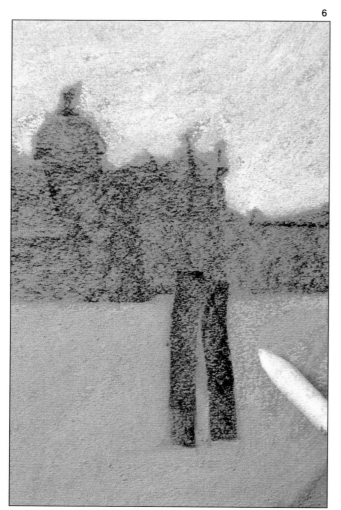

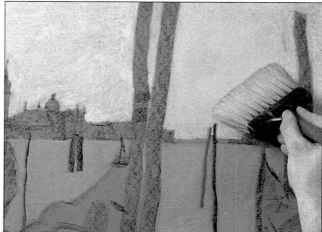

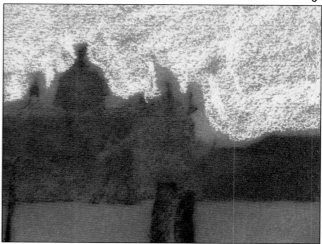

**6**  For the sea the artist uses a tint that is a little darker than the one used for the sky. He blends the pigment in using a torchon to produce a smooth texture, and sprays this area with fixative to protect it.

**7**  To remove some of the pigment from the sky and to even out the texture, a large brush is used. Any powdery pigment that falls on the rest of the drawing can be blown away.

**8**  When the sky texture is finished it, too, is given a light spray of fixative. A little of the powdery pigment may adhere to the area of the buildings, but this helps to emphasize their misty look across the water.

**9** The sky and sea now look very smooth after blending with the torchon and brush. To firm up the various elements of the drawing the outlines of the boats and poles are redrawn in black.

**10** The artist decides to add more texture to the sky to give the impression of cloud cover, and lays on another coating of blue, again using the side of the pastel in broad, random strokes. He then adds some colour to the boats in the foreground.

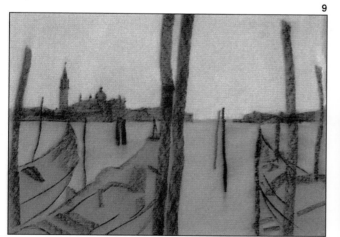

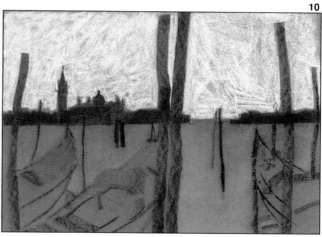

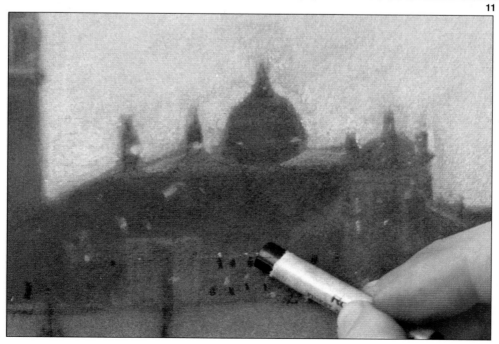

**11** Across the water the buildings take on a blurred look as they are worked on in greys and greens. Tiny details are added in black with the end of the pastel.

**12** To give more intensity and form to the colours on the gondolas a soft layer of pigment is put in, with darker areas denoting shadow and shape. A little green colour is added to the water in the foreground and dark shadow near the boats to create depth.

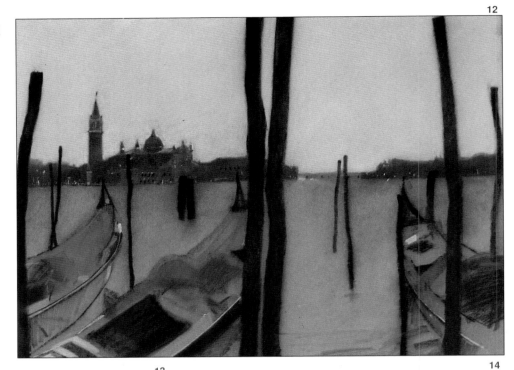

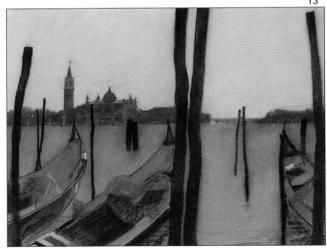

**13** A further layer of undercolour is added to the gondolas.

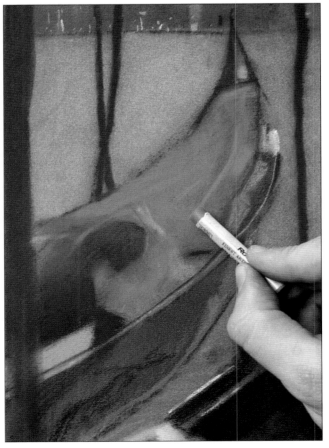

**14** Top colour is then added onto the gondolas using the end of the pastel. Although they are from the cool end of the spectrum, the colours mix to produce vibrant tones that contrast with the cold surrounding water.

**15** Dark green ripples are added to the water in front of the short mooring poles where the water is likely to break and eddy.

**16** The artist then works areas of grey shadow into the gondola on the right to give it form.

**17** Further areas of dark green ripples are drawn around the poles and boats to give movement and depth to the water.

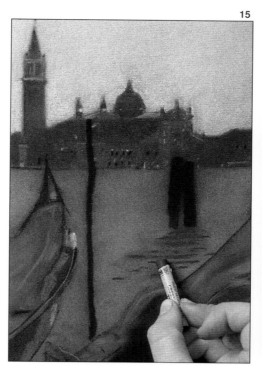

15

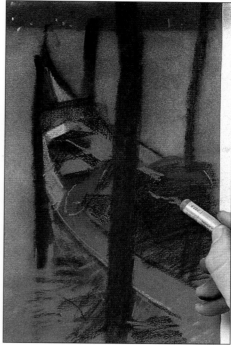

16

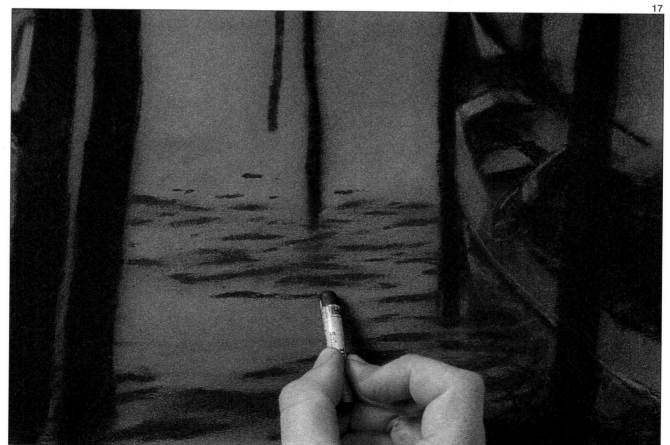

17

## PASTEL/VENETIAN WATERFRONT

**18** The drawing is nearly complete, but there is still some work to be done to the water to increase the feeling of recession and space.

**19** To widen out the expanse of water small dots of white are placed across the width of the picture and stretching right out to the horizon.

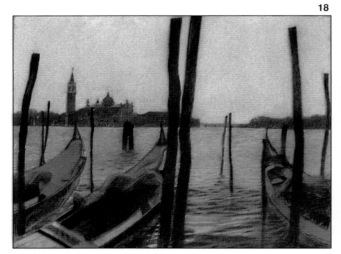

18

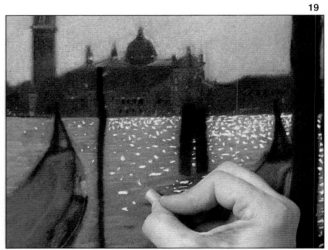

19

**20** Pale blue dots are then interspersed among the white, and darker blue streaks are dabbed into the foreground water where the artist will blend them with the dark green ripples.

20

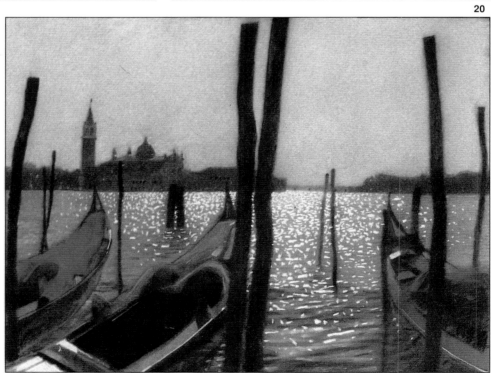

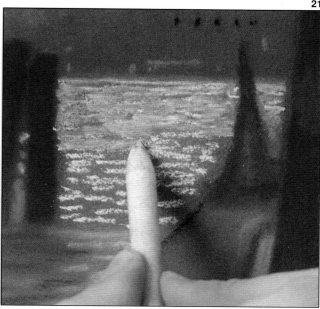

**21** To achieve a smooth, shimmering finish to the water the artist blends and mixes the dots of colour with a torchon.

**22** The picture is finished. The artist has captured a feeling of space, mood and subtle movement using only a limited palette of blues, greys and greens.

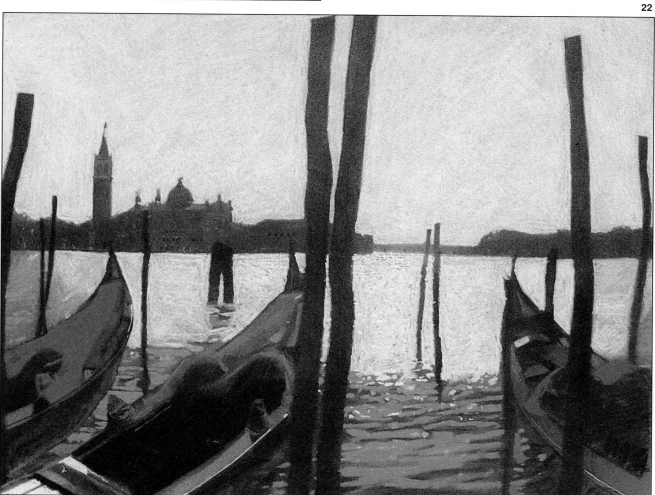

# Flotsam and Jetsam

## PASTEL

Here we have a perfect example of a 'natural' still life. This heap of flotsam and jetsam lying at the high tide mark on the beach was not at first an obvious choice for a work in pastel; however, the drab colours in the old wood did, on closer inspection, lend themselves readily to a rather moody depiction – something pastels can be very good at.

The aim of this project, therefore, is not only to get to grips with pastel techniques, but also to gain experience in capturing the mood of a scene. In this particular case the artist decided not to include any of the people sitting on the beach, so as to focus attention on the group of objects and to emphasize the sense of isolation. This mood is further underlined by the use of a limited 'palette'. The colours in the group are echoed in the pebbles on the beach. This not only evokes a quiet, restrained mood but also creates a uniformity of colour which helps to pull the whole composition together and give it strength.

Pastels are renowned for being a 'fast' medium, but they are also suited to a slower, more considered way of working. This project will demonstrate that you can take your time when using pastels, working towards a fairly 'finished' effect while losing none of the vibrancy and expressiveness for which they are so admired. The beauty of pastels is their ambiguity, and when you can harness this the rest is easy.

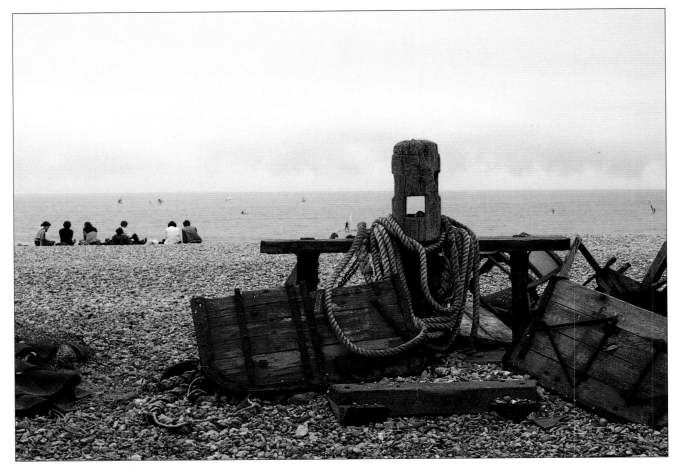

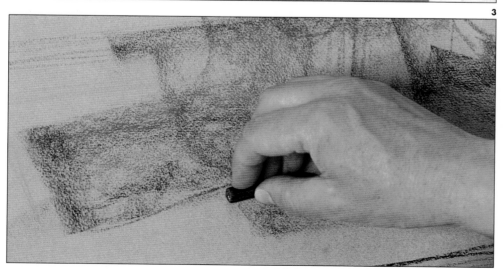

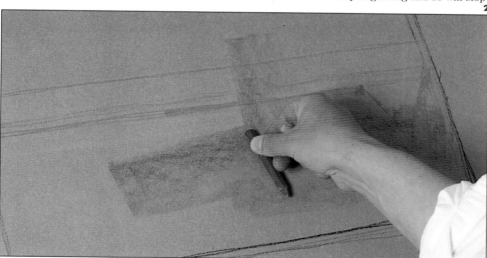

**1** In this case the artist made a quick thumbnail sketch in charcoal before starting on the work in pastel. Although this stage is not imperative – and it is stressed that you do not have to follow any of the projects in this book religiously – if you do decide to do the same you will discover that it is a wonderful device in establishing the composition – often the most difficult part of any still-life.

**2** The first true stage in this project is to use the charcoal to roughly mark out the area to work in. This has the effect of limiting your work to the confines you set up at the very beginning and so will stop you getting 'lost' later on, especially if working on a large piece of paper. When working in pastels, the colour of the paper itself will nearly always affect the end result. In this case a muddy green colour is ideal, since it can be used as the base colour for the pebbles on the beach.

Start by marking out the various elements of the picture in different colours to give a wide variety of hues later on. These colours will largely disappear as your work progresses, but they do help to 'set the scene'. Use a deep maroon to mark the horizon and a dark blue for the shoreline. Then, using the side of the sticks, start blocking in the major elements – the flotsam and jetsam – overlaying orange, blue and deep maroon to build up colour and form.

**3** Continue working up this area, blending and overlaying colours as you go – some deep green, Prussian blue and ultramarine will be perfect. This mixture of colours may seem strange – especially since in the finished picture very little will still be obvious – but they are very important in creating a sense of colour harmony in your work. These colours will be evident elsewhere, and the minute traces of them in these first areas will help pull the whole picture together. As we mentioned in the introduction to this project, the long piece of wood running along the shoreline needs to be moved slightly to avoid a confusing composition. Make sure that you block in its new position at this early stage since it will be much more difficult to alter later on.

**4** Using the side of the pastel sticks, fill in the sky area with bands of sky blue and white. You can then gently blend the whole of the sky area with the tips of your fingers to create a soft, slightly hazy, blur which will be built up further later on. Then use turquoise blue and sky blue to roughly mark in the sea with scribbled hatched strokes. This is also an ideal opportunity to add more body to the main group of objects by blocking over them with burnt umber.

**5** It is now time to start making more positive decisions about the picture by defining and outlining the objects. Although a dark tone is obviously required to separate the group of objects from the background, black would probably be too harsh and overstated for such a picture. Therefore, use a dark blue – which again maintains the colour harmony – to go round and mark in the various outlines, not forgetting those of the coils of rope. Make sure the pastel is sharp, and use the very tip for these lines so that they can be easily altered later.

**6** Now that the group of objects is firmly in place, start working on the pebbles. Begin with the large oval pebbles in the foreground, working back to the merest suggestion of form near the shoreline. Go over the area three times, firstly with brown, then dark blue and finally maroon, dotting in pebbles here and there with each successive pass-over. You will be returning to the pebbles at a later stage.

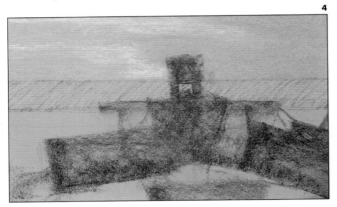

**4**

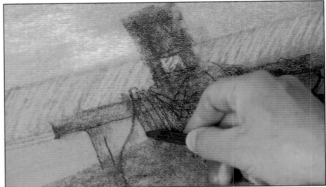

**5**

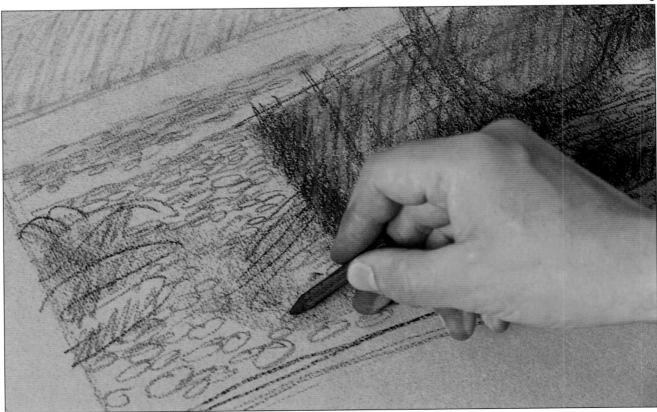

**6**

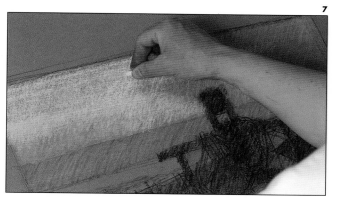

**7** Since all the major elements of the picture are now in place, it is possible to finish off some of the background details. First to receive attention is the sky. Using white, hatch over the cloud area you suggested earlier until the white has quite a bit of presence. Then hatch over the remainder of the sky with sky blue and a small amount of yellow.

**8** Once you have finished blocking in the sky, gently blend the area with your fingers. The hatched strokes have deposited a large amount of colour onto the paper which, when blended, provides a great depth of tone. This technique gives a more lively effect than using the side of the stick to block in an area of thick colour, which tends to create a rather 'flat' and lifeless look.

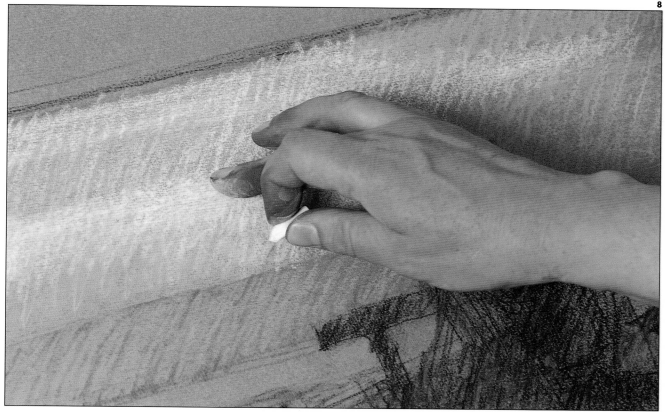

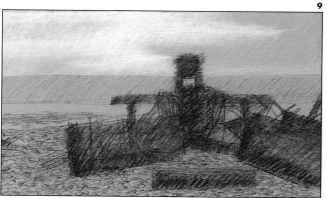

**9** The sky is completed by adding a little more white again and then blending this in with long, thin strokes to imitate high, spindly clouds. Now the sea can be gradually built up by overlaying strokes of sky blue and a dark blue/green over the initial colour. Keep a close eye on what you are doing, and stop the moment it looks all right. If you put down too many layers you will end up with a muddy colour and a surface that is clogged and 'dead'.

**10** With the sea and sky completed, return once again to the pebbles. As mentioned earlier, colour harmony is very important in any picture. You have already included dark blue, brown and maroon pebbles, so, you should now continue with the other colours used elsewhere in the picture – green, orange, sky blue and yellow. Not only will this maintain the unity of colour, it will also provide more interest in the foreground (in reality the pebbles were rather dull and monochromatic, but a little artistic licence is permissible in the interests of creating a lively image!).

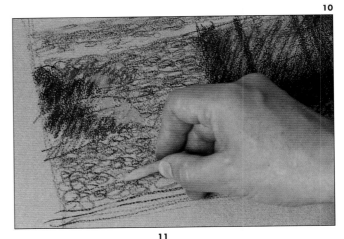

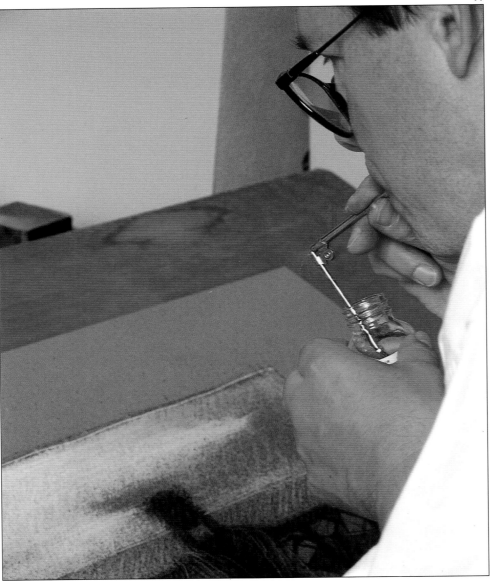

**11** The addition of some white to the rope, as an indication of hue, completes the final base colour. From now on you will be working on the details, so it is important to fix your picture at this stage, to avoid smudging the underlayers. In this photo the artist is using a mouth diffuser, but fixative is also available in CFC-free aerosols which are easier to use (but be warned, the smell is rather over-powering).

**12** Once the picture is dry give the main group of objects a once-over with the burnt umber stick to make them just that bit more solid, and then you can switch back to the gradual build-up of the pebbles. Where the beach fades off into the shoreline simply lay a base colour and then pick out some tiny highlights to suggest pebbles in the distance. All the highlights can be done together at the end, so for now use the side of your brown stick to block in a little colour and then lightly scribble over all the distant beach with a pale yellow. Then switch to a pale violet and scribble over the edge of the pale yellow and the drawn pebbles in front. You can then continue down the picture with this colour to add some highlights to the pebbles in the foreground, on the main body of objects and on the piece of wood lying at the front.

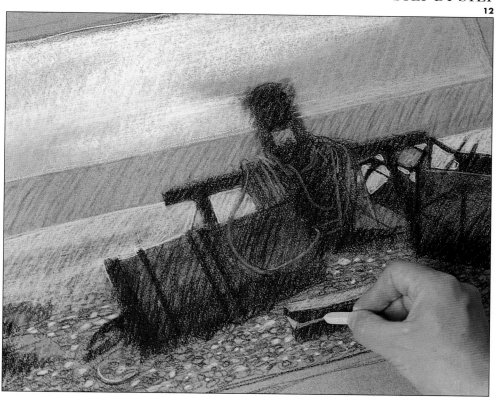

**13** In this close-up detail you can see how the pebbles have been built up with various dots and squiggles of colour. So long as you do not lay too much of any one colour – which would destroy the balance – a remarkably detailed-looking effect can be easily achieved. Apart from the lightest highlights, you can now finish off the beach itself. Go over the area again, firstly adding yellow highlights, then brown lowlights and finally dark blue specks for the more distant pebbles. Then add some loose swirls of dark blue to suggest individual stones in the foreground.

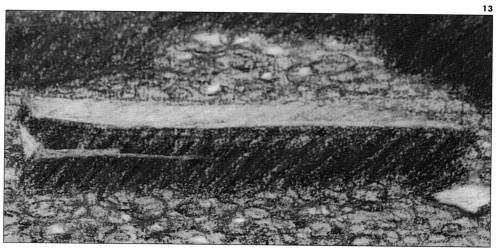

**14** Your still-life should now be really starting to come together. Use orange and pale violet to define the wooden planks on the large panels at the front of the main group, softly smudging the colours together with your fingers. Next, use dark blue and brown to layer more depth into the shadowy areas – including the dark rocks to the left of the picture – again using your fingers to smudge and soften the colours.

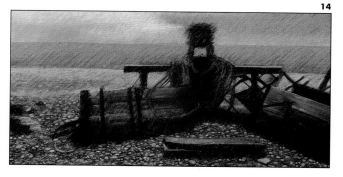

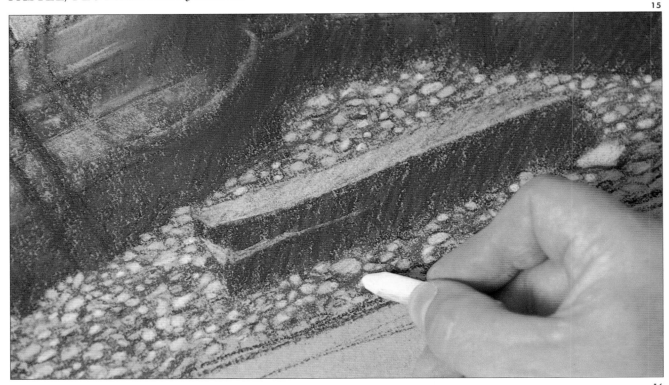

**15** At last the final highlights can be added to the pebbles. Concentrate on the foreground first, using white, pale yellow and pale orange so that you get a complete range of hues. In addition, try to vary the size of the highlights to prevent them looking unnaturally uniform. One final note while on the subject of highlights: do not be tempted to use too much white as this will also appear harsh and unnatural.

**16** For the distant beach the highlights are created with only tiny specks of colour – again the white, pale yellow and pale orange. Be sure to make your marks soft and gentle since only a suggestion is needed to create the illusion.

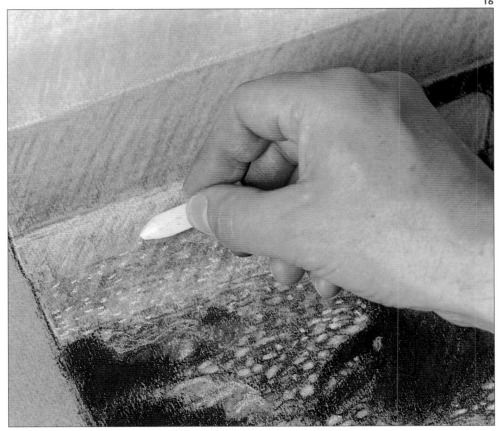

**17** Use sky blue to 'cut in' (give a firm outline) around the top of the foreground group where it stands out against the sea, and then pale violet to mark in the very top of the group where it crosses into the sky. The last item to receive attention is the coil of rope. Although this looks complicated, in fact it is simply a matter of going along the lengths adding grey dashes at regular intervals to suggest the form of spiralling twines in the rope.

**18** A quick spray all over with fixative completes your picture. Now you can step back and view your work at leisure. Notice how the dashes to the rope (a very quick and simple exercise) make them look wonderfully detailed. The same is true of the pebbles – which in reality are just a jumble of dots, specks and swirls in varying colours. Although this picture will have taken you quite a bit of time, it still has a great sense of being loose and spontaneous. This is a characteristic of work rendered in pastels, and part of its great beauty. So often people experiment with pastels and are disappointed to find that when they try working in details the picture goes a bit 'flat'. Pastels are normally at their best when used in a very loose manner – and budding artists who want to produce very detailed pictures would probably be advised to avoid this medium – but as you will have seen from this step-by-step project it is possible to create the illusion of complexity when required, while still maintaining the true character of the pastel medium.

**17**

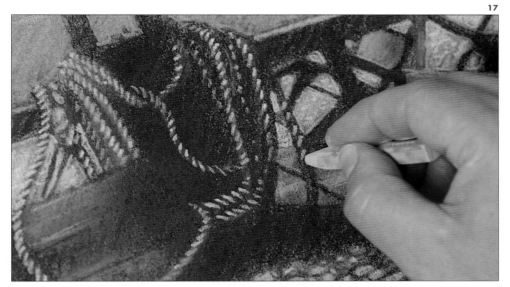

**18**

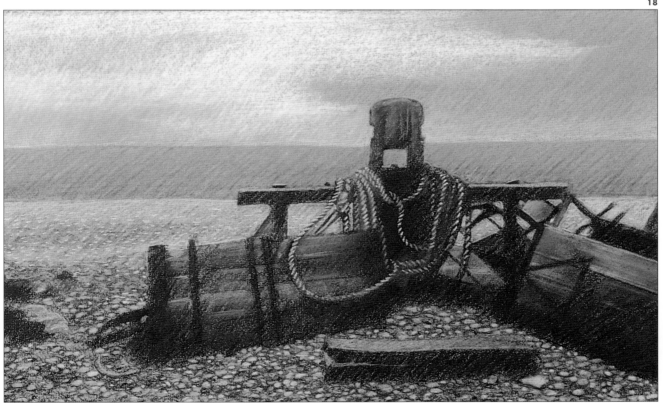

# Lloyd's Building at Night

PASTEL

The famous Lloyd's building in London seems a rather daunting subject. Not only is it so huge that you can only look up at it, but there seem to be so many details to include that are impossible to study at close range. Just where do you start?

The way to approach a subject like this is to concentrate on getting the overall shape and proportions of the building correct and to provide an approximation of its various parts. Here the artist has taken a viewpoint at some distance from the building and drawn it in perspective so that it seems to soar into the sky. He has drawn it much as the architect must have planned it, by first putting in a framework before gradually adding the different elements piece by piece.

Yet the mood of the picture conveys much of the life of the building and what happens in it. By choosing to illustrate it at night with lights blazing the artist communicates something of the atmosphere of an institution that is always active. The choice of a dark support is ideal since it throws the building into relief against the night sky.

**Colours**
Blue
Green
Orange
Yellow
Violet
White

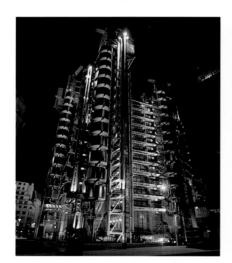

**1** The artist starts work by putting in the vertical lines and shapes of the building, making sure that the perspective is correct.

**2** Some of the horizontal window areas and the areas that will contain the 'balcony' towers are lightly shaded, while more detail is added to the ground floor. Throughout, the colours used are rather harsh, indicative of the artificial lighting and typical materials of a large office building.

**3** When drawing a building of this size it is virtually impossible to put in precise detail and so the artist encircles areas near the entrance which he will later build up in an impressionistic manner.

2

3

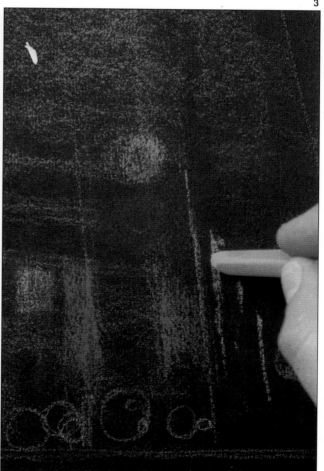

**4**

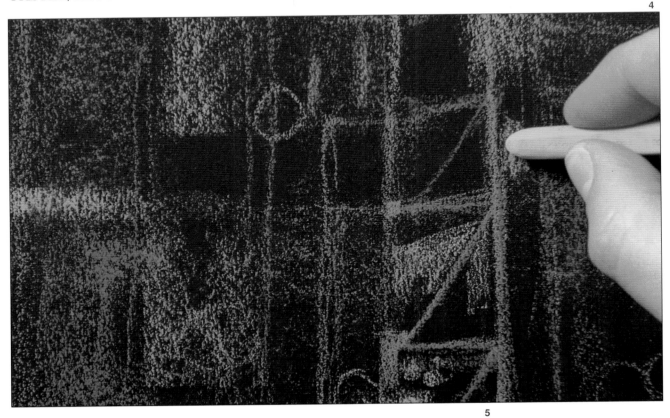

**5**

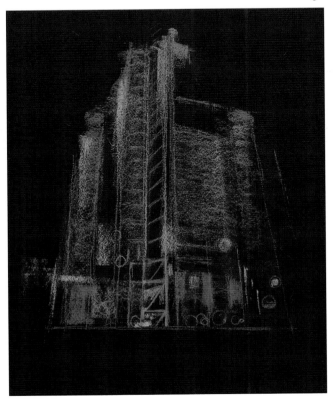

**4** The general feel of the drawing is sketchy and the dark support provides a great deal of the shadow and substance of the building.

**5** The main areas of the building have been denoted in line or shaded in. The shading is starting to give the building a solid look although the main structural detail has still to be worked on, and the areas of orange for the glare of sodium streetlamps are beginning to set the night-time scene.

**6** Structural detail is added to the building. The towers are given their green 'balconies' which make such a feature, and the window frames are outlined in blue.

**7**

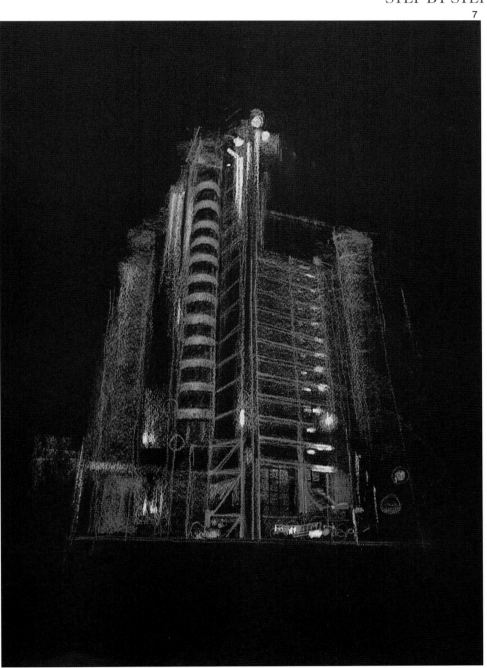

**6**

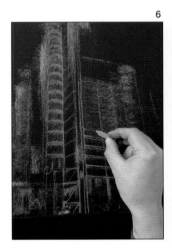

**7** The artist starts to add spots of reflected light and highlights onto the glass windows and the building begins to come alive.

8

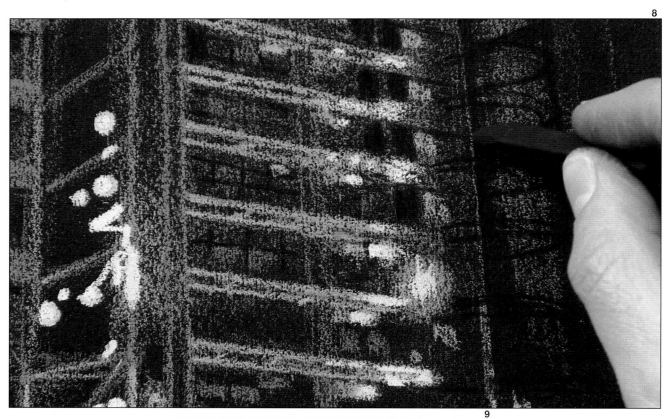

9

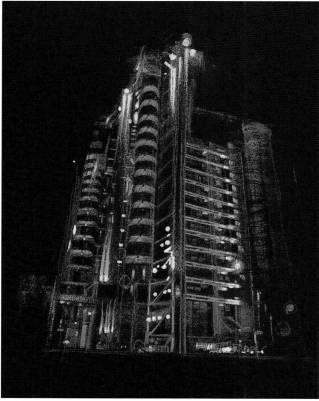

**8** The darker areas of the balconies are defined in black and here the artist is adding the spiral shape to the right-hand tower. Further areas of colour are shaded in squares into the window frames to give more substance to the glass.

**9** Impressionistic detail is added to the entrance to show how far the viewer is from the building and to emphasize its size. The tower on the right still needs to be completed.

**10** The finished picture looks much more complicated to draw than is the case, and simple techniques have been used throughout to produce an architectural picture with a great deal of atmosphere.

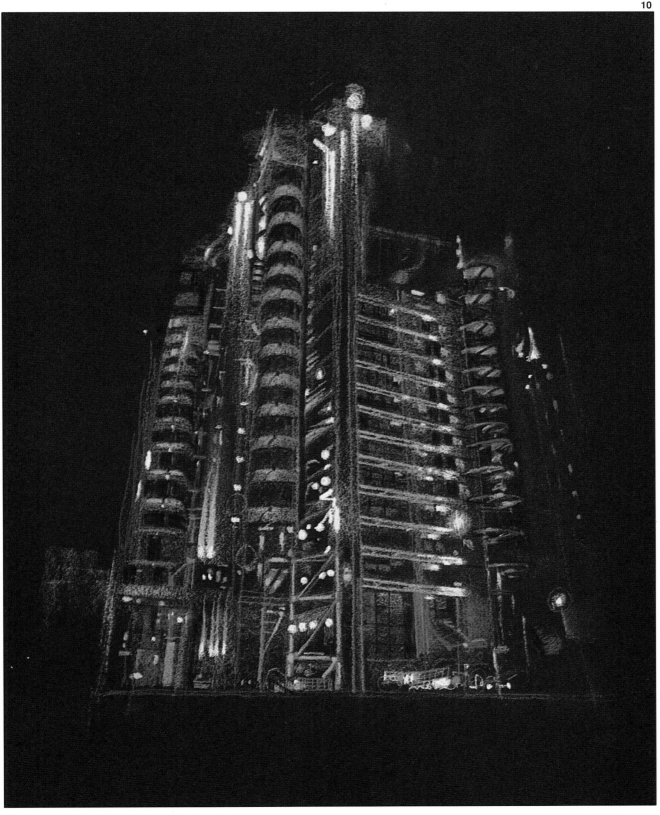

# French Church

## PASTEL

Many small towns have a wealth of interesting features that the artist can put to good effect. The simple bell tower of this church contrasts with the more ornate architecture of its façade and by drawing the building from the side the artist can outline both shapes in silhouette against the sky.

    The picture immediately evokes the bright light and hot sun of the Mediterranean, produced by juxtaposing flat areas of complementary colours. The soft yellow of the tower is balanced by the bright blue cloudless sky. Each colour is confined within a shape – the blue sky, the yellow tower, grey walls and green trees. This precision of line gives the drawing a sense of immediacy usually associated with a screen print.

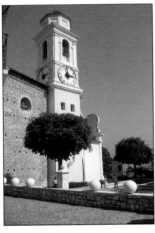

**Colours**
Coeruleum Blue
White
Intense Black
Green Grey
Cool Grey
Yellow Ochre
Lemon Yellow
Lizard Green

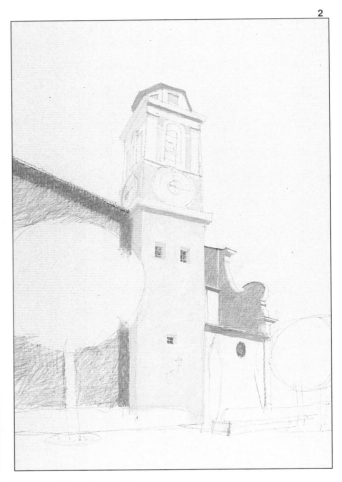

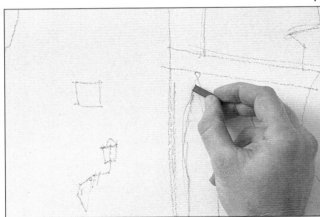

**1** The basic outlines for the church and tree are drawn in, including the details of windows and the lamp.

**2** The ochre colour of the tower is gently blended in with a little white with a torchon, using a darker tone for the areas in shadow such as its side and the window reveals, and the windows are blocked in with black. A slightly looser technique in grey is used for the back of the façade to create a little texture, and loose hatching in warm tones is used for the wall in the foreground.

**3** Using white, the artist cross-hatches the brown on the walls. This mixes the colours and produces a soft textured look. He then gently hatches a soft pale greenish grey tone to the wall on the right.

**4** The bright blue sky is laid down, using pastel with a torchon to build up the depth of tone.

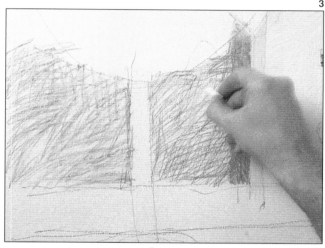

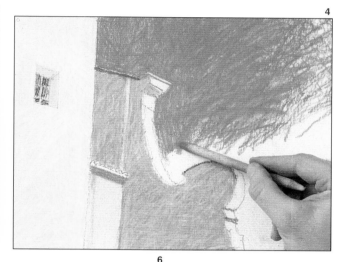

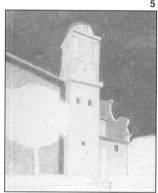

**5** With the sky completed, the artist can now concentrate on the trees and details of the building.

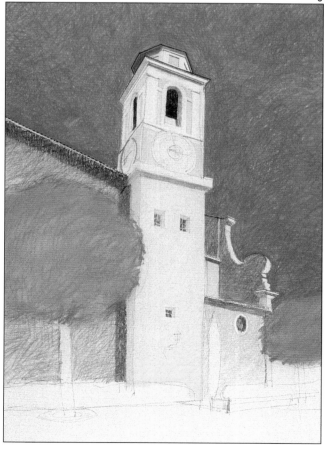

**6** Green pastel is added to the rounded shapes of the trees, and the colour is softly blended. The outlines of the tower are delineated in black and the belfry openings shaded in. A dotted black line suggests the tiled roof line on the left.

**7** To obtain a precise line for the shading at the top of the wall the artist works against the edge of a wooden rule.

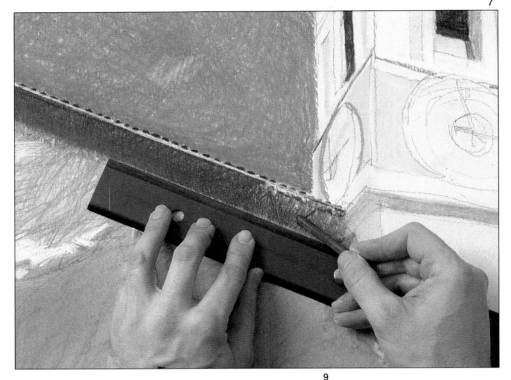

8

**8** The wall on the right is now completed by mixing over a layer of white to give the textured effect of white stucco. Shading is added to the reveal of the round window. Notice that perspective causes this window to appear as an ellipse.

9

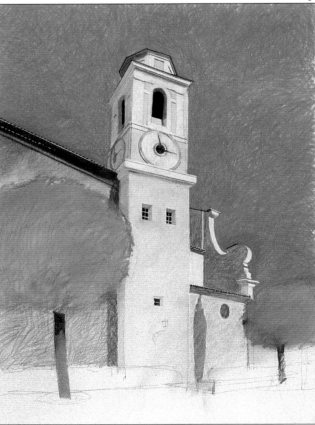

**9** Shading is added to the clock to define its shape and depth. The tree trunks are filled in and blended at the bottom to denote the shadow cast by the foliage, and undercolour is laid down for the shrub by the wall.

**10**

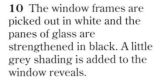

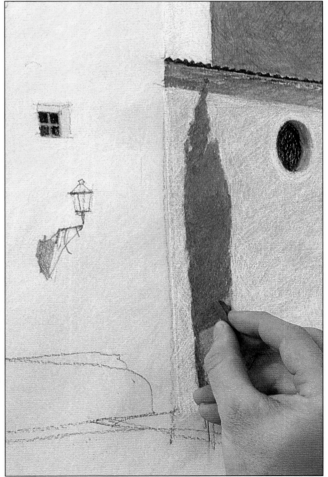

**10** The window frames are picked out in white and the panes of glass are strengthened in black. A little grey shading is added to the window reveals.

**11** The windows now show up as clear architectural features of the tower. The artist adds in the details of the clock face.

**12** A further layer of dark green colour is added to the shrub by the wall, keeping the edges soft to convey the way the foliage grows.

**11**

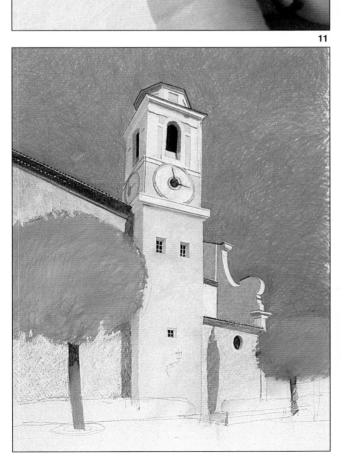

**12**

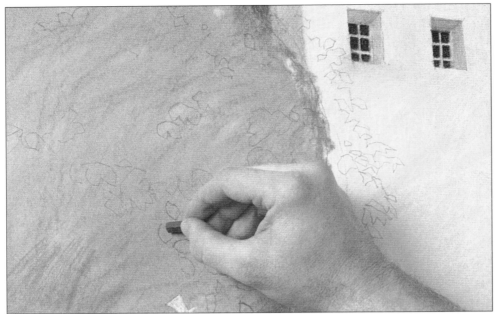

**13** Attention now turns to the foliage of the trees. The artist outlines random areas of leaves in a slightly darker green than that used for the blended flat colour.

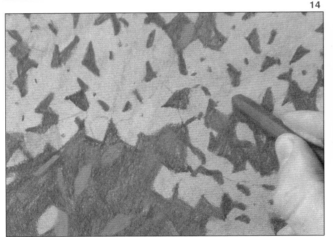

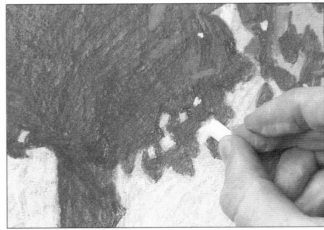

**14** Impressionistic dashes of varying tones of green are layered onto the trees to illustrate leaves. A lighter yellow green is used for the top layers of foliage to represent new growth.

**15** Odd dashes of white are introduced at the edges of the foliage to break up the harshness of line and give some movement to the leaves.

**16** Finally, detail is worked into the foreground of the picture. A hedge and pavement are added, the trees are firmly planted in a circle of earth and the lamp on the bell tower is firmly drawn in.

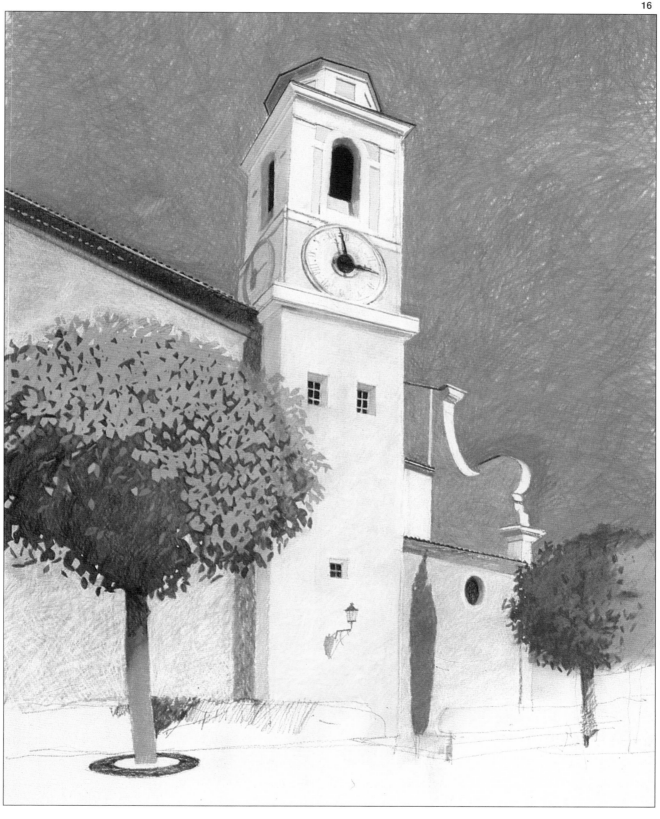

# Cowboy

PASTEL

This imaginative drawing of a rodeo scene is all about movement. As the horse bucks to try to unseat its rider so the cowboy leans back in the saddle to balance, and the artist seems to capture a split second in time.

The success of this picture lies for the main part in the accuracy with which the horse is depicted. The animal's arched back and stiff forelegs as it leaps into the air to kick out its hind legs are the typical actions of a bucking horse. Its nostrils flare with the effort and strength of its task. All this is the result of careful observation and numerous sketch studies over a period of time.

Technique and colour work hand in hand. The anger of the horse is shown in its red eye and nostril. An orange blur around its body radiates the intense heat of exertion, and speed whips away behind its tail. Amidst all this the cowboy, dressed in pale blue, keeps his hat and appears balanced and composed.

| **Colours** | Violet |
| --- | --- |
| Orange | Pink |
| Yellow | Yellow Ochre |
| Red | Brown |
| Green | White |
| Blue | |

**1** The artist chooses a warm-coloured support and outlines the horse and cowboy in orange. He uses the side of the pastel to block in the curves of the horse's flanks.

**2** Areas of dark blue shadow are placed under the horse's head and tail and under the strap holding the saddle blanket. The cowboy's arm and knee are also shaded in blue to help build form.

**3** The orange outline is strengthened in places by the addition of a red one. This is in the areas where action is most intense – around the horse's head, mane and hindquarters and around the cowboy as he is jerked violently about. Blurred orange behind the horse's flanks and cowboy's hat implies speed.

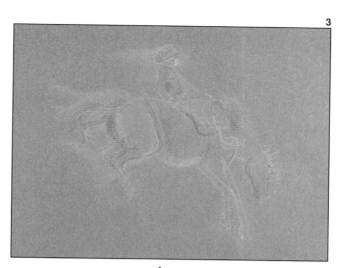

**4** Blue-green undercolour is applied to the horse's body with the side of the pastel. This enables the artist to achieve even areas of shading. Layers of other colour will be mixed on top to create brown tones for the horse.

**5** Areas of highlight are added to the cowboy's hat, apron and boot with the end of a white pastel.

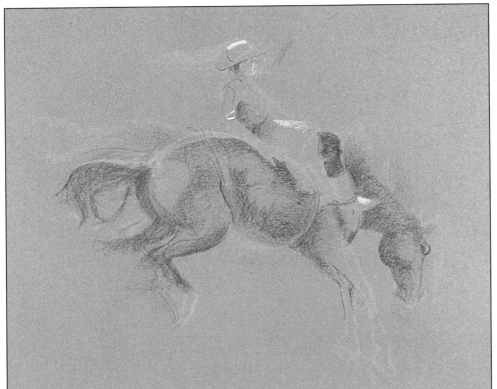

**6** The picture is beginning to take shape. The horse's back arches in one continuous curve and the power of the hind legs is suggested.

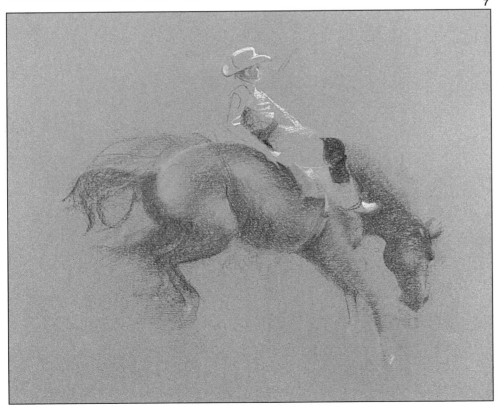

**7** To make the deep brown tones of the horse's body the artist mixes red pastel with the existing blue-green. Areas of the support are left blank to give tone and shape to the horse's flanks.

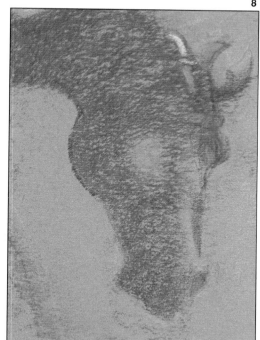

8

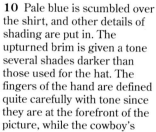

10

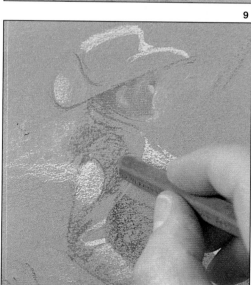

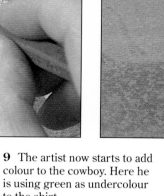

9

**8** This detail of the horse's head shows how the layers of blue-green and red shading mix to give brown textured tones. Red is added to the horse's eye and nostril.

**9** The artist now starts to add colour to the cowboy. Here he is using green as undercolour to the shirt.

**10** Pale blue is scumbled over the shirt, and other details of shading are put in. The upturned brim is given a tone several shades darker than those used for the hat. The fingers of the hand are defined quite carefully with tone since they are at the forefront of the picture, while the cowboy's face is handled with a much more impressionistic style.

11

12

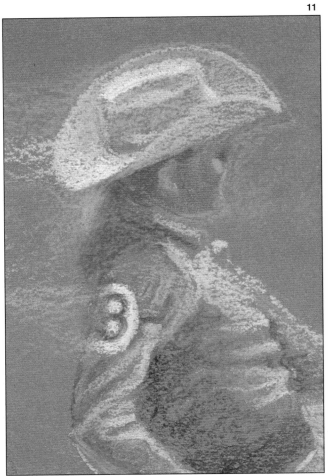

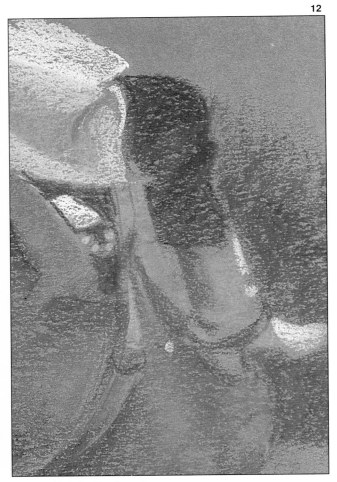

**11** A close look at the cowboy's face and shirt shows a careful use of layered colours and odd dashes of complementary colour to build up the detail. The blurred features on his face and blurred edges to the left side of his hat, scarf and arm show that he is moving through the air with a great deal of speed.

**12** Detailed shading has also been added to the cowboy's apron and leg. The toe and front of his boot are highlighted in white and a great deal of the colour of the boot is formed by areas of the support which have not been coloured.

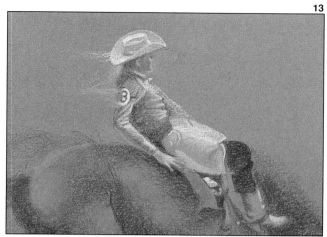

**13**

**13** Lines of white across the cowboy's shirt show him twisting slightly as he tries to keep his seat on the horse. His calm pose, emphasized by the light colours of his clothes, is in sharp contrast to the fury of the horse.

**14** From a distance soft, loose layers of colours blend with the colour of the support to give a surprising amount of detail in the final work.

**14**

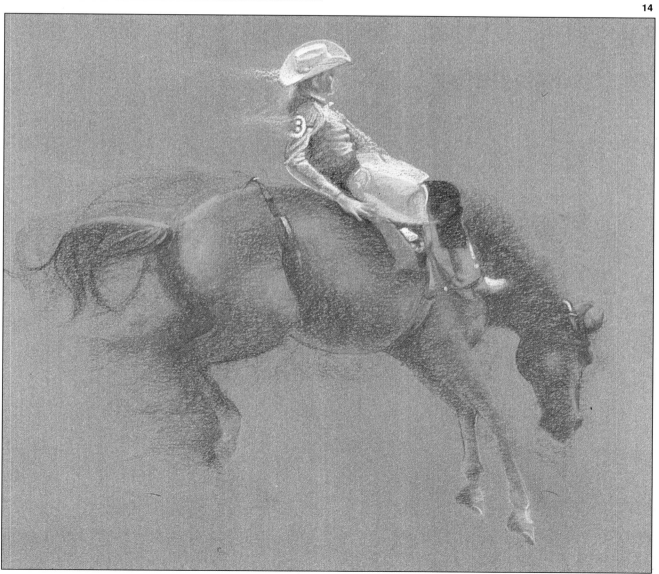

# The Couple

PASTEL

The two models in this double portrait were of very different heights. When they were standing next to each other the man's head was so far above the woman's that the picture did not have any focal point, making it difficult for the viewer to concentrate on any one part of the image.

To overcome this problem, we decided the woman should stand and the man sit; as you can see, this arrangement works much better. By turning the man's head to the side, we then achieved a portrait which included a 'face on' and a profile, adding even more interest to the composition.

Pastels are extremely versatile, and although they are renowned for being a 'fast' medium they can also be used to produce a more finished work in a fairly tight way of working. For this project we have tried to aim for a mixture of these two styles, taking the faces to a higher state of finish than the rest of the portrait. The important thing is to take care not to overwork your picture or you will lose the vibrancy and expressiveness which makes pastels such a joy to use.

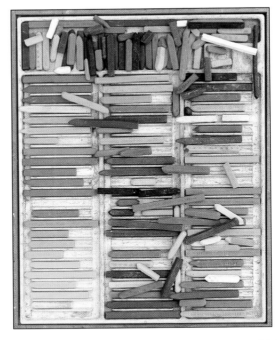

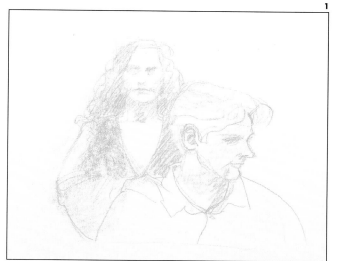

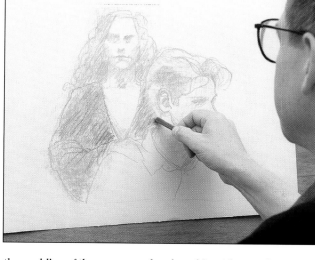

**1** For this project we used a grey tinted drawing paper with a rough surface measuring 20 in ×15 in (51 cm ×38 cm). Grey provides a good base tone to work from for both light and dark colours and will not create a harsh contrast for the background. The initial drawing is sketched in orange, which is visible and yet will not overpower the portrait as it appears in the final piece.

**2** Throughout this project we use a mix of red and dark green to suggest the darker tones. This is more subtle in the shadows of the face and hair and more obvious on the woman's top. So, with dark green, loosely cover the area of the woman's black top, then go over it again with red in the same fashion. This, as you can see, gives the effect of black – but it will be a deeper, more 'living' colour by having been produced from overlaying the colours.

**3** Continue with the red and sketch over the woman's hair and some areas of the man's hair. This is done over both, even though the hair colour is different, to create a sense of unity. Switch back to the dark green and go over the black top again to darken it a bit more. Now, with a pale lilac, go loosely over the man's shirt,

the neckline of the woman and lightly over the background to keep everything in harmony. Now – again loosely – go over the shirt and the background in pale blue.

**4** Returning to the faces, start work on the shadows using the red and green formula. Start with a bright red to model the details of the woman's face, such as the eyes and the lips, as well as the outline of the hair. Smudge the red under

her chin with your finger to soften the edges and create the shadows. Switch to dark green and go over all the really dark areas again. The red showing through and around the green softens these darker tones, which is why the face is built up in this way.

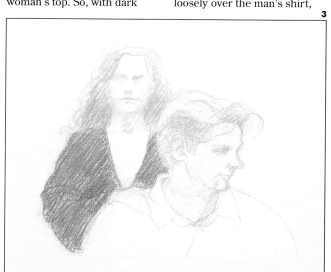

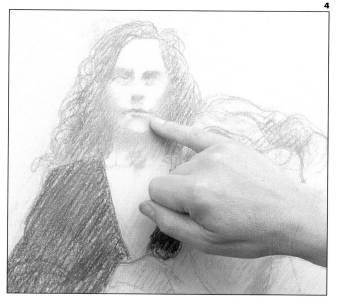

**5** Now for the background, which is a white wall. First hatch over it with some white and then introduce a variety of pale colours to the background: pale green, pale yellow, pale pink and pale lilac worked into the white. This will liven up the wall and avoid it from becoming a flat white.

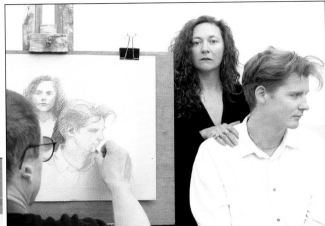

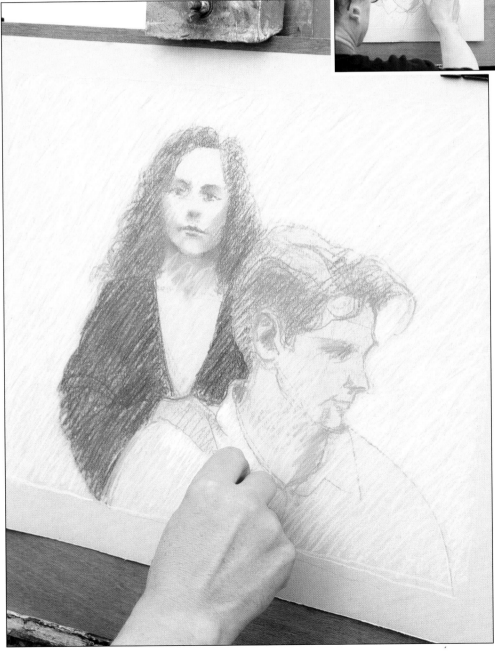

**6** Start to go over the man's white shirt in white including the collar. Now draw a rough frame around the image which will give you a self-imposed border to work within. Cut in with the white around the man's face, which will sharpen the contours of the face and make it stand out against the background. Then go over the whole of the background, starting at the top with clear strokes which get weaker at the bottom. This will make the background appear darker at the bottom where the grey shows through more and suggests light from above. When you have completed the layer of white over the background, fix the drawing.

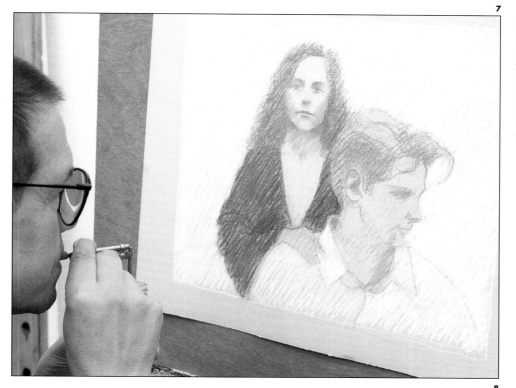

**7** Although we use a 'blow pipe' to spray the drawing with fixative, a CFC-free aerosol is just as good. If you cannot get to an art shop, hair spray is a useful alternative. While waiting for the fixative to dry, step back and take an overall view of your drawing and plan your next step.

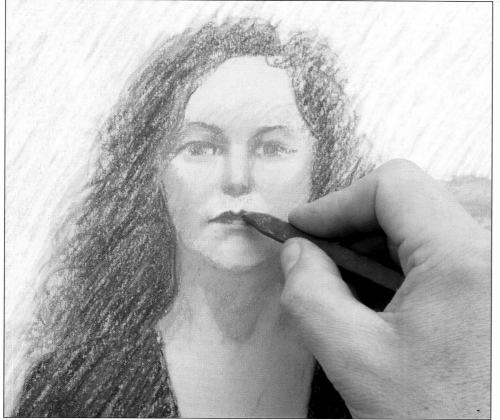

**8** Go over all the darkest areas once more in the dark green before starting to model the facial features with a pale and a medium flesh tint. Change to a reddish brown and re-define the woman's eyes, nose and eyebrows, softening the edges by gently smudging with your fingertip as you go. Moving over to the man, adjust his hairline with a pale flesh tone, then switch to the reddish brown for the contour of his nose. Continue to model the nose by alternating between the pale flesh and the reddish brown. With the medium flesh tone, work up the side of the nose and the shadows on the chin and lips. Go back to the reddish brown to go over the man's hair and the shadow cast by the shirt collar on the bottom of his neck. Returning to the woman and sticking to the reddish brown, add the outline of the lips and then fill them in before going over her hair to deepen its tone.

**9** Now alternate between the pale and the medium flesh tints and continue to model the woman's eyes and nose, then with the medium flesh tint work up the chin.

At this stage it is useful to look at the models objectively and check on your likeness. In this case the woman's face appeared to be too broad, so alternate between the reddish brown, medium flesh and pale flesh tint to re-define the shape slightly. With cream and then white add the earring and the highlights to the woman's face. Using the same two colours model the man's face. With the dark green, add depth to the hair and then redefine it with reddish brown. Add the highlights with a mixture of pale lilac and cream. Accentuate the creases of the shirt with a layer of white, leaving the base colours to show through to form the shadows.

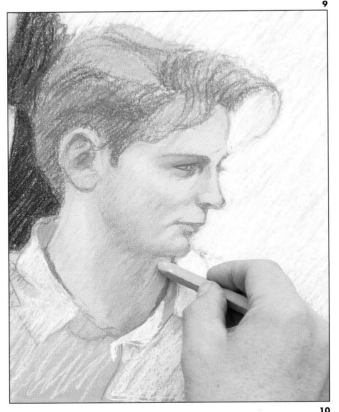

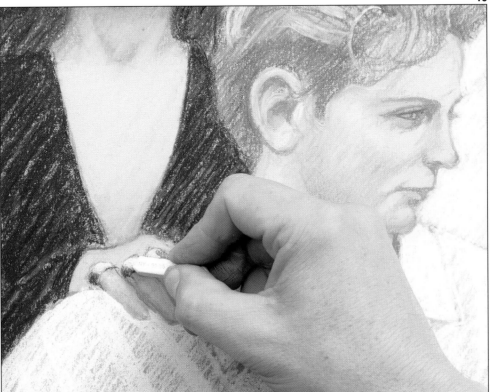

**10** Moving on to the woman's hands, outline the fingers in the medium flesh tone. Change to the white and go back over the shirt, giving it a final tidying up. Work up the man's ear with the pale flesh tone, switching to white for the highlights. Smudge the ear gently with your fingertip to soften it and tighten up its outline with the reddish brown.

Outline the girl's hand with the medium flesh tone and highlight with the pale flesh tone, running the reddish brown between the fingers. Moving on to the rings, fill them in with dark green and define the outlines in reddish brown before going over them in white to show the reflective nature of the metal.

**11** Now it is just a matter of stepping back to take an overall view of the composition to see whether or not any final finishing touches are required. This will differ from person to person but in this case it was obvious that the highlights needed to be emphasized with more white.

Having completed the gruelling task of keeping still for so long the moment arrived for us to see the final piece. We felt that it was very flattering, but the artist was keen to point out that it was only his interpretation and that another artist's finished piece could be completely different. Of course, this applies to every drawing that you do. On the practical side, the artist's final word is to refrain from fixing the image all over at the end as this will change the tones and the white areas will disappear. Either fix near to the end and then re-establish the highlights or just fix the dark colours. When you come to store this portrait, therefore, you will need to protect it carefully with tissue or tracing paper and pack it flat and preferably in a place where it will not be moved around.

**11**

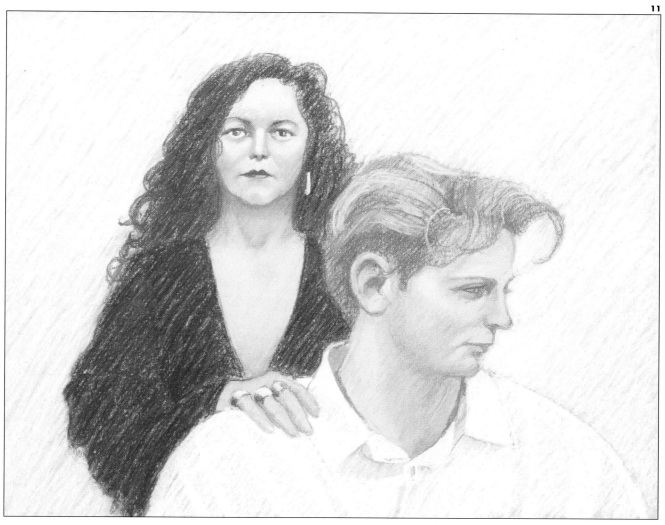

# Potted Primroses

## OIL PASTEL

Oil pastels are an ideal sketching medium. They offer a bold, exciting and immediate way of tackling a subject, and many artists use them to make preliminary colour sketches for this reason. Even in a finished drawing it is important to maintain their sketchy quality and not to overwork. A feeling of freshness, sometimes even an incomplete look, suits oil pastels best. These characteristics have been drawn into this picture of three potted primroses.

The picture is on a much bigger scale than real-life – a deliberate ploy by the artist. It was felt that a small subject, blown up, could produce enlarged sketchy textural qualities of the type which can be seen here. The veins and ridges of the foliage, for instance, are indicated by loose directional strokes. To have worked on a conventionally small scale would have denied the pastels their full potential. Oil pastels are not suited to tight, dense work which requires graded colour or detail.

To maintain the spontaneity and immediacy, the artist decided not to make a preliminary sketch. Instead, the aim was to start with one bloom, working outwards from this in a dynamic, organic way.

**1** Working on stiff off-white card measuring 22 in×30 in (56 cm×76 cm), the artist starts with just one of the blooms. In this case there is no preliminary drawing. The petals of the centre bloom are blocked in with light and dark red, and the centres of the flowers with yellow.

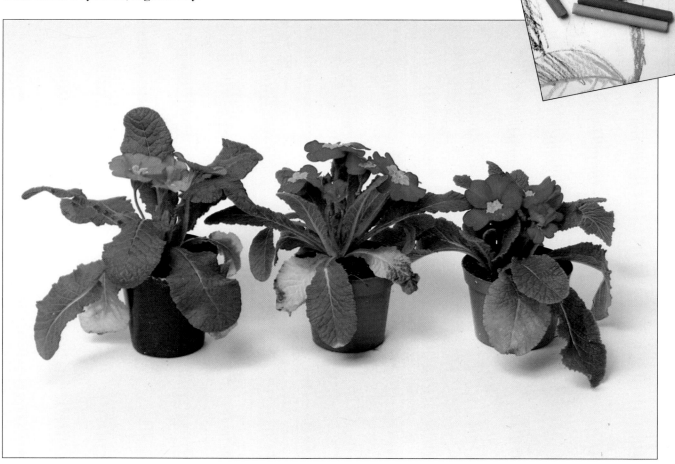

**2** The artist works down the same plant, blocking in the leaves and picking out the tones in three different greens. Because the pastels are chunky and not suited to line, this blocking-in is done with loose strokes, close together, to obtain fairly solid areas of colour. The deep shadows visible between the flower-heads are established in black and blue. There is no point in trying to achieve a subtle graduation of tone or colour with this medium. The purpose of oil pastels is to establish an immediate lively image and these are the characteristics which you must look for in the subject. The pastels, however, are easier to control if you do not use them too thickly in the initial stages.

**3** The artist is still on the first plant, blocking in scribbly areas of tone as they are picked out in the actual leaves. In this picture the artist is taking one colour lightly over the edge of another. Because oil pastels do not blend easily, this over-laying of colour is the only way of avoiding a harsh effect. Highlights and pale colours are dictated by the amount of white paper which is allowed to show through between the strokes. In this illustration the light side of the plant is lightly rendered with pale green, allowing plenty of white paper tone to remain. The flower pot is drawn in its local colour, a reddish brown, with strong black shadows thrown by the overhanging leaves.

2

3

**4** The shadow underneath the pot is blocked in with yellow and brown. The first plant is now complete. The artist has aimed directly at representing the bright colours and shapes of the primrose – an unusually bold approach for such a delicate subject. It is sketchy and textural, and the scale is something like twice as large as life-size, enabling the artist to make the most of the textural pastel marks on the surface of the plant. Already the drawing is beginning to take on the brightness and sparkle which is such an advantage with oil pastels. The artist knows when to stop. If too much detail and finishing was added in oil pastels, the picture would start to lose its spontaneity.

4

**5** The artist now moves on to the next bloom, blocking in the petals in exactly the same way. In this illustration the pastel stick is being pressed quite heavily on to the paper to achieve a fairly solid mark. Notice how the direction of the strokes is being exploited to describe the organic structure of the plant. The foliage has been sketched in lightly with pale and dark greens. One way in which the artist has varied the somewhat inflexible marks of the pastel is to leave the foliage in a fairly loose linear state, contrasting this with the more solid wedges of colour on the petals.

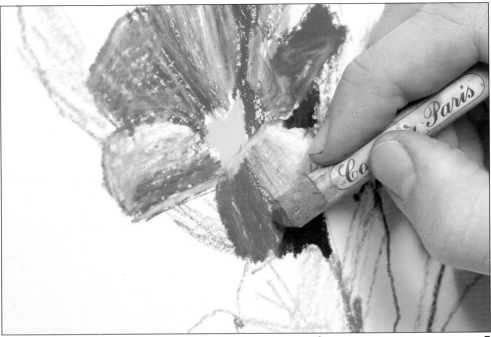

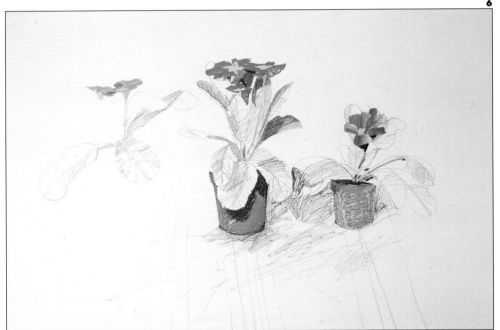

**7** The artist now turns to the flower pots, seeking to add texture and tone to some of the solid colours. Here a scalpel blade is being used to scratch back the reddish brown and reveal the bright yellow underneath. This textural highlight brings a degree of contrast to the composition, again helping to avoid a uniform row of similar pots which would look dull. The somewhat symmetrical nature of the subject in real-life has been deliberately offset in order to create a more varied and visually interesting image.

**6** Two of the plants are now complete, and the artist has made a start on the third, indicating the blooms in approximate shades of pink, purple and yellow, and sketching in the position of some of the leaves. By making the leaves on this third plant light and feathery, the artist is establishing a subtle difference between the various blooms, thus a rank-like picture of three identical pots, with the same density of colour, has been avoided.

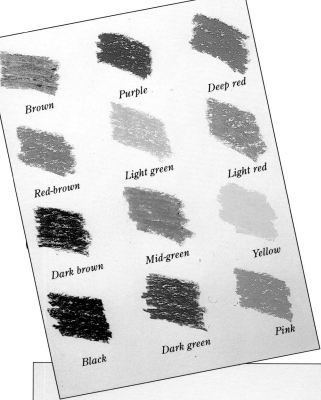

Brown

Purple

Deep red

Red-brown

Light green

Light red

Dark brown

Mid-green

Yellow

Black

Dark green

Pink

**8** The artist knows that you can only work with bold strokes if you are using oil pastels. Blending is difficult and subtleties are not possible. An obvious subject for this medium would have something like a large-scale landscape, with sweeping hills, or a wide seascape. These subjects are frequently chosen by oil pastelists because of their wide expanses of bold colour.

For this project, however, it was necessary to demonstrate how the textures and sketchy hatching of oil pastels can be used in place of literal detail. Therefore, instead of taking a big subject and condensing it, the artist chose to work on a small object and blow it up to larger-than-life proportions. In this way, the real nature of the medium could be fully explored. One pot of primroses would have sufficed

for this. But the artist also sought to demonstrate that the textural nature of oil pastels can be used to achieve variety. This contrast of treatment can be exploited even within one image, to make an interesting picture. Thus three pots were placed in a uniform row, and the challenge was placed before the artist to produce lively variety in the composition.

The artist has avoided having three completely separate objects with no visual compositional link by using the shadows and extending these in lightly scribbled black shapes. The shadows are sketched behind and between the pots, inter-relating with the foliage and establishing a sense of continuity.

**8**

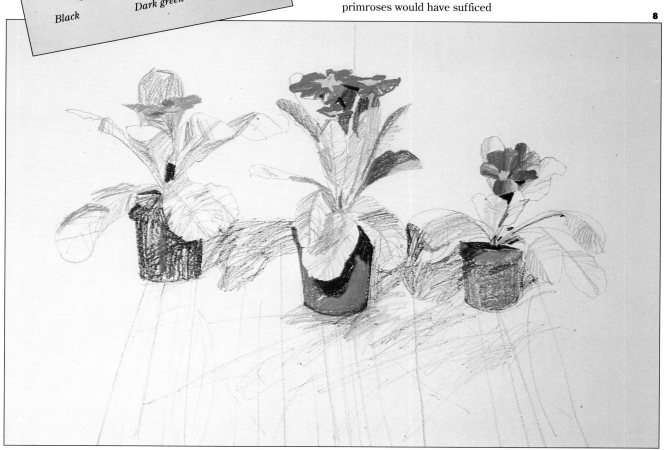

# Still-life with Vegetables

## PASTEL PENCIL

The fact that with pastel pencils you can switch easily from solid areas of colour to line has been exploited to the full in this picture of a group of vegetables on a kitchen table. The objects themselves were chosen with this in mind. Although the artist has used solid blocks of colour here, the picture is essentially a drawing. It is the line which holds the image together. The solid colour is used to substantiate what the lines have already suggested.

The size of the drawing is important. The advice from the artist was 'Work on a large scale so that you can make full use of the pastel pencils'. Even if your inclination is to work on a small scale, you should still aim at enlarging the actual objects you draw, when using these materials. It is a very common mistake with beginners to work too tightly; lack of confidence makes them fill in the colours meticulously, over-blending and overworking. Notice how the artist here has worked larger than life and is not inhibited from allowing the scribbled texture and loose pencil strokes to remain. If you wish to return eventually to small-scale pictures, what you have learned by this freer approach will be of enormous benefit.

The quality support, Canson pastel paper, was chosen here because it would stand up to the heavier treatment of pastel pencils. Its warm, neutral colour provides a basis for the wood-coloured tones of the kitchen table. The mellow tint also enhances the bright colours of the vegetable arrangement – thus the paper tone quickly becomes integrated into the composition.

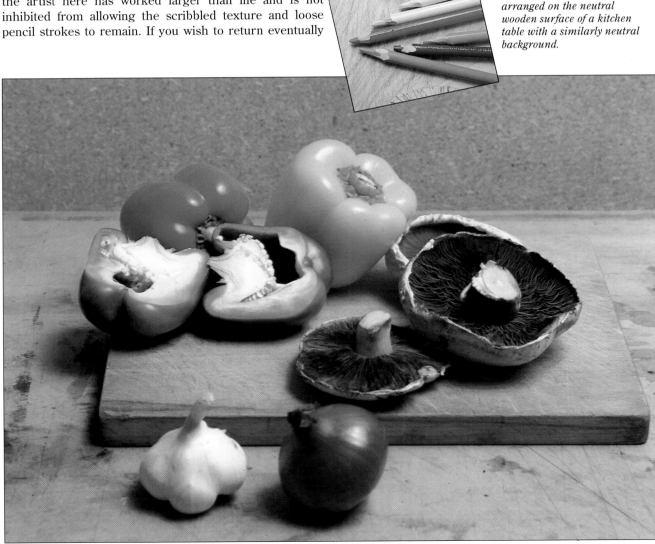

*Before starting work the artist selects all the colours which are likely to be used in the drawing. The subject itself is a colourful selection of vegetables, with different types of surfaces, arranged on the neutral wooden surface of a kitchen table with a similarly neutral background.*

**1** A neutral warm beige paper is chosen – one which reflects the tones of the table and the background wall. The support, measuring 22 in×38 in (56 cm×71 cm), is good-quality pastel paper which will take the heavy pressure sometimes applied to the pastel pencils. These are harder and less crumbly than pastel sticks. The artist uses olive green to make an initial

drawing, placing the subject centrally on the support, occupying most of the space in the composition. The sketch is made lightly, the artist feeling around the objects, correcting a shape by re-drawing it. If the drawing is incorrect at this stage, no amount of rendering will put it right later. The errors will simply be magnified.

**2** The artist starts to block in the drawing, carefully picking out planes of local colour, light and shade, and drawing these as simplified blocks of solid hue. Because it is fairly easy to control this material, blending the colours with your fingers or an eraser is not absolutely necessary. Generally, you can merge two colours together by gently grading the overlapping strokes, as the artist has done

here, where the dark green shadow fades gradually into the lighter, local colour – where the artist has pressed lighter with the strokes farther apart to allow more of the underlying colour to show through. Here, the artist fills in the cut cross-section of the green pepper, using even white cross-hatching to create a flat colour.

**1**

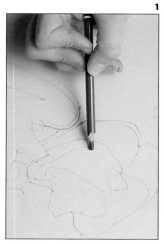

**2**

**3** The artist is drawing the deep orange shadow into the forms of the yellow pepper. In this case, the colour is being applied densely to an equally dense undercolour. The strokes are applied closely but the artist makes a smooth blended transition from the orange to the lighter yellow by gradually decreasing the pressure on the pencil. The neighbouring highlights have been applied in a similar way, and the artist has gradually allowed the very pale yellow to taper off into the local colour to create a reflection on the shiny surface of the vegetable. At this stage of the work, the artist applies a light spray of fixative to preserve the colours and tones of the drawing so far.

**3**

**4** One of the great advantages of pastel pencils is that they can be used just as well for line drawing as for blocking in areas of tone and colour. Here the artist seeks to combine these qualities in the same picture by treating the underside of the mushrooms in a linear way. The gills beneath the mushrooms are drawn in loose lines with black pastel pencil.

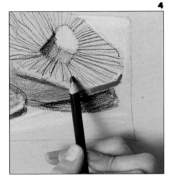

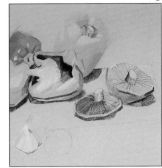

**5** Without blending or smudging the colours, the artist has conveyed a variety of surface textures by using the pencils in different ways. The shiny peppers are rendered, with medium, dark and light tones being gradually merged to produce their hard reflective nature. The pithy core of the cut pepper is conveyed by flat matt white.

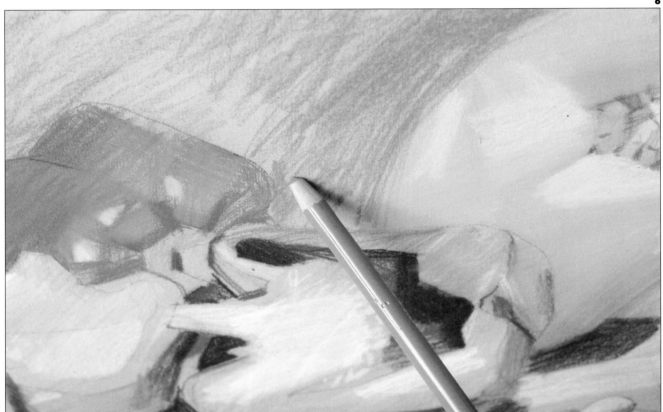

**6** A cool grey has been used for the background. Strong directional strokes are applied to block in the shadow thrown onto the wall behind the vegetables. It is this shadow which defines the space between the subject and the background. The artist avoids a solid area of tone which would compete with the subject, and allows patches of the beige paper tone to show through.

**7** Because they are soft, pastels and pastel pencils tend to blur and lose their crispness as work progresses. The artist has given the work the occasional spray of fixative to help alleviate this problem, yet for this final stage it is still necessary to go back over the image, re-defining the lights and darks to bring the subject back into sharp focus. First, the shadows are darkened, deepening the recesses and increasing the feeling of space and three-dimensional form. Then it becomes necessary to go round and bring up the light areas, the highlights and reflections on the objects. This lifts them to the same point of sharpness as the shadows. In this illustration the artist is re-establishing the white highlight on the shiny yellow pepper.

Alizarin

Light mid-green

Pale yellow

Red

Light green

Dark orange

Grey

Emerald green

Light orange

Black

Brown

Yellow

**8** Two more vegetables have been added to complete the finished composition. A Spanish onion and a garlic bulb have been placed in the foreground, looking as if they have been scattered slightly away from the main group, and this draws the composition forward to prevent it from becoming simply a single mass of objects. The two additions create space on the paper.

Although the artist has blended the colours during the various stages, in order to create form, the texture of the pencil strokes is still an important aspect of this picture. The objects are naturally rounded and could easily become too spongy and amorphous, with each one looking too much like the others. This has been avoided here by the strokes of the drawing. The artist has paid careful attention to the direction of the marks, so that they become emphatically separated into visible planes, both of texture and of light and shade. In the case of homogenous forms such as the onion and red pepper, which possess very little variety of tone within themselves, the artist has used the direction of the pencil strokes to separate the planes.

As an essential finishing touch, the picture is given a final spray of fixative.

**8**

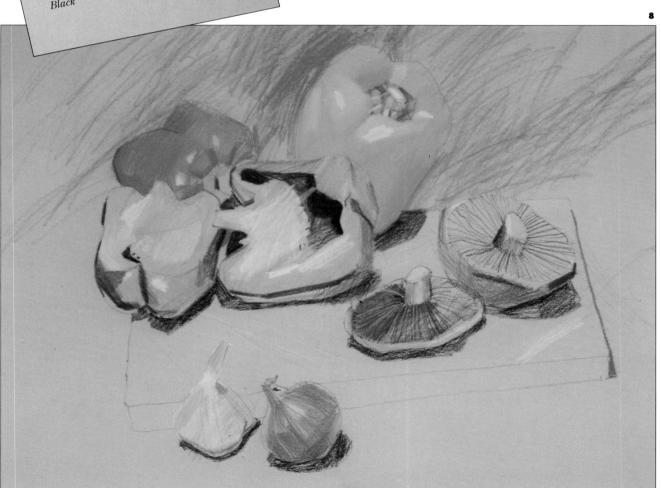

# Chapter 7
# Pencil and Graphite

The most common of all drawing instruments, the graphite pencil, is by no means the easiest to use. Compared with many other drawing tools, its lines can get small and fussy. They invite detail, and all too often this leads the beginner into a trap – for it is best not to pay too much attention to detail at first; far better to aim initially for the bold strokes and outlines, or areas of tone, which make up the main characteristics of a composition.

When it is mastered, however, the pencil is a versatile drawing tool with which you can create beautiful and finished pictures as well as make rough outline sketches. Although not as bold and chunky as some other materials, it has a varied range, allowing for broad, heavy and light strokes, fine lines and subtleties of shading.

A crystalline form of carbon, real graphite has historic links with the English Lake District, where it was extensively mined and from where it was widely exported. It is found in many parts of the world, including North Carolina, Mexico, Sri Lanka and eastern Siberia. It is also manufactured artificially, both in iron furnaces and by electrical methods. The graphite available on today's markets comes in pencil, stick and powder form.

The term 'lead pencil' gives the wrong impression. Early deposits found in England were originally thought to be lead. The first graphite pencil was made in 1662, and the design of the pencil has not changed greatly over the centuries. Early ones were rods of graphite (ground graphite mixed with gum or resin) pressed into a grooved piece of wood, rather like the modern pencil, or held in a metal holder very similar to today's clutch or propelling pencils.

The Latin 'pencillus' referred to brushes, used with ink in the Middle Ages, rather than to the pencil as we now know it. A more closely related ancestor was silverpoint, a narrow rod made from lead and tin. In the hands of such artists as Leonardo da Vinci (1452–1519) and Albrecht Dürer (1471–1528), silverpoint was made to produce beautiful pictures – fine lines, varied to create an immense range of tones. Silverpoint has its drawbacks. It needed a special ground which was time-consuming to make.

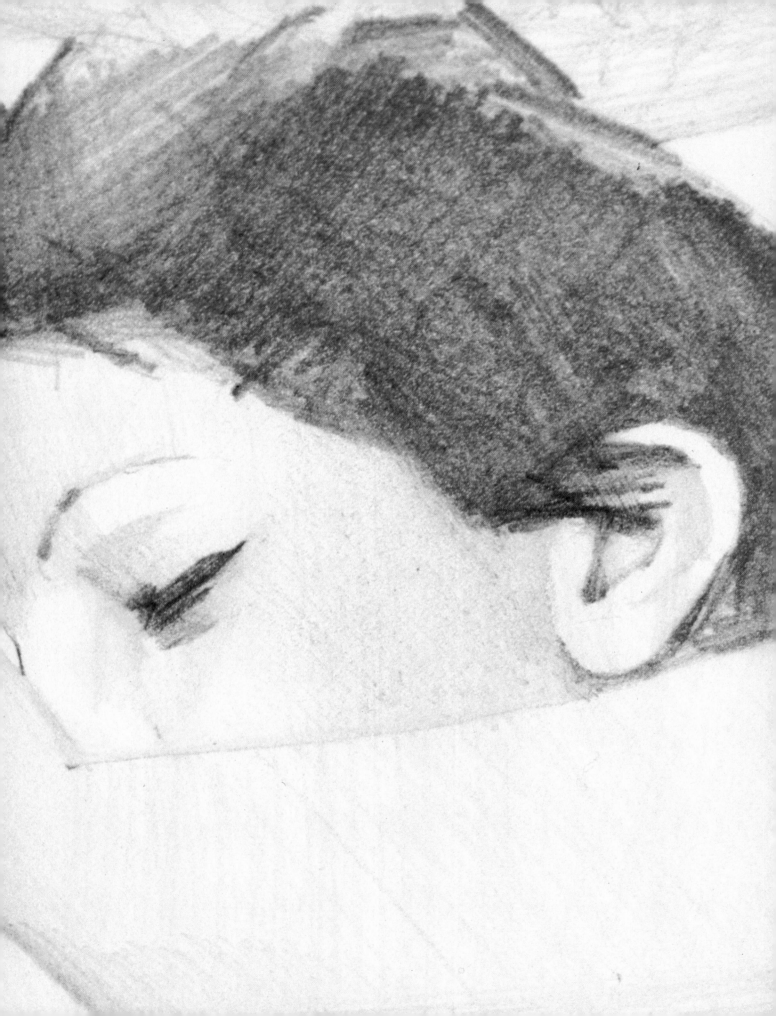

# Materials

## PENCIL AND GRAPHITE

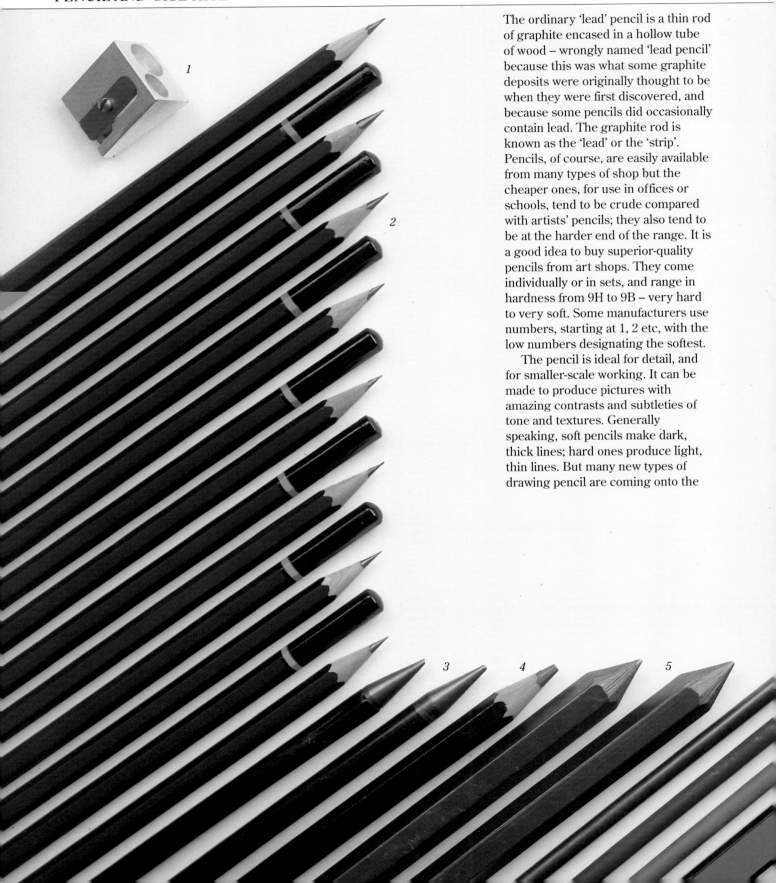

The ordinary 'lead' pencil is a thin rod of graphite encased in a hollow tube of wood – wrongly named 'lead pencil' because this was what some graphite deposits were originally thought to be when they were first discovered, and because some pencils did occasionally contain lead. The graphite rod is known as the 'lead' or the 'strip'. Pencils, of course, are easily available from many types of shop but the cheaper ones, for use in offices or schools, tend to be crude compared with artists' pencils; they also tend to be at the harder end of the range. It is a good idea to buy superior-quality pencils from art shops. They come individually or in sets, and range in hardness from 9H to 9B – very hard to very soft. Some manufacturers use numbers, starting at 1, 2 etc, with the low numbers designating the softest.

The pencil is ideal for detail, and for smaller-scale working. It can be made to produce pictures with amazing contrasts and subtleties of tone and textures. Generally speaking, soft pencils make dark, thick lines; hard ones produce light, thin lines. But many new types of drawing pencil are coming onto the

market. Some of these are extra soft, with softer, thicker strips than any in the standard range, and these can be used for large-scale work. 'Studio' pencils are also specialist tools – rectangular in shape, with a rectangular strip – and again, these are good for bigger-scale drawings, allowing you to vary the thickness of the line by turning the pencil. Traditional carpenters' pencils were made to a similar design.

## Clutch Pencils

Most ordinary pencils can be sharpened with a pencil sharpener, either manual or electric, as well as with a craft knife or other type of blade. But the flat studio pencils must be sharpened with a blade or knife. Instead of sharpening your pencils, you can obtain clutch pencils or propelling pencils – which hold the rods of graphite in place so that they

can be extended as necessary. These rods, too, come in a full range, from soft to hard, like the wood-covered normal versions.

A wide variety of papers can be used for drawing with pencils. Smooth boards and cards, cartridge, watercolour papers, tinted paper – all these are suitable. The paper's texture dictates the effects and type of line. Generally, hard pencils do not take very well on smooth surfaces, and very soft pencils can be difficult to control on extremely coarse papers.

For lasting results, a finished pencil drawing should be fixed – and for soft pencils this is essential.

## Graphite Sticks

For spontaneous and less detailed work, graphite can be obtained in chunky sticks. These are especially recommended when operating on a very bold, large scale. They allow you

to achieve various degrees of softness and thickness, coming in soft-to-hard ranges like ordinary pencils and also in varying thickness. The lines can be altered by using the point, the side of the pointed end, or the flattened length of the stick.

## Graphite Powder

For special effects such as softly graded tones, graphite is available in the form of fine powder. This is obtainable in some art shops and is used to produce varied areas of tone in a drawing. Rub the powder on with your finger or with a cloth, and use the smudged areas in conjunction with line. An eraser can be used to remove parts of the powder and create white zones in the dark patches. Graphite powder needs practice. It can be slippery, and must be fixed.

1 *Pencil sharpener*
2 *Graphite pencils*
3 *Graphite sticks (hard)*
4 *Extra soft drawing pencil*
5 *Graphite sticks (soft)*
6 *Refill strips*
7 *Studio pencils*
8 *Eraser*
9 *Graphite powder*

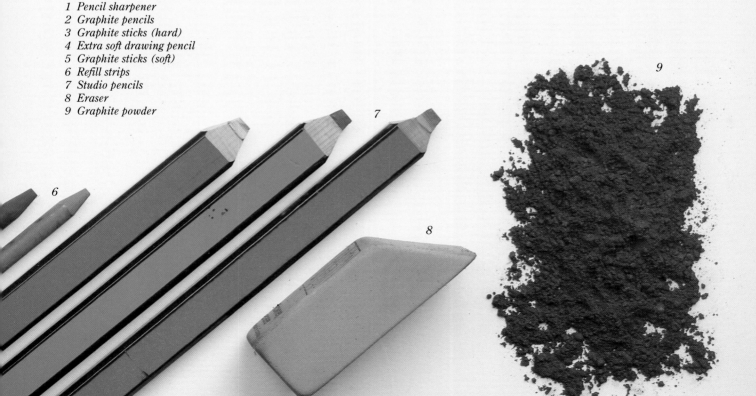

# *Techniques*

PENCIL AND GRAPHITE

## Hard Line

Hard pencils produce a paler, thinner line than the softer grades, and are generally less popular with artists than soft pencils. But the thin light line is sometimes useful for an initial drawing which is required to be inconspicuous and not to smudge. So choose a hard pencil when you specifically require a lighter tone – you will get a cleaner line than trying to use a soft pencil lightly. Avoid the mistake of so many artists who tend to stick to one pencil, varying the pressure to change the line. There is a full range of pencils to choose from, so use them! Here the artist cross-hatches with a 2H pencil *(1)* to create an area of crisp, light grey tone *(2)*.

## Soft Line

Dark soft lines characterize the graphite pencils at the soft end of the range. The cross-hatched lines below are drawn with a 3B pencil. Without pressing too hard, the artist is able to make a fairly concise line by using a freshly sharpened pencil *(1)*. Yet, at the same time, the finished sample has a dark, mellow quality *(2)*. The slightly rough cartridge paper contributes to the soft look, and close observation shows that the pencil lines are broken, with flecks of white showing through.

1

1

2

2

## Hard Scribble

The marks you can make with a hard pencil are limited to light grey, whether you are working in line, tone or texture. Make the most of this limitation; when you want to quickly block in a large area of pale texture and tone choose one of the H pencils. There is a considerable difference between an H and a 7H pencil, so experiment and explore the possibilities of the whole range. In the illustrations below, the artist is working with a 4H pencil, using loose scribble on white cartridge paper *(1)*. The result *(2)* is a loose and natural texture which the artist frequently employs to break up flat expanses of background in figure and still-life drawing.

## Soft Scribble

The B pencils, the soft ones, offer a range of deeper tones. Here scribbled texture takes on a more velvety appearance than that created by their harder counterparts. A 4B pencil is being used *(1)* to cover an expanse of white paper with wide, regular scribbles *(2)*. The soft, curved strokes are an ideal technique when dealing with sweeping landscapes, where areas of sky, water, hills and fields require a broad, expansive treatment.

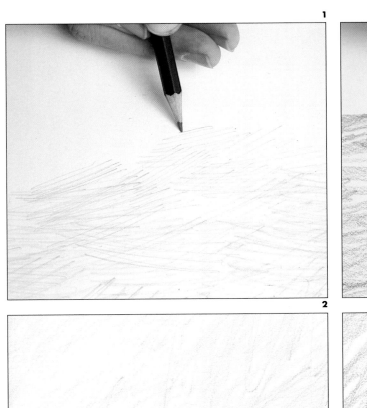

1

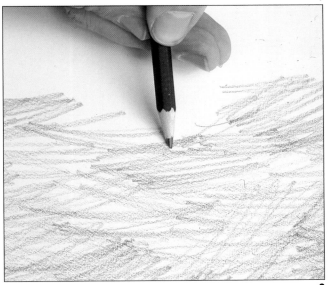

1

2

2

# PENCIL AND GRAPHITE

## Studio Pencil

A newcomer to the pencil family, these chunky studio pencils have flattened strips. The advantage here is that, by turning the pencil round, you can alter the width of your line. Here *(1)*, the artist uses the broad edge of the graphite to block in a flecked texture of broad marks.

## Graphite Stick

Graphite sticks allow you to make bold lines and to block in solid areas. Try the various types – hard and soft; thick and thin – practising their various effects. For example, in the illustration here *(2)* the artist uses the flattened edge of the point to lay an area of light tone on rough paper.

## Blending

You can rub pencil lines to soften their effect. The softer the pencil, of course, the more effective this type of blending will be. Rubbing hard pencil lines will produce a slightly out of focus effect *(1)*; with soft pencil marks, the result can look very smudgy and dark *(2)*. Most artists restrict such blending to selected areas of a drawing – using it to contrast with the linear character of most pencil drawing or to knock back a tone or texture which has become too strong. Carry out your own experiments, fixing the final effects so that your work does not become more blended than you intended!

**Studio Pencil** 1

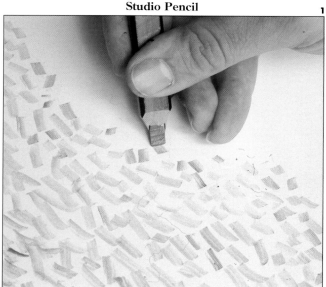

**Blending Hard Pencil** 1

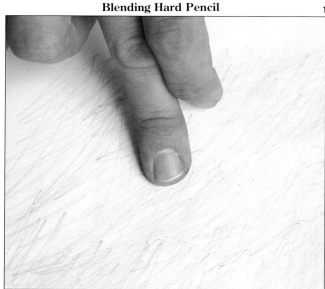

**Graphite Stick** 2

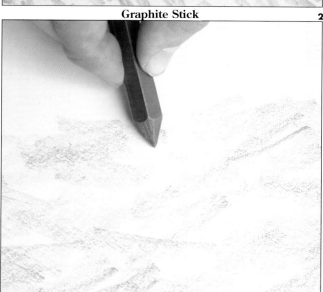

**Blending Soft Pencil** 2

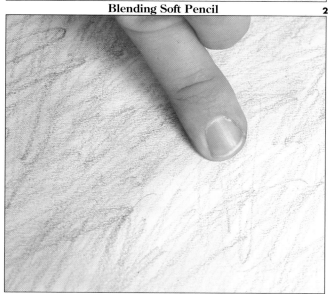

## Graphite Powder

Graphite powder is slippery and smudges easily, so don't expect to get immaculate results first time. Here you must be extremely patient and be prepared to leave some of your drawing to chance! Once again, practice is the key to successful use, and even when you are well acquainted with the material it does not lend itself to fine detail or precision work. Use the powder in conjunction with graphite and graphite pencil, as the artist does in the demonstration on page 220. Or, if you are after a more subtle, amorphous effect, work with graphite powder alone. Start by placing a little of the powder in the area to be toned – here *(1)* the artist tips the graphite from the jar.

If you only require a small amount, take a pinch between the fingers. Rub the graphite on to the support using your fingers *(2)* or tissue *(3)*. Any loose excess powder can be put back in the jar and re-used. The grey-toned areas can be removed easily with a kneadable eraser *(4)*. This is useful if you want to create light areas within the darker ones, or if you have simply made a mistake and used too much powder. Remember to fix this fragile medium immediately you have finished work.

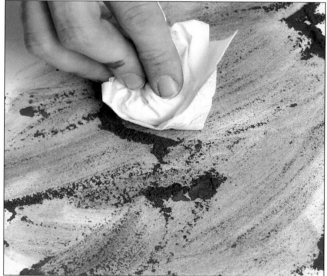

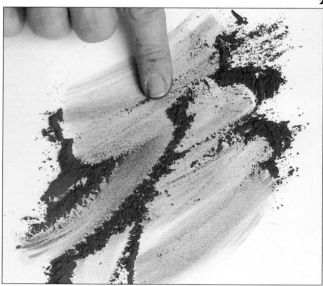

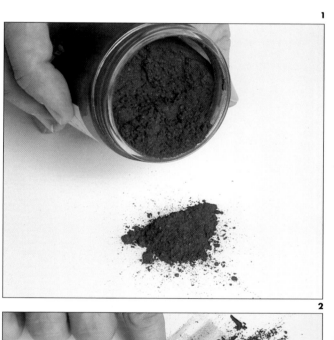

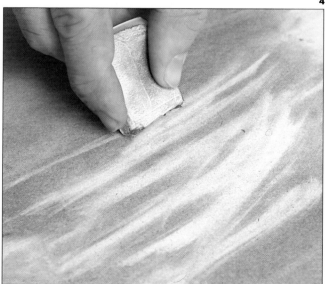

# *Gorilla*

## GRAPHITE POWDER

The artist visited a zoo to study the gorilla in this picture. Naturally, the basic problem was that the animal would not keep still. The artist is therefore presented with the problem of depicting an animal in a state of 'captured movement', in as short a time as possible before the constant continuous movements produce too much confusion. Graphite powder is one answer. It can be smudged onto the paper at high speed, and is fairly easy to manipulate afterwards.

The technique of drawing 'from the inside' was also employed here. It is a fallacy to imagine that drawing must always start with an outline – or even include line. A familiar exercise in many art schools is that of making a drawing without using line of any description. This develops the skill of building a picture from the internal forms and shadows, working outwards towards the edge of the subject. In the illustration here, the use of this technique means that the graphite powder is smudged rapidly onto the paper to block in the areas of shadow that are present within the form of the animal. But the artist has taken care to notice the structure of the creature, paying attention to the fact that shadows and highlights are determined by the bones and muscles lying under the skin. Some patient observation of the animal and how it moves is essential before committing any marks to the paper.

It is important to think about how the animal will fit on to the support – taking careful note of the scale and proportions to visualize where those first marks should be made on the paper.

*The problem is to capture the movement of the gorilla as quickly as possible, in order to produce a lively picture. To do this, the artist has to work rapidly, immediately blocking in the main volumes of the animal, so that they can be developed later. The artist must get down an instant impression right at the start.*

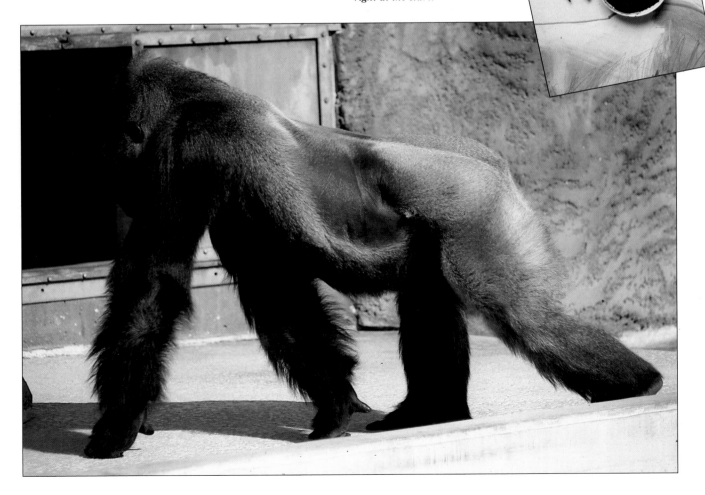

**1** The artist is going to work from the 'inside out' – starting with the shadows and tones rather than the outline, and working outwards from there. A small amount of graphite powder is taken up into the fingers and smudged onto a sheet of smooth white drawing card measuring 20 in×28 in (51 cm×71 cm). In this picture a tissue is being used to create the swirling shapes of the moving animal's body and limbs. You could do the smudging with your fingers but a tissue is cleaner and enables you to spread broader marks. Any excess powder can be blown off the surface, or you can tilt the paper and tap the powder off carefully so that it can be used again.

**2** Using a 2B graphite stick, the artist sketches in the rugged, furry outline of the gorilla. The graphite stick produces a bold line, and the artist builds up the outline in feathery strokes, making small jagged movements. The objective is to avoid having a hard, sharp and unnatural outline which is not suited to the soft furry contour of the animal.

**3** Already the soft graphite has helped the artist to produce a convincing portrayal of movement, as the gorilla walks across the composition. The gorilla is represented purely as an animal study without background. A hard outline would have tended to flatten the image, losing the sense of flow and rhythm so essential to this picture. In smudging on the graphite powder, the artist has picked out the broad shadow areas visible, creating a sense of form without being committed to sharply defined contours. These regions of light and dark are only approximate at this stage; they will eventually be worked into and developed to create a more specific form.

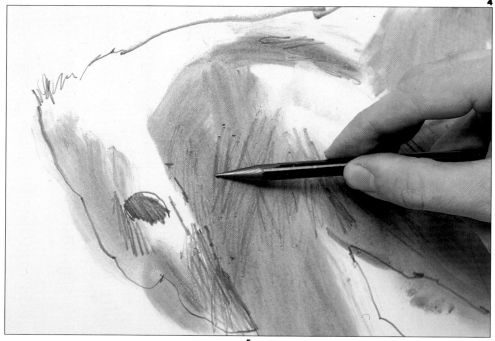

**4** The artist changes to a stick of harder graphite, Grade H, and scribbles lightly over the shadows made by the previous smudging. The fur texture is built up in this way, while the artist constantly refers to the subject in order to pick out the particularly deep tones, leaving other areas untouched.

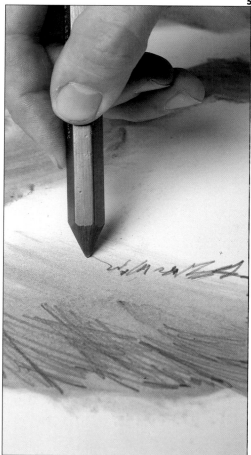

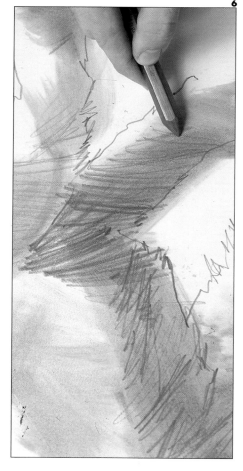

**5** Changing back to the original, softer stick, the artist continues to develop the fur textures. The softer stick gives a slightly broader, softer line for this stage of the work, offering some linear variety. In this illustration the artist is using a jagged irregular line to suggest the tufted contours of the inside of the limb.

**6** The artist moves across the animal in the same way, continuing with the brushing, to-and-fro movement, drawing freely from the wrist. This develops the overall fur texture. It is important to avoid texture which is too even. If you look at animals, you will see that their fur varies in places. Some is even and smooth, and some parts are more tufted and ruffled. Even though it is often difficult to get an exact impression when looking at an animal, your representation will be unrealistic if you produce too smooth and uniform a look.

**7** One of the advantages of graphite powder is that a broadly defined shape can be drawn onto the paper without worrying about areas of light. You are not committed to an irreversible dark tone. In this picture, the artist is using a soft, kneadable eraser. The graphite powder is easy to remove, so the eraser should be able to rub areas of highlights completely clean, making them as light as the paper. Nothing is permanent and any surplus tone can be removed.

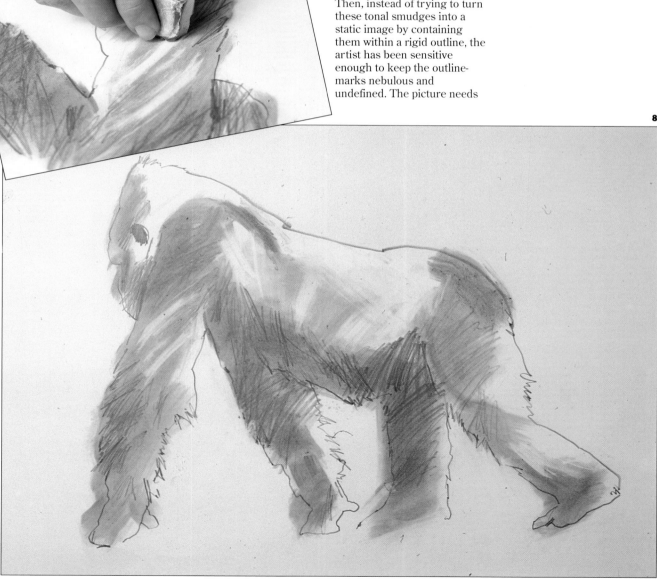

**8** Because of the fragile nature of the graphite powder, it is essential to fix the picture as soon as it is finished. The smudgy nature of the medium makes accidental smudges look all the worse!

The powder has enabled the artist to make a mark on the paper straight away – on a large scale – and to block in these large areas with any other drawing material would have taken time. When you are dealing with animals there is rarely any time available – they are constantly on the move. Then, instead of trying to turn these tonal smudges into a static image by containing them within a rigid outline, the artist has been sensitive enough to keep the outline-marks nebulous and undefined. The picture needs to be developed in the same spirit as the initial marks that established the shadows. In this case the artist achieves this soft definition by making a broken line of short, jerky marks to indicate rather than to define the contours of the animal.

# Self-portrait

## GRAPHITE PENCIL

Probably the most testing yet approachable type of portrait is the self-portrait. This is because the artist can concentrate on the characteristics (not only the obvious outer features but also the more subtle 'essence' which sums up a person) without having to cope with the 'separateness' of another person. In addition, for the beginner especially, the self-portrait uses the most perfect of models who will never get tired before you do!

The way you position yourself for a self-portrait is very important. You need your paper as upright as possible to avoid foreshortening and you also need a mirror at face height set up so that you can see yourself without having to get up. The size of the mirror is largely irrelevant, but you may find it helpful to use a small one which will concentrate your attention. For this project the artist included the mirror in his drawing to accentuate the 'self-portrait' aspect.

Select a pose which arrives naturally when you look from the paper to the mirror (in this case with the head slightly turned to one side). By doing this you will be able to switch from your reflection to your drawing with the minimum of effort.

For this self-portrait, various graphite pencils, some harder and some softer, are used. The result, however, is not a sketch but a finished drawing, concentrating on the modelling of the form without the complication of colour.

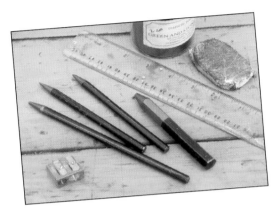

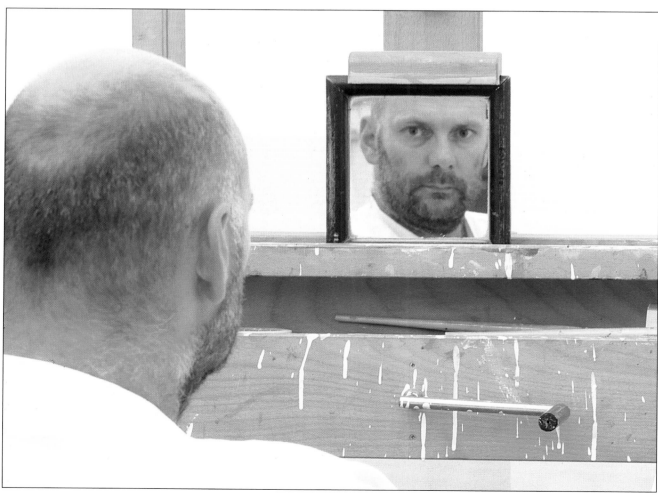

**1** Start roughly in the centre of a 30 in×22 in. (75 cm× 56 cm) sheet of drawing or watercolour paper by marking in one of your eyes with an HB graphite pencil or stick, switching to a softer 3B for creating areas of darkening tone. By starting in the centre of a large sheet of paper and with a central point on your face, you can work from this point, relating back to the eye. In this way, with constant reference back to your own reflection, you are more likely to get the proportions right.

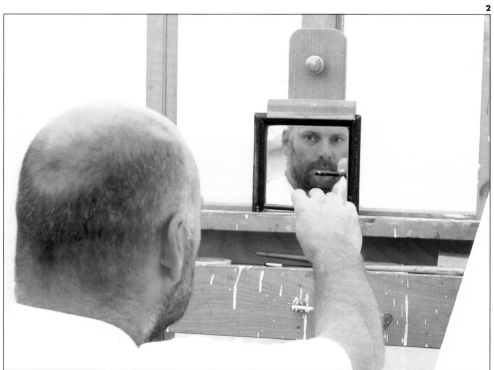

**2** With this type of work, it is helpful to use your pencil to measure the proportions as you go. If you hold your pencil at arm's length – or at a constant distance from the mirror if you are too close – you can measure crucial distances (such as the space between the eyes) with your thumb along the pencil. You then transfer this measurement to your drawing.

# GRAPHITE PENCIL/SELF-PORTRAIT

**3** It is important to pay special attention to your eyes as they hold so much of the character. Take your time, working with small strokes and gradually building up the area around them.

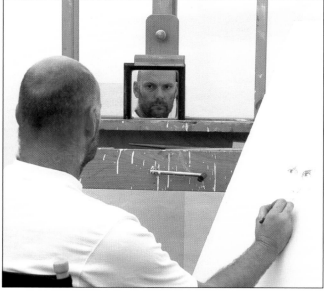

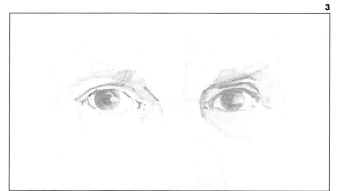

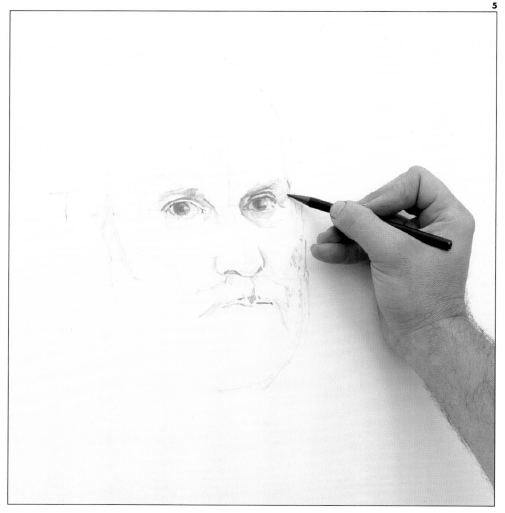

**4** From the eyes, the logical way to work is down the nose to start to define the length of the face. You can then begin to outline loosely the limits of the head. Feel free to use an eraser if you think that any of the marks are too strong or in slightly the wrong place. A putty rubber is generally the best type of eraser to use as it does a good job of lifting the graphite without damaging the surface of the paper.

**5** Once the whole form has been established you can start to work up small sections at a time using a combination of loose hatching and cross-hatching. Allow yourself to move around the drawing freely, switching from feature to feature, and so preventing the overworking of any given area. In addition, by building up the picture as a whole, it is far easier to see if there are any problems. If there are, it is far easier to correct them early on.

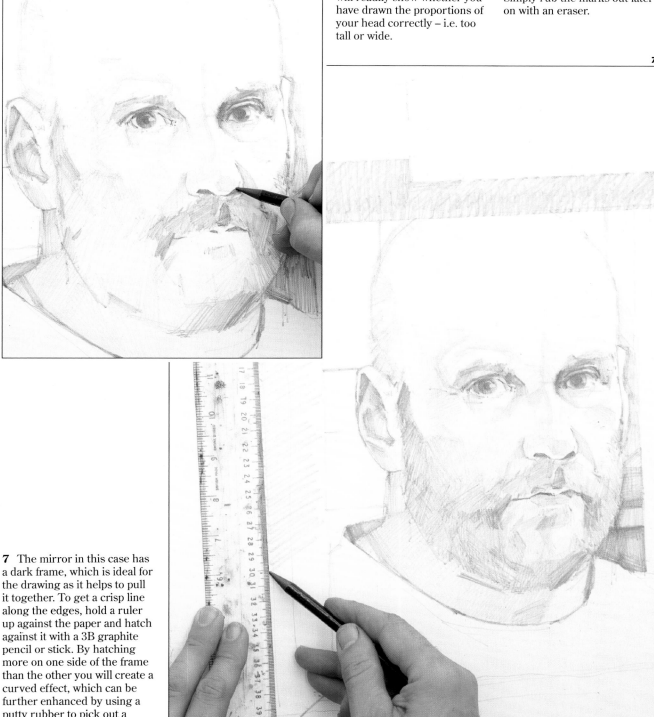

**6** If you are working with a small mirror which frames your head well, then it can be very useful to include the mirror in your drawing as it will readily show whether you have drawn the proportions of your head correctly – i.e. too tall or wide.

If you do not wish the mirror to appear in your drawing you can still lightly mark in its outline at this stage to check the proportions. Simply rub the marks out later on with an eraser.

**7** The mirror in this case has a dark frame, which is ideal for the drawing as it helps to pull it together. To get a crisp line along the edges, hold a ruler up against the paper and hatch against it with a 3B graphite pencil or stick. By hatching more on one side of the frame than the other you will create a curved effect, which can be further enhanced by using a putty rubber to pick out a highlight along its length.

**8** As you work it will become obvious which areas need to be darker or lighter. You can suggest large areas of fairly flat tone with a very loose hatching motion, almost laying the pencil flat on the paper to give a much softer mark.

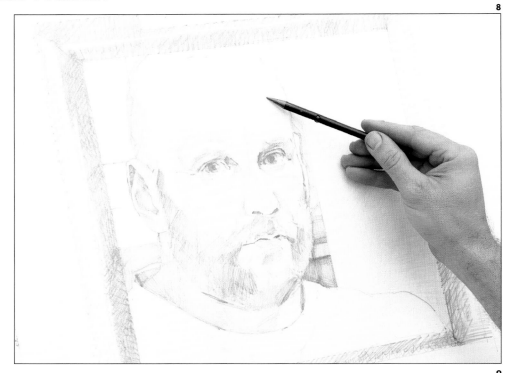

**9** Once you are happy with your drawing, put the highlights in place to finish it off. These are loosely suggested by dragging a putty rubber over the appropriate areas. As an alternative you could have left the white of the paper showing through to give crisp highlights, but this is much more time-consuming as you have to carefully work around them and, as this is a drawing in a mirror, crisp highlights would spoil the 'reflected image' effect.

**10** Finally, to further accentuate the fact that this is a drawing of a face in a mirror, rather than a framed drawing of a face, vague 'slivers' of light need to be added over the surface of the mirror. Again, this is simply done by gently dragging the putty rubber over the surface of the drawing in wide sweeps. Make sure you keep the pressure on the eraser light as you do not want to ruin your finished masterpiece!

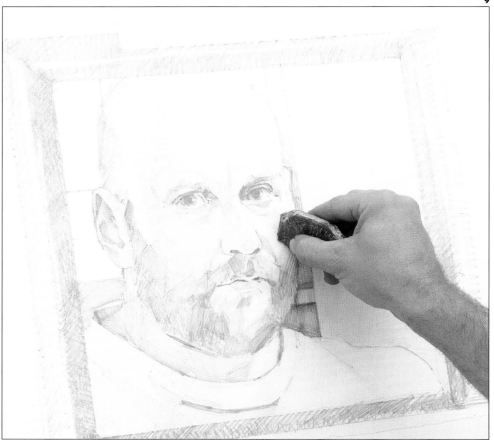

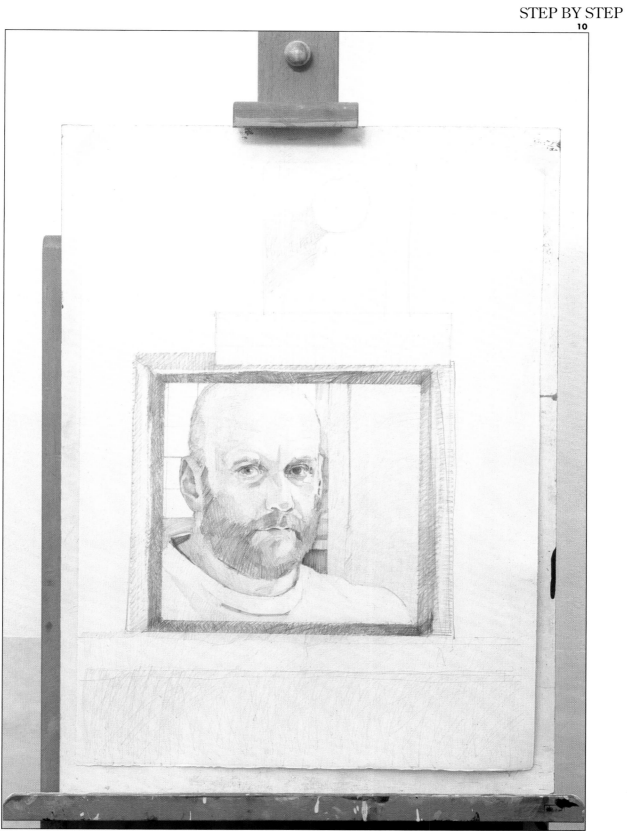

# New York's Central Park

GRAPHITE PENCIL

The reference for this project is a photograph the artist took while on a trip to New York. He went for a stroll in the famous Central Park and was struck by how beautiful it looked, especially with the blanket of snow covering the ground. Being the ever-ready artist he is, he had his camera at hand and was able to take a number of shots. The only thing that could have made the experience even better was for it to have actually been snowing as he was standing there – it was close to Christmas after all!

The artist selected this image because he knew that its stark, monochromatic beauty would translate perfectly to a drawing in graphite pencil. However, as you will see, he did not slavishly copy the scene but used it as the basis for a composition of his own. He decided to omit the fence, the path and all the other man-made elements of the picture, and to include large flakes of falling snow to create an image with a delicate, dreamy quality.

This is one advantage of working from a photograph. If the artist had sat down in the park and sketched the view, not only would he have been exceptionally cold (and probably mugged!), but it is likely he would have depicted the scene as it was. The photograph allowed him to 'step back' from the view and make calculated decisions about what he actually wanted to draw. There is absolutely

nothing wrong in altering the elements of a landscape if necessary in the interests of what you want your picture to say. If something looks very complicated or spoils the rest of the scene, then by all means leave it out. There are no rules; you can depict whatever you want. In fact some artists simply make up landscapes that they feel they would like to see. There is nothing wrong in this, art is meant to be for enjoyment, not to conform to someone else's standards.

For this picture a large range of graphite pencils and sticks is used to capture all the subtleties of tone as the trees gradually blend into the background haze as they get further away. A common mistake when starting out with graphite is to stick to just one or two pencils. As pencils are cheap there is no reason why you should not buy a complete range, which will give you far more scope for creating interesting textures and effects as well as enabling you to produce a more subtle range of tones.

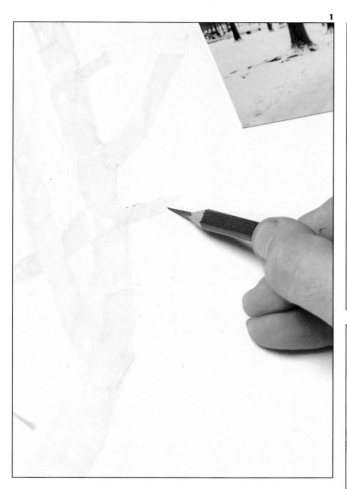

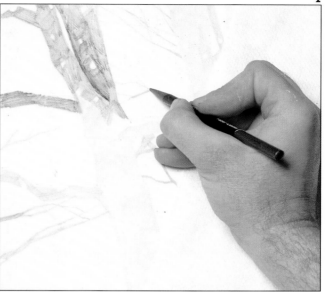

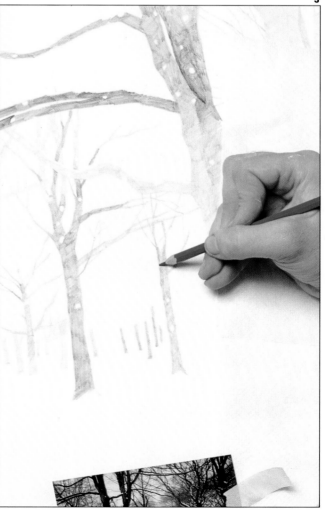

**1** On a large sheet of smooth, heavy cartridge paper lightly sketch in the outlines of the trees with an HB pencil. These lines are for your reference only, so keep them very faint. Then, using an F pencil, start on the large tree to the left, building up the form slowly with light cross-hatching. An F pencil is good for starting a drawing with because it does not deposit a large amount of lead onto the paper.

**2** Once you have marked in where these first few trees are with your light cross-hatching, go back over them with a graphite stick to darken down the tones, and then add in some of the smaller branches in the background. Note how the artist is resting his hand on a piece of kitchen tissue to prevent smudging the work he has already done.

**3** Now switch back to a graphite pencil, but this time a B, to continue the darkening of tones in this first area of the picture. Leave occasional white spaces in your work to indicate flakes of snow gently falling to the ground. You could alternatively indicate the snowflakes when the drawing is complete by using the corner of an eraser to rub out small areas; but by leaving the paper showing through from the start you will get much crisper spots of white.

**4** Continue working over this quarter of the picture, switching from graphite pencil to stick as you complete each progressive layer of cross-hatching, putting in more detail at each stage. You may think that this approach of building up the darker tones by going over them again and again is unnecessary, and that it would be far simpler to launch straight into them with a 6B pencil; for example, but you would be wrong. Not only does this considered approach allow you to adjust the tones slowly until they are perfect, it also results in a much richer variety of tones and textures, from areas that are cross-hatched only once up to the darkest areas that are worked on numerous times.

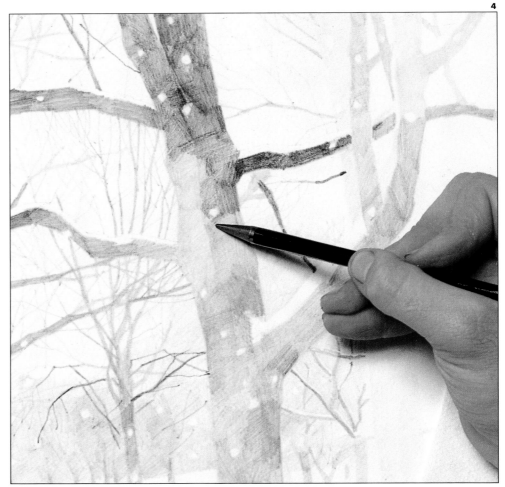

**5** By concentrating on one section of the picture at a time you will find it much easier to put in the amount of detail that is required to make this type of drawing work. If you try to work over too large an area at the beginning you may find yourself getting 'lost', and the finished picture will suffer as a result. Now that the first quarter of the drawing has most of the detailed areas mapped out, it is time to move on to the next section. Rather than diving straight in, first work along a couple of the long branches that create a natural bridge from one side of the picture to the other.

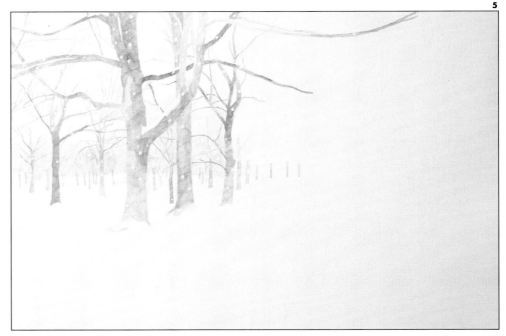

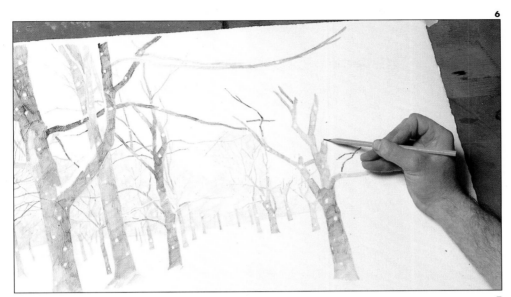

**6** Now you have to start the lengthy process of building up tone all over again for this second section, but at least you now have the first part of your drawing for reference, so you should be able to aim for the correct tones in fewer steps. If you have enough time and patience to build up the tones slowly and methodically, you will find this technique highly absorbing, and the results will justify all your hard work.

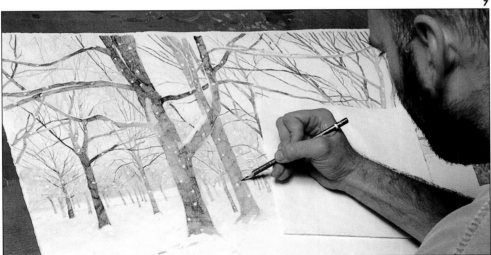

**7** Once all the trees and their branches are in place you can go back to add in all the finishing touches to the top half of the picture. In order to give the scene a convincing sense of depth, the tones should graduate from dark and strong in the foreground to pale and hazy in the distance. The tree trunks in the foreground should therefore be the darkest part of the drawing, so quickly cross-hatch these again with a B pencil, and then for the very darkest areas use a 6B.

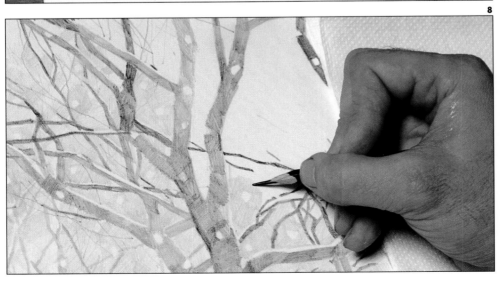

**8** To recreate the hazy blur of thousands of branches and twigs stretching off into the distance, use an HB pencil and lightly cross-hatch right across the area, filling in all the gaps between the trees. Make this cross-hatching solid along the horizon, and gently fade it out towards the top of the foreground trees. Remember to leave spaces for snowflakes as you are doing this – the drawing will look very odd with snow falling only in front of the tree trunks and solid branches!

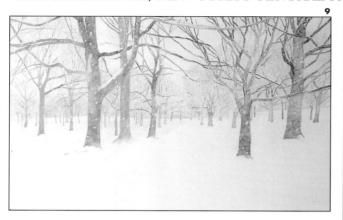

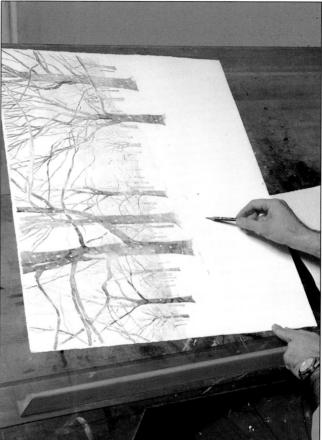

**9** You can now step back and take a critical look at your work, because you are almost finished. The lower half of the paper remains uncovered at this stage, but, as this is going to be fallen snow which is white anyway, only a hint of shading will be required.

**10** Using an HB pencil, lay down a light tone over the remaining white paper with some very loose cross-hatching. Place the paper at a slight angle so that your strokes can be long and relaxed.

**11** To finish the drawing off, rub out some loose patches all over the foreground cross-hatching which you have just laid, to soften the overall texture. If you look at even the most freshly fallen snow you will see that it does not sit as a pure white cover. Rather, where there are undulations in the ground, it catches the sun or falls into shadow, creating a range of subtle tones.

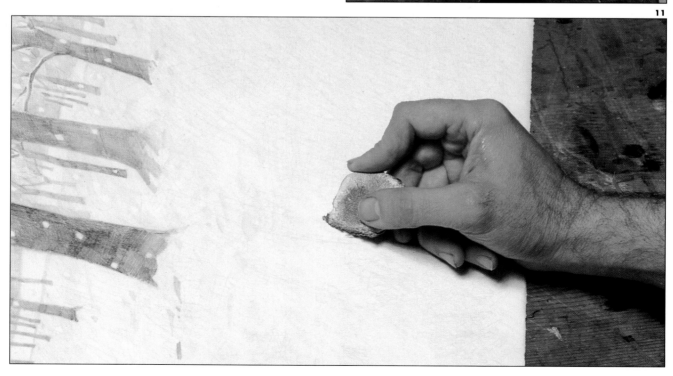

**12** This is one of numerous ways of drawing a landscape, and perhaps one of the slowest and most complicated. Many artists favour a particular approach to drawing and then try to make every landscape they do fit their preferred style. Although there is nothing wrong in this, it is not advisable for beginners to limit themselves to a certain style or technique too early on. In this case the artist selected a drawing style which he felt was appropriate to the subject – tight cross-hatching built up slowly to mimic the tightly interwoven branches of the trees and to catch the individual flakes of falling snow. However, the same scene under storm or blizzard conditions would have required a very different technique, using loose sketching to capture the wildness and ferocity of such intense weather conditions. It is important to experiment as much as possible with different styles, then once you have tried them all you can go back and perfect the ones you like the most. But, even then, think about the nature of a scene before you select the style to draw it in; that way your pictures are much more likely to succeed.

**12**

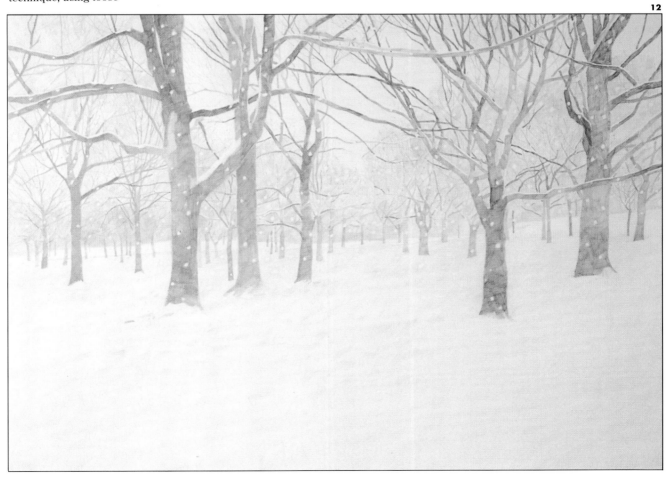

235

# Chapter 8
# Coloured Pencil

The striking characteristic of coloured pencils over the last few decades has been their coming of age. They are no longer exclusively the playthings of children experimenting in the nursery. They are sophisticated tools, continually evolving into more refined products. This is not to criticize the activities of schoolchildren – what we learn with coloured pencils in the classroom is probably the best grounding of all for potential artists and designers. But, nowadays, large sets of artists' pencils, some of them containing a range of 72 colours, give the adult artist command over an extremely subtle variety of tones. This vastly increased range can even threaten to overwhelm the beginner.

Both ordinary coloured pencils, and their water soluble versions (sometimes called watercolour pencils), are extremely popular with illustrators and animators. They produce a certain effect which has become fashionable – a lightly textured delicate finish seen in many animation films and children's and magazine illustrations. This lightness, in fact, is the symptom of a characteristic which, for the fine artist, can be quite a problem. It is difficult to build up tonal contrasts; the white paper is rarely completely obliterated. Even if you are using black, it is difficult to prevent the paper from playing a lightening role. It is not easy to build up tone as you would with paint, because the waxy nature of the pencil colours obliterates the slight texture of the paper surface, the 'key', making the support increasingly smooth with each additional pencil stroke. Most artists take this into account, and use pencils for certain tasks and particular subjects, working within these limitations.

For work on a smaller scale with coloured pencils, you can combine blocked-in areas of colour with linear drawing, producing a detailed or naturalistic finished picture. But one of the areas where coloured pencils really come into their own is in mixed media work. Here you can combine the light touch of the coloured pencil with the stronger, denser tones of inks, paints and many other materials. These, and other adventurous combinations, open up a range of unusual and experimental effects.

# Materials
## COLOURED PENCIL

Coloured pencils are made from a mixture of clay and pigment, bound together with gum, soaked in wax and pressed into rods encased in wood. In recent years, there has been an enormous increase in the variety of coloured pencils available on the market. Not only has the range of colours been vastly expanded, but you can now obtain watercolour pencils – allowing you to dissolve or partially dissolve the colours on the paper with water. Ordinary coloured pencils differ according to the manufacturer and the series you choose. Some of them are waxy and extra hard; others are soft and crumbly, approaching the pastel pencils in texture and effect.

Factories produce billions of coloured pencils to a high degree of precision, ensuring that once a hue has been established – careful measurements of components churned automatically in huge drums – the same colour is reproduced exactly. The wood encasements are often made from soft Californian cedar so that the pencils can be sharpened without splitting.

Coloured pencils are more difficult to erase than graphite pencils. The only way to remove a heavy coloured pencil mark is to scrape it back to the surface with a sharp blade. However, this type of correction must be severely restricted because the roughened paper surface quickly becomes unworkable.

1 Coloured pencils
2 Chunky coloured pencils
3 Watercolour pencils

1

2

## Ordinary Coloured Pencils

You can buy ordinary coloured pencils individually or in sets of up to 72 colours. Children's and general-purpose coloured pencils are all right for quick sketching and drawing, but they are less refined than those made specifically for use in the studio. The pencils can be obtained in round or hexagonal wooden encasements. They look practically indestructible – but like all pencils they must be handled with care. This is something a lot of people do not realize – if you drop them or treat them roughly, the colour strips inside the wood will fracture. Thus when you sharpen the pencil the short crumbled pieces will simply fall away.

Special coloured pencils are produced for use on film and acetate. This type of pencil is used mainly by illustrators and in animation studios, and is unnecessary for ordinary drawing.

## Watercolour Pencils

These can be used as ordinary coloured pencils, or as 'painting' pencils. When using them in a painterly way, apply clean water with a soft brush to those areas which you want to blend or soften. Alternatively, you can dampen the paper first, so that the marks made by the pencil will bleed and expand slightly to produce a broad, soft line.

Very soft, chunky jumbo-sized watercolour pencils are now available, ideally suited to large scale work. They come in sets, complete with their own pencil-sharpener – standard sharpeners do not fit these outsize materials.

*3*

# *Techniques*
## COLOURED PENCIL

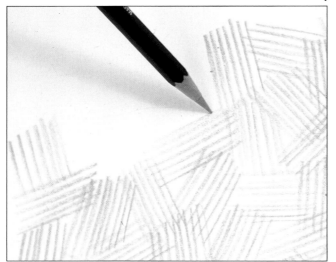

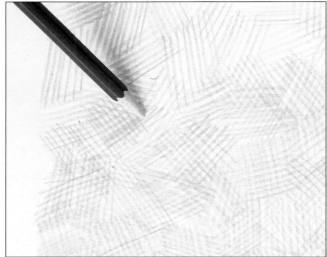

### Cross-hatching

The secret of mixing coloured pencils is to make the white or light tone of the paper work for you. Artists and illustrators who work frequently with this versatile medium know that you cannot bully coloured pencils into forming a particular colour – you have to cajole them. For example, if you decided to mix green from blue and yellow – and a 'mixed' green composed of flecks of yellow and blue is far more interesting than a green which is merely picked from the box – you could not easily achieve this by simply scribbling dense yellow over dense blue. The result would be uneven and unattractive, and such closely worked strokes would automatically prevent you from building up further colour should you so wish, because the surface would already have become shiny and unworkable. By far the best approach is to build up the colour gradually, using widely spaced lines with plenty of white paper showing through – as the artist is doing in the illustrations on this page. Cross-hatching is a good way of doing this because the fine, regular lines give you maximum control over the final result. First, patches of regular blue hatching are applied evenly over a fairly large expanse of white cartridge paper *(1)* – if the area is too small it will be difficult to appreciate the overall effect. Yellow hatching of a similar texture is then worked on top of this *(2)*. The result is a lively, broken colour in which the pure yellow and blue are still discernible, yet which is interpreted by the viewer as green *(3)*.

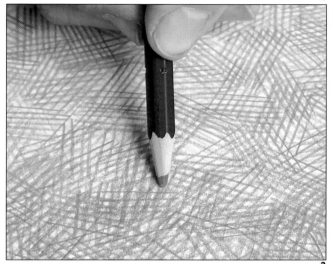

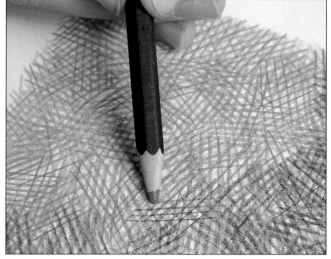

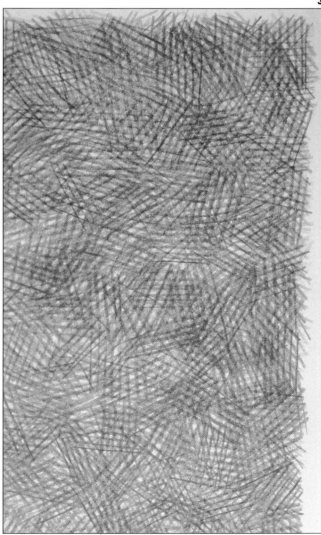

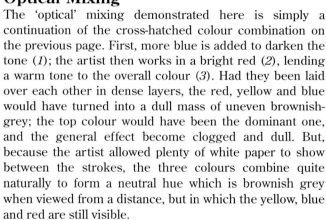

## Optical Mixing

The 'optical' mixing demonstrated here is simply a continuation of the cross-hatched colour combination on the previous page. First, more blue is added to darken the tone (1); the artist then works in a bright red (2), lending a warm tone to the overall colour (3). Had they been laid over each other in dense layers, the red, yellow and blue would have turned into a dull mass of uneven brownish-grey; the top colour would have been the dominant one, and the general effect become clogged and dull. But, because the artist allowed plenty of white paper to show between the strokes, the three colours combine quite naturally to form a neutral hue which is brownish grey when viewed from a distance, but in which the yellow, blue and red are still visible.

These illustrations demonstrate one of the basic principles of coloured pencil drawing, and they also help to explain why the medium has become such a popular one. With coloured pencils you can achieve glowing and shimmering effects by building up the colours. And the more you can exploit these colour combinations the more interesting the result is likely to be. Why use flat orange, for example, when you can create a whole range of exciting, multi-colour oranges from red, yellow and tinges of any other colour you care to add? The resulting mixtures – often delicate and unusual – have far greater visual impact than flat, commercially mixed colours. Try your own colour mixing. The result will be surprisingly effective and encourage you to experiment further with this innovative medium.

## Colour Mixing

We have talked about the various ways of mixing colours –
including cross-hatching, optical mixing and overlaying.
And with a little practice you will be able to use the
materials without any problem. But knowing how to blend
and mix the pencils does not actually tell you what colours
to choose if you want to make a particular colour. For this
you need to know a little about colour theory, and to
experiment by trying as many colour combinations as
possible. Work through your pencil set, taking each colour
in turn and overlaying this with every other colour in the
box (1). You might find it useful to keep a chart of your
discoveries, a handy reference to help you see at a glance
how to mix the colour you want.

Water soluble pencils can be blended with water.
After lightly overlaying the required colours, take a soft
brush and work the overlaid colours with a little clean
water. The result is similar to that of watercolour paint, and
often has the same delicate transparent quality (2). There
is one problem with this technique; the colours tend to
darken and change – sometimes quite dramatically – when
they are wet. It is not always easy to know what the result
will be. Again, practice will help you to anticipate a likely
outcome. But, in any case, you should not attempt to
imitate watercolour paint with watercolour pencils – they
are essentially a drawing medium and are at their best
when blending is restricted to limited areas.

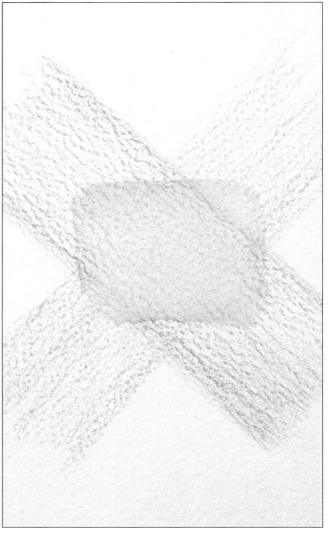

## Blending

On the previous pages we looked at effective ways of mixing colour, of overlaying two or three separate colours to create a new one. This was made possible by using the white paper and by building up the pencil lines gradually in several easily controlled stages. The 'blending' here is done more directly, by overlaying colours, one flat area on top of another. If you decide you want this type of flat tone rather than the broken colours of optical mixing and cross-hatching, you must remember the limitations of the material and proceed carefully. First, apply the initial colour as lightly as possible with the side of the pencil (*1*). This method does not completely destroy the key of the paper surface and enables you to add one or two more colours if you continue to work as lightly as possible (*2*). Deeper tones can be created by building up two or three flat, light colours (*3*) but already the artist is finding it difficult to add further red because the underlying pencil is too dense to receive more colour.

The texture of the paper is important when blending coloured pencils. Here the artist made the task easier by using fairly coarse cartridge paper – the waxy colour got caught on the raised parts of the support's surface texture, leaving the minute indents as white. Regular sharpening is another essential if you want to keep the colours unfuzzy and clear, and the surface of the paper as unclogged as possible.

# Palm Trees

## WATER SOLUBLE PENCIL

With these chunky, water soluble pencils, you can produce a picture which reflects a sense of fun. These palm trees have not been represented in exact realistic detail, but have been converted into a bright design in which the colours combine in cheerful harmony. The whole emphasis is decorative, a stylized version of an organic subject, capturing some of the familiar aspects we associate with palms, such as their broad leaves. The background has been left out, isolating the palms so that they form an almost abstract pattern. This fits the medium, because it is difficult to create a sense of space and recession which would require more graded tones.

The medium is best suited to work on a large scale, so the artist here aimed for a bold overall design. The chosen colours are based in reality, yet they are bright – a range of five greens, two browns, black, and an orange used occasionally to warm up the otherwise cool colours. In the final stages water was used to create a wash of light colour on selected areas. The artist applied clean water with a brush.

Alternatively, these pencils can be used with water to produce a soft, bleeding line. To do this, dampen the paper with clean water, and then draw onto the surface while the paper is still wet or partially wet.

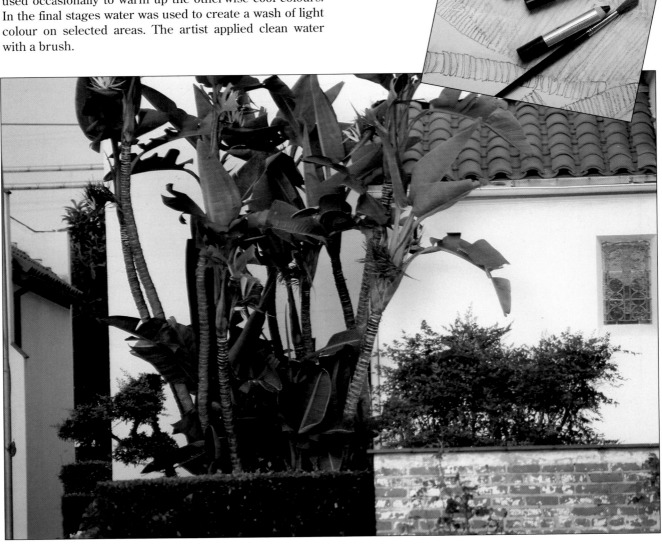

*The chunky, water soluble pencils shown here are best for colourful, large-scale line work. For this reason the artist chooses a clump of palm trees, whose characteristic wide flowing leaves are ideal for the bold lines so suitable for this medium.*

**1** As the artist is not aiming for a particularly naturalistic effect here, the work is begun with an outline which has a more flat look, offering a simplified view – rather like the approach often used by illustrators and designers. Heavy white cartridge paper, measuring 30 in × 20 in (76 cm × 51 cm), is being used. The paper should be as strong as possible; card could be used instead. For the artist intends to dissolve the colours with water in the later stages.

**2** The first tree has been well established in outline, using the local colour of the part of the tree being depicted. For example, the trunk is in brown and the leaves in browns and greens. Some of the early textural blocking-in has begun to describe the leaves. The artist has simplified the image and has been selective about which parts of the subject should be included. Brown, black and dark and light green are used to shade in the leaves.

**3** The artist continues to build up the patterns in the leaves, using a bright leaf green over a darker green. In this way, the artist develops the foliage, blocking in each leaf with a slightly different combination of colours. This produces a decorative effect, but is also used to make the subject look slightly realistic, in that subtle variations, even on one leaf, can give a hint of light and shade. By creating so many different colour combinations, from a basic selection of pencils, a bright, yet harmonious, theme is established.

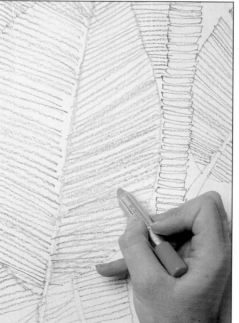

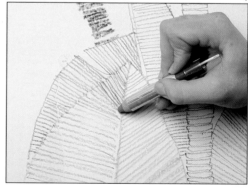

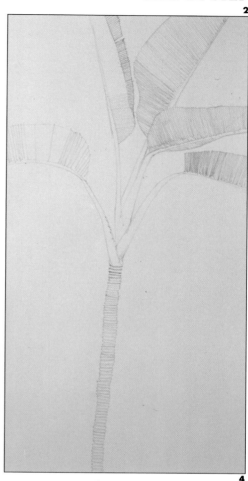

**4** The artist uses a darker green along on side of a leaf, building up a density of tone and colour. The other side is left lighter, with more white space between the lines. This adds a touch of realism to the overall design effect.

# WATER SOLUBLE PENCIL/PALM TREES

**5** The artist is pressing harder on the pencil in order to draw in the segments on the trunks of the palm trees. This is aimed at producing a darker tone. Remember that with this type of pencil blocking-in is not easy. The pencils are too soft to enable you to control the tone. You have to find other ways of developing tonal contrast. This can be done by pressing hard as the artist is doing here, giving an extremely soft, broad line. Alternatively, you can use hatching and cross-hatching to build up a more controlled area of tone. Best of all, however, is the principle that tools should be used for the task that suit them best – so do not make life hard for yourself by choosing a subject which requires substantial solid areas, requiring blocking-in, or subjects which need carefully graded areas of tone. In these cases, chunky water soluble pencils such as these are not the right tools for the job. When looking for a subject, go straight for the bold linear qualities that will bring out the best characteristics of this medium.

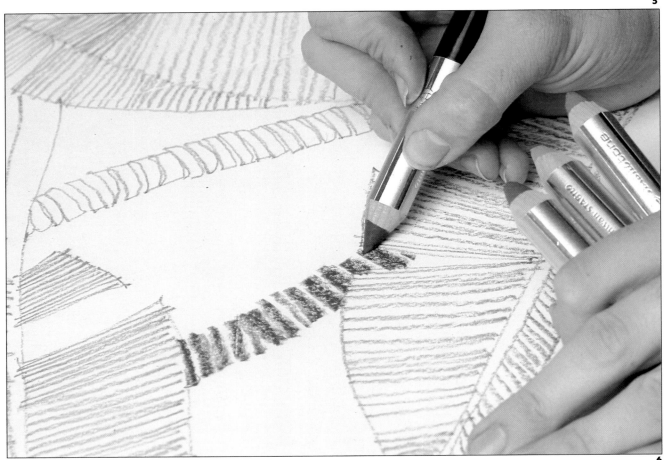

**5**

**6**

**6** This close-up of a section of the leaves shows how the artist has exaggerated the subtle veins and texture of the subject, making them into an intricate pattern of directional lines and interesting variations of colour. The leaves cease to be leaves and become interwoven into an almost abstract design. Black, brown, dark and light green and a dull olive green are used here to build up the combination of inter-relating colours. This brings together elements of what the artist sees in the subject, plus some creative and imaginative interpretation.

**7**

**8** The artist has aimed for the vital elements in this picture. Right from the beginning, the decorative aspects of the image and the flat patterns were important. With this medium it is not advisable to attempt an intricately realistic image. So the artist sought the overall effects of simple, straight hatched lines to build up a design of criss-cross colour. It is a perfect example of the importance of choosing a subject and a medium which suit each other, a point so often forgotten when beginners embark on a drawing. The pencils should be used gently and loosely. In this picture, the artist used water in the final stages, in order to introduce a contrast between some areas of line and some of wash.

**7** Still conscious of the overall design, the artist uses water on selected areas to blend the colours into each other. Clean water is worked lightly across the drawn lines without rubbing too hard. This releases just enough colour to produce a light wash which complements rather than replaces the linear pattern.

**8**

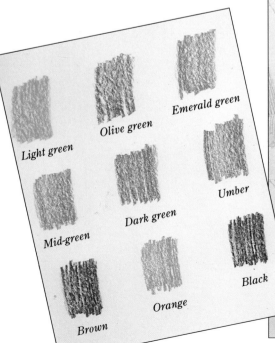

Light green

Olive green

Emerald green

Mid-green

Dark green

Umber

Brown

Orange

Black

247

# Girl on the Beach

## COLOURED PENCIL

For a bright, sunlit picture with stark contrasts between light and shade, the artist uses only coloured pencils, sketching in the outline with various local colours. There is no need to use an ordinary graphite pencil. Although the colours here look simple – predominantly red, yellow and blue – a surprisingly large range has been used, and this is particularly necessary to depict the subtle tones of human flesh.

Skin colour is so complex that it is not just a question of separating the areas between those which are touched by light and those which are in shadow. Each one of these regions, in fact, has its own combination of warm and cool tones. The skin of all races is transparent, with blended colours, and the best way of portraying this is to render it literally in layers. With coloured pencils, you can work over an area lightly, layer by layer, leaving some of the underlying tones to show through between the strokes. This gives a transparent effect if built up in extremely thin layers. If the colours become too dense, use an eraser to remove some of the excess.

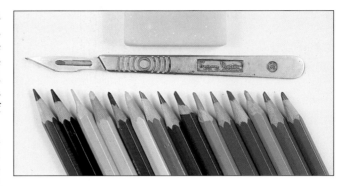

*A selection of 15 pencils is used here. The artist has to hand an eraser, and also a scalpel – it is essential to keep the pencils sharp, or the lines will become fuzzy. The subject is strong. A tanned figure in a bright yellow swimsuit sits against a red windbreak under a clear blue sky. Strong light produces emphatic tonal contrasts and the figure is defined by deep shadows and clear highlights. Sunlight casts a strong dark shadow across the sand.*

*White cartridge paper is used, measuring 20 in × 30 in (51 cm × 71 cm).*

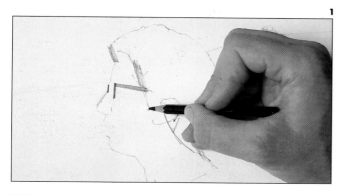

**1** The artist starts by drawing the outline of the figure. Each part of this initial outline is depicted using the local colour of the area it represents. Here, for example, the flesh tones of the face are drawn in terracotta; the hair and sunglasses are outlined in black.

**2** The artist blocks in the hair. The flesh tone is built up on the face by lightly drawing one area and then placing another layer on top. Starting with Naples yellow, warmer shades of brown and red are then worked in. Cool shadows are hatched on top of this in black and blue. Areas of white paper represent the strong highlights.

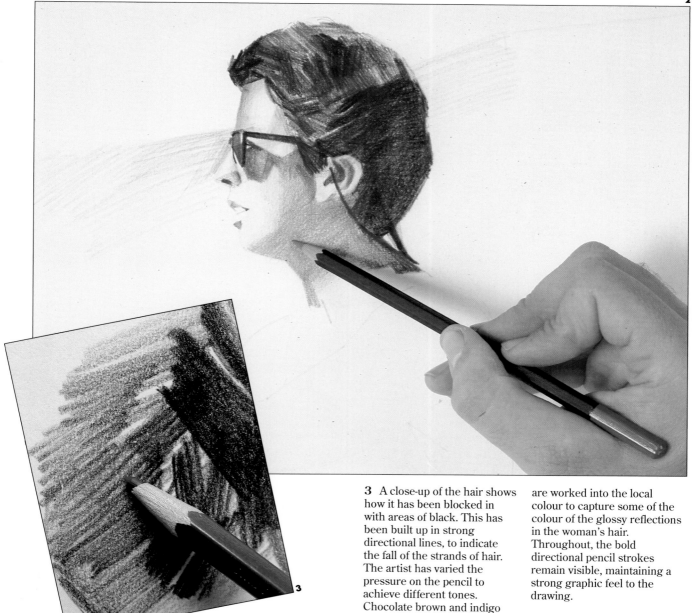

**3** A close-up of the hair shows how it has been blocked in with areas of black. This has been built up in strong directional lines, to indicate the fall of the strands of hair. The artist has varied the pressure on the pencil to achieve different tones. Chocolate brown and indigo are worked into the local colour to capture some of the colour of the glossy reflections in the woman's hair. Throughout, the bold directional pencil strokes remain visible, maintaining a strong graphic feel to the drawing.

249

**4** The red awning and yellow swimsuit have been blocked in lightly, without developing any of the colour variations within the forms. The artist has tried merely to establish an approximate tone around the figure. Now the flesh colours can be built up. In this illustration the artist is working on the darker flesh tones of the arm, using brown, chocolate, Naples yellow, lemon, burnt umber and terracotta.

**5** Working across the image, the warm and cool tones are picked out. In this picture the artist applies a cool indigo tone over a light shadow area.

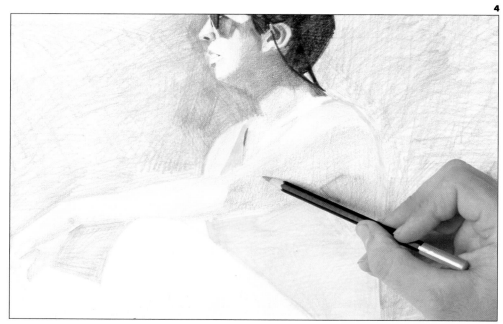

**6** The artist moves into the red awning behind the figure, which has already been established as a flat shape. The shapes of the creases are drawn in. Their upper edges, which catch the light, are left as light red with touches of orange. The shaded areas generally fall into two tones – medium and dark.

**7** Red pencil is used on the shaded side of the leg. This has already been built up densely with layers of blue, browns and terracotta. The darkest planes are on the top and underside, and the entire area is built up with smooth directional lines. A definite cool bluish shadow is added where the figure is seated on the sand.

Light blue

Terra cotta

Cobalt blue

Deep vermilion

Prussian blue

Madder carmine

Indigo

Orange chrome

Black

Naples yellow

Chocolate

Lemon yellow

Burnt umber

Gold

Burnt carmine

Viridian

**8** Although the finished picture is a composition, the figure is the central part. This has been emphasized by bringing into sharp focus the red awning immediately surrounding the figure while leaving paler, sketchier areas towards the edges of the picture. A major part of this project has been involved with building up flesh tones, which are a subtle mixture of warm and cool tints. Coloured pencils are ideal for this, so long as you lay the colours lightly, building up the tones gradually to enable the colours underneath to show through. In this way it is possible to achieve the delicate transparent effect of human flesh. The artist worked with a wide range of tones to achieve this effect. The cool, shadowy areas, for instance, were developed with four blues and a green; the warmer sunlit tones with three yellows and four reddish tints.

**8**

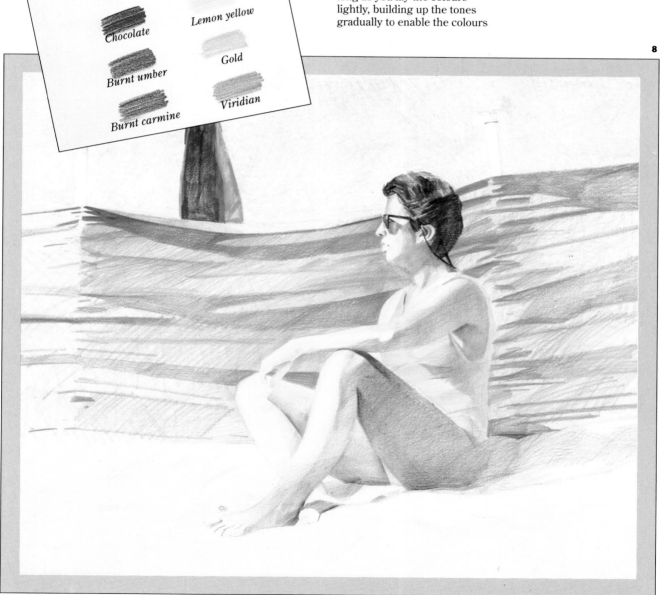

# *Four Trees*

## COLOURED PENCIL

The delicacy and simplicity of this image makes it an ideal choice for rendering in coloured pencil. Although often associated with children and colouring books, coloured pencils really do have a lot more going for them and are capable of producing a very subtle, delicately textured effect. Although the dense, waxy nature of this medium means you cannot easily blend colours together as you can with, say, pastels, this is not a drawback. Indeed, the beauty of coloured pencils lies in the range of shimmering hues you can achieve by building up separate strokes of colour, which resonate against the white of the paper.

Although this drawing project is a very simple one, it offers those of you who are new to this medium a chance to try out a variety of techniques, which range from rendering fine details to covering broad, open areas.

Incidentally, this particular project also demonstrates the value of keeping an open mind and using your imagination. Here, for example, the artist turned a potential disaster into a 'happy accident': what happened was that he had a laser copy made from his original reference transparency, but the copy came out too dark. Undaunted, he capitalized on the fact that the sky now had a very purple hue, and, as you can see, it has given the picture an added sense of drama.

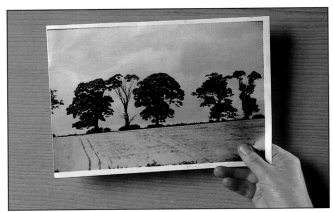

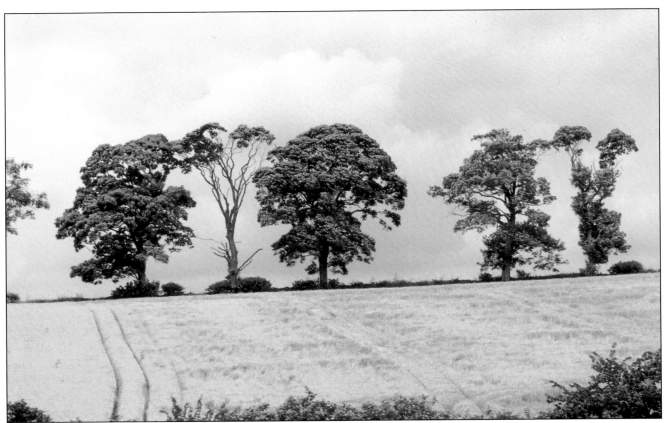

**1** The focal point of this landscape is the trees, but on looking at the original reference the artist felt that there was too much space between them, making the image too static and bare, so he decided to pull the trees closer together. Using a pale orange pencil, start by mapping in where the trees will stand. With coloured pencils it is always advisable to use very pale shades for your initial sketch so they will not intrude on the finished piece. Switching to pale blue, draw the outlines of the clouds. Referring to the colours in the laser print, take a purple pencil and loosely hatch over the cloud areas. This will add drama later on.

**2** Using the orange pencil, loosely sketch in the field in the foreground. To create an overall sense of colour harmony in your drawing, use the purple pencil to sketch over the fields, employing the same loose style and applying very little pressure.

253

**3** Now you can start pulling things into shape. Choosing a deep shade of green, begin adding form to the bushes on the horizon, still sticking with your loose, sketchy technique.

**4** With the same green pencil, move up towards the trees. Do not cover the trees totally with green but concentrate on the areas of dense foliage to add definition. Do not be tempted to press too hard with your pencils, otherwise the surface will become shiny and unworkable and prevent you from building up further colour as the drawing progresses. Instead, build up the colour gradually with delicate strokes, leaving plenty of the white paper showing through.

**5** Choosing a deep shade of blue, darken the tone of the sky in between the clouds. At every stage now your drawing will take on a new dimension. You can see how, rather than starting with a tightly defined outline and then just filling it in, this way of working also gives you a little more freedom and allows you to make changes as you go.

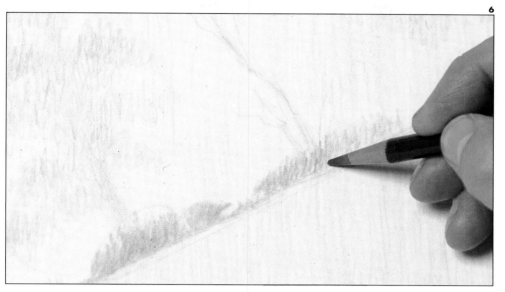

**6** Now go back to the bushes on the horizon. Holding your green pencil much closer to the point, and applying more pressure, add further strokes of colour to give an impression of their form.

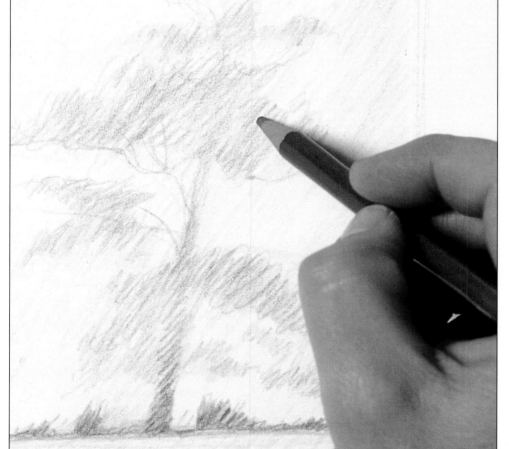

**7** As explained earlier, purple is going to be used as the unifying colour, so, as it has now become almost invisible, it is time to re-introduce it. Reverting to your loose technique, gently re-work the trees, sky and field, and also add the outline of the track.

**8** Now it is time to do some real work on the trees. These are the most important part of your drawing and require special attention in order to make the finished image work successfully. A good starting point is the trunks, so, using a reddish brown pencil and applying a little more pressure, carefully follow their contours and block them in.

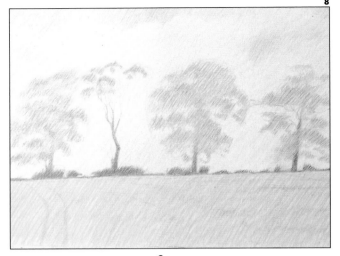

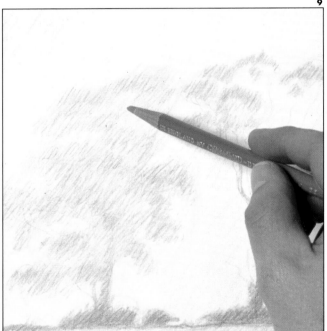

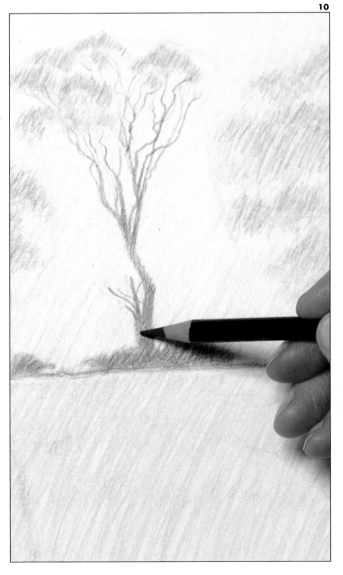

**9** Before you attempt any further work on the branches and foliage of the trees, it is important to finish off the sky. Take your blue pencil and fill in all the gaps between the clouds, running over the edges of the trees to fill in the white spaces between the leaves. The reason for doing this now is because the outline of the trees has already been established, so the 'sky holes' can be readily identified. In addition, establishing the correct tones of the sky will make it easier to judge the colours and tones of the trees accurately later on.

**10** You can now return to the trees once more and begin some more heavily detailed work. With the reddish brown pencil, work over your initial pale guidelines, following the shapes of the branches and adding any extra ones that you feel will bring the trees to life.

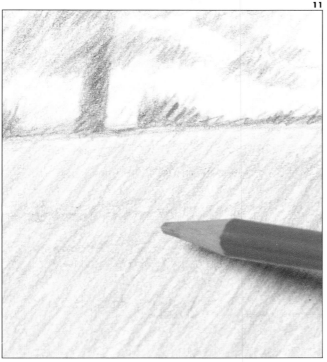

**11** Once you are satisfied with the trees, the lower half of your picture will need some working up to finish it off and to balance it with the upper half. Taking the purple pencil, pick out the tufts of stubble in the field and run over the track again to give it some definition. Changing to a darkish yellow, shade over the whole area, slowly darkening the tone as you move from left to right across the drawing by gradually applying more pressure on the pencil. This will prevent the field from looking flat and unnatural, as well as adding interest to the overall drawing.

**12** The drawing is now complete. In this case the artist felt that the trees required a little more definition, so he quickly worked over the foliage again with green and purple pencils. It is fine to do some small-scale 'tinkering' to your drawing if you feel that any areas need extra definition, but take care not to overdo this as you then run the risk of over working the picture and ruining the result.

This project demonstrates the value of using a gentle touch with the pencil to build up delicate masses of line and tone that deepen and add interest to the drawing.

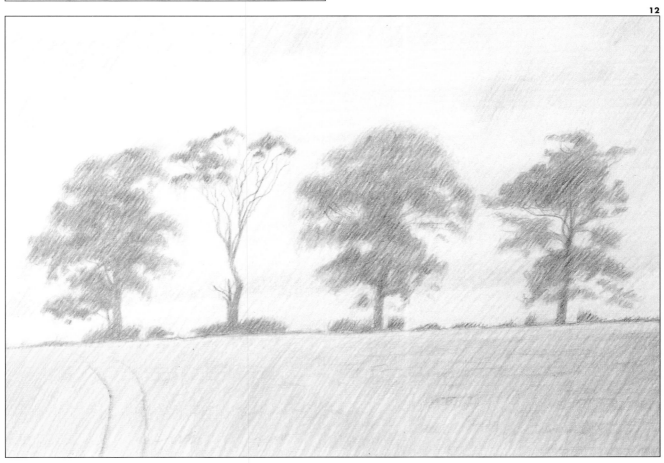

# Chapter 9
# Markers and Fibre Pens

Technology is relentlessly improving upon the marker and fibre-tip pen, and new products are coming onto the market all the time. There is no need to recoil in puritanical shock from this brash young medium – it is available for all types of artists to experiment with, even though they have come to be associated normally with the graphic artist's studio. For the fine artist, the wide variety of products available offers a whole range of colours and lines which can be used in a completely different way from their normal commercial role.

The 'traditional' wedge-tipped studio markers, with their thick rectangular drawing points, are commonly used for presentation work, graphic design and occasionally for animation. In the commercial studio, marker artists are specialists who learn a whole range of techniques to fit the product. Wood grain, reflective metal surfaces and even the subtle gradations or tints of portrait and figure work can be miraculously rendered with markers. However, without going to these lengths of expertise, and without producing the finish necessary in studio work, markers can be borrowed from their commercial settings to produce lovely and unusual drawings. They exist in their own right as a colourful and chunky drawing material.

Our artist, a painter, uses them in an individual way – creating graphic pictures which exploit the crisp quality of markers; yet making the colours work in a controlled manner. However, he has not forgotten the basic characteristics of the medium. Remember that you cannot produce traditionally rendered pictures with a flat colour. There are limitations. The secret is to choose a subject which suits this medium, something which can be illustrated in a striking, graphic manner, rather than a subject calling for traditional toning. Look for something bright and bold – and have a go.

There are numerous felt-tip pens, liners, fibre-tip brushes and other tools which come into this broad new category. You don't have to become an expert in them all. You are probably familiar with some of these pens as writing tools. Be open-minded and experiment with the different marks. A good artist is not dependent on conventional pens and pencils – a marker or felt-tip pen can be made to do some spectacular work.

# Materials

## MARKERS AND FIBRE PENS

As any graphic artist knows, there are thousands of markers, fibre-tip pens and related drawing implements now on the market. Not only does every manufacturer produce its own range of such materials, but these are changing and being developed all the time, with superb and bewildering ranges to choose from.

For the fine artist, however, there is no need to worry too much about technical categories, or about their specialist role in the designer's studio. Your interest will probably be of a more general and experimental nature.

### Markers

Wedge tipped-markers come in sets or can be bought individually. Each marker has a broad, obliquely cut felt tip which draws the ink from the cylindrical, glass holder. This glass holder has a removable screw top to allow for refills. Many artists prefer these traditional markers to some of the more recent streamlined types because when not in use they can be

stood upright rather than left rolling around the desk or table. Markers come in a wide range of colours, and each colour is usually available in a number of shades. For example, one product has nine cool greys and nine warm greys. The colours are very accurate, but they do darken with use. The life of a marker can be extended by diluting the ink with lighter fuel, although this obviously lightens the colour.

Marker artists generally work on special marker paper because the colours tend to bleed on ordinary, more porous surfaces. This makes them unsuitable for the slick finish which markers are most often used for. However, as a drawing and sketching medium this may not matter. Indeed, you probably prefer a brighter, more spontaneous effect.

The marker ink is soluble in lighter fuel, making it easy to spread the colour in graded washes. It is also an effective way of creating broken colour and texture – in the

demonstration on page 276, the artist spatters the fluid onto a flat area of dried marker colour to make the pebble texture of the beach.

### Felt-tip Pens

Broadly speaking, felt-tips are flexible and wide. Markers fall into this category. There are many other brands available. Some, such as the luminous 'highlighters', are made specifically for office use. Others come in a range of colours and are available from art and graphic suppliers. Look at the label to see if you are buying a soluble or waterproof product.

'Brush' pens have a soft, pliable tip and produce lines similar to those made with a watercolour brush. Some of these have a solid, pithy tip; others are actually made like brushes, with tiny synthetic bristles.

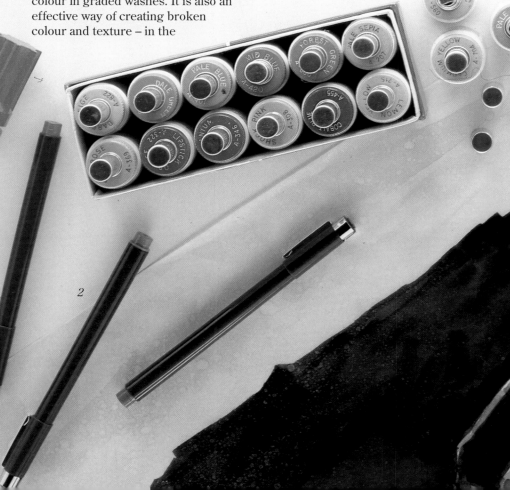

## Fibre-tip Pens

Again, the choice is a wide one. Try one or two brands to see which suit you best. Some have hard tips, others are more flexible; some pens are water soluble, others permanent. You can buy sets of felt-tips in a wide range of colours – some of these are manufactured specially for the artist, others for use in the office or playroom. The 'office' variety tends to come in limited colours, often black, blue, red or green.

For drawing and sketching, your main concern will probably be with the width and type of tip. New tips are usually rigid and produce a hard line, and become more flexible after being used. Many artists keep two pens to hand – a new one for strong, hard lines, and an old favourite with a 'broken-in' tip for softer shading.

## Fine Liners

The terms 'fine liner' is used broadly for all those synthetic-tip pens which produce a characteristic thin, spidery line. These pens are used in offices and graphic design and illustration studios. In many ways the fine liner is a disposable version of the technical pen – the drawing on page 266 is almost indistinguishable from one done with a technical pen. Fine liners are excellent for detailed, illustrative work and for small-scale drawings and sketches.

1  *Jumbo-size markers*
2  *Fine liners*
3  *Wedge-tipped markers*
4  *Assorted felt- and fibre-tips*
5  *Brush pen*

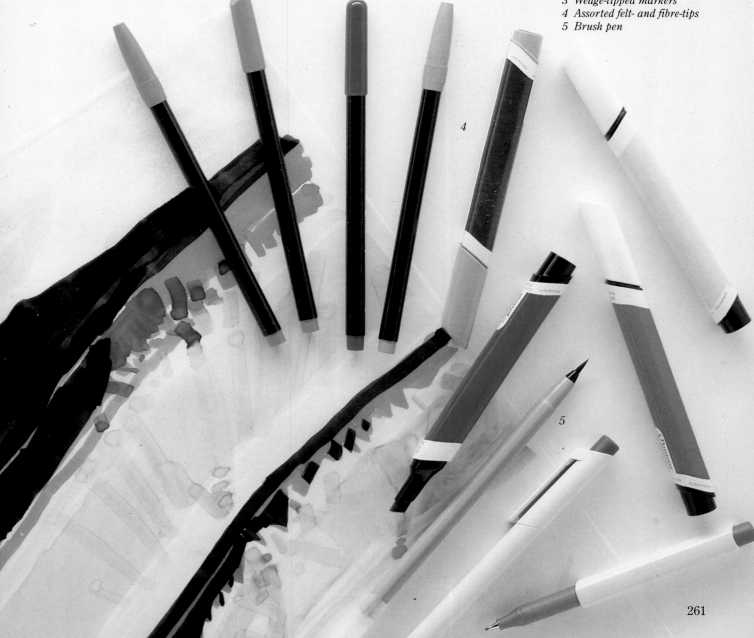

261

# Techniques

## MARKERS AND FIBRE PENS

### Using Markers

Probably the most popular type of marker in use is the wedge-tipped variety, so-called because of its broad chiselled end. With this one drawing tool you can make three widths of line, lay broad areas of colour and tone, and glaze one colour over another.

Practice is the key to successful marker work. Markers have definite limitations, and specialist marker artists readily admit that their job consists chiefly of finding ways round these limitations. However, if you are using markers solely as an adventurous drawing and sketching medium, you need not worry about these professional drawbacks. Your main concern is to familiarize yourself with the materials so that you can use them confidently and quickly. The techniques on this page are simple and straightforward, but you do need to try them out several times before attempting to integrate them into a drawing. Use good-quality products – not only are the results smoother and easier to achieve, but the colours are less likely to bleed and 'drag' into each other when one marker is laid over another.

**1** The wedge-tipped studio marker is capable of producing a variety of marks. Here the artist uses different sides of the felt-tip to make broad, medium and narrow lines. Practise this until you achieve a smooth, even flow – by turning the marker as you draw, you can vary the width of a particular line, producing a flowing, undulating mark.

**2** To lay a flat colour, work quickly in broad, horizontal lines, taking each line over the edge of the previous one before it has time to dry. For a large expanse of colour, use lighter fuel to spread the ink (see page 265).

**3** To overlay colour, allow the first layer to dry before working quickly over this with a second colour. Providing you choose a good-quality product, work quickly, and allow the first colour to dry properly, the second colour should not 'drag' or disturb the underlying colour.

## Stripping a Marker

To block in large areas of really flat colour, you will find it convenient to use the whole of the length of the felt strip rather than being confined to the comparatively narrow tip. This entails the careful removal of the strip from its container – a process which is only possible with the screw-type of marker container. You must then lay the colour fairly quickly before the colour dries. As the strips run out of colour, they become fainter, but if you only need to lay a small quantity of colour replace the strip in the container and screw the top back on ready for re-use.

**1** To strip a marker, first cut the plastic seal around the metal cap. (Remember, 'stripping' is only possible with markers which have screw tops.)

**2** Remove the metal top. The drying process begins as soon as the strip is exposed to the air, so work as quickly as possible.

**3** Tip the container to bring the strip to the mouth of the container.

**4** Hold the strip firmly and remove from container. When you have finished work, this strip can be replaced for further use.

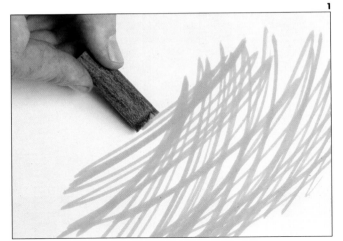

## MARKERS AND FIBRE PENS

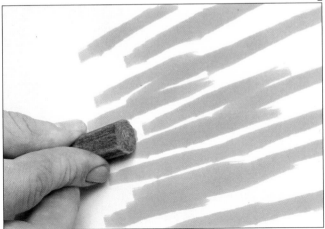

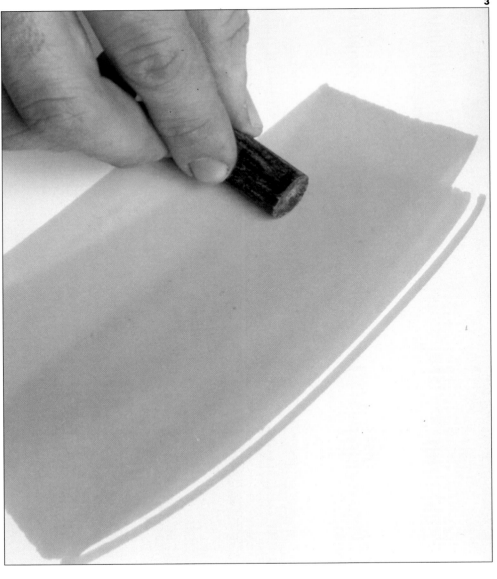

## Making Texture

**1** Markers produce a steady flow of even colour. This makes them excellent for some types of work, but limits their use in other ways. For instance, to produce the light feathery texture demonstrated here, the artist works in loose, scribbly strokes, relying on the irregular, broken shapes of white paper showing through to produce the textural effect.

**2** Broad flecks of colour are laid with the wide end of the marker strip. The pattern of such marks can be varied to suit the subject in hand, and the flecks can be close and dense or wide apart, depending on the required texture and density of colour. Here the marks are laid in a loosely parallel fashion. The technique is often used by this artist to block in wide expanses of flat ground – the direction of the marks being used to indicate the direction of the flow of the landscape.

**3** Use the side of the marker strip for blocking in broad areas. Again, the technique is useful for wide, directional sweeps of colour. To achieve a flatter effect, use lighter fuel with the marker (see opposite page).

264

## Using Lighter Fuel

Lighter fuel – normally used to refill cigarette lighters – is extremely versatile and useful, and an essential item in the marker artist's studio. Not only can it be used to dilute the ink, thus extending the life of a marker, but it can also be exploited to create a whole range of texture effects. Although most marker manufacturers make proprietary solvents, specially suited to their particular products, lighter fuel is a cheap, all-purpose alternative and works quite adequately with all petroleum-based markers. You must, however, treat lighter fuel with respect. It is highly flammable and it also gives off dangerous fumes, so be sure to work in a well-ventilated area, away from cigarettes and naked light.

Although markers can be used to create flat areas of colour, this becomes tricky if you have to cover very large areas. The ink tends to dry in streaks before you have time to blend the edges. However, if you first spread lighter fuel over the area to be rendered, the marker colour remains wet long enough for the marks to bleed, or blend together, and the result is completely even. This technique can be adapted to create multi-coloured 'washes', and to lay graded colours.

Choice of paper affects results, especially when using lighter fuel to spread the colour. Proper marker paper is sealed on one – occasionally, both – sides. This stops the marker inks from bleeding, thus producing brighter colours and also enabling you to produce crisp shapes and hard edges. Other papers, not specially prepared for use with markers, absorb colour and give a softer, amorphous effect. One drawback with 'non marker' papers is that the colour soaks through to the reverse side. This can be messy and will spoil any paper underneath, especially if you are working on a pad.

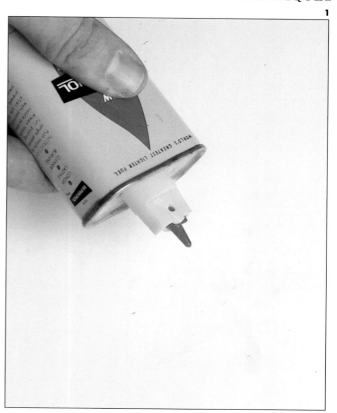

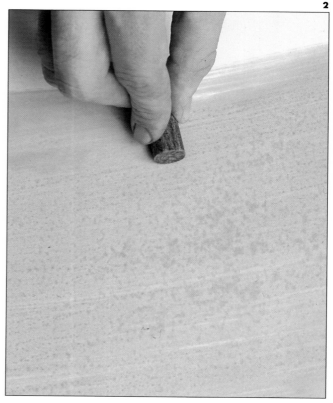

**1** To lay an area of flat colour, first sprinkle the lighter fuel across the area to be blocked in. Work on the sealed side of the marker paper, using enough fuel to cover the area properly, but taking care not to flood the paper. Spread the fuel with a clean rag or tissue.

**2** Holding the marker strip firmly between the thumb and forefinger, lay the colour with parallel, overlapping stripes. As the marker ink starts to run out, the colour becomes lighter.

# Orange Lily

## FINE LINER

An extra-fine member of the fibre-pen family is used for this drawing. The 'fine liner' offers a precision which can draw detail. But it also produces a mark on the paper which is regular – almost like a technical pen – and which is uncompromising. The lines cannot be harder or softer, narrower or wider. Tone and form must be made with one unchanging type of line. For this reason, the exercise is ideal for beginners – a true challenge, because the pen acts against you as you try to vary the tonal effects. If you can use the fine liner for a subtle drawing like this, controlling tone only with line, you will find other work much easier when you come to use more sympathetic materials. More malleable materials will allow you to create grey areas, but here you must operate purely in black and white. The 'greys', the less dark shadows, are made up of black lines by means of hatching.

The size of paper here is immaterial because the image does not fill the available space. This picture is a study of an individual flower, not a complete composition.

The shading around the central object fades into white space. The artist does not have to worry about background. The subject is presented as a vignette – an image without a defined edge – traditionally a popular way of portraying an isolated object.

*A 'fine liner' is chosen for this black and white drawing of the multi-bloomed orange lily. This sort of very fine fibre-tip pen can be bought cheaply in an ordinary stationery store, and is the type often used in offices. Its use here is a demonstration of how it is possible to make very creative drawings with everyday stationery items.*

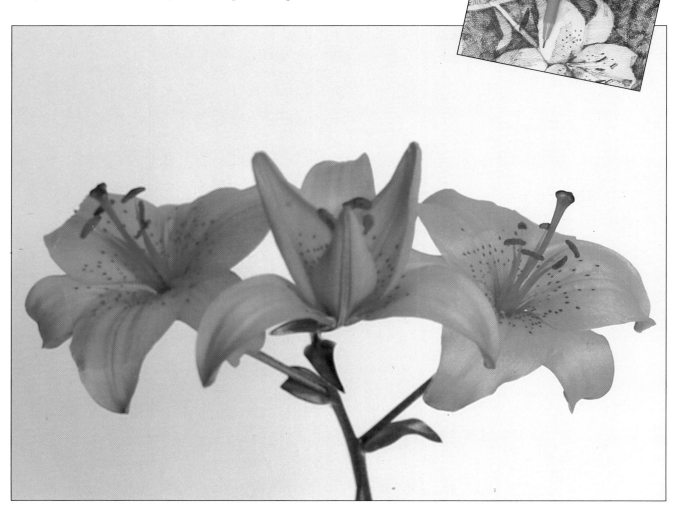

**1** Working on smooth white card, measuring 20 in×24 in (51 cm×61 cm), the artist starts drawing the main part of the flower in the centre of the support. In this case, the pen was used directly, without any preliminary pencil sketch. But there is no reason why you should not make a light pencil drawing first, to act as a guide, if you wish. Shading is begun immediately – before the whole outline is complete. A small portion is outlined and then shaded in.

**2** Rather than picking out the flower, the artist is depicting the shapes of the bloom and stem by blocking in the areas behind them. The point of the pen is too fine to allow any practical attempt to block in solid areas of tone. It is a tool for drawing line. However, the artist does not want a flat tone – little patches of hatching and cross-hatching are built up instead. This is taken carefully up to the outline of the detail, so as not to destroy the delicate shape. The background is actually made quite dark, with extensive hatching, and this throws out the shape of the flower in stark silhouette.

**3** The first bloom is now established by this 'negative' process of blocking in the surrounding areas. Notice how, as the shading was taken farther away from the flower, it became less dense, allowing the edge of the picture area to fade slightly into the surrounding white instead of standing out as a sharply cut-out shape. The artist has also moved into the area of the flower itself. Again, it is the shadow parts which are worked upon, with cross-hatching on the petals. But these areas are kept relatively light at this stage. Otherwise the crisp white shape would be overworked, and the image would be lost. The artist continually thinks about the relative tones. Too much deepening of tone, too early, can lead you into an irreversible situation, so always be patient when building such areas as shadows.

**4** The next bloom is treated in exactly the same way as the first, by indicating the outline and then emphasizing the shape with darkened background behind it. Instead of simply drawing the second bloom onto empty space, the artist has observed and drawn the shape of the space between the two blooms.

**5** Before moving on to the next flowerhead, it is important to get the tones absolutely right in this one. The artist therefore moves into the petals, looking carefully to find the darker tones. These are established in regular directional strokes which describe the direction of the petals. Parallel criss-cross lines are hatched down the length of a bud.

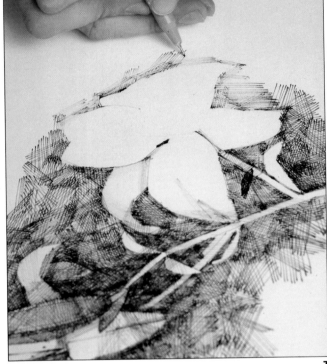

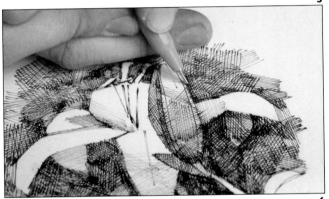

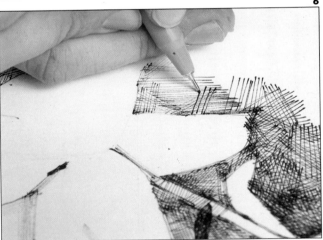

**6** The artist develops the background tone around the newly established flower. This background appears very daunting, as if every line has to be meaningful, and drawn in exactly the right place. In fact, however, the artist is working very quickly. If each line was a considered, slowly drawn mark, you would lose the effect of the almost mechanical criss-cross motion, and the overall tone would in fact be much harder to control. Here, the artist adds the tone patch by patch in a series of rapidly drawn lines. Each patch is assessed in much the same way as a brushstroke would be, if you were painting – i.e. it is either left, or darkened by more strokes to build up the required tone.

**7** In this picture you can see quite clearly the light and precise shape of the subject. Yet it is the background, not the flower, which essentially has been drawn. The artist has been able to control this drawing by working from light to dark – the way a watercolourist would operate – starting with light tones and gradually darkening as necessary. This is the only way to work with all types of pen, because it is difficult and time-consuming to erase the lines. Normally with pen drawing, once a mark has been placed on the paper you are committed. Thus it would be a mistake to over-darken a particular area too quickly. The gradual approach is the only one.

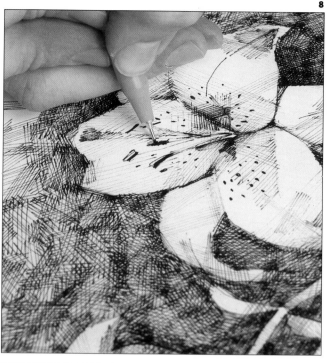

**8** The background is now complete around both blooms, and the artist has also developed the flower petals with cross-hatching. Again, the artist is aware that the petals must remain considerably lighter than the background. In this picture, details of the flower's anatomy are being dotted in. These finishing touches bring the flower to life, giving it an identity.

**9** The final picture demonstrates how cross-hatching, although it appears to be a haphazard zig-zag, can in fact be used to produce carefully controlled effects. For instance, on the petals you will notice that the hatched lines describing the shape of the petal are closer together towards the darker centre of the flower. The lines gradually spread out as they move towards the outer edges of the petals, where the light is falling more directly. Thus, not only can you indicate simple light and dark tones by varying the density of hatching – you can also describe form by means of light. The final illustration also shows how the fine liner produces an effect similar to that of a technical pen – regular and unforgiving – yet it is slightly softer.

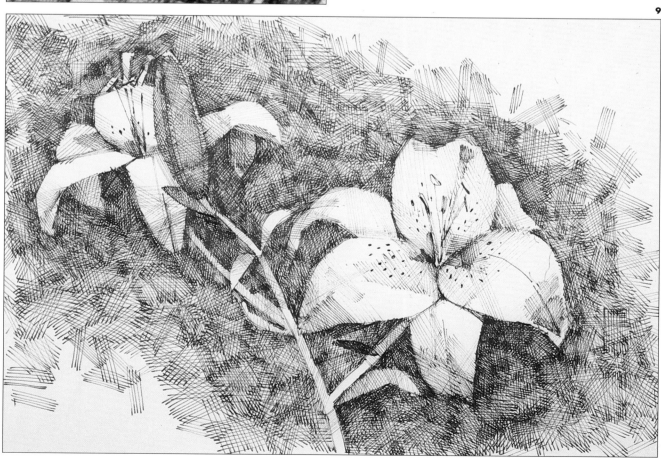

# Venetian Washing Line

## FINE LINER

This still-life presents an opportunity to further develop the skills you learnt in the previous project. Still-life falls into three distinct categories – the 'artificial', the 'found' and the 'natural'. Randomly placed 'found' objects is the one that people have problems seeing as a true still-life form. This is especially true when the objects have been found outdoors. Draped material often plays an important part in a still-life, and, anyway, due to the lack of a breeze, this washing line was still when the photograph was taken!

As an artist you must be aware of the importance of carrying a camera or sketchbook around with you whenever possible. This helps you to build up a visual 'library' of reference so you will never be short of something to draw. This was the case here. The artist was on holiday in Venice and while out sightseeing he chanced upon this intriguing view which has an almost surreal feel to it.

What appears to be a very simple scene holds a multitude of challenges for any artist, with all the various textures of the crumbling plasterwork, the weatherbeaten bricks, the shuttered windows and the crisp white shapes of the shirts on the washing line and the perfect shadows they create.

In fact this particular image could be rendered in any medium but the artist opted for a monochromatic interpretation in ink using fine liners. Given the essentially linear, uncompromising nature of fine liners, this may seem a strange choice. But the artist welcomed the challenge of producing a range of subtle tones by building up a network of hatched and cross-hatched lines, working from light to dark. As you will soon discover, this is really quite a satisfying and surprisingly simple approach which results in a wonderfully detailed finished drawing.

Throughout this project you will in fact be using two pens – one new and one old. An old pen contains less ink, therefore it is easier to control than a new one and allows you to make a cautious start, 'feeling' your way into the drawing. With a pen drawing, once you make a mark on the paper, you are stuck with it! Therefore a gradual approach is a sensible one, allowing you some control over the build-up of tones and textures.

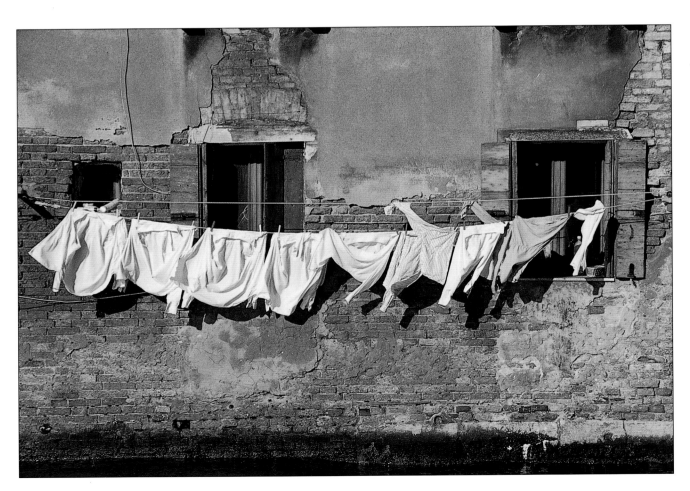

**1** Your chosen support for this fine liner rendition should be a reasonably heavy, smooth cartridge paper, which allows the pen nib to glide easily over the surface. Start by making a a fairly tight pencil sketch of the subject, following the original reference. This will act as a guide, but apply only light pressure with the pencil as you do not want these marks to show through in the finished drawing. With your old pen, start defining the shapes of the washing line by blocking in the shadows cast on the wall behind them using hatched and cross-hatched strokes. These initial strokes will be further defined as the drawing progresses.

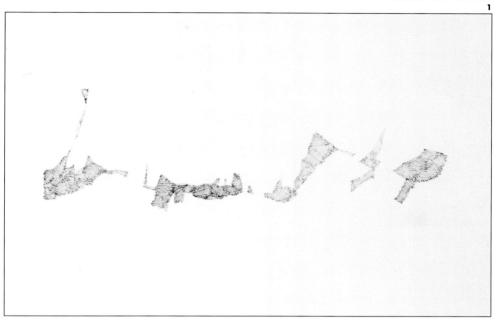

**2** Now move on to the windows behind the washing line. Switching to your new pen, define the darkest shadows using dense cross-hatching strokes. Unlike the shadows in step 1, the shape of the windows are rigid and well defined – you may find it helpful to use a ruler to achieve clean, straight edges.

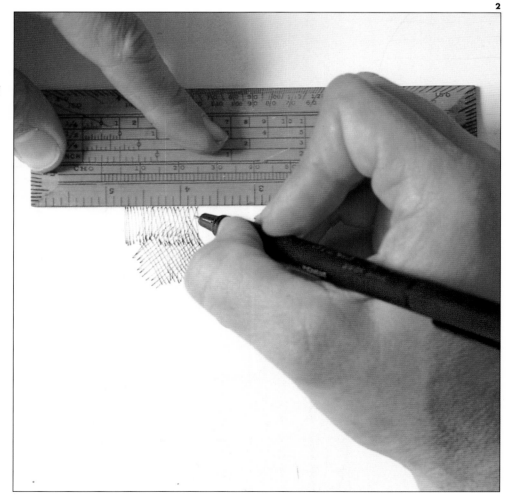

**3** Sticking with the new pen, return to the shadows behind the washing and go over them to sharpen them up. You could have used a new pen initially, but the first marks of any drawing are always the most nerve-racking, and this method allows you the opportunity to gain a little more confidence as you gather momentum. The shapes of the shirts on the washing line are established by the 'negative' process of defining the surrounding shadows.

**4** Switching back to the old pen and again using a ruler to define the straight edges, add in the lighter areas of the window. The reason for working in the darker tones first is that when you come to do the lighter tones you do not have to be quite so precise. After all, if any of the lighter lines do run over into the darker areas, no one will notice! Another advantage of using an old and a new pen is that you have a choice of dark and light tones. Moving back to the washing, start to add in the lighter shadows between the shirts and in the folds of the material with closely hatched strokes.

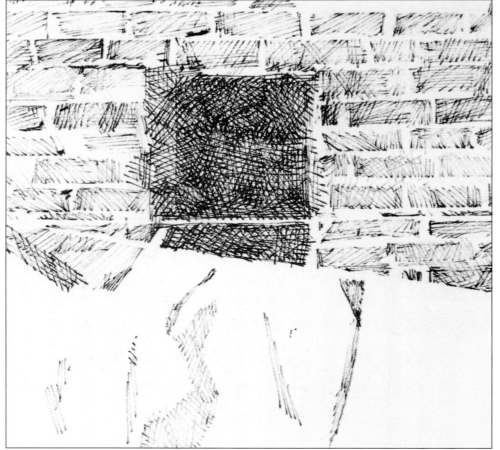

**5** Now your drawing is really beginning to take on some shape. With the old pen, start to define the brickwork. In an old building, the bricks are not neat and tidy. This is to your advantage as they will not have to be rendered precisely, so it will not be a tedious job. As you can see from this detail, a lot of random work is being done. So have some fun and use a mix of cross-hatching, hatching and scribbled strokes. Some of the bricks have a straight edge, which has been created with the aid of a ruler, but this combination of tight and loose work – when you stand back – will have created the illusion of bricks worn and crumbled due to the effects of age and weather.

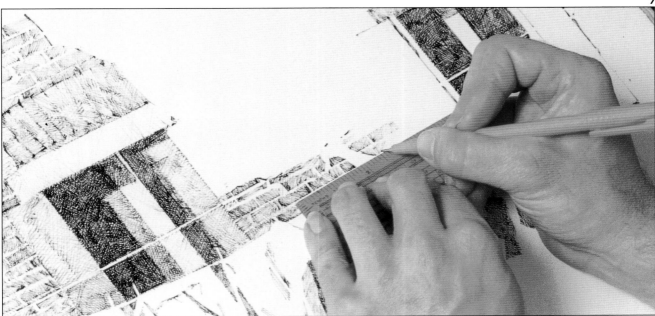

**6** This is one of those drawings where, if you become bored with one area, there is no reason why you should not move on to another area. Again using the old pen, begin to add the cracked and crumbling plasterwork of the building. Only a suggestion of line work is necessary here, so very loosely hatch in the areas to the left. By now you should be getting a real feel for the medium, and gaining plenty of confidence as your drawing takes on a new dimension at every stage.

**7** Switching to the new pen, and again using the ruler, add in the darkest areas of the window on the right-hand side. Continuing with this area, change to the old pen and finish off the lighter areas of the window and complete the rest of the brickwork as well as the outline of the shutters. Once again use a combination of loose hatching and precise, ruler-aided work. In this drawing you will notice how the white of the chosen support is used to its full potential. Whole areas, such as the shirts, are given their form purely from the shadows that are rendered around them.

## FINE LINER/VENETIAN WASHING LINE

**8** With the old pen, fill in the rest of the plasterwork using the same technique as in step 6. At this stage it is wise to a step back from your drawing and assess your progress so far. You will notice that now that the brickwork is complete your original shadows around the shirts are slightly lost. Return to them with the new pen and cross-hatch over them once again.

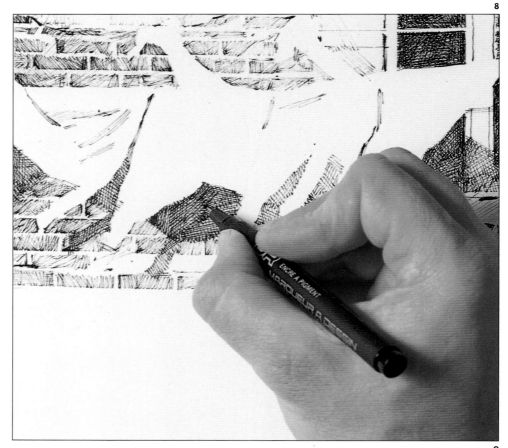

**9** The top half of your drawing should by now be looking fairly complete. However, the lower part is totally empty and it is important at this stage to obtain a correct overall view of your drawing and to create the right sense of balance. With your trusty 'old' pen, start by defining the line of the building where it meets the water, using densely hatched strokes.

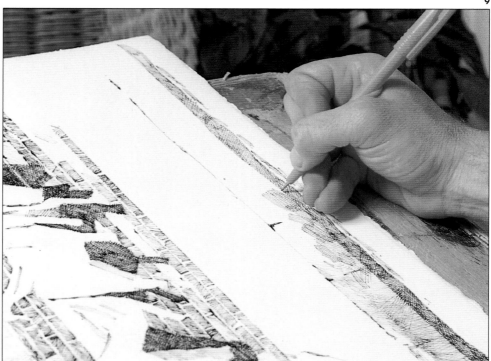

**10** Apart from the waterline mark, the whole of the lower area of the building is made up of odd patches of plaster and brickwork which have been eroded away over the years with the coming and going of the tides. Therefore your rendering can be fairly loose, using a combination of hatching, cross-hatching and scribbling, but always referring back to the original reference.

**11** At last you have reached the best stage of every drawing or painting – when you feel it is complete! Avoid the temptation to overwork the drawing. Often it is best just to walk away from it at this point and return to it at a later stage, when your involvement with it has decreased and you can view it from a more objective standpoint. The completed drawing shows how cross-hatching can be used to produce carefully controlled effects, particularly when using fine liners. Yet the finished result, far from being stilted and dead, has a lively, animated feel because the artist worked quickly and intuitively. Working with a medium which you have no real way of correcting – once you have made your mark – is a pretty nerve-racking experience. However, hopefully you have succeeded and at the very least learnt how to put an old pen to good use!

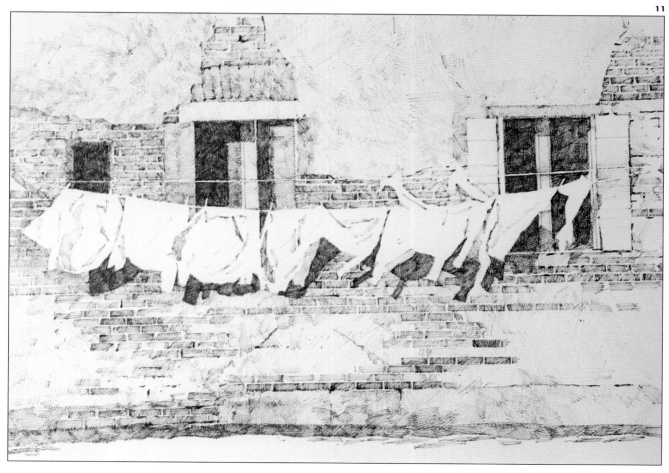

# Deserted Beach

## WEDGE-TIPPED MARKER

The composition is perfectly suited to the medium – a deserted beach, with no figures and few objects; not even the sea to introduce complicated shades of reflected colour. Yet there are challenges. The shadows play an important role and must be dramatically emphasized, in order to hold the composition together. The very simplicity could result in an uninteresting picture. And there are also technical problems involving the medium. Yet here, however, the upright umbrella and the strong horizontal shadows thrown across the sand divide the rectangular support into a harmonious and visually satisfying arrangement of shapes.

When you lay one marker on top of another, the second colour dissolves the first. This means you have to work quickly and decisively with the second colour, not returning to change or rework what went before. Alternatively, you can exploit this property, using the top colour in the same way as the artist uses lighter fuel – dabbing the colour off so that the white paper shows through in places to give a desired effect. With magic markers, it is difficult to build up tone and colour in order to describe form. So this artist avoided any subject which involved complex portrayal of form and space. Instead, a graphic picture has been produced, in sympathy with the somewhat drastic emptiness of the scene.

*Eleven markers are selected for this strikingly graphic beach scene. The markers are mainly blues and greys, the main colours in the subject, and these provide an overall theme to the colour composition. But a black permanent felt-tip marker is also added, as the black of the marker range in this case is not as deep as will be required.*

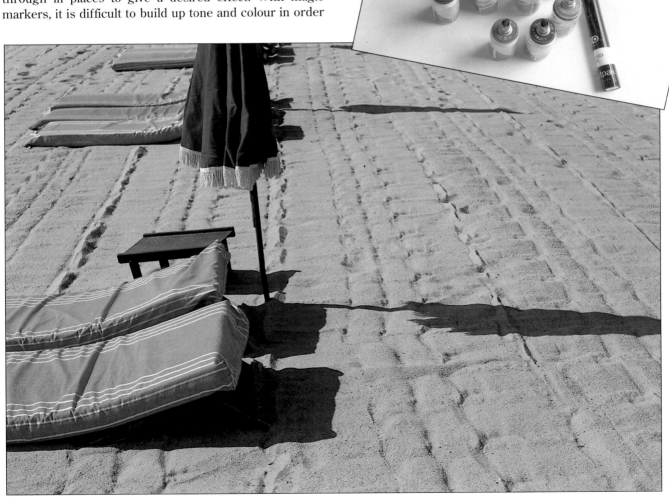

276

**1** Because marker bleeds when used on ordinary drawing paper, the artist opted for a thin sheet of special marker paper, measuring 15 in × 20 in (39 cm × 51 cm). However, the artist made a pencil drawing of the subject on a sheet of cartridge paper and laid the transparent marker paper on top of this so that the lines would show through. Brick white is used for the sand, stripping the marker (see page 263) in order to lay a broad expanse of colour quickly. Lighter fuel is sprinkled on the sand area, to achieve a slightly mottled effect. This is dabbed with a piece of tissue.

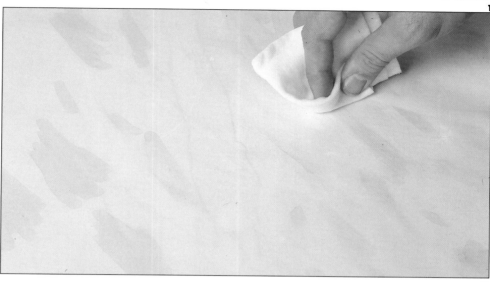

**2** The beach colour dries quickly and when this has happened the artist starts to apply more colour, working from light to dark. With markers it is important to start with the palest colours as nothing can be toned down in later stages. Two tones of blue stripes are laid on the folded umbrella; a single stroke of marker being used for each stripe.

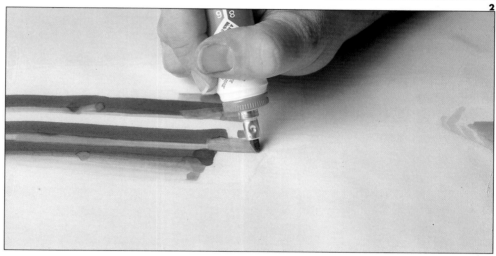

**3** So far, the artist has followed the principle of working in broad, graphic shapes. The subject was specially chosen for this, making the procedure easier – there are no rounded forms or subtle graded shadows. The lightest tones have been indicated, including an initial pale blue area in preparation for the darker blues – of the sun-beds. Before going on to the next stage the artist waits for this early blocking-in to dry thoroughly.

**4** A small decorator's brush is dipped in lighter fuel and the artist flicks this across the sand, creating more texture. This 'spattering' technique, done by rubbing the fingers across the ends of the bristles, is a popular marker method for creating mottled and marbled effects. The fluid dissolves the dried colour, showing up the white of the paper in speckled areas.

**5** When the mottled beach has dried, the artist works into the light blue of the sun-beds. First, a mid-blue is used to define the basic shapes. In this illustration, a shaded edge is being added in a darker blue. The shapes are kept flat and graphic. When using markers you have to work quickly, so shapes need to be simplified.

**6** The artist has worked into the area of the sun-beds with greys and more blues, adding these as simple flat shapes. Again, it is important to allow the colours to dry before applying new ones. Even then, the artist works quickly, to avoid disturbing the colour beneath, which dissolves as new marker is applied. The next stage is to indicate the deepest shadows in the composition, in the areas of the umbrella and sun-beds. This was initially done with the marker black, but the result was not dense enough, so the artist resorted to the stronger tone of a permanent felt-tip pen.

**7** The shadows are strengthened, the dark blacks being emphasized with permanent felt-tip. Here, it is employed in a continuous bold stroke down the shaded side of the umbrella. The marker black is reserved for the elongated shadow shapes which the evening sun throws across the sand. The shadows in this composition are as important as the actual objects. Without them, the picture would consist only of the isolated umbrella and the beds on the left-hand side. Therefore the very definite shadow shapes have to be boldly depicted, with hard edges, rather than being merely suggested by a few wispy strokes. It is this strong graphic approach which is so well suited to this particular medium.

**8**

**9** For this picture, the artist has employed markers in an unconventional way. Usually, the marker belongs in a commercial studio. It is used for layouts, for drawing up designs which will be presented to potential clients, and for producing slick photographic images. Here, however, it has been employed by a traditional artist seeking to portray an outdoor, landscape scene. The exercise succeeded, not because the artist was skilled with this medium, but because a subject was chosen which could be treated in the same, simple, graphic terms as those employed in the commercial studio. In other words, you should not overdo the adaptation of a medium for a task outside its normal role. Had the artist chosen a portrait or something similarly complicated, the experiment would not have worked. But this subject – the empty beach with a minimum of clutter and disturbance, and also a minimal amount of form – presented a perfect opportunity for a dramatic, simplified approach.

**8** The strong, dark, horizontal shadows have now been established across the sand; but this causes a problem. The sand has been textured, giving an impression of a rough, bumpy surface. The artist therefore uses the same spattering technique on the shadows, to integrate these with the sand.

Antwerp blue

Manganese blue

Cool grey (dark)

Prussian blue

Phthalo blue

Cool grey (medium)

Black

Light blue

Cool grey (light)

Black (felt-tip)

Mid-blue

Brick white

**9**

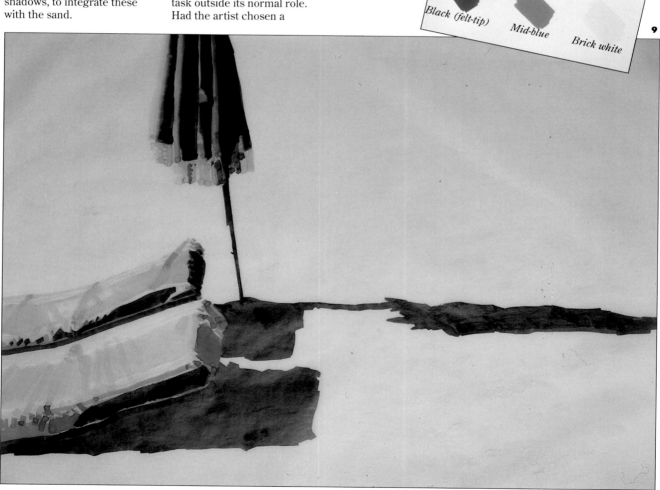

279

# City Street

## FELT-TIP PEN

The monumental buildings and wide vista of this cityscape demanded careful attention to perspective and to perpendicular lines. Despite the superficial detail and activity in the picture, the basic elements are quite simple, and the artist has exploited this underlying simplicity in the construction of the composition.

When tackling a subject such as this, in which blocks and buildings play an important role, it is useful to follow some basic rules. Firstly, make sure that all your buildings are standing upright. This advice may sound obvious, but in beginners' work there is a frequent and surprising tendency for the perpendiculars to lean outwards from the centre of the paper. This common mistake can be avoided by keeping the upright in line with the edges of the paper.

Another important principle here is that of linear perspective. Remember that parallel lines on the same plane meet at a 'vanishing point', a theoretical spot on the horizon (see page 24). This rule is particularly important in urban street scenes like this one, because the buildings are usually uniform and geometric. If your perspective is wrong, the whole drawing will look odd. Applied perspective gets easier with practice, although even experienced artists occasionally get it wrong! Meanwhile, you might find it helpful to plot the vanishing point and converging lines of your composition in the very early stages of the drawing to act as a guide. This subject also contains some aerial perspective, notably the haziness of the further buildings. However, the hard, dark lines of the felt-tip pen restricted the artist in this respect, making any indication of atmosphere and recession impossible.

All the tones and shading were left to the final stages; the prime concern lay with establishing the main elements of the composition. When this crucial stage was complete, the linear sketch had the formal and impersonal quality of an architect's drawing – a feeling emphasized by the uncompromising, mechanical nature of the line made by the felt-tip pen. The subsequent shading is free and loose in comparison, and to some extent this provided the artist with an opportunity to put a personal stamp on an otherwise anonymous drawing.

*This wide New York street recedes into the distance, converging at a theoretical spot on the horizon – a good example of linear perspective.*

**1** Working in a sketchbook measuring 16½ in × 11½ in (29.7 cm × 42 cm), the artist starts·by drawing the outline of the distant yet dominant Empire State Building; the correct positioning of the main compositional elements in this intitial stage is crucial to the finished work.

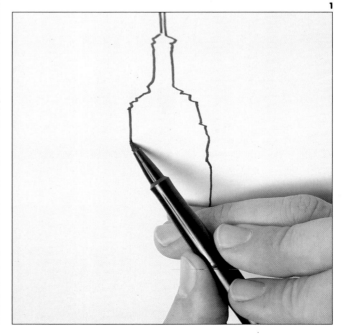

**2** Adjacent shapes are established with the same single outline. Because the felt-tip pen cannot be erased, care is taken to establish these accurately, and this is done by relating the size and position of each new building to shapes already established.

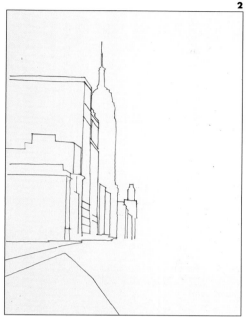

**3** The artist continues to build up the composition, with each new line being drawn in carefully observed relationship to its neighbour. Here the building on the right-hand side of the street is drawn – again, the artist plans the position of each new mark with care before committing it to paper.

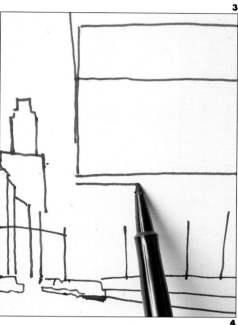

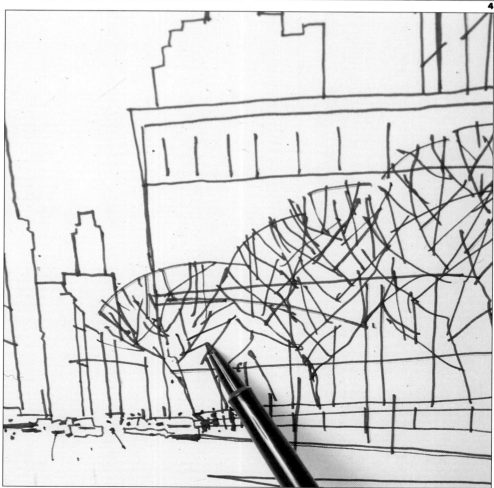

**4** The trees are treated simply, each being drawn as a basic arrangement of main branches and a trunk. However, the artist pays careful attention to the scale – the effect of distance is dependent on the receding sizes of the trees. The principle of linear perspective applies here; if an imaginary line was drawn along the bases and tops of the trees, those lines would meet at a vanishing point on the horizon.

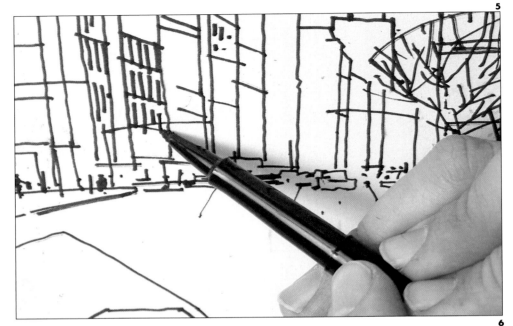

**5** The uprights of the buildings are kept strictly perpendicular and should be at right angles to the bottom of the paper. Here the artist suggests the windows of one of the blocks with short, broad upright strokes.

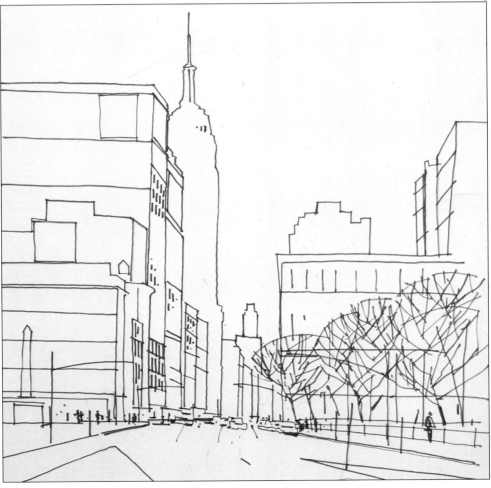

**6** The outline drawing is now complete. The main shapes and forms are established in outline; some details, such as windows and the people in the street, are suggested with short upright strokes to lend a sense of scale to the whole composition.

**7** With the basic drawing now complete, the artist turns to the tones – the lights and darks of the composition. Although the subject itself is on a grand scale, and the composition seemingly complex and busy, the basic forms are actually quite simple.

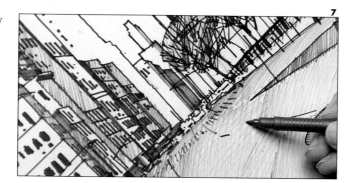

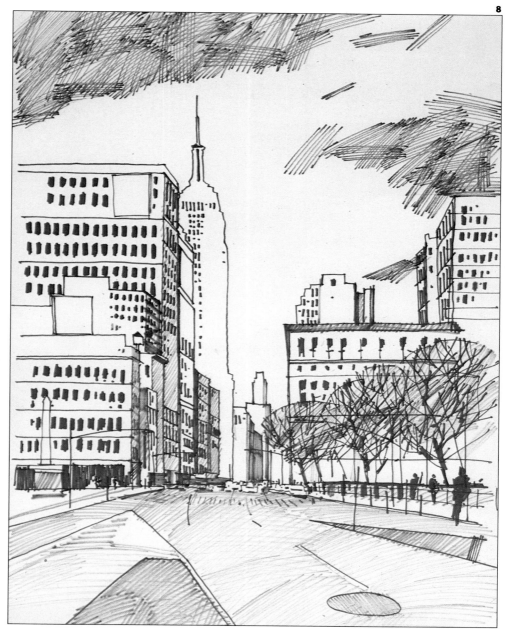

**8** In the finished sketch, the buildings are treated as simple blocks, the strong directional sunlight making it easy to pick out the light and dark sides of the rectangular forms. Some local colour is suggested in the same way – for example, the street is lightly hatched with long horizontal strokes, and the sky is broken up with patches of cross-hatching.

# Glossary

**Abstract** A drawing which relies on shapes, colours, textures and forms rather than on a realistic impression of the subject.

**Aerial perspective** Space and distance indicated by tone and colour. Objects in the distance appear lighter and bluer than those in the foreground.

**Bistre** Rich brown colour. Bistre pigment was originally obtained from soot.

**Bleed** The effect of two or more wet colours running into each other, or the effect of one colour applied to a wet support.

**Blending** Merging two neighbouring colours so that the join is gradual and imperceptible.

**Blocking-in** Refers to the initial stages of a drawing, when the main tones and forms of the subject or composition are laid.

**'Boneless' style** Brush drawing technique which does not rely on outline. The term is usually used to describe a specific Oriental style.

**Broken colour** Technically, this term refers to a colour mixed from two secondary colours. However, it is more generally used to describe a method of mixing colours on the support rather than on the palette. **Optical mixing** is one way of applying broken colour.

**Clutch pencil** Graphite or other type of pencil **Strip** held in a metal holder.

**Composition** Arrangement of elements – objects, shapes, forms and colours – in a painting or drawing.

**Conté crayon** Square, pastel-like crayons.

**Contour** Line defining shape or form.

**Cool colour** Colours can be divided into two main groups, 'warms' and 'cools'. Blues, greens and blue-violets are all cool colours.

**Cross-hatching** Technique of laying tone by building up a series of criss-cross lines.

**Dip pen** Drawing and writing tool consisting of a handle, or holder, and a changeable nib.

**Erasing shield** A small metal or plastic shield with tiny cut-out shapes. The shield protects the rest of the drawing allowing the tiny shapes to be precisely erased.

**Felt-tip pen** Drawing and writing tool with a pliable tip.

**Fibre-tip pen** Term used for one of the many new disposable writing and drawing tools which have synthetic, fibre tips.

**Fixative** Thin varnish which is sprayed onto drawings to prevent smudging.

**Form** The outward surface of a three-dimensional object.

**Graphite** A type of carbon. This is compressed with clay to make the 'lead' or **Strip** of a pencil. Graphite is also available in stick and powder form.

**Hatching** A technique for drawing areas of tone in fine, parallel strokes. The closer the strokes, the deeper the tone.

**Highlight** Emphatic patches of light, usually on a smooth or reflective surface.

**Internal colour** Actual or suggested lines describing the form within the outlines of a drawn object.

**Key** The irregularities – the dints and bumps – on the surface of the support which enable drawing materials to adhere to the paper. The key is sometimes referred to as the **Tooth**.

**Linear perspective** A means of indicating a sense of distance and recession on a two-dimensional surface by means of converging lines and a **Vanishing point**.

**Local colour** The real colour of the surface of an object without being modified by light and shade.

**Masking** The use of fluid, paper or tape to isolate a particular area of a work. This enables the artist to work freely, drawing and painting over the mask. The masked area remains unaffected.

**Mass** Bulk or volume. The satisfactory arrangement of the main masses in a composition is an important factor when planning a drawing.

**Maulstick** A support stick for the drawing hand, to avoid smudging the picture.

**Monochrome** Usually refers to a drawing tone done in black and white, but can also mean a drawing done in another single colour.

**Negative shapes** The spaces between the shapes. For example, in a plant drawing, the leaves and stems are the positive shapes; the spaces between these are the negative shapes.

**Neutral** True neutrals are greys mixed from the three primary colours – red, yellow and blue. More generally, the word refers to a mixture of colours which approaches grey.

**Oil pastel** Pastels made from pigment suspended in oil. Oil pastels are soluble in turpentine and white spirit.

**Optical mixing** Mixing colours optically, in the eye, rather than on the support. For example, dots of red and blue combine in the eye to produce an impression of purple.

**Overlaying** Putting one colour or tone on top of another.

**Pigment** Basic colours obtained from earth, mineral, plant or animal sources, or synthetically manufactured.

**Plane** Flat areas which make up the surface of an object. These can be large and obvious, such as the sides of a geometric form. Alternatively, they can be small and subtle, as on the human figure. Planes are revealed in terms of light and shade.

**Propelling pencil** Similar to a **Clutch pencil**. The **Strip** of a propelling pencil can be controlled, usually by turning a small knob.

**Rendering** Drawing or reproducing a subject.

**Sanguine** Traditional drawing colour of light reddish brown.

**Scumble** A method of mixing colours, by overlaying one colour with a thin layer of another. The overlaying colour should be applied with a rounded scribbling action.

**Sepia** Traditional drawing colour. Brownish pigment, originally obtained from the ink of the cuttlefish.

**Shading** Blocks of tone used to indicate shadow areas.

**Silverpoint** Method of drawing used extensively during the Renaissance. The technique involved the use of silver-tipped drawing tool on a specially prepared ground.

**Soft pastel** Pastels made by compressing pigment with gum and chalk. 'Soft' differentiates them from oil pastels.

**Spattering** Producing a marbled or mottled texture. This is done by drawing the fingers across a stiff brush loaded with colour to flick the texture onto the support.

**Still-life** Drawing and painting of inanimate objects such as flowers, fruit, utensils, etc.

**Stippling** Applying colour or tone as areas of fine dots. These can be done with brush, pencil, pen and ink and most other drawing implements.

**Strip** The coloured or graphite core of a pencil. Sometimes wrongly referred to as the 'lead'.

**Support** The surface on which the drawing or painting is executed. This can be paper, canvas, board, or other material.

**Technical pen** Pen with a fine tubular tip which produces a regular, precise line.

**Texture** Drawing the patterns, minute moulding or structure of a surface.

**Tint** Slight or subtle colour.

**Tone** The degree of lightness and darkness of a colour. The tonal scale runs from black to white and every colour has an equivalent tone on this scale.

**Tooth** See **Key**.

**Torchon** A pointed stump, usually made from rolled paper. It is used for spreading and blending drawing materials such as pastel, charcoal and chalk.

**Value** Tonal value, sometimes referred to merely as 'value'. See **Tone**.

**Vanishing point** The theoretical point on the horizon at which two parallel lines meet. See **Linear perspective**.

**Warm colour** Colours can be divided into 'warms' and 'cools'. The warm colours are red, orange and yellow.

# Index